LOUVRE

ABRAMS
NEW YORK

MUSÉE DU LOUVRE
ÉDITIONS

LOU

PHILIPPE APELOIG
Design

ERICH LESSING
Photographs

HENRI LOYRETTE
Foreword

DANIEL SOULIÉ
Text

VRE

400 MASTERPIECES

CONTENTS

FOREWORD

MOST VISITORS THINK of the largest museum in Paris—the Louvre—as a vast palace housing an immense collection.

And the Louvre is certainly immense. Its façades extend for nearly two miles along the riverbank and surrounding streets, enveloping sundry courtyards, and its total surface area covers forty acres. It is a living monument that has witnessed centuries of the most momentous events in the history of France and of Europe; and it is an edifice that serves as a veritable encyclopedia of all the architectural styles developed in Paris from the Middle Ages to the twenty-first century.

The Louvre consists of approximately 400,000 works of art and archaeological artifacts arranged within eight departments. Its collections can lay claim to illustrate the cultural history of the Mediterranean and Western worlds from the sixth millennium BC to the mid-nineteenth century; in addition, a selection of works represents the art of Africa, Oceania, Asia, and the Americas.

The scale of these dates and figures amply suggests how difficult it was to select from among these treasures the few hundred works that illustrate this volume. Leafing through the book, readers will, of course, find "essentials" such as the *Mona Lisa,* the *Winged Victory of Samothrace,* and the *Venus de Milo.* They will recognize the hand of Michelangelo, Dürer, and Ingres; but they will also discover numerous artworks from every epoch and in every medium that are little known beyond specialist circles. So sweeping, so comprehensive is the Louvre collection that it has a matchless ability to provide visitors who have been to the museum dozens of times with a new discovery, be it a previously unnoticed artifact hidden at the back of a display case, a newly acquired work, a sculpture taken out of storage or restored, or simply a painting the visitor's eye had not previously engaged. For a museum, this is a priceless asset.

The quality of the works on display in the museum's galleries is undeniable, and each one of them would merit a place in this book. The decision to present the works within the context of the Louvre's departments provides an overview of the entire museum without getting lost in a labyrinth of cultures and styles often difficult for the public to construe. This book certainly does not aim to replace a visit to the museum: nothing could be more surprising, seductive, interesting, and impressive than to directly confront the artworks in their appropriate architectural settings. The illustrations featured in this volume are intended only to stimulate the appetite, to preserve the memory of a few admired objects, and, above all, to make readers want to immerse themselves in the treasure troves of the Louvre.

This book represents the image the museum wishes to project: that of an illustrious collection installed in an equally illustrious historical monument. As with any choice, that of the objects selected is arbitrary. Some readers will be surprised not to find a personal favorite. Thus I leave it to each one to fill in the missing pages with images of those artworks necessary to furnish his or her imagined Louvre.

HENRI LOYRETTE
President-Director, Musée du Louvre

A HISTORY OF THE PALAIS DU LOUVRE

IN THE CENTURIES before it became one of the world's great museums, the Louvre served as a fortress and then as a royal residence.

Its origins date back to the late twelfth century, a period of incessant war between France and England. Paris, the capital of the French kingdom and the most populous city in the West, was defenseless. Around 1190, King Philip II, known as Philippe Auguste (reign 1180–1223), decided to remedy this situation. Preparing to leave on a crusade to the Holy Land with Richard the Lionhearted, the young king of England (r. 1189–99), and Holy Roman Emperor Frederick I Barbarossa (r. 1152–90), he ordered the construction of a gated wall reinforced with towers to surround his city. Since the border with Normandy, which belonged to the English king, was in Gisors, barely forty-five miles west of Paris, Philippe Auguste decided to build an additional fortification outside the city's western limits. This would be the Louvre. From its ramparts, guards could survey the old road leading north to the province of Normandy, the present-day Saint-Honoré, and the Seine, by which an enemy flotilla could strike at Paris from the south.

Construction of the first castle was promptly begun and completed around 1205.

It was not a residential palace but the site of a garrison, for the Louvre was first and foremost a stronghold, equipped with an arsenal and intended for defense. Its structure was simple: the building formed a vast quadrilateral with towers at each corner and at the center of its north and west façades. Doors flanked by massive towers were at the center of the south and east façades. Living quarters and an enormous dungeon were built into the castle walls. The keep, known as the "Great Tower of the Louvre," formed the heart of the fortress, surrounded by a dry moat, a defensive ditch without water. A second, wider moat adjacent to the exterior walls of the edifice provided an additional line of defense. Once completed, the Louvre was a modern fortress that provided efficient defenses and set a standard for the many similar fortified castles throughout the kingdom. Although Philippe Auguste's immediate successors contributed some alterations, the castle overall remained virtually unchanged until the middle of the fourteenth century.

The first significant alterations were made under Charles V (r. 1360–80). By this time, the environment of Paris had changed. The city, though still embroiled in the Hundred Years' War, had spread far beyond Philippe Auguste's protective walls, and outlying areas

again stood at the mercy of the English. In 1358, Étienne Marcel, the merchants' provost, had commissioned a new defensive wall on the right bank, which Charles V would complete and reinforce. Unlike the earlier rampart, which did not completely enclose the Louvre, the new wall surrounded the castle. The Louvre thus lost its position as a front-line defense protecting the gates to the city; now the king could transform it into a royal residence.

In 1360, Raymond du Temple began the work that would turn the gloomy fortress into a modern palace. New living quarters were constructed in the central courtyard; walls were pierced for windows; and apartments were created. The roofs of the living quarters and towers were revamped, and endowed with ornate lead decoration. A miniature from the renowned fifteenth-century illuminated manuscript, the *Très Riches Heures du duc de Berry* (The Very Rich Hours of the Duke of Berry) and two paintings in the museum's collections, the *Altarpiece for the Parliament of Paris* (no. 1) and the *Pietà of Saint-Germain-des-Près* (no. 2), show the Louvre as it was at the time. But the fairy-tale château was abandoned soon after the king's death and the madness of his son, Charles VI (r. 1380–1422). When the English once more occu-

pied Paris, they quartered a garrison there. Meanwhile, the new king, young Charles VII (r. 1422–61), had settled in Bourges and in the Loire Valley. For more than a century, no French sovereign resided at the Louvre.

The situation changed during the Renaissance. In 1527, Francis I (r. 1515–47), who had been held captive in Spain after the French defeat in Pavia, returned at the end of the Italian wars to announce that he intended to come back to his capital. Work on the Louvre began with the demolition of the Great Tower, the old keep that for three centuries had occupied the center of the courtyard. The tower's demise brought light and air to the palace. Inside, changes were limited to restoring, cleaning, and modernizing the old rooms. When Charles V, Holy Roman Emperor (r. 1519–56) and king of Spain, visited Paris and stayed at the Louvre, it was still a badly patched-up old palace. It was probably this visit that provided the impetus for Francis I to thoroughly renovate the building: the king desired to create modern accommodations for receiving distinguished guests.

Nonetheless, construction started very late. In 1546 it was decided to destroy the west wing of the medieval Louvre and replace it with a modern structure designed by

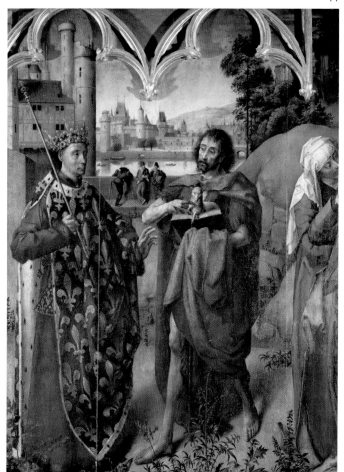

1

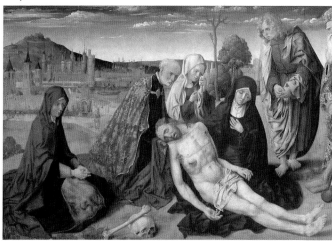

2

1
Master of Dreux Budé (André d'Ypres)
French, active 1428–c. 1450
Altarpiece for the Parliament of Paris (detail), first half of 15th century
Oil on wood
89 × 106 1/4 in. (226 × 270 cm)

2
Master of Saint-Germain-des-Prés
French (German), active c. 15th–16th century
Pietà of Saint-Germain-des-Prés, last quarter of 15th century
Oil on wood
38 1/4 × 78 in. (97 × 198 cm)

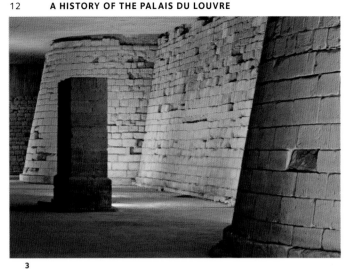

3

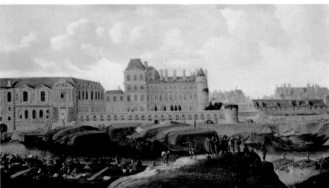

4

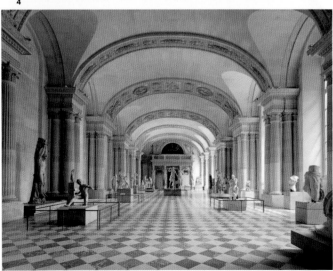

5

architect Pierre Lescot and decorated by the sculptor Pierre Goujon. Francis I, who died a few months later, lived to see nothing beyond the foundations of his new palace. His son and successor, Henry II (r. 1547–59), completed the project after major alterations that included the addition of a new level. Inside the palace, in place of the traditional central grand staircase leading to smaller rooms on both sides, a lateral staircase left room on each floor for a single vast hall. As these plans were being carried out, the king ordered the demolition of the south wing of the medieval Louvre, along the Seine, and had it replaced with a new edifice emulating the façades of the wing designed by Lescot. The King's Pavilion, an imposing multilevel edifice intended to house the sovereign's apartments, was erected in the southwest corner of the Louvre to connect these two wings. The Renaissance Louvre was a perpetual construction site. The court lived in a building that contained sections more than 350 years old—and sometimes in an advanced state of disrepair—while other parts were newly finished or in the midst of construction. The attendant difficulties in organizing court life, along with the noise, crowds, and odors from the nearby city, tended to make stays in Paris rather disagreeable.

Parts of the sixteenth-century Louvre that remain visible to this day, despite the changes made during the seventeenth and nineteenth centuries, include the Caryatids Room (no. 5), which retains its Renaissance appearance, and the fabulous gallery with its sculptures by Jean Goujon. There also remains part of the ceiling of Henry II's antechamber, which has since been furnished with paintings by Braque (no. 19), as well as paneling removed from the king's large bedroom and remounted in the Sully Wing.

Construction in the south wing of the palace continued through the last third of the sixteenth century, and its decoration was not completed until the reign of Henry IV. Yet, a short distance from the palace, more significant changes were underway. In 1564, Catherine de Médicis, widow of Henry II, began building a new palace on land bought by the Crown: the Tuileries (nos. 13, 14) had entered history. The structure was erected near the Louvre, outside the ancient ramparts of Charles V and therefore outside the city; its location allowed for a vast park to be installed in front of it. The park was decorated with flower beds and a celebrated artificial grotto covered in ornamental terracotta works by Bernard Palissy. Work on the new palace dragged along. The project, which was initial-

ly entrusted to Philibert de l'Orme, then Jean Bullant, was perhaps too ambitious. Construction was halted during the 1570s, and gradually picked up again only after the scale of the initial plan was significantly reduced.

As work on the Tuileries proceeded, there developed the idea of a direct passage from the new palace to the Louvre. This "Grand Design," devised in 1594 under Henry IV (r. 1589–1610), called for the construction of the Grande Galerie (nos. 9, 23); completion of the Tuileries; and the potential quadrupling of the Louvre's surface area. The grand design also included plans for the present-day Cour Carrée. Work began almost immediately. By the time of the king's death in 1610, the Galerie du Bord-de-l'Eau, the current Grande Galerie, was finished, with only the interior décor awaiting completion. Two architects were hired to offset the monotonous effect of a 1,450-foot wing with a single long façade: Jacques II Androuet du Cerceau designed the western part and Louis Métezeau the eastern part. At the same time that this immense structure was being completed, Henry IV ordered the construction of an additional floor above the Petite Galerie, the main body of a building erected in the 1560s, probably at the request of Catherine de Médicis. The Gallery of Kings and Queens, now replaced by

the Apollo Gallery (nos. 6, 7, 8), was installed on the new level to provide a direct passage from the King's Pavilion to the Grande Galerie and a sumptuous new reception hall for the Louvre.

The death of Henry IV in 1610 put a halt to work on the Louvre. It wasn't until 1624 that Louis XIII (r. 1610–43), guided by Cardinal Richelieu, took things in hand. He ordered the demolition of the north wing of the medieval Louvre and the addition of a pavilion as well as a new wing symmetrical to Lescot's Renaissance wing. At first Clément Métezeau was commissioned to design the pavilion and the new wing, but he was later replaced by Jacques Lemercier. Both architects followed the broad outlines established sixty years earlier by Lescot's design for the façades. The bulk of the construction work had been finished by the time of the king's death in 1643, but a century and a half would pass before the interiors were completed. Under Louis XIII, the Cour Carrée began to assume the dimensions it retains to the present day.

It was Louis XIV (r. 1643–1715)—and much later, Napoléon III (r. 1852–70)—who had the most significant impact on the structure we know today. From 1660 to 1678, Louis turned the Cour Carrée into the magnificent place that astounds twenty-first-

3
Dry moats to the north of the medieval Louvre and support of bridge leading to the king's garden
4
Zeeman (Reiner Nooms)
Dutch, 1623–c. 1668
View of the Old Louvre and the Petit Bourbon, c. 1650
Oil on canvas
17 ³/₄ × 30 ³/₄ in. (45 × 78 cm)

5
At the heart of the Renaissance Louvre, the Caryatids Room—renovated in the eighteenth and nineteenth centuries—and the musicians' platform decorated by Jean Goujon

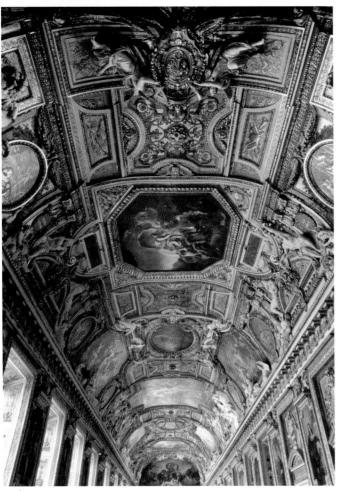

6

7

8

6
The Apollo Gallery
Interior view

7
Charles Le Brun
French, 1619–1690
Night, or Diana (detail of
Minerva and Mercury, armed),
1663–77
Decoration for the vaulted
ceiling of the Apollo Gallery
Oil on glued canvas
122 × 201 1/8 in. (310 × 511 cm)

8
Eugène Delacroix
French, 1798–1863
Apollo Slays Python (detail),
1850–51
Decoration for the vaulted
ceiling of the Apollo Gallery
Oil on glued canvas
315 × 295 1/4 in. (800 × 750 cm)

9
Hubert Robert
French, 1733–1808
The Grande Galerie, c. 1801–5
Oil on canvas
14 5/8 × 18 1/8 in. (37 × 46 cm)

10
Prosper Lafaye
French, 1806–1883
*Petit Salon of Marie d'Orléans
at the Tuileries*, c. 1841–42
Oil on canvas
28 3/8 × 40 1/8 in. (72 × 102 cm)

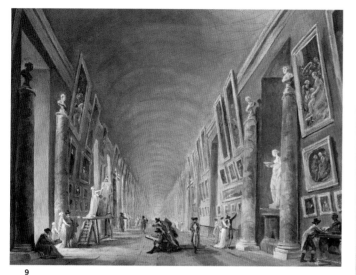

9

10

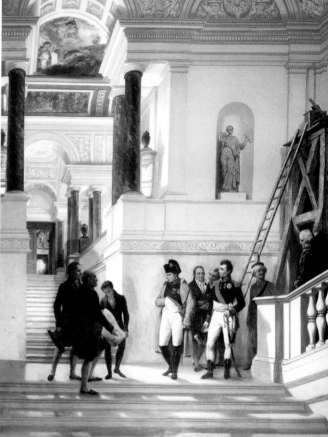

11

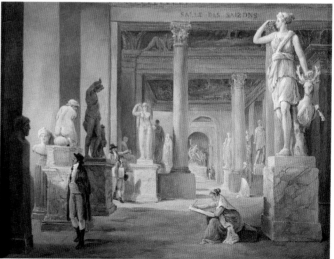

12

11
Louis Charles Auguste Couder
French, 1789–1873
Napoléon at the Louvre
Staircase Guided by the
Architects Percier and
Fontaine, 1833
Oil on canvas
69 3/4 × 53 1/8 in. (177 × 135 cm)

12
Hubert Robert
French, 1733–1808
The Seasons' Room, 1802–3
Oil on canvas
14 5/8 × 18 1/8 in. (37 × 46 cm)

century visitors. Work on the Louvre under Louis XIV was long and arduous, stretching far past its deadlines. The initial stage involved the demolition of the last vestige of the medieval Louvre: the eastern wing that had been serving as the entrance to the palace courtyard. Actual construction began with the north wing, along the current rue de Rivoli, from 1661 to 1667. At the time the north wing was erected, the length of the south wing was doubled to match the new wing's dimensions; the first part of the south wing was begun under Henry II and completed under Henry IV. The construction of the east wing would take far longer. A succession of plans was submitted: an initial plan by Louis Le Vau and two by the great Italian Baroque sculptor and architect Bernini were rejected before a design by a council of French architects and artists—including Claude Perrault, Louis Le Vau, and Charles Le Brun—was eventually adopted in 1667 and carried out. This colonnade facing the church of Saint-Germain-l'Auxerrois remains the Louvre's monumental entrance.

Louis XIV, barely ascended to the throne, arranged for summer apartments for his mother, Anne of Austria, to be built in the oldest part of the palace. The Anguier stucco and Romanelli paintings decorating the apartment ceilings, which have been preserved, are marvelous examples of the interior design of the period. In 1661, a fire destroyed the Gallery of Kings built by Henry IV; and the young king ordered its reconstruction under the name of the Apollo Gallery.

While the Louvre was under construction, Louis XIV completed the Tuileries Palace and temporarily moved in. However, the king's stays at his residence in Versailles became increasingly frequent, and in 1678 work on the Parisian residences came to a virtual halt. It would not begin again until 1754.

Aside from establishing the Louvre as an art museum and renovating the Grande Galerie to accommodate the collections of paintings recently decreed national property, the Revolution did not initiate notable architectural changes. Although many renovation plans were submitted by designers such as Charles de Wailly, a distinguished eighteenth-century Neoclassical architect and one of the first curators of the Louvre, none were actually carried out. Napoléon I (r. 1804–15) commissioned work for a few new galleries in which to display the art collection. But his principal contribution to the Louvre was the construction of a "second Grande Galerie" along the current rue de Rivoli, intended to enclose the space between the Louvre and the Tuileries and thus complete the "Grand Design" of Henry IV. However, only a west wing attached to the Marsan Pavilion was constructed, and the project remained unfinished.

Napoléon did take advantage of this opportunity to open up some space that stood between the two palaces. The entire area between the rue Saint-Nicaise—which no longer exists—and the Tuileries was razed, and in its place a main courtyard was laid out in front of the palace. Enclosed by a grille, the entrance to the courtyard is still marked by the Arc du Carrousel, designed by the Imperial architects Charles Percier and Pierre-François-Léonard Fontaine (no. 11), known for their development of the neoclassical Empire style. As for the Louvre itself, Napoléon completed the wings Louis XIV had planned for the Cour Carrée. Missing sections of the top floor were added, and the upper portions of the building were unified to create a harmonious space.

Decades would pass before the next major changes to the structure. In 1852, shortly after becoming emperor, Napoléon III (r. 1852–70) took on the task of completing the Louvre. This involved finishing the north passage begun by Napoléon I and clearing the blocks of housing surrounding the building.

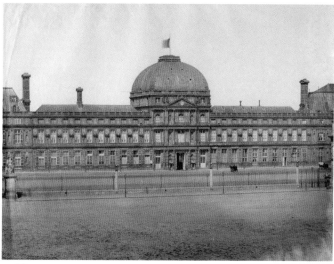

13

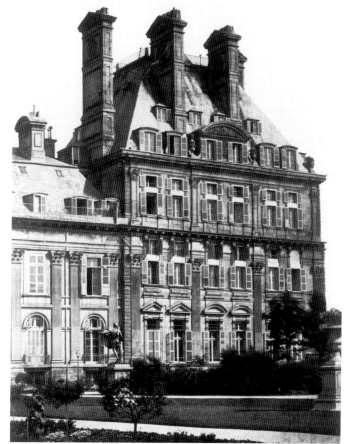

14

13
Édouard Denis Baldus
French, 1813–1889
Tuileries Palace, east façade of the central segment facing the Carrousel Courtyard, c. 1860
Photograph Musée d'Orsay

14
Tuileries Palace
View of the Flore Pavilion, c. 1860
Photograph

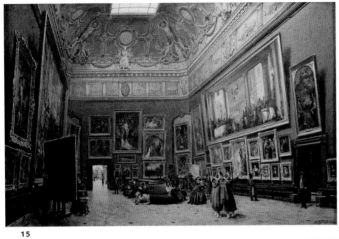

15

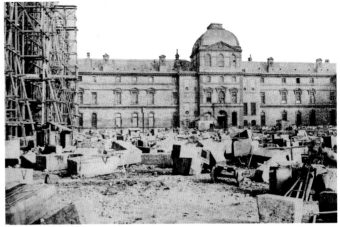

17

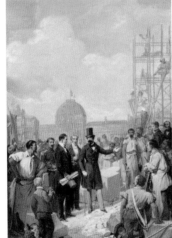

16

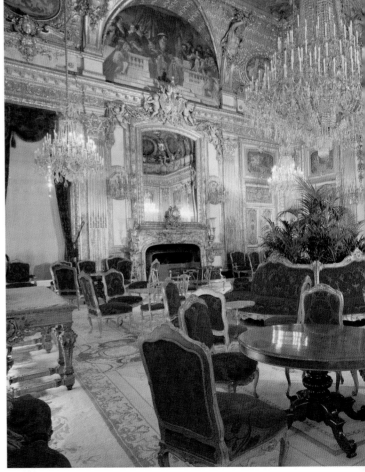

18

The demolition of the last residential structures standing between the two palaces took only a few months, and the construction of the new wings, started that year, was finished in 1857. At the same time, the eastern extension of the rue de Rivoli, initiated under Napoléon I, was completed. The architects Visconti and Hector-Martin Lefuel built two large structures around several courtyards. To the north, along the rue de Rivoli, the Richelieu wing was erected surrounding three vast courtyards, with its main façades facing rue de Rivoli and the Cour Napoléon to the south. The Denon Wing, also to the south, surrounded two courtyards; its north façade, facing the Cour Napoléon, was new, while its south façade consisted of the Grande Galerie. The richly embellished new buildings were inspired by the palace's older structures, emulating the dimensions and general outlines of the pavilions, while the sculpted décor was modeled on the Renaissance style. The truly lavish interiors were reached by several monumental stairways. Most are still extant, as are the apartments of Napoléon III. The most acclaimed nineteenth-century sculptors were called upon to realize the décor. Jean-Baptiste Carpeaux, among others, created a number of works for the new Flore Pavilion.

The emperor did not devote himself solely to the Louvre. He also devised an ambitious program to restore and reconstruct the Tuileries in order to create a more comfortable residence and reception rooms for the imperial family. Maintenance work was carried out in different parts of the palace that were in particularly bad shape. Between 1861 and 1864, for example, the old Flore Pavilion (no. 14) and the western part of the Grande Galerie, which was on the verge of collapsing, were demolished. Only a few years later, in 1871, the communards—chased out of the heart of Paris by government troops—set fire to the Tuileries and burned it to the ground. The demolition of its ruins in 1882 marked the demise of one of the most venerable Parisian monuments; but it also opened up views of the Tuileries gardens, the Place de la Concorde, the Champs Élysées, and the Arc de Triomphe.

Apart from some interior refitting and modifications, the Louvre changed little during the following decades. It survived the flood of 1910 as well as the First and Second World War. Despite minor modernizations and alterations, the old palace seemed to be frozen in time, its masterpieces safely locked inside.

In 1981 things suddenly changed. The election of François Mitterand to the presidency

15
Giuseppe Castiglione
Italian, 1829–1906
View of the Salon Carré at the Musée du Louvre, 1861
Oil on canvas
27 1/8 × 40 1/2 in. (69 × 103 cm)

16
Nicolas Gosse
French, 1787–1878
Napoleon III Visiting Workers at the Louvre, 1854
Oil on canvas
13 3/8 × 9 in. (34 × 23 cm)

17
Attributed to Édouard Denis Baldus
French, 1813–1889
Construction Site of the Napoléon Courtyard, c. 1854
Photograph

18
Napoleon III apartment, grand salon

of the Republic (1981–95) was soon followed by an announcement: the state planned to significantly expand the Louvre by turning over to it the Richelieu Wing, then occupied by the Ministry of Finance. The "Grand Louvre" project was born. This called for the museum to inhabit the entire palace, except for the Marsan Wing occupied by the Museum of Decorative Arts; and, most important, it envisioned the restoration of all the buildings and construction of a new main entrance to accommodate the projected increase in number of visitors. Selected as architect in 1983, Ieoh Ming (I. M.) Pei (nos. 21, 22, 24–26) designed the glass pyramid and conceived the plan for the interior refitting and reconstruction of the palace.

The beginning of restoration work on the Cour Carrée added a significant new element to the general plan when archaeologists working on the courtyard unearthed extremely well-preserved remnants of the Louvre of Philippe Auguste and Charles V. It was decided to preserve these ruins and incorporate them into the visitors' circuit of the modernized Louvre. The new museum was built in several stages: the first made it possible for the pyramid and the medieval Louvre to open to the public in March 1989; a second stage culminated in the inauguration of the Richelieu Wing and its four floors of new exhibition space in 1993; next came the Cour Carrée galleries; and, finally, in 1997, the renovated and expanded spaces devoted to the departments of Near Eastern and Egyptian Antiquities. In 2006 it was decided to build new galleries in one of the courtyards of the Denon Wing to house the new Department of Islamic Arts; this is the latest and perhaps final stage in this long project that will have lasted nearly twenty-five years.

In more than eight hundred years of history, the Louvre has been the stage for innumerable major events—both happy and unhappy—recorded in the history of France. The first prisoner in the keep—and the only one of any importance—was Ferdinand of Portugal, count of Flanders, who was held captive there after the Battle of Bouvines in 1214. Charles V studied the books lining the shelves of his Library Tower for hours before strolling through the gardens beneath the current Cour Carrée. In 1541, Charles V, Holy Roman Emperor and king of Spain, was received with much pomp and circumstance by his former enemy Francis I and housed in the old château. The Renaissance Louvre bore witness both to the Saint Bartholomew massacres of August 24, 1572—Protestants were killed in the royal apartments—and to the festivities arranged by Henry III (1574–89) for the wedding of the duc de Joyeuse, his favorite. In 1610, a wax effigy of Henry IV was displayed for several days in the Caryatids Room so that Parisians could pay tribute to their assassinated king. A few years later, on April 24, 1617, Concini, the favorite of Queen Mother Marie de Médicis, was assassinated on the palace's drawbridge by order of young Louis XIII. Molière performed for the king in the Caryatids Room, which also housed meetings of the French Academy before Napoléon I had it moved across the Seine. Napoléon I wed Archduchess Marie-Louise in the Salon Carré, which was turned into a chapel for the occasion. During the Revolution, following the night of August 10, 1792, and their imprisonment in the Temple, the royal family moved into the Tuileries. Having taken the royal family's place in the Grand Palais, the Revolutionary assembly made many important decisions there. Charles de Gaulle wanted to build a new presidential palace where the Tuileries Palace had stood. Had his project not gone unrealized for financial reasons, the Louvre would have remained what it had always been—the true heart of Paris and of France.

19
Georges Braque
French, 1882–1963
The Birds, 1953
Decoration for the Henri II Hall
Oil on canvas
106 1/4 × 83 1/2 in. (270 × 212 cm)

20
Anselm Kiefer
German, b. 1945
Athanor, 2007
Emulsion, shellac, oil, chalk, lead,
silver, and gold on canvas
13 1/8 × 32 3/4 ft. (4 × 10m)

21
**The Winged Victory of
Samothrace Staircase**

22
I. M. Pei (architect)
American, b. 1917
The Richelieu Wing
escalators, 1993

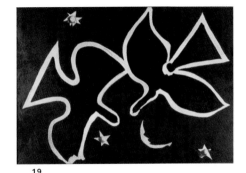

19

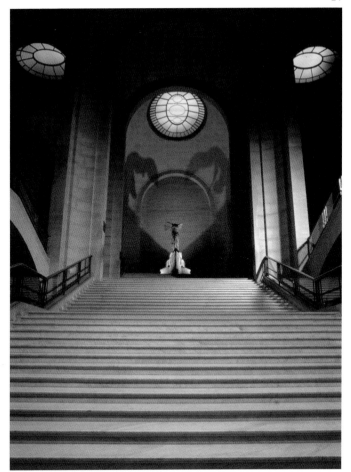

21

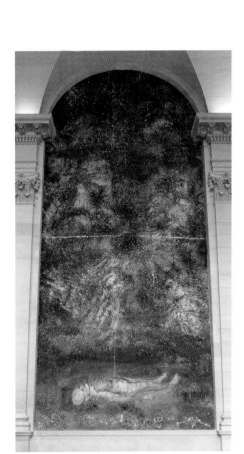

20

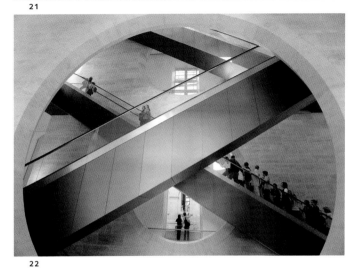

22

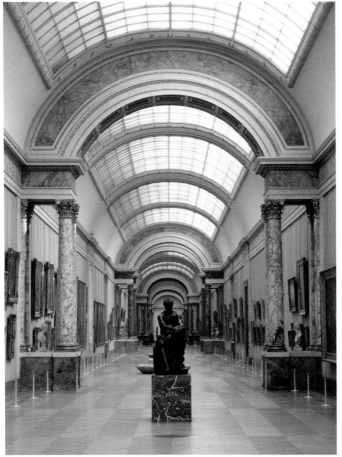

23

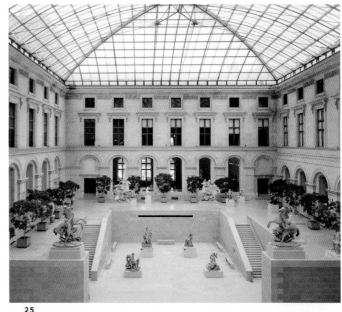

25

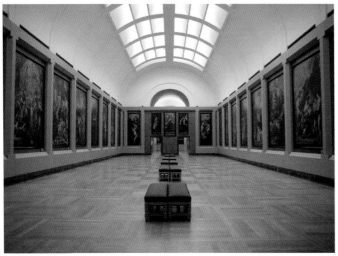

24

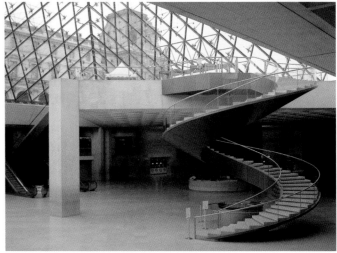

26

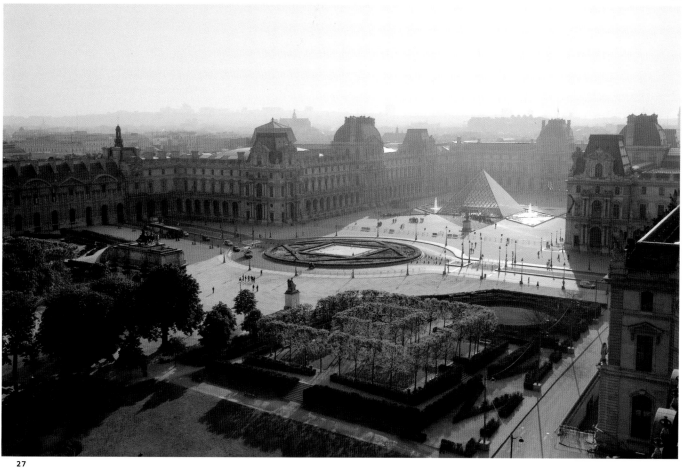

27

NEAR EASTERN ANTIQUITIES

THE LOUVRE IS one of the few museums with major collections devoted to the civilizations of the ancient Near and Middle East; they are installed in the Department of Near Eastern Antiquities. The museum enjoys historic eminence in this field because it was the first public institution to build a collection from this part of the world. Even today, only the British Museum in London and the Pergamon in Berlin, among Western museums, can claim such important holdings.

Archaeological excavations conducted from 1843 to 1854 by Paul Émile Botta on the site of the Palace of Khorsabad, near Nineveh, led to a rediscovery of the ancient Mesopotamian civilizations. The Assyrian Museum that opened shortly thereafter in the Cour Carrée was the first of its kind, in both France and the entire world. The collection was largely assembled through a program of architectural expeditions to the Near and Middle East that lasted from the mid-nineteenth century until the Second World War. The Louvre's expeditions to Khorsabad, Telloh, Ugarit, and Susa excavated the sites where history was written. Agreements on sharing its finds according to principles accepted by the Near and Middle Eastern countries in which the archaeological sites were located made it possible for the Louvre to build its impressive collection.

The Department of Near Eastern Antiquities encompasses the longest time span and largest geographical area of any department in the Louvre. Its collections range from the tenth millennium BC to the Arab conquest. The territorial domain is equally vast, stretching from the western shores of the Mediterranean to the mountains of Afghanistan, including entire nations such as Turkey, Cyprus, Syria, Iraq, and Iran as well as the Arabian Peninsula.

Embracing great reaches of the Near and Middle East, the Louvre's collection is exhaustive in each area. The Mesopotamian holdings portray the birth of cities and creation of the first empires through development of the powerful states of Babylon and Assyria. The Louvre's collection of Sumerian sculpture is unequaled outside of Baghdad. At its heart is an impressive series of statues of Gudea, prince of Lagash (no. 31) and an exceptionally beautiful representation of Ebih-il (no. 28). The department's Sumerian holdings also include reliefs, steles (grave markers), a great many inscribed clay tablets, and a valuable collection of cylinder seals. Babylon is represented by a large series of objects discovered in Susa, in the former kingdom of Elam, where they had been brought as spoils of war. Among them is one of the most important artifacts in the history of these civilizations, the Code of Hammurabi (no. 33), considered the oldest law text to have survived to the present day. Remnants of the sculpted walls of the palaces of Khorsabad and Nineveh, with their numerous inscriptions, comprise the Louvre's Assyrian holdings.

The Near Eastern Antiquities collection is particularly strong on ancient Iran. Excavations in Susa uncovered tens of thousands of objects illuminating the city's history for nearly five thousand years. These include great quantities of ceramics and everyday objects as well as decorations from a palace of the Persian era, with its glazed brick friezes of archers (nos. 54, 55) and its monumental dome rising several meters high.

The department's Syrian collection benefited from archaeological digs undertaken during the period of the French mandate over the region. Ras Shamra, the former Ugarit (nos. 61, 62), yielded many objects ranging through several millennia. The Louvre's Mesopotamian holdings were significantly enhanced by the discovery of a

vast palace from the second millennium BC in Mari, an ancient site in eastern Syria. Funerary busts and Roman-era sculptures found in Palmyra and Dura-Europos illustrate more recent Syrian periods.

Lebanon and its colonial territories, particularly Carthage and the Punic world, are also well represented in the collections. The historical link connecting France to Lebanon and Tunisia accounts for the richness and quality of the museum's holdings from these areas. Monumental sarcophagi of rulers and private citizens, sculptures and steles, ceramics and glass objects provide a comprehensive overview of the region's cultures that are so important because of their close relationships with both Egyptian civilization and the classical world of Greece and Rome.

Along with Carthage, Cyprus is the westernmost area included in the department's collections. This eastern Mediterranean island was a place where the Egyptian, Syrian, and Greek cultures made contact, and a virtually unavoidable stopping place for the navigators of antiquity. The Louvre owns beautiful statuary and numerous artifacts ranging from the Bronze Age to the Roman era.

The Arabian Peninsula brings up the rear, both in space and time. Its sculptures and inscriptions worked in alabaster and metal constitute an excellent stepping-stone to the Department of Islamic Arts, a natural extension of Near Eastern Antiquities.

Since 1993, the museum's Mesopotamian galleries have been located on the ground floor of the Richelieu Wing, surrounding an old courtyard filled with reliefs excavated at the site and thus partially re-creating the palace of Khorsabad (nos. 37, 38, 43). The inauguration in 1997 of the Sackler Wing, on the ground floor of the Cour Carrée's north wing, allowed for a particularly rich display of other cultures represented in the department's collection.

Because of the political and military situation in parts of the Middle East, the department can acquire few new works. However, an active borrowing policy enables it to exhibit important objects loaned by foreign institutions, which helps to fill the few gaps in its holdings.

28
**Ebih-il, Superintendent
of Mari**
Mesopotamia, Mari (Syria),
Archaic Dynasties, c. 2400 BC
Gypsum, lapis lazuli, and shell
Height 20 1/2 in. (52 cm)

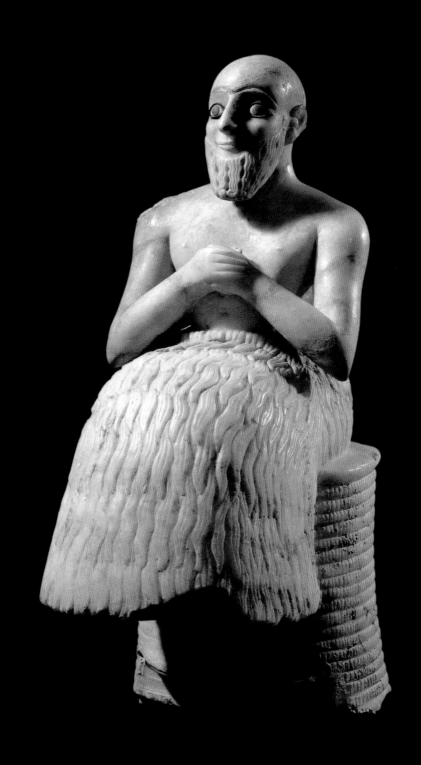

29
Victory Stele of King Naram-Sin
Mesopotamia, Susa (Iran), Akkadian, 2254–2218 BC
Pink limestone
78 3/4 × 41 3/8 in. (200 × 105 cm)

30
Perforated Relief of Ur Nanshe, King of Lagash
Mesopotamia, Telloh (Iraq), 2500–2250 BC
Limestone
15 3/8 × 18 1/8 × 2 3/8 in. (39 × 46 × 6 cm)

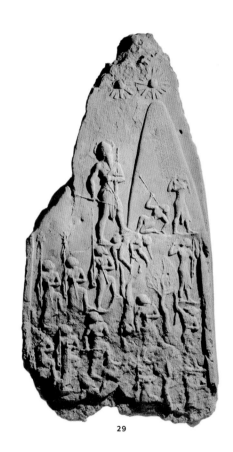

29

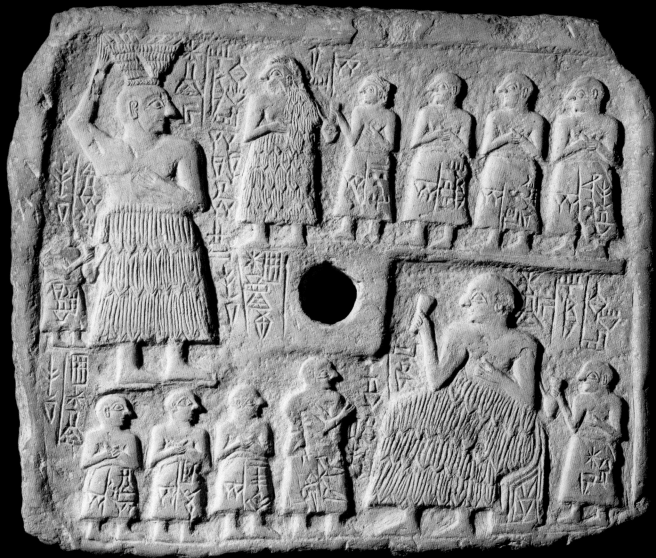

31A, 31B
Standing Gudea
Mesopotamia, Telloh (Iraq),
C. 2120 BC
Diorite
Height 14 1/4 in. (36 cm)

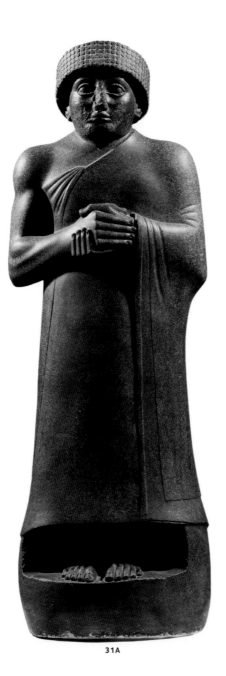

31A

31B

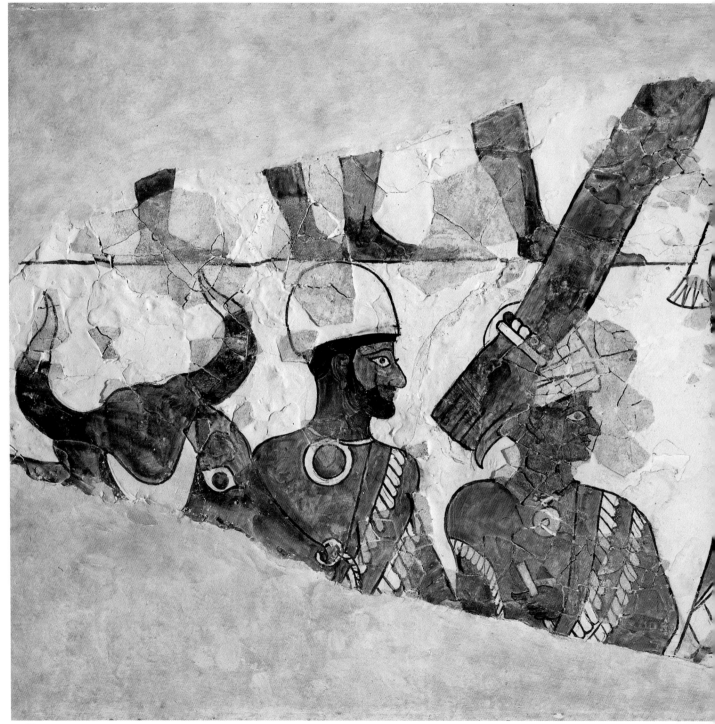

**Wall Painting (The Director
of the Sacrifice)**
Mesopotamia, Mari (Syria),
c. 1780 BC
Tempera paint on plaster
29 7/8 × 52 in. (76 × 132 cm)

33A, 33B
**Law Code of Hammurabi,
King of Babylon**
Mesopotamia, Susa (Iran),
1792–1750 BC
Basalt
Height 88 ⅝ in. (225 cm)

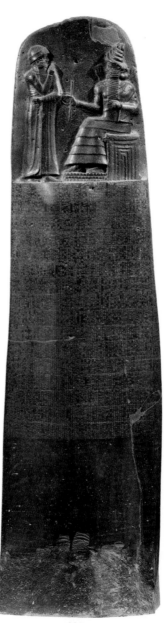

33A

33B

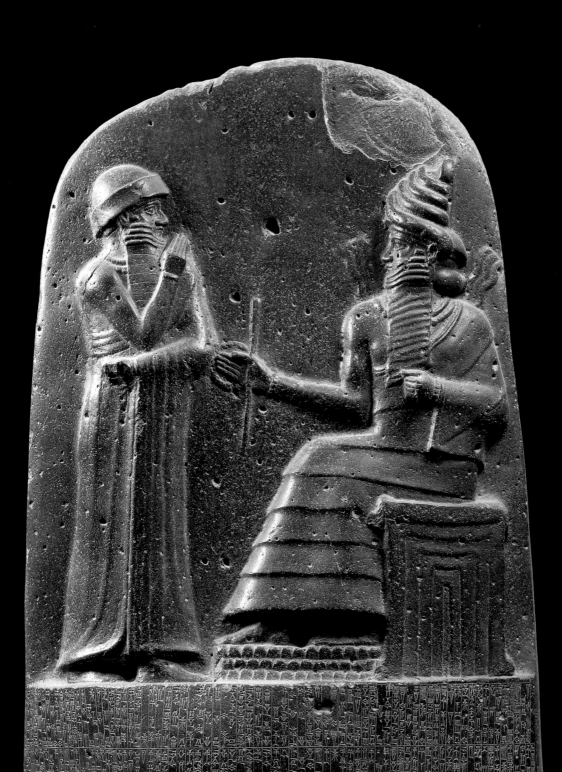

34A, 34B
**Frieze of a Mosaic Panel
(The Mari Standard)**
Mesopotamia, Mari (Syria),
C. 2500–2400 BC
Shell and shale
Height of figures 4 ³/₈ in. (11 cm)

34A 34B

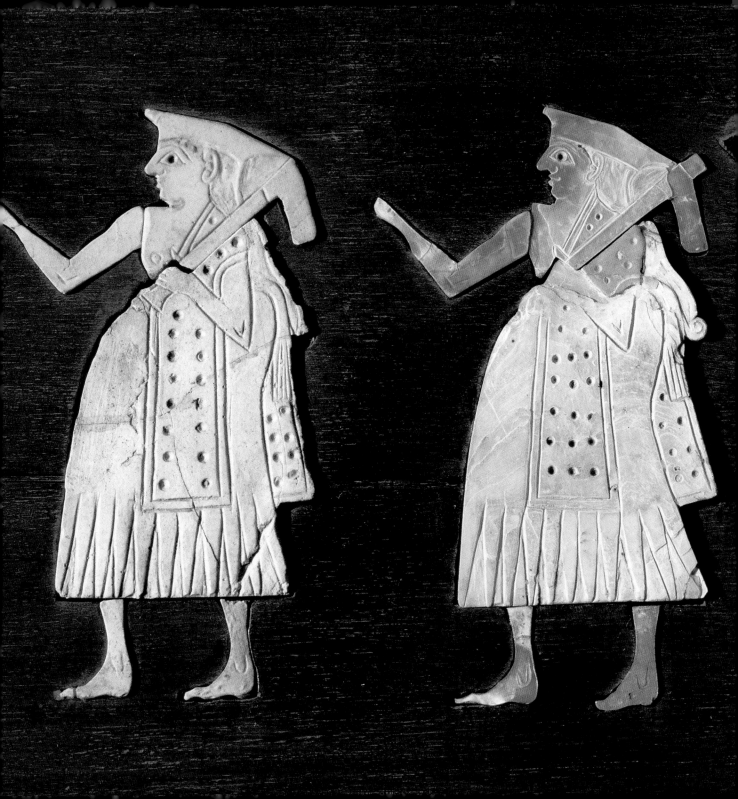

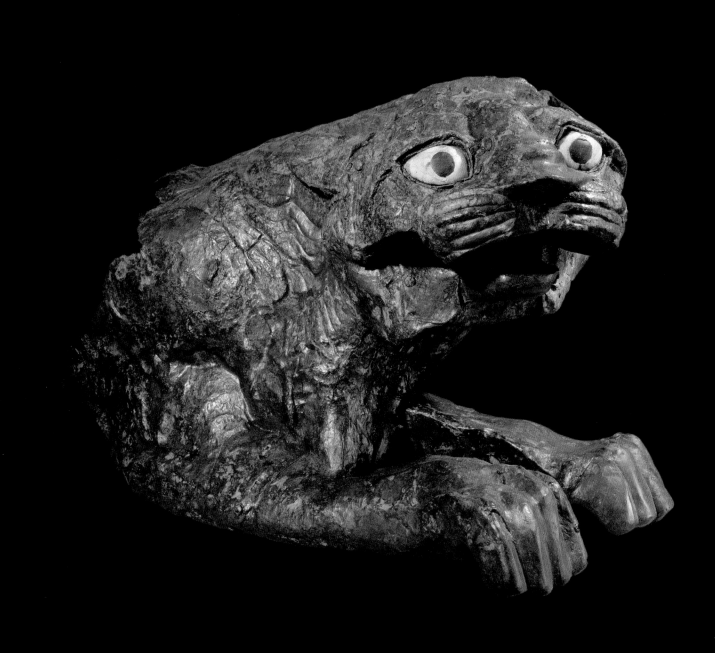

35
Lion from the Temple of
Dagan (Mari Lion)
Mesopotamia, Mari (Syria),
2nd millennium BC
Hammered copper, with eyes inlaid
in shale and limestone
Height 15 in. (38 cm);
width 27 1/2 in. (70 cm)

36
Statuette of the Demon
Pazuzu with an Inscription
Mesopotamia, 1st millennium BC
Bronze
Height 5 7/8 in. (15 cm)

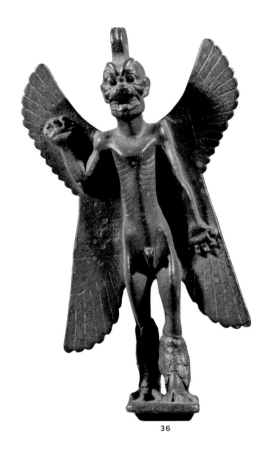

36

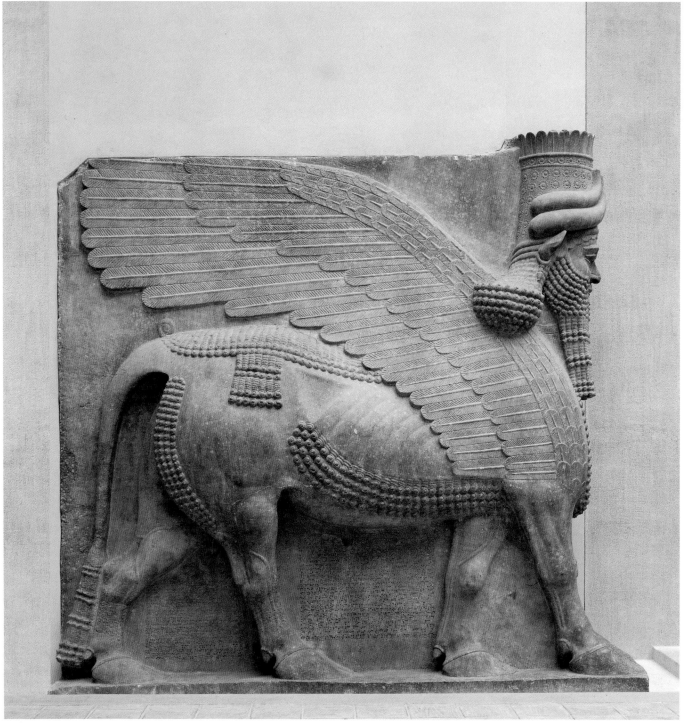

37
Human-Headed Winged Bull
Mesopotamia, Khorsabad
(Iraq), Neo-Assyrian,
721–705 BC
Gypseous alabaster
Height 165 ³/₈ in. (420 cm);
width 171 ⁵/₈ in. (436 cm)

38
Hero Overpowering a Lion
Mesopotamia, Khorsabad
(Iraq), Neo-Assyrian,
721–705 BC
Gypseous alabaster with traces
of paint
Height 217 ³/₈ in. (552 cm)

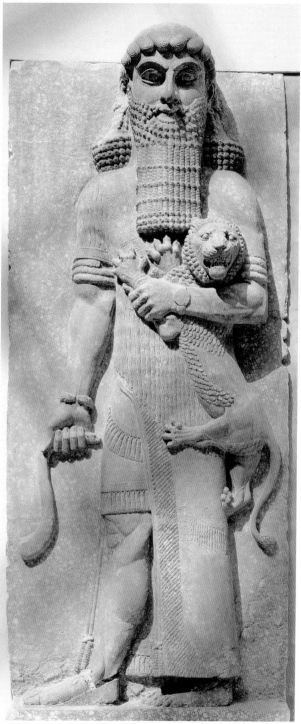

38

39
Musicians of the Assyrian Army
Mesopotamia, Nineveh (Iraq), Neo-Assyrian, c. 645 BC
Gypseous alabaster
43 1/4 × 39 in. (110 × 99 cm)

40
King Ashurbanipal on his Chariot
Mesopotamia, Nineveh (Iraq), Neo-Assyrian, c. 645 BC
Gypseous alabaster
64 1/8 × 30 1/4 in. (163 × 77 cm)

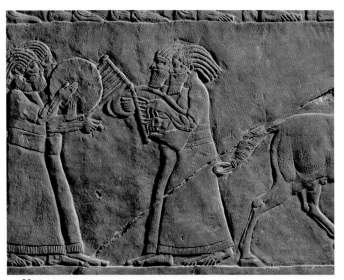

39

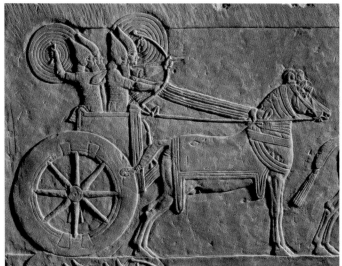

40

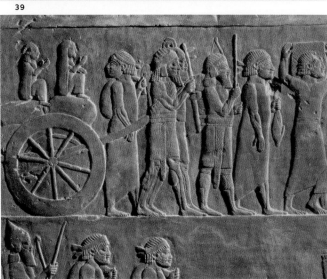

41

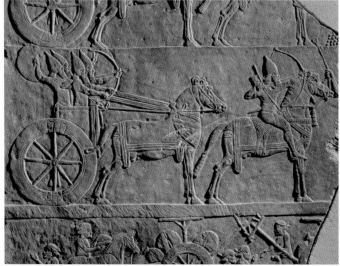

42

41
Defeated Soldiers and Musicians
Mesopotamia, Nineveh (Iraq), Neo-Assyrian, c. 645 BC
Gypseous alabaster
63 3/4 × 5 1/8 in. (162 × 13 cm)

42
Chariots and Riders of the Assyrian Army
Mesopotamia, Nineveh (Iraq), Neo-Assyrian, c. 645 BC
Gypseous alabaster
43 1/4 × 39 in. (110 × 99 cm)

43
Servants Holding Lion-Headed Situlae (buckets) and the Rolling Throne of the King
Mesopotamia, Khorsabad (Iraq), Neo-Assyrian, 721–705 BC
Bas-relief, gypseous alabaster
132 1/4 × 70 1/8 in. (336 × 178 cm)

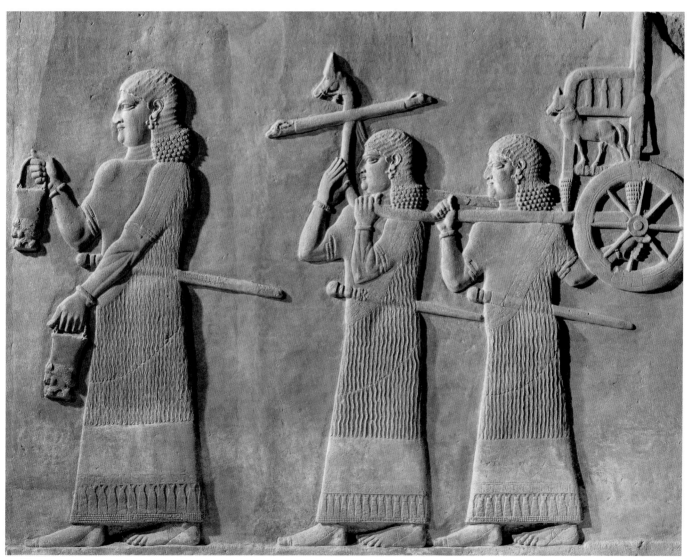

44
Statuette of the Goddess Ishtar
Mesopotamia, Babylon (Iraq),
Parthian, 143 BC–AD 224
Alabaster, rubies, and gold
Height 9 7/8 in. (25 cm)

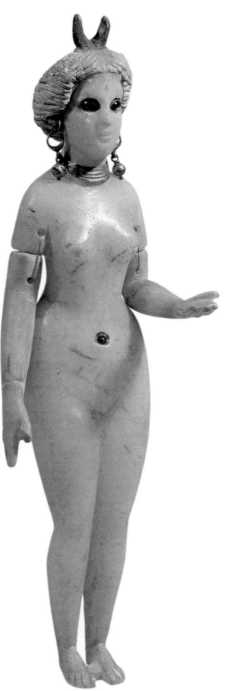

44

45
Cylinder Seal with Worship of
the Storm God Adad (Ishkur)
Mesopotamia, Neo-Assyrian,
8th century BC
Agate
Height 1⅛ in. (3 cm)

46
Cylinder Seal with Herd of
Oxen in a Wheat Field
Mesopotamia, Uruk,
c. 3700–2900 BC
Limestone
Height 1⅝ in. (4 cm)

47
Cylinder Seal with Archaic-
Style Quadriga (two-wheel
chariot pulled by four horses)
Mesopotamia, late 19th or
18th century BC
Hematite
Height 1⅛ in. (3 cm)

48
Cylinder Seal with Ea (Enki),
God of Water and Wisdom
Mesopotamia, 1st or 2nd
millennium BC
Red jasper
Height 1⅛ in. (3 cm)

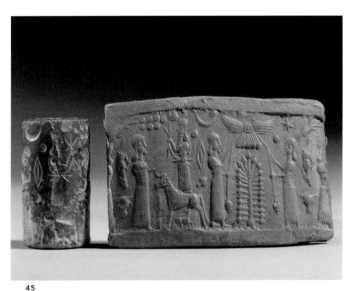

45

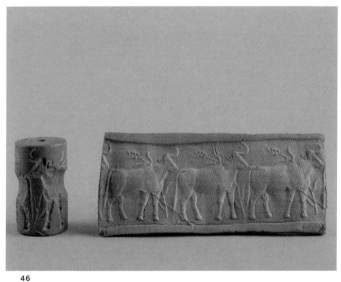

46

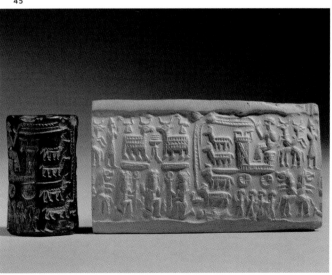

47

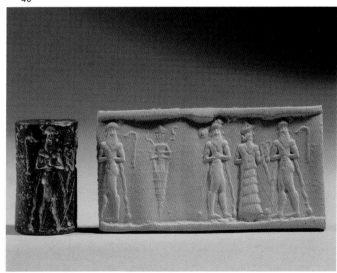

48

49
**Composite Female Statuette
(The Bactrian Princess)**
Iran, late 3rd millennium or
early 2nd millennium BC
Serpentine and calcite
Height 7 1/8 in. (18 cm)

50
**Mythological Spirit
(Scarface)**
Iran, late 3rd millennium or
early 2nd millennium BC
Chlorite, calcite, iron, and shell (?)
Height 4 3/4 in. (12 cm);
width 2 in. (5 cm)

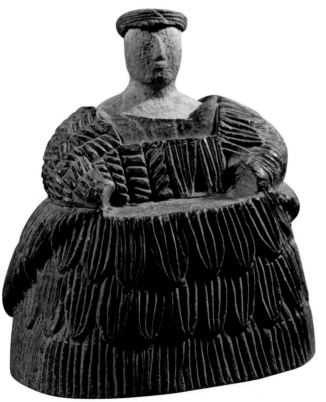

49

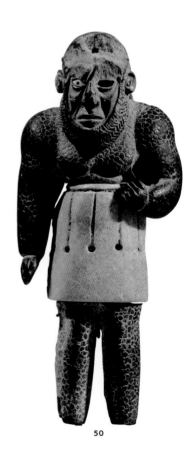

50

Beaker with Ibexes
Iran, Susa, Susa I period,
C. 4200–3500 BC
Painted terracotta, hand-thrown
Height 11³/₈ in. (29 cm);
diameter 6¹/₂ in. (16 cm)

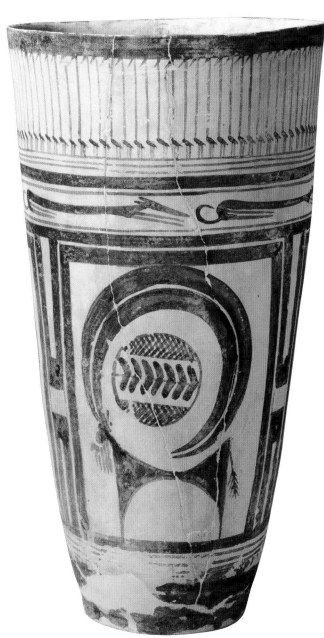

52
Statue of Queen Napir-Asu
Iran, Susa, Middle Elamite,
c. 1340–1300 BC
Bronze
Height 50 ³/₄ in. (129 cm)

53
**Horse Bit in the Form of a
Human-Headed Winged Bull
Trampling an Animal**
Iran, Neo-Elamite, 8th or 7th
century BC
Bronze
Height 7 ¹/₂ in. (19 cm);
width 7 ¹/₈ in. (18 cm)

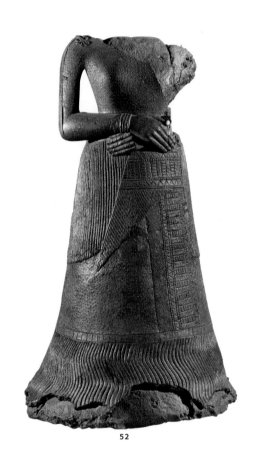

52

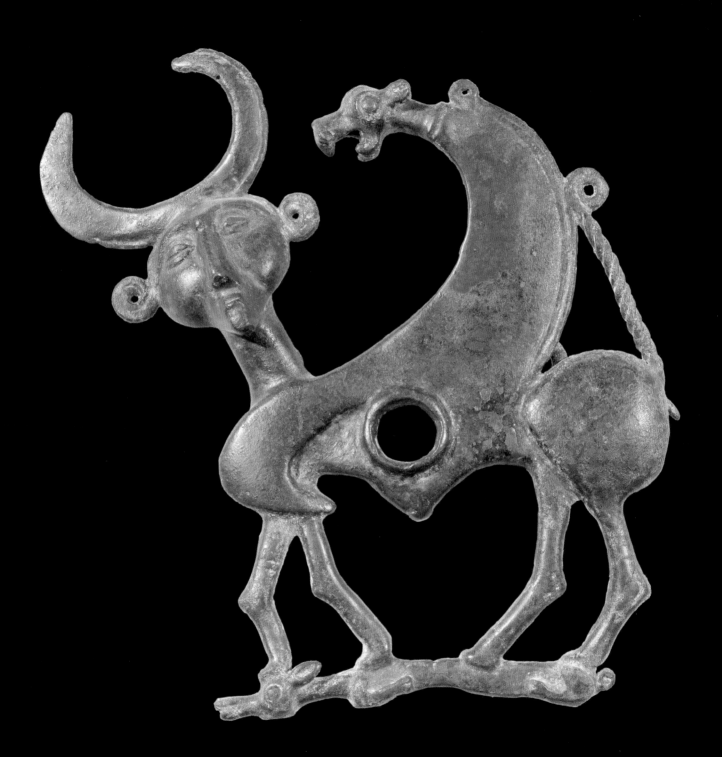

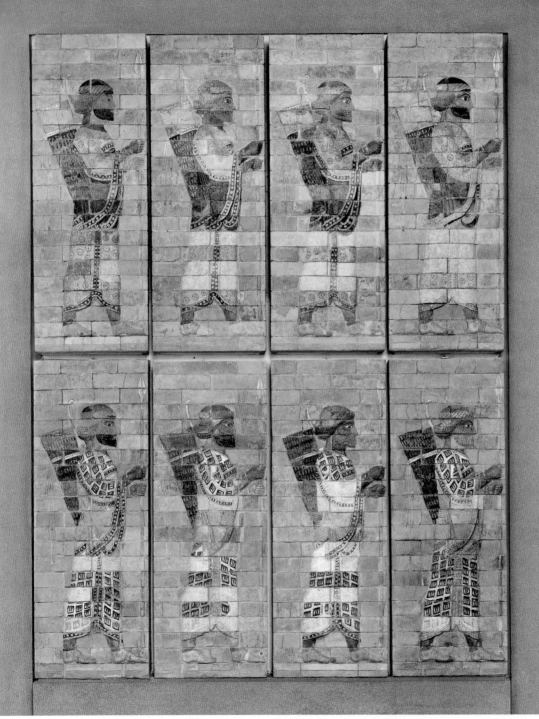

54
The Archers of Darius
Iran, Susa, Achaemenid,
c. 510 BC
Siliceous brick with polychromatic
glaze
187 × 147 5/8 in. (475 × 375 cm)

55
Frieze of Griffins
Iran, Susa, Achaemenid,
c. 510 BC
Glazed siliceous brick
65 × 166 1/8 in. (165 × 422 cm)

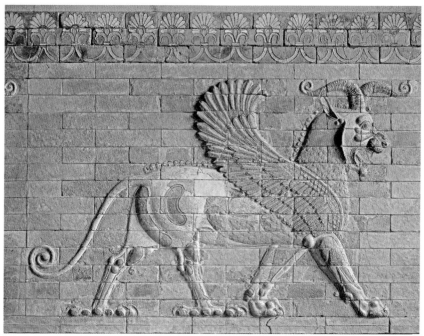

55

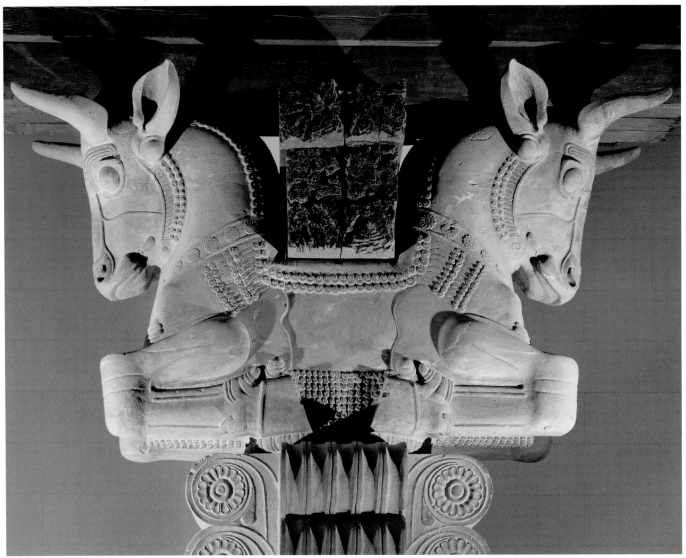

56
Capital from a Column of the
Apadana (columned hall),
Palace of Darius I
Iran, Susa, Achaemenid,
c. 510 BC
Limestone
Height 299 1/4 in. (760 cm)

57
Vase Handle in the Form of a
Winged Ibex
Iran, Achaemenid, 4th
century BC
Partially gilt silver
Height 10 5/8 in. (27 cm)

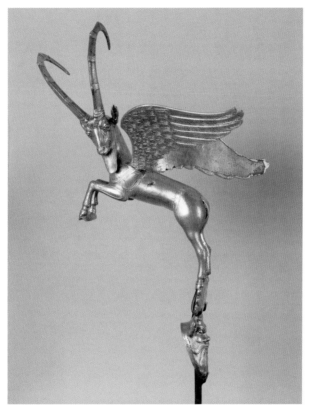

57

Standing Human Figurine
Jordan, Pre-Pottery Neolithic,
7th millennium BC
Gypseous alabaster plaster, with
eyelids and pupils in bitumen
Height 41 3/8 in. (105 cm)
ON LOAN FROM THE DEPARTMENT
OF ANTIQUITIES, JORDAN

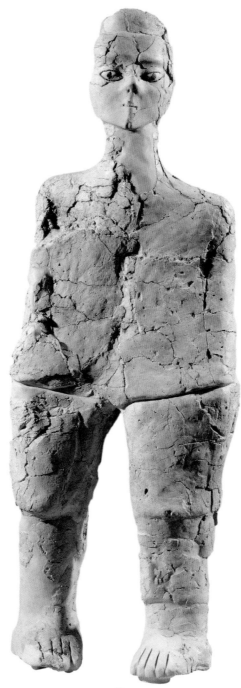

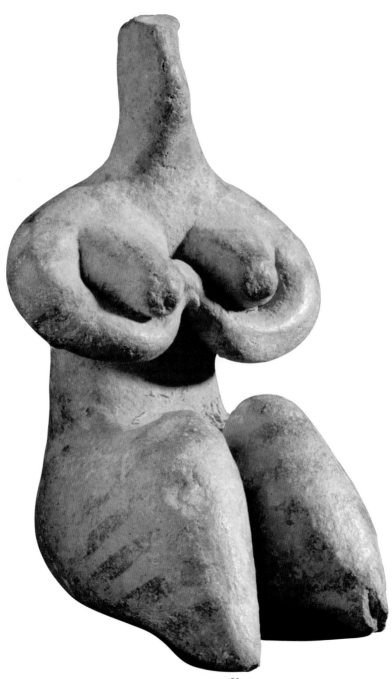

59

Female Figurine in the Halaf Style

Mesopotamia or Northern Syria, Halaf, 6th millennium BC

Painted terracotta

Height 3 1/8 in. (8 cm); width 2 in. (5 cm)

60

Idol of the Storm God Baal

Syria, Minet el-Beida, 14th–12th century BC

Bronze and gold

Height 7 1/8 in. (18 cm)

61

Stele Showing the Storm God Baal

Syria, Ras Shamra (ancient Ugarit), Late Bronze Age, 15th–13th century BC

Limestone

55 7/8 × 19 3/4 in. (142 × 50 cm)

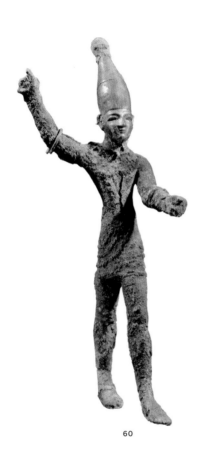

60

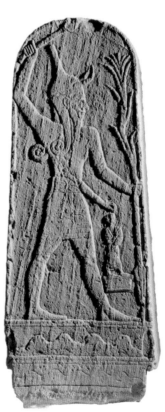

61

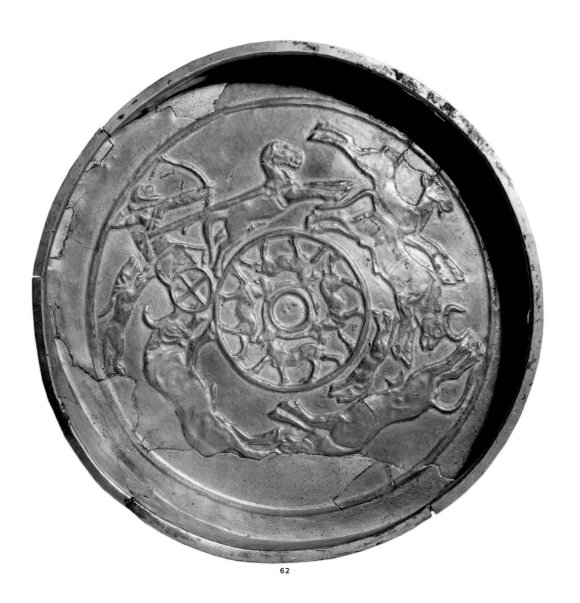

62

62

The Hunt Patera (Dish for Drinking)

Syria, Ras Shamra (ancient Ugarit), Late Bronze Age, c. 14th–13th century BC

Repoussé gold

Diameter 7 1/2 in. (31 cm)

63

Lid of a Cosmetic Box with the Mistress of the Animals

Syria, Minet el-Beida, 13th century BC

Elephant ivory

Diameter 5 1/2 in. (14 cm); depth 4 3/4 in. (12 cm)

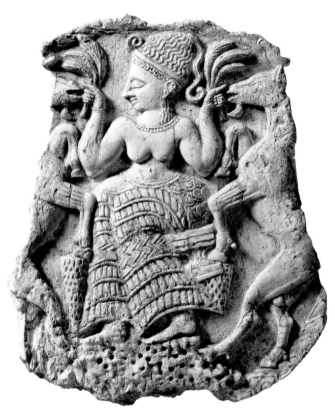

63

64
Mask: Head of a Bearded Man
Phoenicia, c. 600–300 BC
Glass
Height 1 1/8 in. (3 cm)

65
Bust of Ummayat, Daughter of Yarhai
Syria, Palmyra, second half of 2nd century AD
Limestone
20 7/8 × 16 7/8 in. (53 × 43 cm)

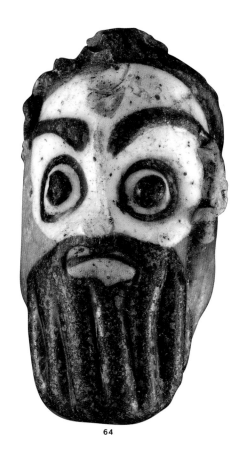

64

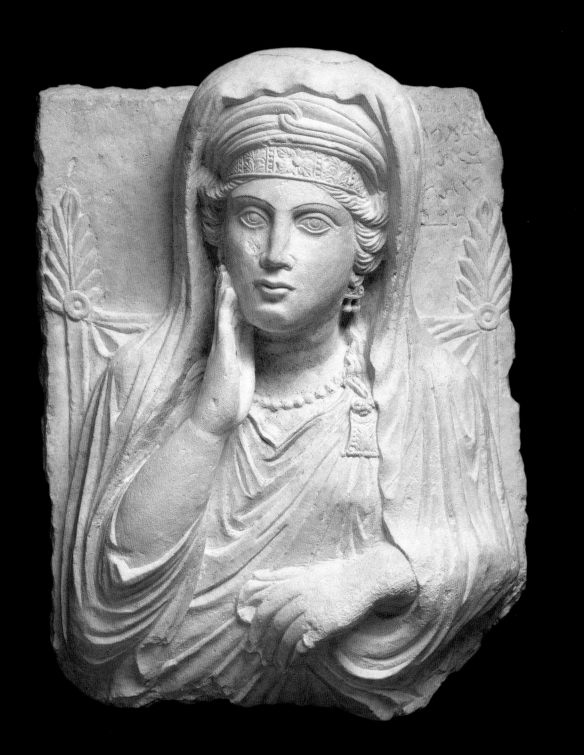

EGYPTIAN ANTIQUITIES

THE LOUVRE'S EGYPTIAN holdings are deservedly famous. By the number of pieces they contain—nearly 55,000—and their quality, they are among the most important in Europe.

The Department of Egyptian Antiquities was born at the same time as Egyptology—the study of ancient Egypt, its culture, arts, and language—probably no coincidence given that its first director was none other than Jean-François Champollion, who, in 1822, after years of dogged work, cracked the secret of hieroglyphics. During a relatively short period of several years, Champollion managed to convince the royal authorities to acquire three great collections, those of Durand, Salt, and Drovetti, which brought several thousand pieces, some of enormous size, into the museum. He also presided over the official founding of the department on May 15, 1826, and its inauguration on December 15, 1827. During the following decades, the museum acquired both individual objects and entire collections. Then, in the mid-nineteenth century, it began to receive massive shipments of objects excavated during archaeological expeditions. In 1852 and 1853, for instance, Auguste Mariette, who was working for the Louvre in the necropolis of Saqqara, sent the museum 5,964 pieces, including *The Seated Scribe*. Later, the collection's core holdings were enhanced by some of the discoveries at Deir el-Medina, Abydos, Tod, Medamud (nos. 74, 75), and Baouit. Thanks to this protocol, the Louvre's Department of Egyptian Antiquities now portrays the history of civilization in the Nile Valley from the fourth millennium BC to the Christian era.

The museum exhibits works from all major periods of the Pharaonic civilization. The oldest objects date from the end of prehistoric times to the epoch prior to the country's unification under the authority of a pharaoh; these objects include ceramics, stone vases, and ivory statuettes that were found primarily in necropolises. Excavations in the necropolis of Saqqara were particularly fruitful in yielding artifacts from the Old Kingdom (c. 2650–2150 BC), the period when the pyramids were built. Aside from statuary, reliefs, and funerary furnishings, the Louvre's Egyptian collection features an actual funerary chapel from a *mastaba*, an ancient Egyptian tomb, whose walls are decorated with polychromatic bas-reliefs depicting scenes from daily life, such as hunting, fishing, and farming.

The veritable golden age that was the Middle Kingdom (c. 2010–1640 BC) is represented by beautiful statues of rulers and ordinary citizens as well as numerous steles, or grave markers. Works from the Middle Kingdom also include complete ensembles of funerary objects found in tombs; for example, the tomb of the chancellor Nakhti (no. 73) yielded dozens of objects of the highest quality, including statuary, a sarcophagus, toiletries. and simulated weapons and tools.

The New Kingdom (c. 1550–1070 BC), which was perhaps the peak of Egyptian civilization, is one of the high points of the Louvre's collections. The reign of Amenophis III is particularly well represented, both by monumental works and pieces in virtual miniature displaying thousands of details in the rendering of clothing and hairstyles. Amenophis IV (nos. 86, 88), Tutankhamun, and the powerful Eighteenth Dynasty pharaoh Ramses II (no. 91) are all represented in the museum's galleys in sculpture or on steles.

During the first millennium BC, Egypt experienced a certain political and military decline; but the arts of the period remained highly diverse, and again the Louvre's collection includes beautiful sculpture, an unrivaled set of bronze statuettes, and magnificent

sarcophagi. Following Alexander's conquest, Egypt became Greek, then entered the Roman sphere, and eventually adopted Christianity. The museum displays many objects from this important period marking the transition to modern times. The Louvre's exhibition of works from Christian Egypt are rivaled only in Egypt itself: the sculptures, everyday objects, and, especially, thousands of preserved textiles allow us to understand how traditions evolved and are respected. The Coptic section is unique among museums in displaying a sixth-century church with its original capitals, columns, and frescoes. In 640, Arab armies conquered the Nile Valley. The more recent history of Egypt can thus be found in the Department of Islamic Arts.

The Louvre's collection is notable for the number of first-rank works it contains. Everyone knows *The Seated Scribe* (nos. 68A, 68B), one of the major works of its era, characterized by its stark realism and remarkably lifelike rendition of the scribe's face. Highlights of Egyptian art at the Louvre also include the *Stele of the Snake King* (no. 66), probably the most important monumental work dating from the origins of Egyptian culture; the two fragmentary statues of Sesostris III (nos. 74, 75) from the temple at

Medamud; and delicate Eighteenth Dynasty (c.1550–1295 BC) wood statuettes. From a more recent period comes a bronze statue of the divine consort Karomama, inlaid with gold and silver (no. 102), appropriately considered a masterpiece of metalwork.

The Louvre's Egyptian collections are so rich that they currently occupy thirty-three of the museum's galleries. In 1997, the museum opted for a double presentation: on the ground floor, works are shown in a thematic display integrating subjects such as the country, agriculture, hunting, fishing, writing, everyday life, gods, and the world of the dead. On the second floor, the art of the pharaohs is exhibited in chronological order from its origins to the Ptolemaic period. Several galleries in the Denon Wing are dedicated to Roman and Christian Egypt. The design of the department's new spaces, for example, has allowed for a "life-size" rendition of an Egyptian temple with its alley of sphinxes, columns, colossal statues, even a sanctuary with a sacred barque nearby.

The Egyptian holdings continue to expand. Although the department certainly no longer receives shipments of hundreds of objects, the acquisition of the statue of Queen Weret in 1997 brought to the Louvre a major work

unrivaled outside Egypt. More recently, in 2006, the purchase of a medical papyrus classified as a national treasure filled an important gap in the collection.

Stele of the Snake King
Egypt, Abydos, Thinite Period,
1st Dynasty, c. 3000 BC
Limestone
56 1/4 × 25 5/8 in. (143 × 65 cm)

67A, 67B
The Gebel el-Arak Dagger
Egypt, Gebel el-Arak,
southeast of Cairo, Nagada II
Period, c. 3300–3100 BC
Flint blade and hippopotamus ivory
handle
Height 9 7/8 in. (25 cm)

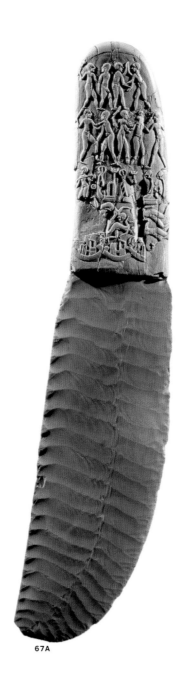

67A

67B

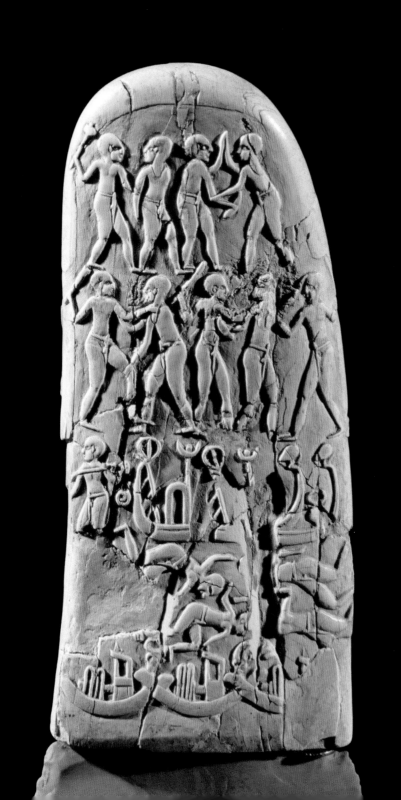

68A, 68B
The Seated Scribe
Egypt, Saqqara, Old Kingdom,
4th or 5th Dynasty, 2600–
2350 BC
Painted limestone; eyes in rock
crystal, magnesite, and copper;
nipples in wood
Height 21¹/₄ in. (54 cm);
width 17 ³/₈ in. (44 cm)

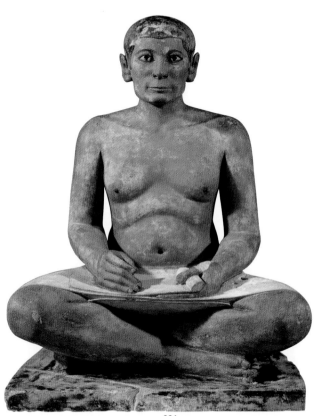

68A

68B

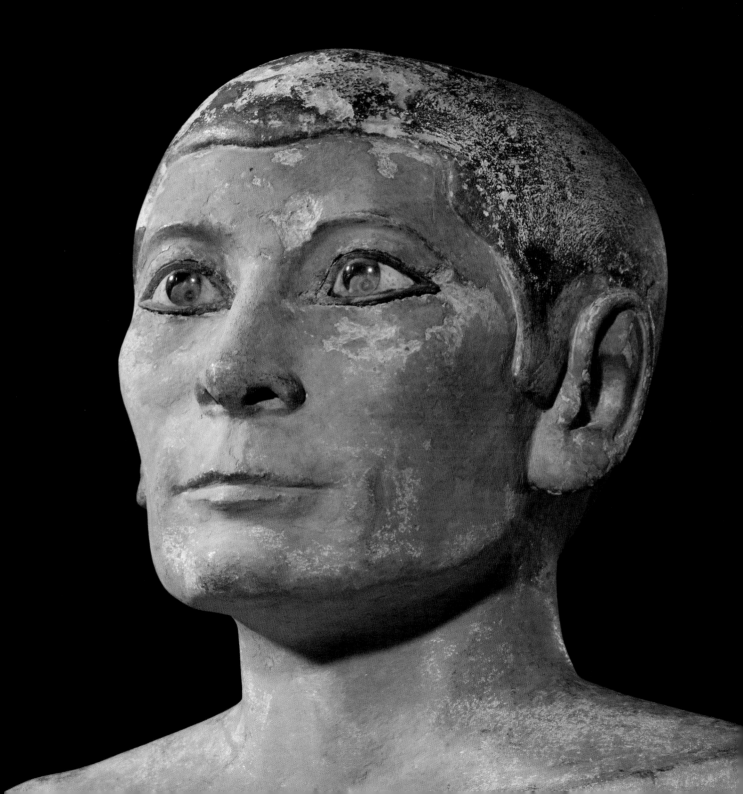

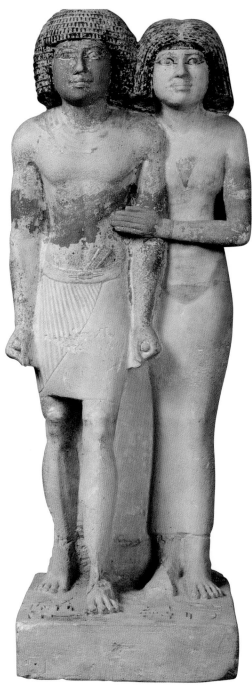

69
**Statue of Raherka and
Meresankh**
Egypt, Old Kingdom, 4th or
5th Dynasty, c. 2350 BC
Painted limestone
Height 20 7/8 in. (53 cm)

70
Stele of Princess Nefertiabet
Egypt, Giza, Old Kingdom,
4th Dynasty (reign of Cheops),
2590–2565 BC
Painted limestone
14 5/8 × 20 1/2 in. (37 × 52 cm)

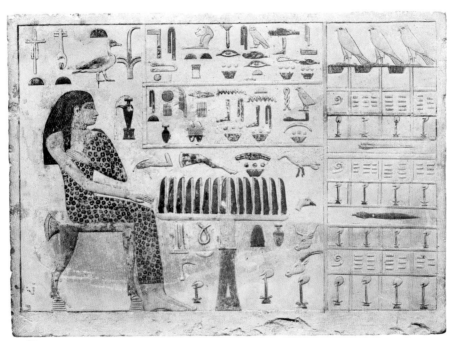

70

71
Statuette of a Young Boy
Egypt, Old Kingdom,
6th Dynasty (?),
2350–2200 BC
Painted ivory
Height 5 1/2 in. (14 cm)

72
Body of a Goddess
Egypt, Middle or Old Kingdom,
2033–1069 BC
Bronze with black patina
Height 4 3/4 in. (12 cm)

73
Statue of Chancellor Nakhti
Egypt, Assiut, Middle
Kingdom, 12th Dynasty, 1963–
1786 BC
Acacia wood
Height 70 1/8 in. (178 cm)

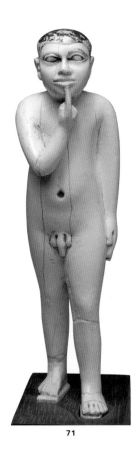

71

72

73

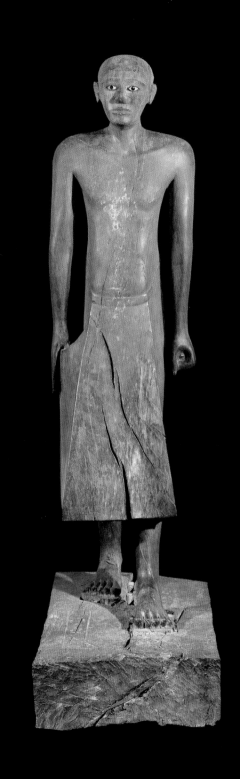

74
Statue of Sesostris III as a Young Man
Egypt, Nag el-Medamud,
12th Dynasty, 1862–1843 BC
Gabbro
Height 46 7/8 in. (119 cm)

75
Sesostris III Affected by the Years
Egypt, Nag el-Medamud,
12th Dynasty, 1862–1843 BC
Gabbro
Height 31 1/8 in. (79 cm)

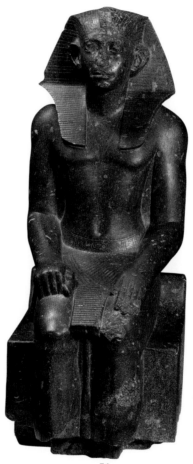

74

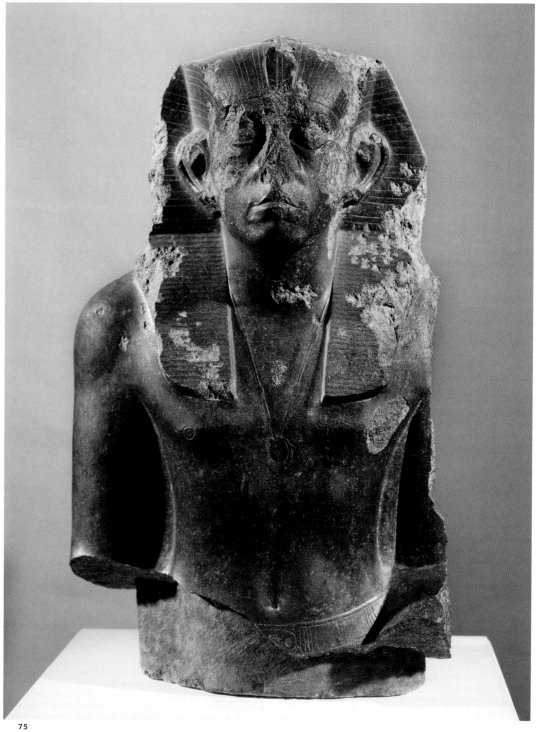

76
Model of a Granary
Egypt, Middle Kingdom,
2033–1710 BC
From the tomb of Chancellor
Nakhti in Assiut
Painted wood
12 5/8 × 16 1/8 in. × 17 3/8 in.
(32 × 41 × 44 cm)

77
Brewery Scene
Egypt, Middle Kingdom,
2033–1710 BC
Painted wood
5 1/2 × 7 7/8 × 11 3/8 in.
(14 × 20 × 29 cm)

78
Model Boat
Egypt, Middle Kingdom,
c. 2000 BC
Painted wood
19 1/4 × 7 1/2 × 30 1/4 in.
(49 × 19 × 77 cm)

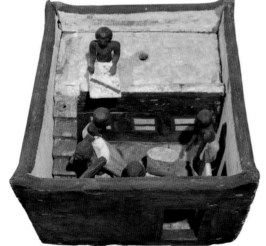

76

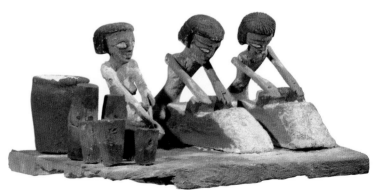

77

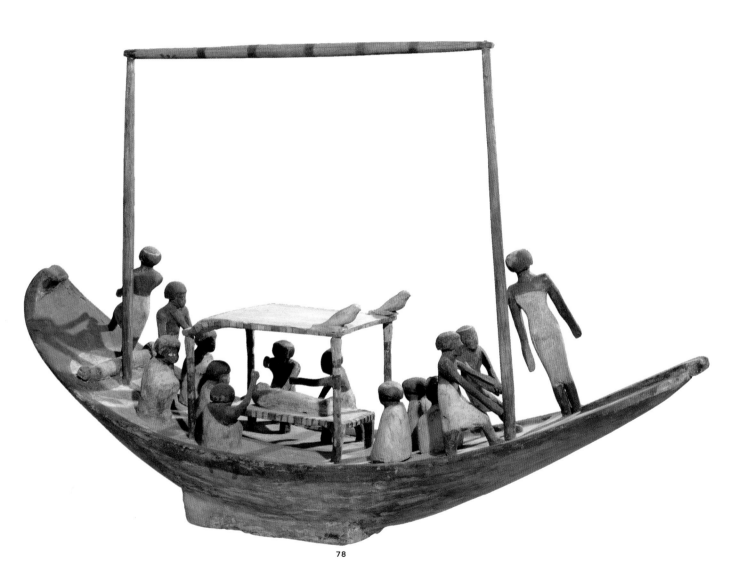

78

79A, 79B, 79C
Female Offering Bearer
Egypt, Middle Kingdom,
2033–1710 BC
Painted ficus wood
Height 42 ¹/₂ in. (108 cm)

80
The Great Sphinx of Tanis
Egypt, Tanis, Old Kingdom,
2600 BC (?)
Granite
Height 72 in. (183 cm);
width 189 in. (480 cm)

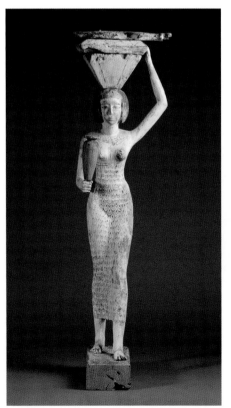

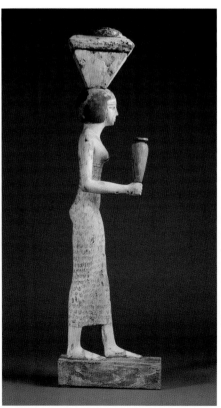

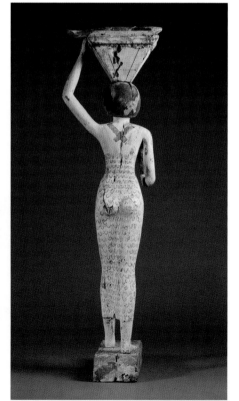

79A 79B 79C 80

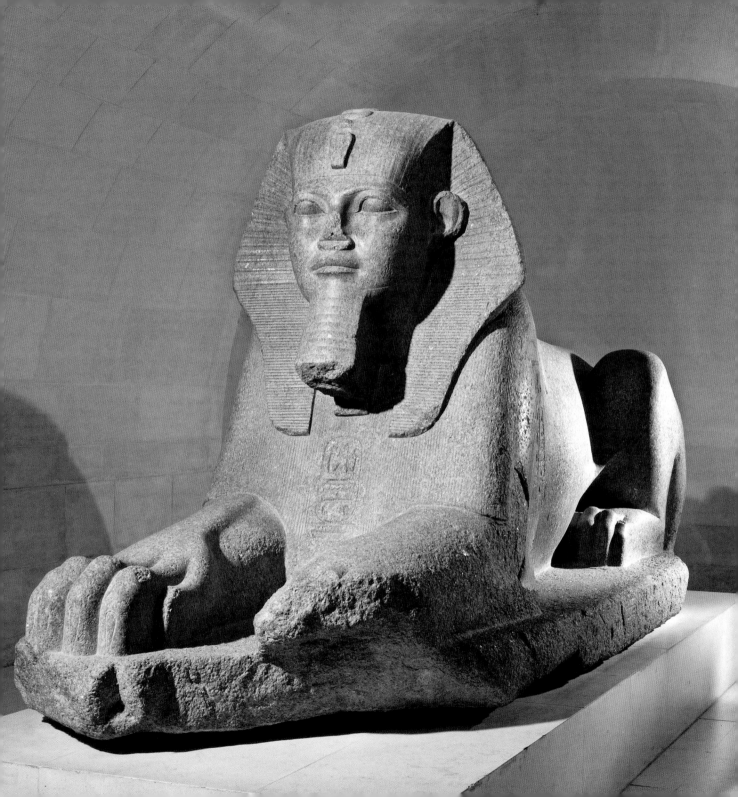

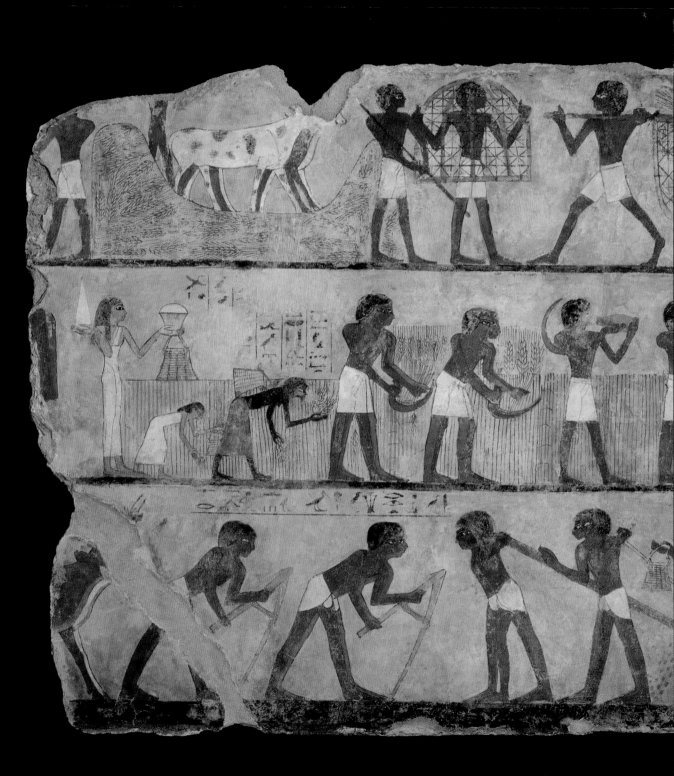

81

Painting from the Tomb of Ounsou: Agricultural Work
Egypt, Luxor, New Kingdom,
18th Dynasty, c. 1450 BC
Painting on silt mixed with straw and
pigments
26 3/4 × 37 in. (68 × 94 cm)

82

Sennefer, the King's Head Clerk, and His Wife, Hatshepsut
Egypt, Luxor, New Kingdom,
18th Dynasty, c. 1427–1401 BC
Painted sandstone
Height 26 3/4 in. (68 cm);
width 33 1/2 in. (85 cm)

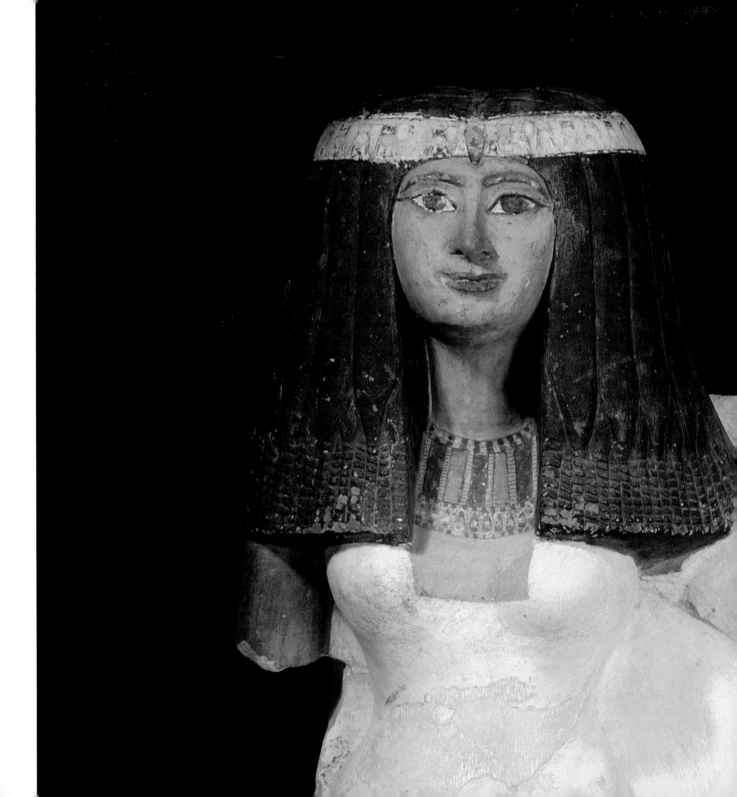

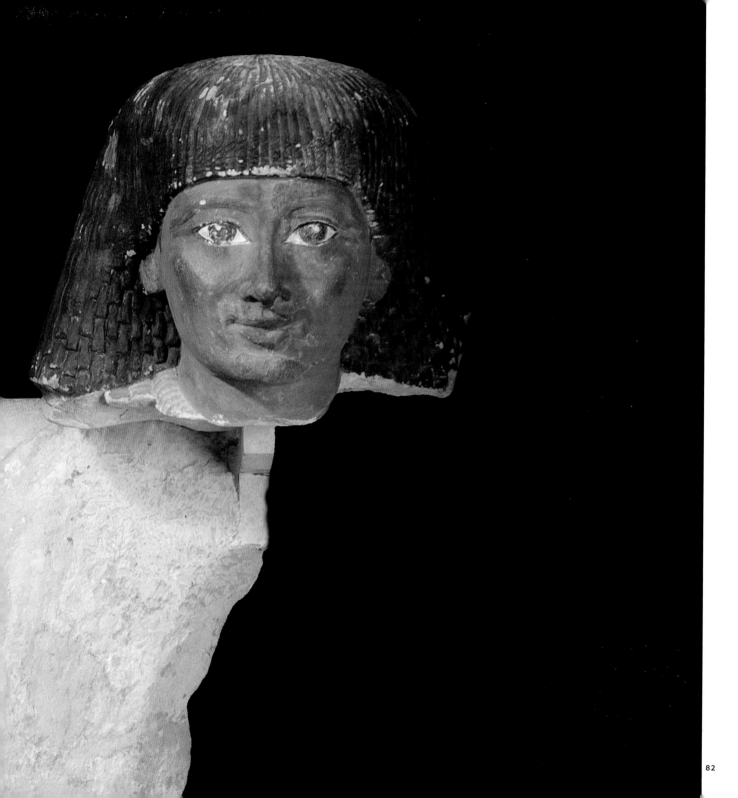

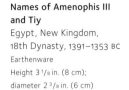

84
**Vase Inscribed with the
Names of Amenophis III
and Tiy**
Egypt, New Kingdom,
18th Dynasty, 1391–1353 BC
Earthenware
Height 3 1/8 in. (8 cm);
diameter 2 3/8 in. (6 cm)

83

84

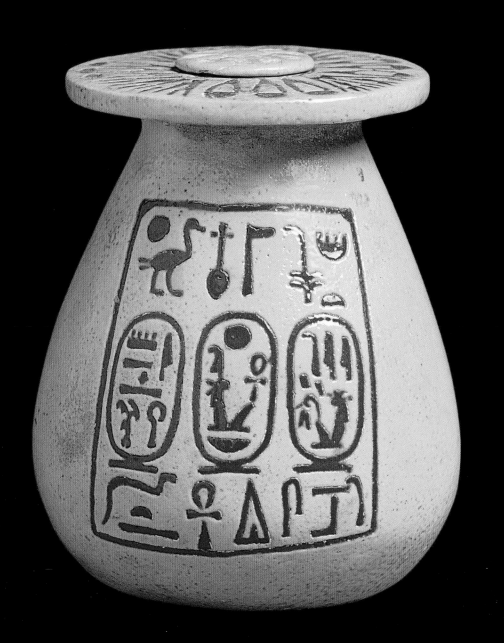

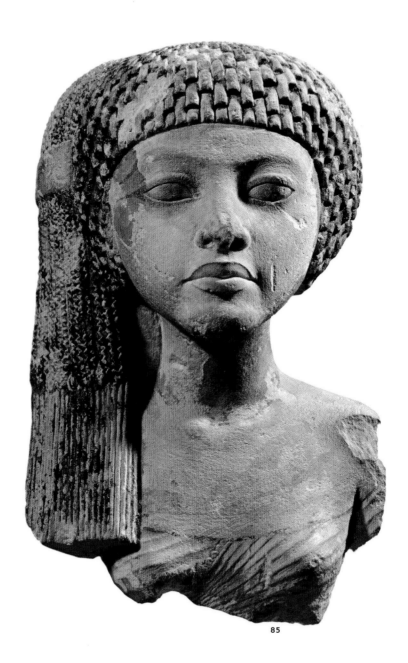

85

85
Head of a Princess
Egypt, Tell el-Amarna, New
Kingdom, 18th Dynasty,
1345–1337 BC
Painted limestone
Height 5 7/8 in. (15 cm)

86
**Statuette of Amenophis IV
and Nefertiti**
Egypt, Tell el-Amarna, New
Kingdom, 18th Dynasty,
1345–1337 BC
Painted limestone
Height 8 5/8 in. (22 cm)

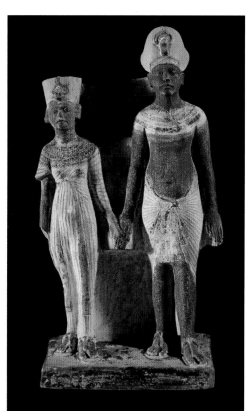

86

87
Cosmetic Spoon with a Swimmer
Egypt, New Kingdom, late 18th Dynasty, c. 1400–1300 BC
Partially painted carob wood
Length 13 3/8 in. (34 cm)

88
Osirid Pillar of Amenophis IV
Egypt, Luxor, New Kingdom, 18th Dynasty, 1353–1337 BC
Painted sandstone
Height 54 in. (137 cm)

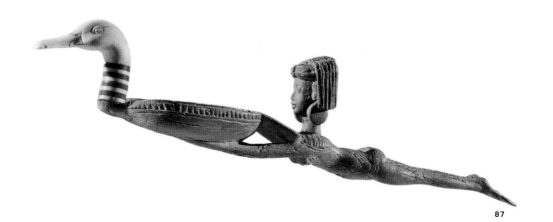

87

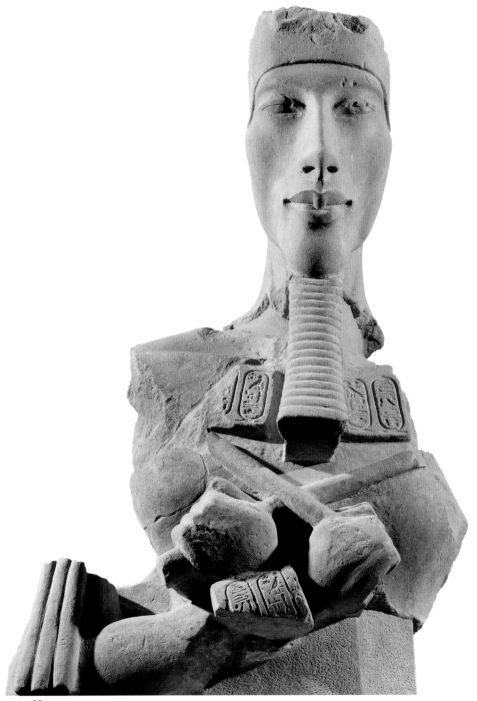

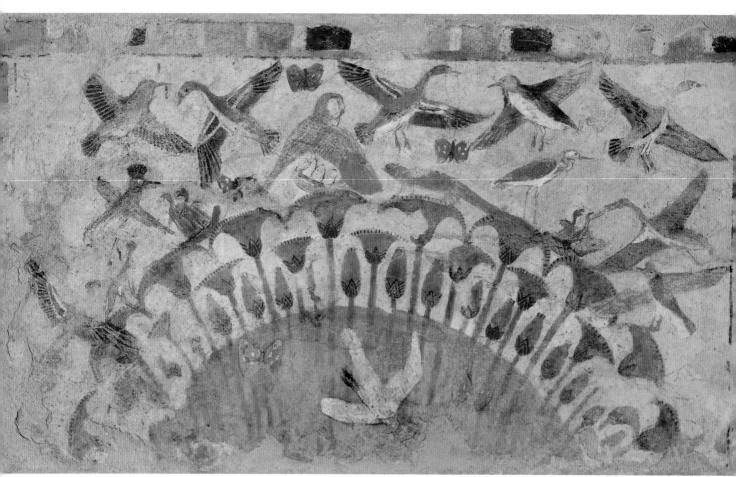

89
Scene in the Nile Marshes
Egypt, New Kingdom, mid-
18th Dynasty, c. 1450–1400 BC
Paint on silt
29 1/8 × 16 7/8 in. (74 × 43 cm)

90
The Goddess Hathor and Seti I
Egypt, Valley of the Kings
in Luxor, New Kingdom,
19th Dynasty, 1290–1179 BC
Painted limestone relief
89 × 41 3/8 in. (226 × 105 cm)

91
Ramses II as a Child
Egypt, New Kingdom,
19th Dynasty, 1279–1213 BC
Limestone
7 1/8 × 5 1/8 in. (18 × 13 cm)

92
**Four Baboons Adoring the
Rising Sun**
Egypt, Luxor, New Kingdom,
19th Dynasty (reign of
Ramses II), 1279–1213 BC
Granite
Height of monkeys: 55 1/8 in.
(140 cm); maximum width
128 in. (325 cm)

91

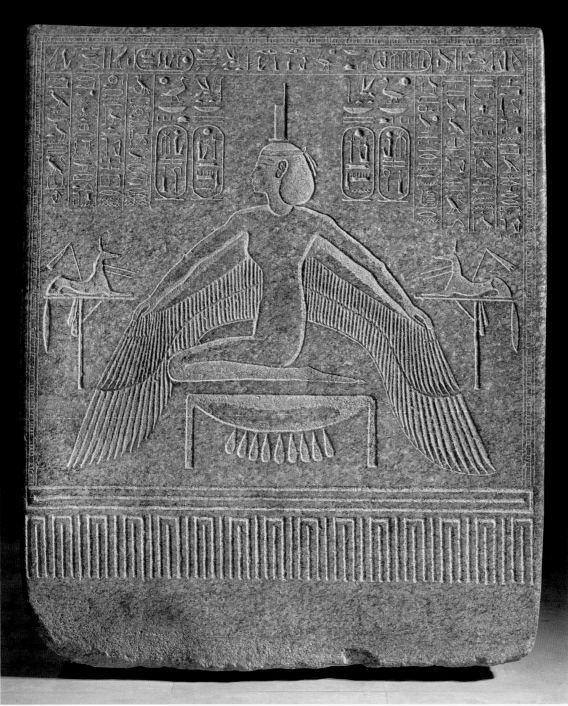

93

Sarcophagus of Ramses III

Egypt, Valley of the Kings
in Luxor, New Kingdom,
20th Dynasty, c. 1184–1153 BC

Pink granite

Height 70 7/8 in. (180 cm);
width 59 in. (150 cm)

94

Pectoral of Ramses II

Egypt, Saqqara, New Kingdom,
19th Dynasty, 1279–1213 BC

Electrum and colored glass inlaid
with cloisonné

5 1/8 × 6 1/4 in. (13 × 16 cm)

95A, 95B

**Book of the Dead of the
Scribe Neqbed**

Egypt, New Kingdom,
18th Dynasty (reign of
Amenophis III), 1391–1353 BC

Papyrus

Length 248 in. (630 cm)

95A

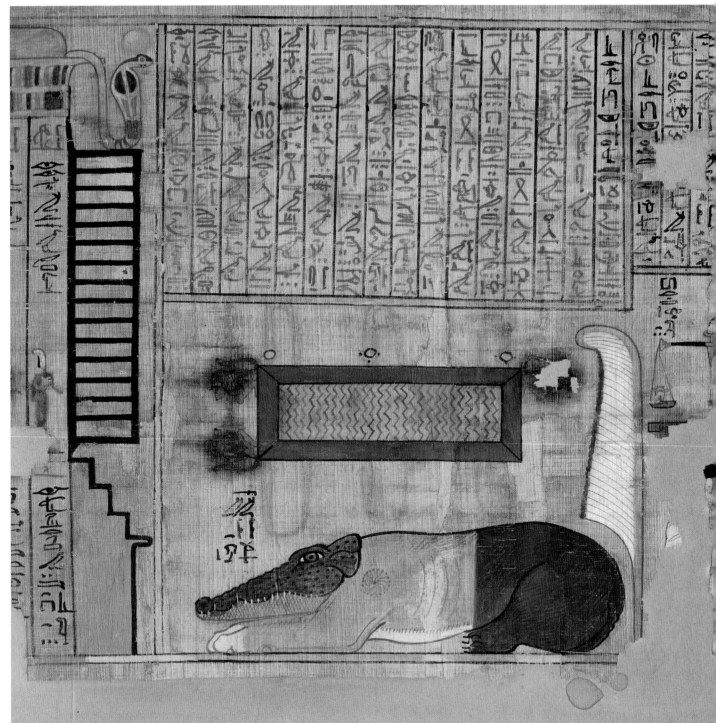

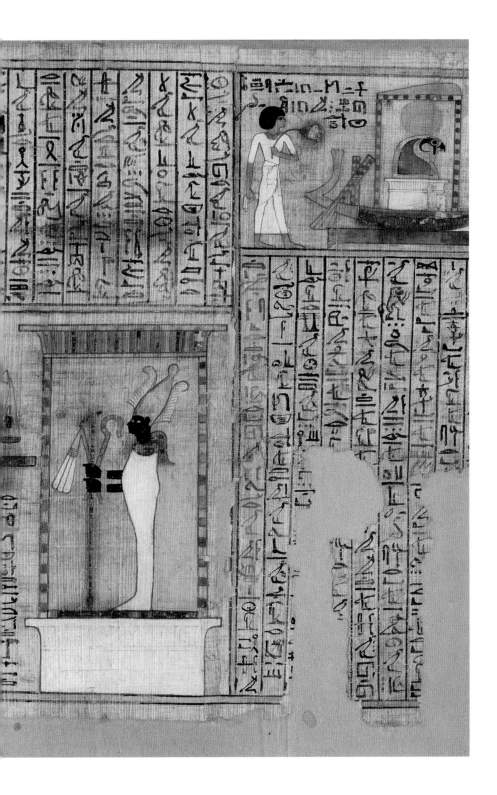

96
Ostracon Sketch: Royal
Profile (probably Ramses VI)
Egypt, New Kingdom,
20th Dynasty, 1143–1136 BC
Painted limestone chip
8 1/4 × 8 5/8 in. (21 × 22 cm)

97
Sarcophagus Mask
Egypt, New Kingdom, late
18th Dynasty, c.1400–1300 BC
Wood and glass
Height 7 1/8 in. (18 cm);
width 6 3/4 in. (17 cm)

96

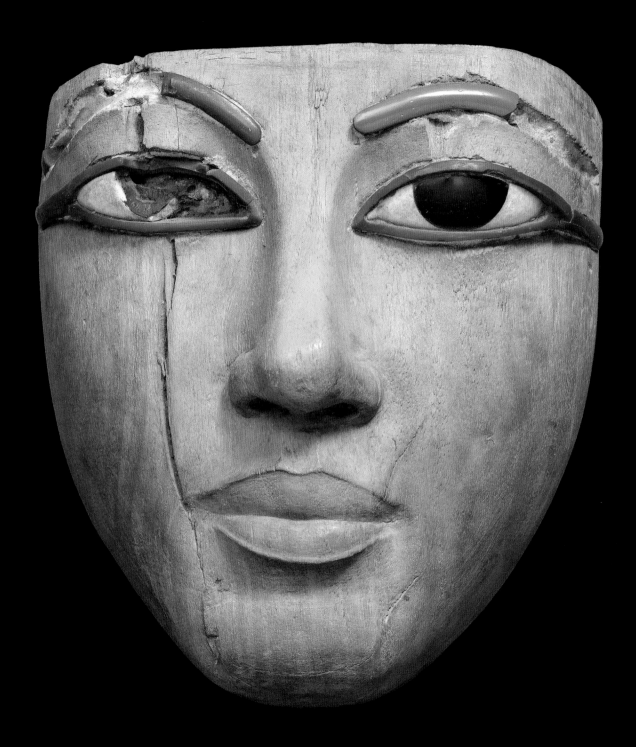

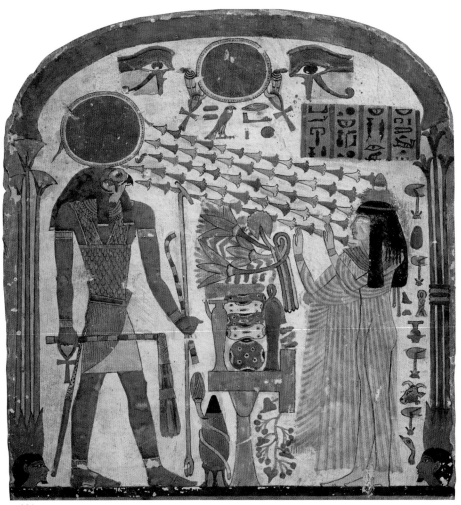

98A

98A, 98B
Stele of Taperet
Egypt, Third Intermediate
Period, 22nd Dynasty, 10th or
9th century BC
Painted wood (front and back)
12 1/4 × 11 3/8 in. (31 × 29 cm)

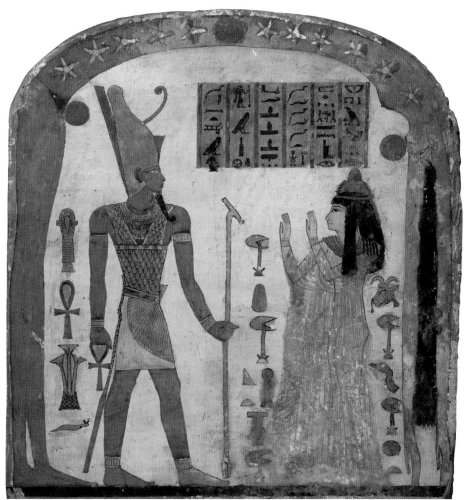

98B

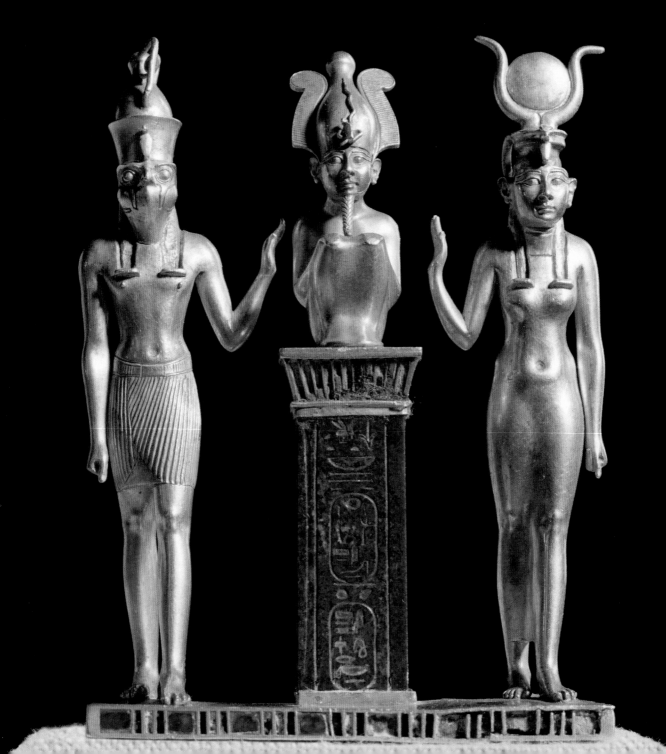

99
Triad of Osorkon II: Osiris Flanked by Isis and Horus
Egypt, Third Intermediate Period, 22nd Dynasty, 874–850 BC
Gold, lapis lazuli, and red glass
Height 3 1/2 (9 cm); width 2 3/4 in. (7 cm)

100
Man Worshipping
Egypt, New Kingdom, c. 1550–1069 BC
Bronze
Height 3 1/8 in. (8 cm)

101
A King Presenting the Goddess Maat
Egypt, 21st Dynasty (?)
Silver partially plated in gold
Height 7 1/2 in. (19 cm)

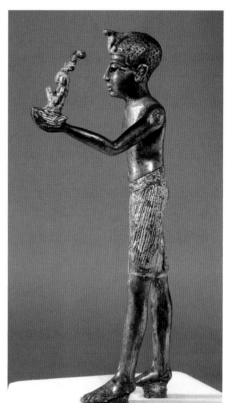

99 100

101

102
**Karomama, Divine Consort
of Amon**
Egypt, Third Intermediate
Period, 22nd Dynasty,
c. 850 BC
Bronze inlaid with gold, silver, and
electrum
Height 23 1/3 in. (59 cm)

103
The God Horus
Egypt, Third Intermediate
Period, 1069–664 BC
Cuprous metal
Height 37 3/8 in. (95 cm)

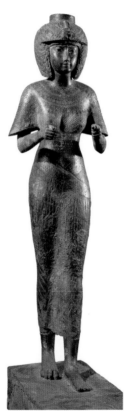

102

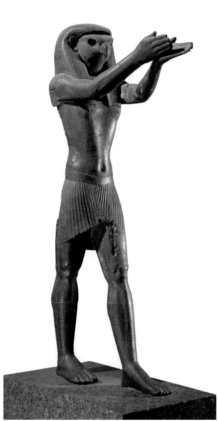

103

104
King Taharqa Worshipping the
Falcon-God Hemen
Egypt, Third Intermediate
Period, 25th Dynasty,
690–664 BC
King: bronze; falcon: gold-plated
greywacke; base: silver-plated wood
Height 7 7/8 in. (20 cm);
width 10 1/4 in. (26 cm)

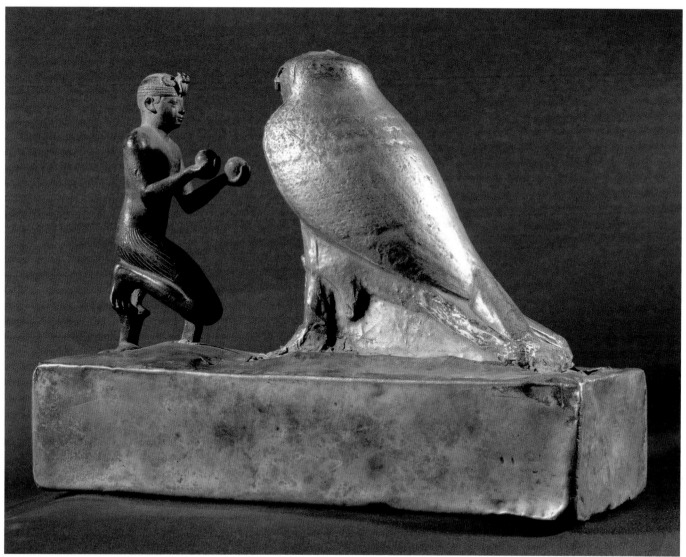

105
Khabekhent's Funerary
Servant and Shabti Box
Egypt, New Kingdom,
19th Dynasty, c. 1250 BC
Statuette: painted limestone; box:
stuccoed and painted wood
Statuette: height 7 1/2 in. (19 cm);
box: height 11 3/4 in. (30 cm)

106
One of Four Canopic Vases of
Horemsaf (containers storing
internal organs of deceased)
Egypt, Late Period,
664–332 BC
Egyptian alabaster (calcite)
Height 14 1/8 in. (36 cm)

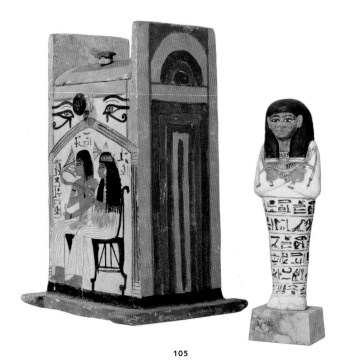

105

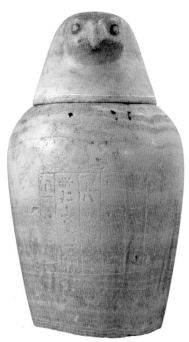

106

107
Sarcophagi of Tamutnefret
Egypt, New Kingdom,
19th Dynasty, 1295–1186 BC
Polychrome wood and gilding
Height 75 5/8 in. (192 cm)

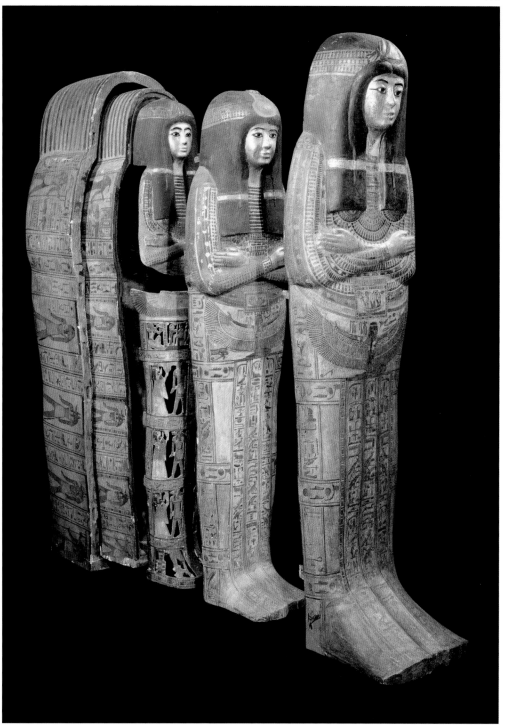

108
Mummified Ram for the God Khnum
Egypt, Elephantine, Late Period, 664–332 BC
Cartonnage, with eyes in bronze and glass
Height 32 1/4 in. (82 cm); width 39 3/8 in. (100 cm)

109
Seated Cat (Bastet)
Egypt, Late Period, 664–332 BC
Bronze inlaid with blue glass
Height 13 3/8 in. (34 cm)

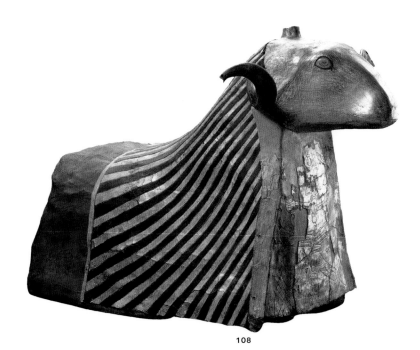

108

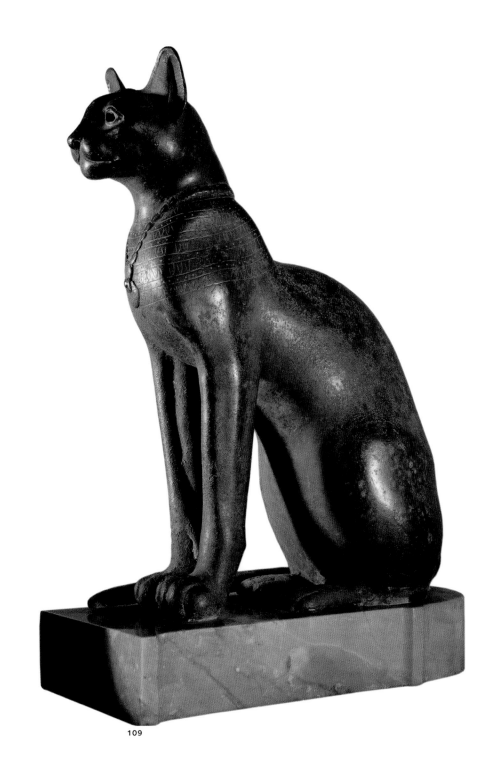

109

110
Portrait of a Woman
Egypt, early 2nd century AD
Linden wood painted with encaustic
and stuccoed plaster
11³/₈ × 7¹/₈ in. (29 × 18 cm)

111
**Portrait of a Woman
(The European)**
Egypt, AD 120–130
Cedar wood painted with encaustic
and gilt
16¹/₂ × 9¹/₂ in. (42 × 24 cm)

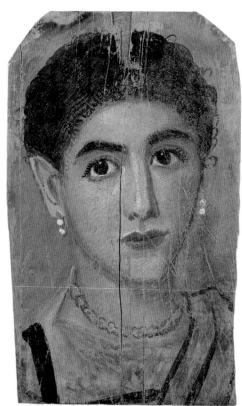

110

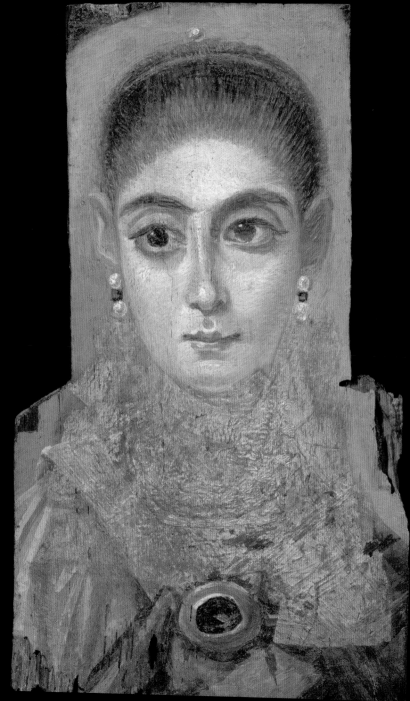

112
**Tapestry square illustrating
the Birth of Aphrodite**
Egypt, Antinoöpolis,
6th–8th century
Linen and wool
$10^{5}/_{8} \times 10^{1}/_{4}$ in. (27 × 26 cm)

113
Christ and Abbot Mena
Egypt, Baouit, late 6th–early
7th century
Paint on sycamore fig wood
$22^{1}/_{2} \times 22^{1}/_{2}$ in. (57 × 57 cm)

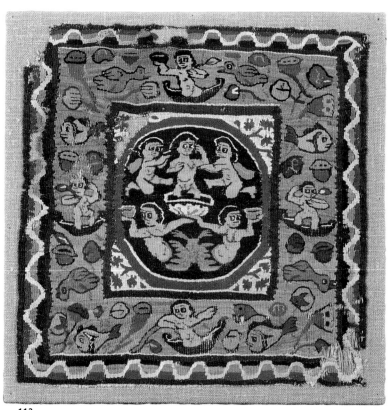

112

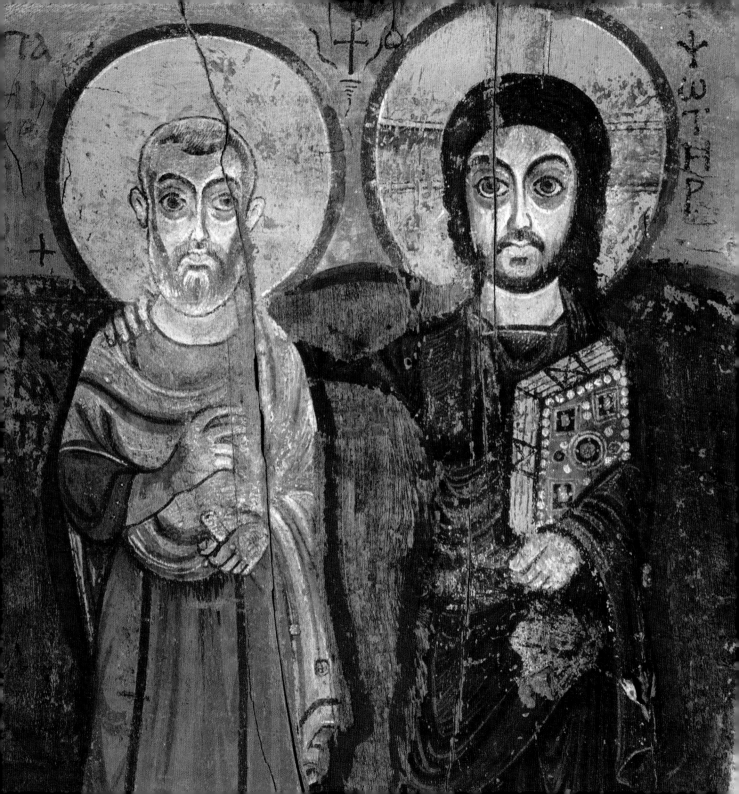

GREEK, ETRUSCAN, AND ROMAN ANTIQUITIES

TWO WORLD-RENOWNED masterpieces lure visitors to this department's incredibly rich collections. But the museum's Greek, Etruscan, and Roman antiquities are hardly limited to *The Winged Victory of Samothrace* (nos. 146A, B) and the *Venus de Milo* (nos. 149A, B, C). Its more than 50,000 works illuminate the artistic production of a vast geographic region ranging throughout the Mediterranean Basin from the third millennium BC to the dawn of the Middle Ages.

As is often the case at the Louvre, the collections date back to the royal era. Under Francis I, a few classical antiquities found their way into the rooms and gardens of Fontainebleau. But here, too, it was Louis XIV who provided the definitive impetus to develop the collections. Like fellow sovereigns who ruled Germany, Italy, and Spain, the Sun King desired statuary from antiquity to decorate his palaces at Versailles and Marly. Either purchased directly in Rome or acquired through the dispersal of a few great aristocratic art collections, these antiquities adorned niches in the Hall of Mirrors or groves in the king's beloved gardens. During the Revolutionary and Imperial eras, Parisians could visit the museum to see for themselves the masterpieces from the Vatican and from

collections of the great Roman and German noble families. Although most of these works were returned to their legitimate owners in 1815, after the defeat of Napoléon I, the memory of their presence haunted the museum's halls throughout the nineteenth century.

The dawn of scientific archaeology coincided with the development of the Antiquities departments. French scholars explored far-flung sites, uncovering objects the Louvre was frequently able to acquire, particularly since arrangements with local authorities concerning the division of spoils were often highly favorable to the excavators. Artworks began arriving by the thousands from Italy, Greece, Turkey, and North Africa. Today, the stream of artifacts has run dry, since most countries have enacted legislation forbidding the sale of their archaeological treasures. Nonetheless the Louvre regularly continues to buy at auction and from individuals to fill gaps in their collection with pieces such as the magnificent late-sixth-century head of a horse acquired in 2006.

Of the three great cultures featured in this department, Greek civilization is the oldest. A few objects from the Cretan and Cycladic civilizations lead the march through

time, which continues with a nearly flawless presentation of the Hellenic world up to the Roman conquest. Stone, bronze, and terracotta sculpture and jewelry are displayed alongside one of the biggest collections of Greek ceramics. The department also contains some world-famous masterpieces—*The Lady of Auxerre* (no. 118), *The Miletus Torso* (no. 132), the *Plaque of the Ergastines* (no. 135) from the Parthenon, and the painted Antaeus Krater (nos. 123A, B)—not to mention countless less celebrated, but not less fascinating, works of art.

The few galleries devoted to Etruscan culture display what may be the most significant collection of objects from this civilization outside Italy. When Napoléon III purchased the Marquis of Campana's collection, the Louvre was already among the leading centers for study of a culture whose language has yet to be entirely deciphered. Today, the museum's Etruscan artworks come from the great necropolises of central Italy whose tombs yielded objects from every era and category.

The Roman collections are the museum's pride and joy. Although Louis XIV had already gathered many important works in his residences, Napoléon I made the col-

lection what it is today by purchasing the hundreds of marble sculptures, reliefs, and sarcophagi collected by the Borghese princes. These were added to the Louvre's treasures and now grace several rooms on the ground floor. A Rothschild family gift in the nineteenth century, the Boscoreale Treasure, brought a particularly fine addition to the museum collection, one of the two greatest pieces of Roman silver work in existence. Today it is displayed beside glass and jewelry, bronze sculptures, and a gladiator helmet, as well as numerous mosaics brought back from Carthage and Utica in Tunisia and Daphne in Syria. Although the Louvre exhibits works found throughout the Roman Empire, paradoxically, the provinces of Gaul are the least well represented in its collections: since the days of Napoléon III, artifacts discovered in France have been sent to the National Museum of Antiquities in the Château Vieux de Saint-Germain-en-Laye.

The museum's collections in classical archaeology are inextricably identified with specific spaces in the Louvre. Louis XIV initiated the tradition of exhibiting classical antiquities on the ground floor of the palace by displaying them in the Petite Galerie wing, and then in the Caryatids Room. Anne of Austria's summer apartments were converted under Napoléon I to display wonders such as the Laocoön as well as countless masterpieces from the papal collections that had been transferred to Paris. The apartments' seventeenth-century décor is still visible on the ceilings, but its walls retain the appearance they were given in the imperial renovation. There is surely no better place for the *Winged Victory of Samothrace* (nos. 146A, B) than the top of the Louvre's central staircase, where it welcomes visitors with a powerful foretaste of the timeless masterpieces awaiting them.

Some works of art in the Louvre are celebrated for reasons other than simply the quality of the artists' work or the fruits of centuries of scholarship. *Hermaphrodite Sleeping* (no. 148), fervently taken up by the public, is one such work. The countless thousands of tourists thronging around to photograph this statue are undoubtedly what persuaded the museum to move it from the niche where it had been displayed to the center of the Louvre's most sumptuous space, the Caryatids Room. It is now among the most photographed works of art in the palace. In this case, it was the general public, and it alone, that imposed its taste.

114
Female Figurine (Head)
Greek, Keros in the Cyclades,
Early Cycladic II, 2700–
2300 BC
Marble
Height 10 5/8 in. (27 cm)
ATTRIBUTED TO THE SYROS GROUP

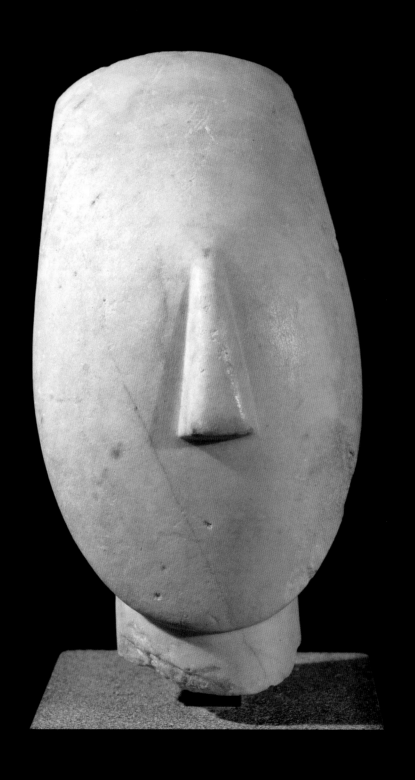

115
Geometric Amphora
Greek, Late Geometric IIB,
C. 720–700 BC
Terracotta
Height 18 1/2 in. (47 cm);
diameter 8 5/8 in. (22 cm)
ATTRIBUTED TO AMPHORA
WORKSHOP OF ATHENS 894

116
Spouted Jug (Sauceboat)
Greek, Heraia of Arcadia, Early
Helladic III, C. 2200 BC
Hammered gold sheet with riveted
handle
Height 6 3/4 in. (17 cm);
width 5 1/2 in. (14 cm);
diameter 4 3/8 in. (11 cm)

117
Boeotian Bell-idol
Greek, Thebes, C. 700 BC
Terracotta
Height 15 3/4 in. (40 cm)
THEBAN WORKSHOP
(OINOCHOE TYPE)

115

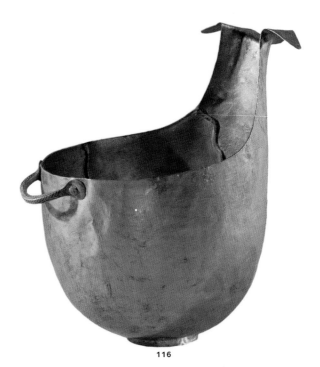

116

117

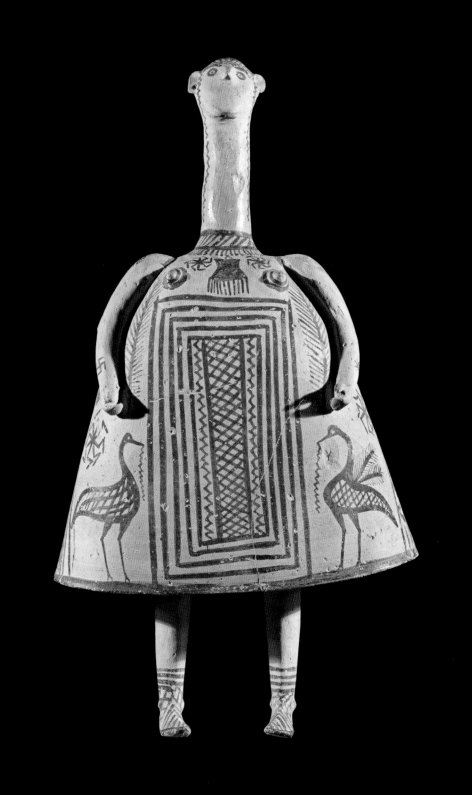

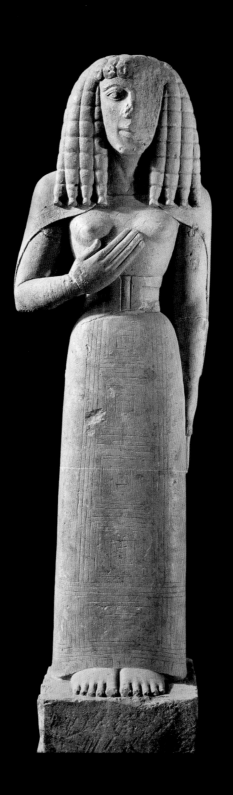

118

Female Statue (The Lady of Auxerre)

Greek, Archaic, c. 640–630 BC

Limestone, sculpted in the round
and painted

Height 29 1/2 in. (75 cm)

119

Statuette of a Butcher

Greek, Thebes, c. 525–475 BC

Terracotta

Height 4 3/4 in. (12 cm)

BOEOTIAN WORKSHOP

120

**Statuette of a Cook with
Mortar and Pestle**

Greek, Tanagra, c. 525–475 BC

Terracotta

Height 4 3/8 in. (11 cm)

BOEOTIAN WORKSHOP

121

Statuette of a Scribe

Greek, Thebes, c. 525–475 BC

Terracotta

Height 4 in. (10 cm)

BOEOTIAN WORKSHOP

122

**Statuette of a Musician:
Lyre Player**

Greek, Thebes, c. 525–475 BC

Terracotta

Height 4 in. (10 cm)

BOEOTIAN WORKSHOP

119

120

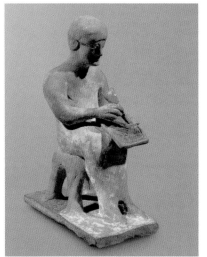

121

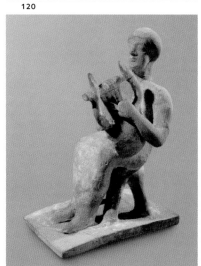

122

123A, 123B
**Red-Figured Calyx Krater
(bowl for mixing wine and
water) Known as the Antaeus
Krater**
Greek, Attic, Archaic,
c. 515–510 BC
From Cerveteri (ancient
Caere), Italy
Clay, gloss paint, line drawing, red
highlights, incisions, and beading
Height 17 3/4 in. (45 cm);
diameter 21 5/8 in. (55 cm)
SIGNED BY THE PAINTER
EUPHRONIOS; ATTRIBUTED TO
THE POTTER EUXITHEOS

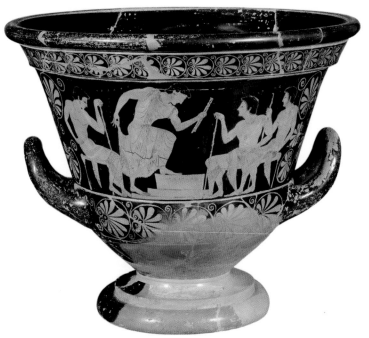

123A

123B

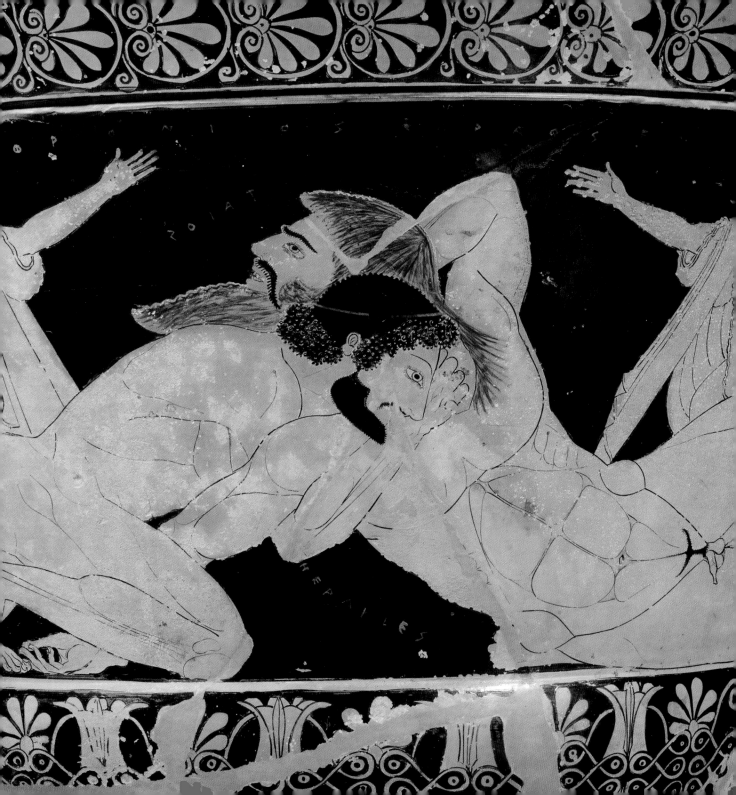

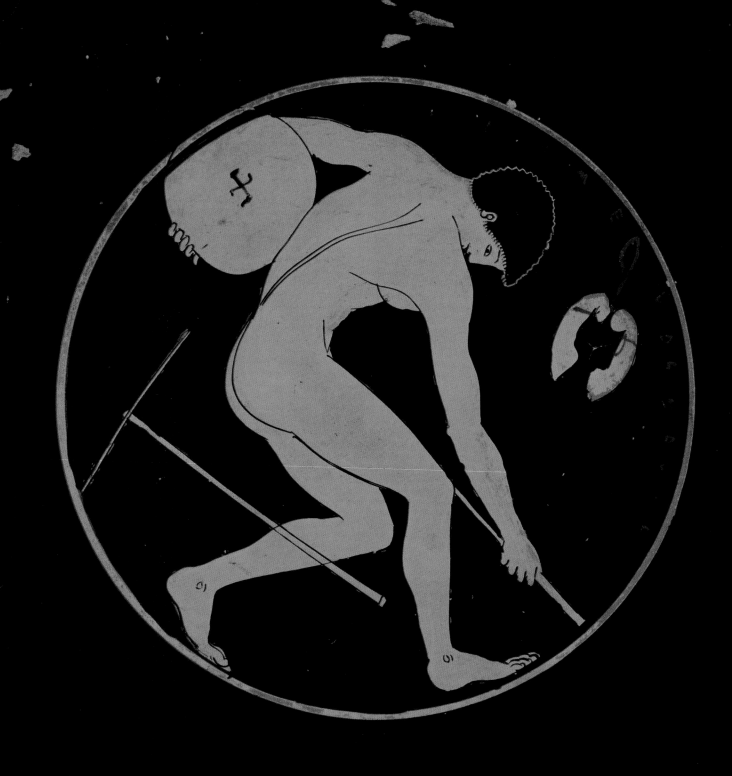

124

Interior of a Kylix (drinking cup) with Discobolus (discus thrower)

Greek, Archaic, c. 510–500 BC

From Etruria (Italy)

Terracotta

Height 3 1/8 in. (8 cm); width 11 3/4 in. (30 cm); diameter 7 7/8 in. (20 cm)

THE KLEOMELOS PAINTER

125

Interior of a Kylix with Lovers, a Cup, and a Cither

Greek, Archaic, c. 510–500 BC

From Etruria (Italy)

Terracotta

Height 3 1/8 in. (8 cm); width 11 3/4 in. (30 cm); diameter 7 7/8 in. (20 cm)

SIGNED BY THE PAINTER PEDIEUS

126

Interior of a Red-Figured Kylix with Warrior

Greek, Tanagra, Archaic, c. 520–510 BC

Terracotta

Height 3 1/8 in. (8 cm); width 10 1/4 in. (26 cm); diameter 7 7/8 in. (20 cm)

THE PAINTER SKYTHES

127

Interior of a Red-Figured Kylix with Kottabos Player

Greek, Archaic, c. 510 BC

Terracotta

Height 4 3/8 in. (11 cm); width 15 3/4 in. (40 cm); diameter 11 3/4 in. (30 cm)

SIGNED BY THE POTTER PAMPHAIOS

128

Interior of a Red-Figured Kylix with Musician

Greek, Corinth, Archaic, c. 500 BC

Terracotta

Height 3 in. (7.5 cm); width 8 1/4 in. (21 cm); diameter 5 7/8 in. (15 cm)

THE CHAIRIAS PAINTER

125

126

127

128

129
**Kore Dedicated by
Cheramyes**
Greek, Sanctuary of Hera,
Island of Samos, Archaic,
c. 570–560 BC
Marble
Height 75 5/8 in. (192 cm)

130
**Akroterion (crowning
architectural ornament) with
Head of a Sphinx**
Greek, Thebes, c. 540–520 BC
Polychrome terracotta
Height 13 3/4 in. (35 cm);
width 7 1/2 in. (19 cm)
CORINTHIAN WORKSHOP

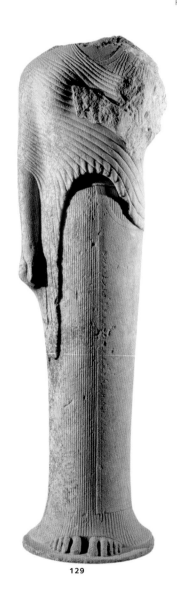

129

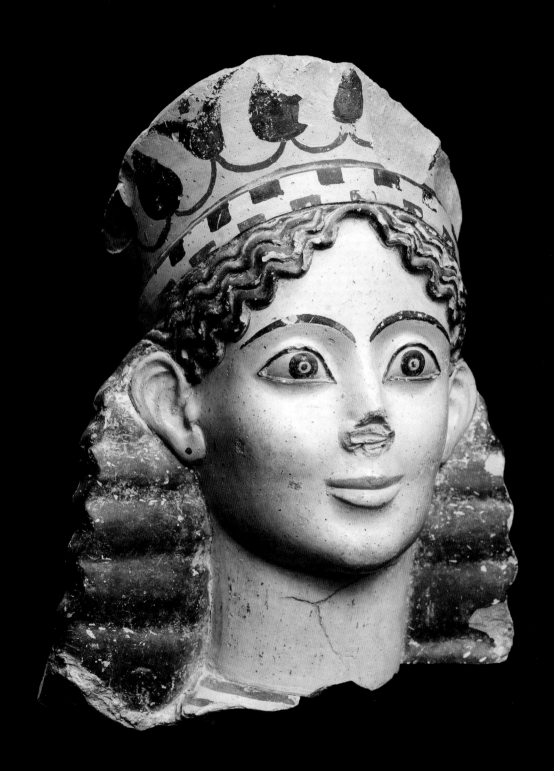

131
Head of a Horseman (The Rampin Horseman)
Greek, Athens, c. 550 BC
Hymetos marble with traces of red and black paint
Height 10 5/8 in. (27 cm)

132
Male Torso (The Miletus Torso)
Greek, c. 480–470 BC
From the Theater of Miletus in Turkey
Sculpted in the round, island marble (from Paros?)
Height 52 in. (132 cm)

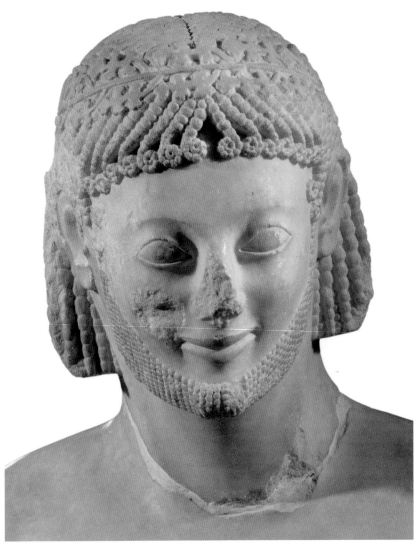

131

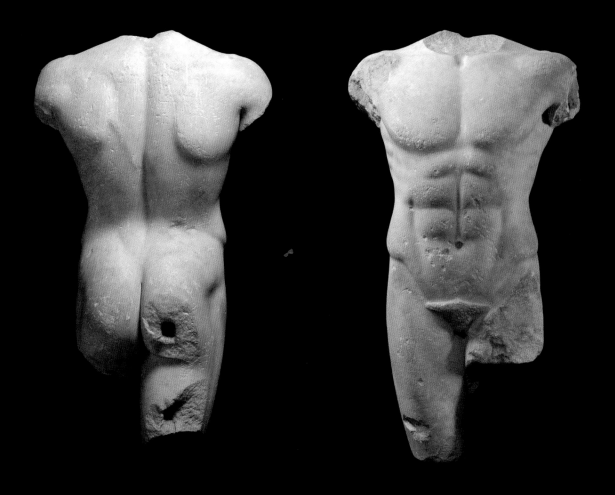

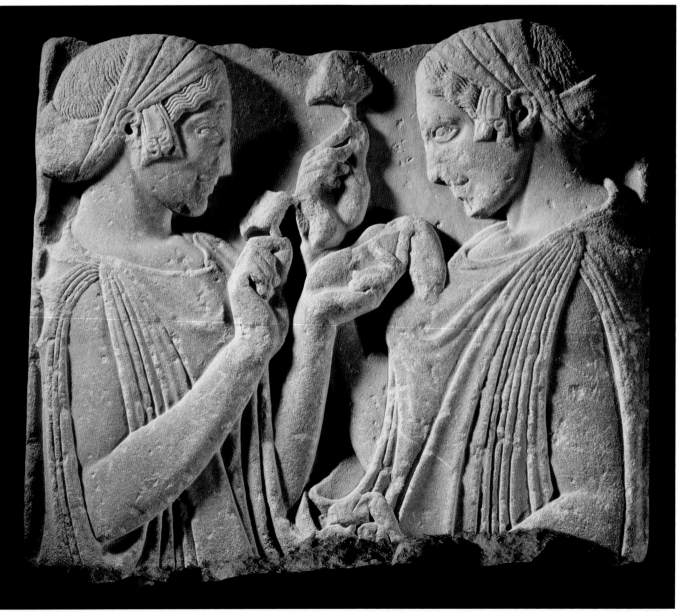

133

133
Fragment of a Funerary Stele,
(Exaltation of the Flower)
Greek, Pharsalus, 470–460 BC
Parian marble
22 1/2 × 26 3/8 × 5 1/2 in.
(57 × 67 × 14 cm)

134
Female Head (The
Kaufmann Head)
Greek, Hellenistic, c. 150 BC
From Tralles, Turkey
Marble (from Asia Minor?)
Height 13 3/4 in. (35 cm)
AFTER PRAXITELES

135
Plaque from the East Frieze
of the Parthenon (Plaque of
the Ergastines)
Greek, Athens, Classical,
445–438 BC
Pentelic marble
37 3/4 × 81 1/2 in. (96 × 207 cm)

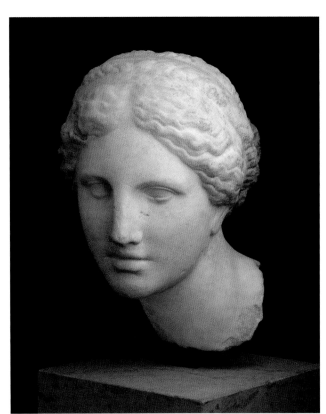

134

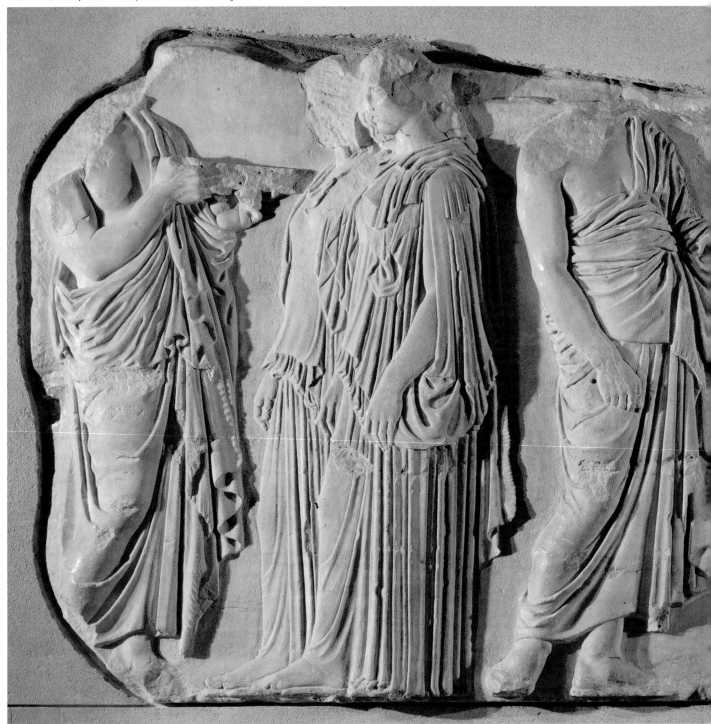

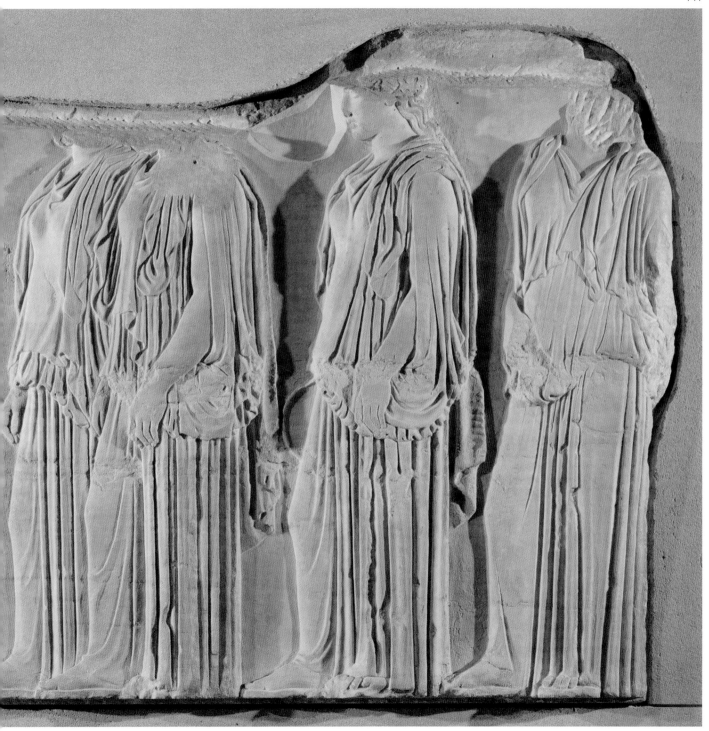

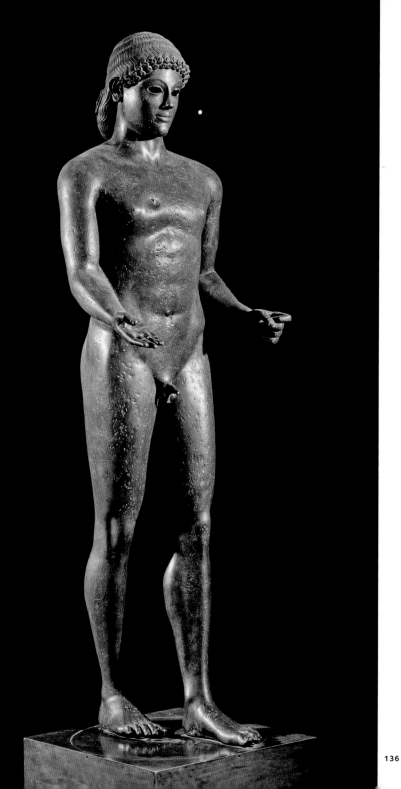

136

Apollo (The Apollo of
Piombino)

Greek, 1st century BC

Found in the sea off the coast
of Piombino (Italy)

Bronze and copper with silver inlays

Height 45 1/4 in. (115 cm)

137

Hermes Tying his Sandal

Roman copy of a Greek
original, 2nd century AD

From the Theater of Marcellus
in Rome

Pentelicus marble

Height 63 3/8 in. (161 cm)

GREEK ORIGINAL ATTRIBUTED
TO LYSIPPOS

138

Apollo Sauroctonus (The
Lizard-Slayer)

Roman copy of a Greek
original, Italy, 1st–
2nd century AD (?)

Marble

Height 58 5/8 in. (149 cm)

GREEK ORIGINAL BY PRAXITELES

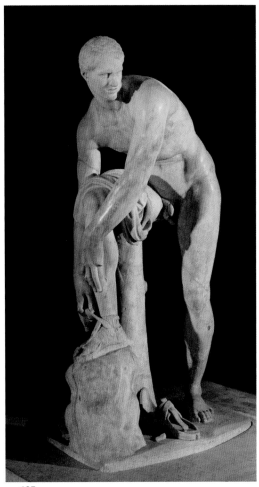

137

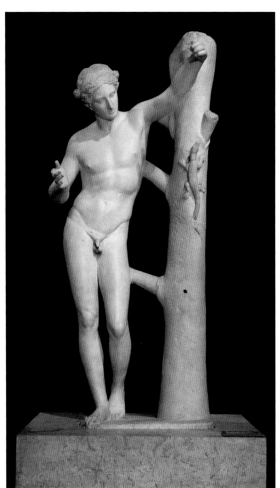

138

139
**Head of a Youth (The
Benevento Head)**
Roman bust inspired by
Polykleitos of Argos (Greece),
c. 50 BC
From Italy
Bronze and red copper
Height 13 in. (33 cm)

140
**Artemis with a Doe (The
Diana of Versailles)**
Roman copy of a 4th century
BC Greek original, 1st–2nd
century AD
From Italy (Nemi?)
Marble
Height 78 ³/₄ in. (200 cm)

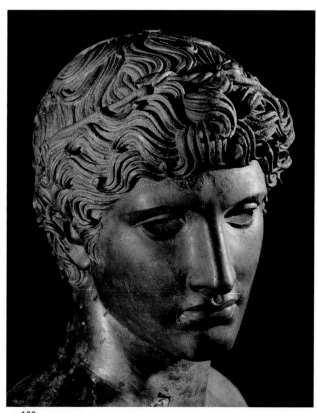

139

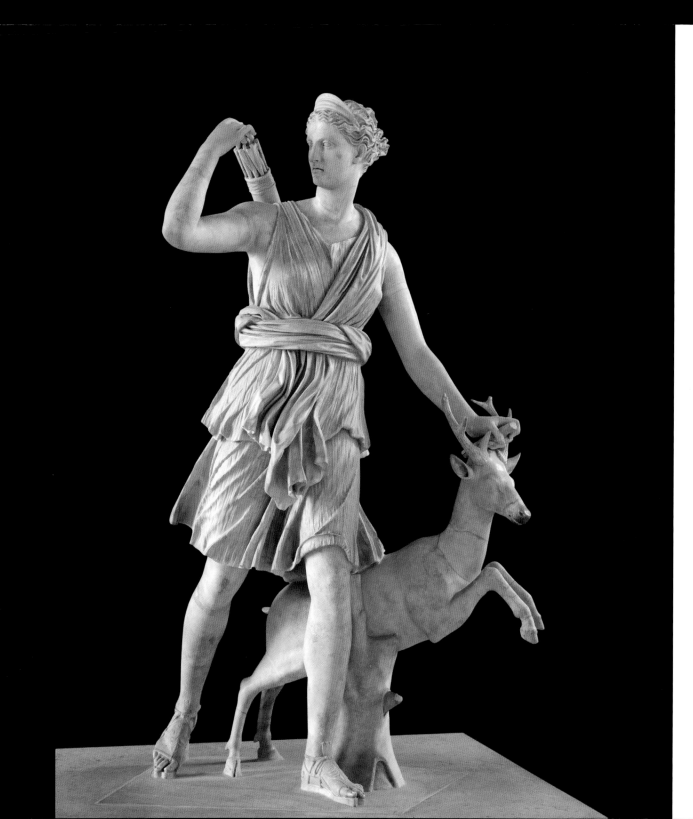

141
Seated Woman
Greek, Tanagra?, 400–350 BC
Terracotta
Height 5 7/8 in. (15 cm)

142
The Aegina Concert Group:
Woman Playing the Cither
Greek, 250–225 BC
Terracotta
Height 7 7/8 in. (20 cm)

143
Veiled Dancer
Greek, Tanagra?, 400–350 BC
Terracotta
Height 7 7/8 in. (20 cm)

144
Seated Draped Woman
Greek, Tanagra, c. 330–200 BC
Terracotta
Height 5 1/2 in. (14 cm)

145
Young Girls Dancing in a Ring
Greek, Tanagra, early 3rd
century BC
Terracotta
Height 7 1/8 in. (18 cm)

141

142

143

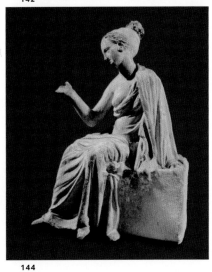
144

145

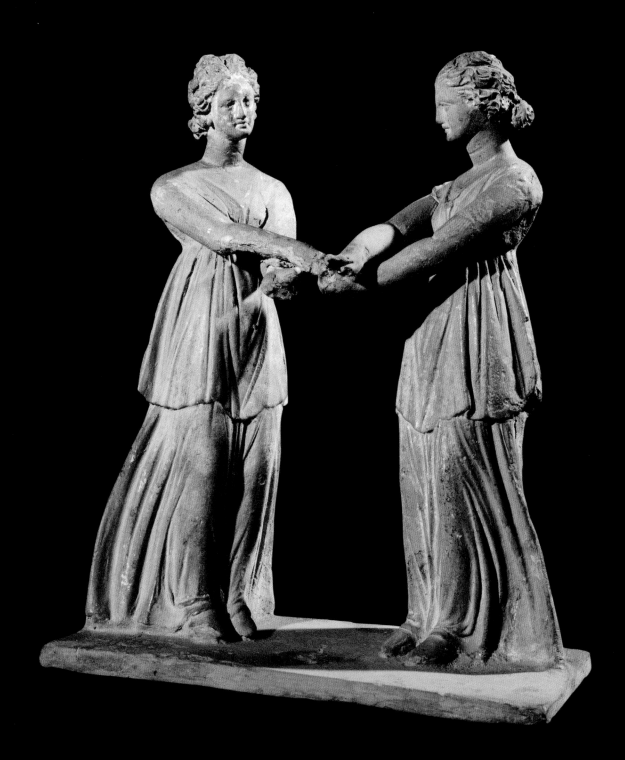

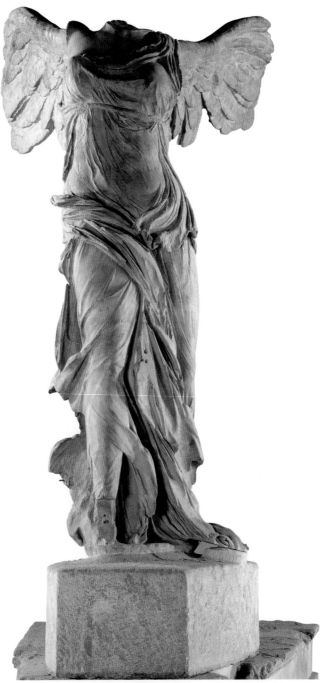

146A

146A, 146B
The Winged Victory of Samothrace
Greek, island of Samothrace,
c. 190 BC
Statue: Paros marble;
ship: Lartos marble
Height 129 1/8 in. (328 cm)

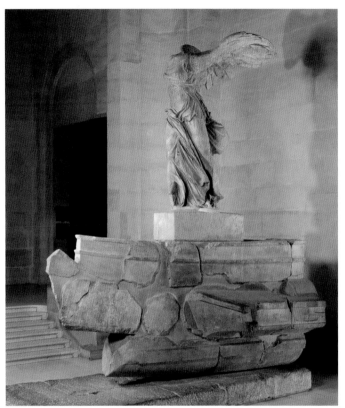

146B

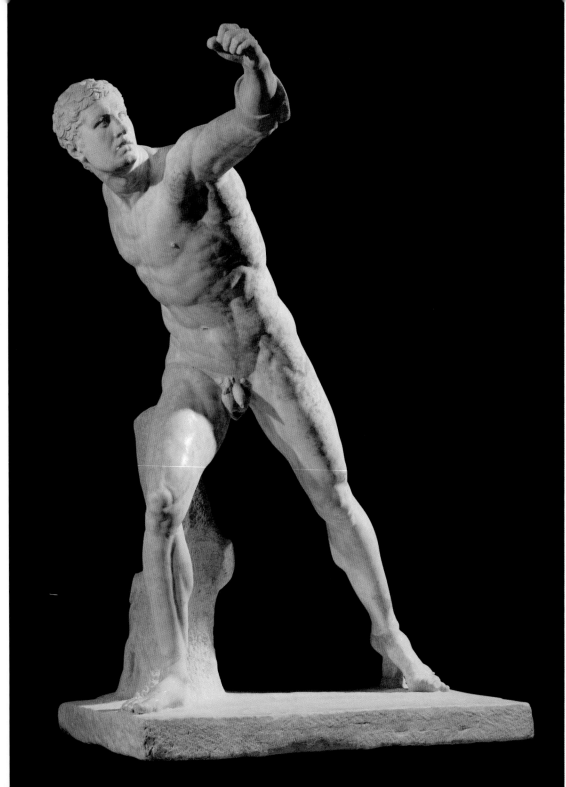

147
Warrior, Known as The Borghese Gladiator
Greek, c. 100 BC
From Anzio (Italy)
Pentelic marble (Attic)
Height 78 3/8 in. (199 cm)
AGASIAS OF EPHESUS,
SON OF DOSITHEOS

148
Hermaphrodite Sleeping
Roman copy of a 2nd century
BC Greek original; Rome, 2nd
century AD
Marble
Length 66 1/2 in. (169 cm)

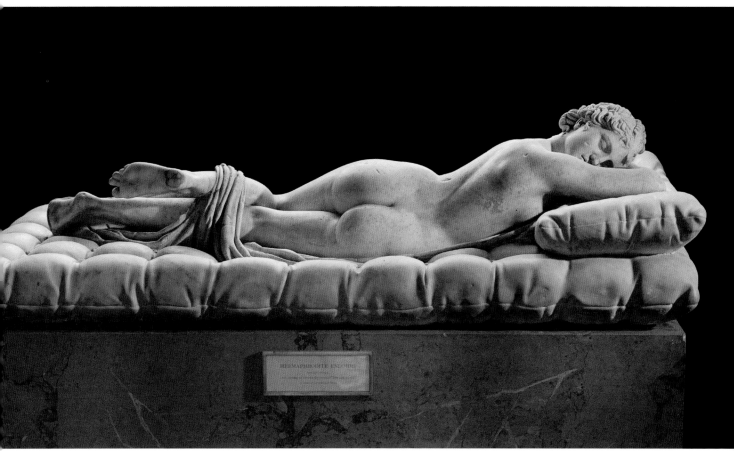

149A, 149B, 149C
Aphrodite (Venus de Milo)
Greek, Melos, late 2nd
century BC
Paros marble
Height 79 1/2 in. (202 cm)

150
**Sarcophagus of a Married
Couple**
Etruscan, Cerveteri (ancient
Caere), Italy, c. 520–510 BC
Polychrome terracotta, clay, slip, and
paint; modeling and molding
Height 43 3/4 in. (111 cm)

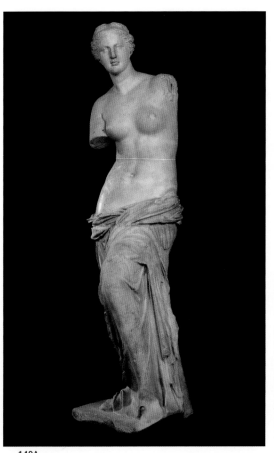

149A

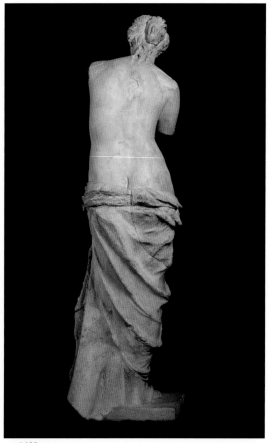

149B

149C

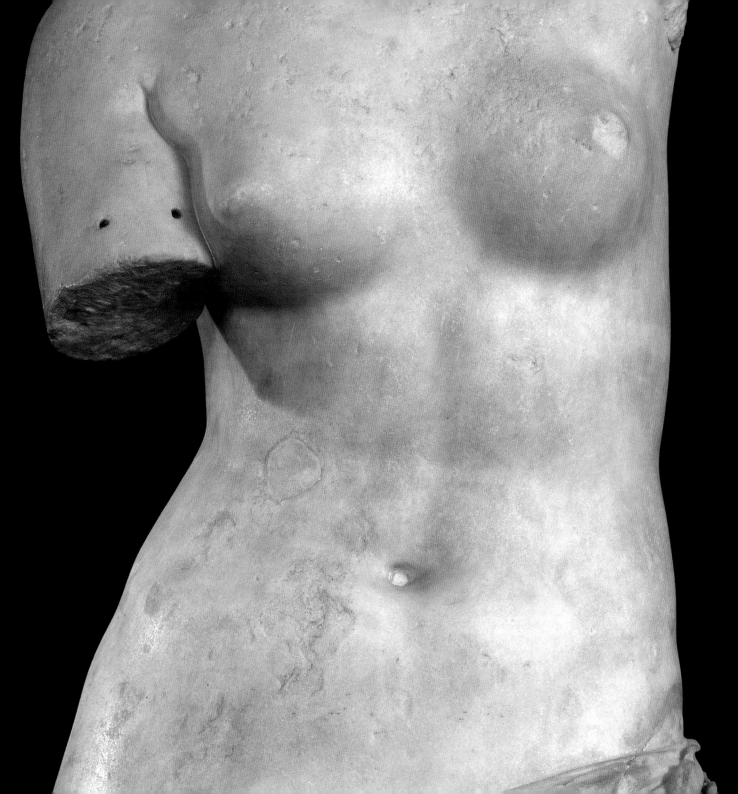

150

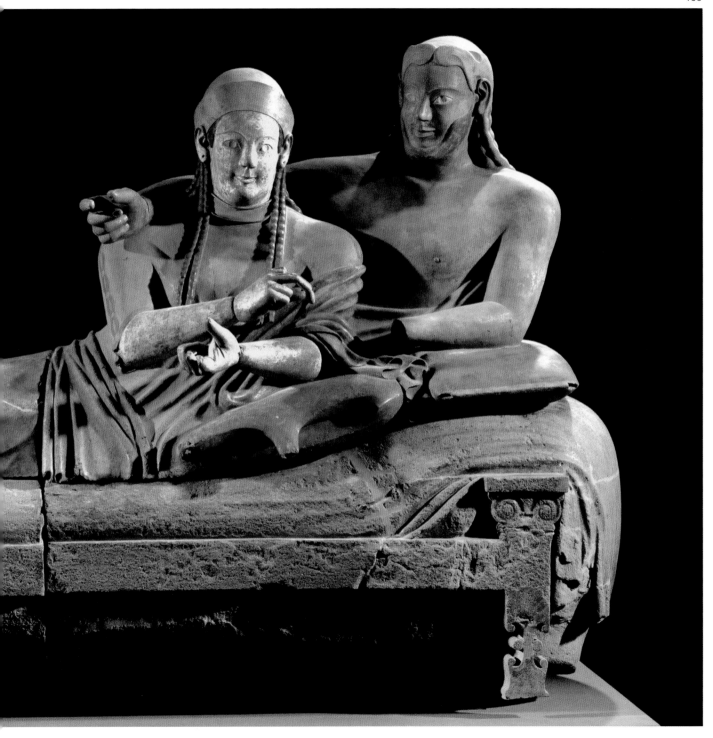

151
Pair of Bracelets
Etruscan, Southern Etruria,
first quarter of 7th century BC
Gold with filigree
Diameter 3 1/8 in. (8 cm)

152
Bracelet
Southern Italy, late 3rd
century BC
Gold
Diameter 2 in. (5 cm)

153
**Pendant with the Head of the
River-God Achelous**
Etruscan, c. 480 BC
Gold with filigree and granulation
Width 14 1/8 in. (36 cm)

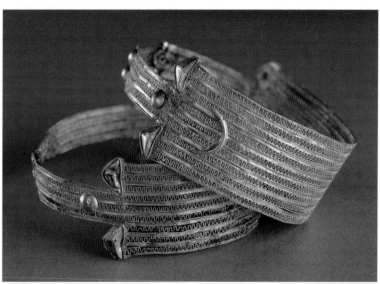

151

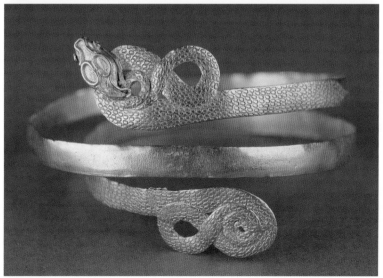

152

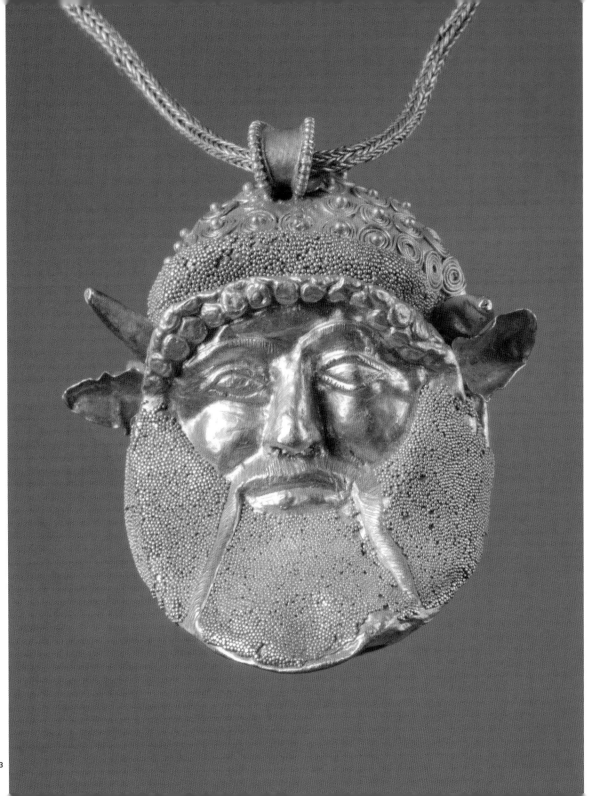

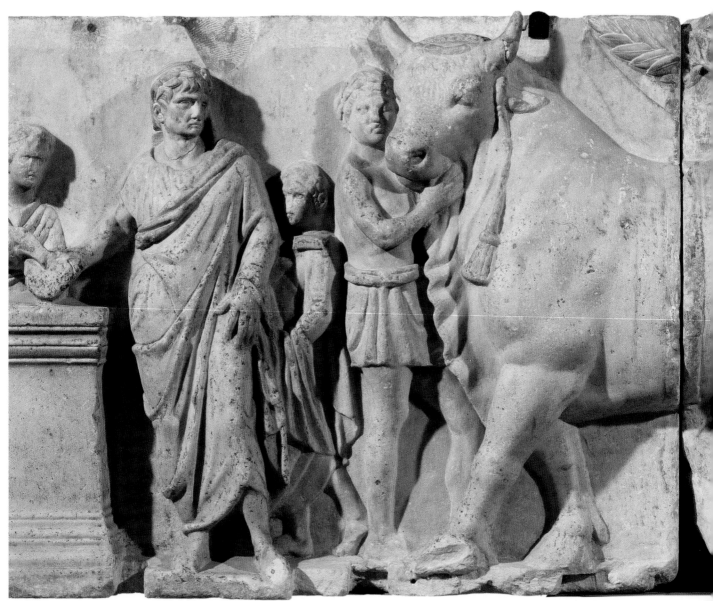

154

154
Relief: Domitius Ahenobarbus
(Census and Sacrifice
to Mars)
Roman, Rome, c. 100 BC
Marble
47 1/4 × 220 1/2 in. (120 × 560 cm)

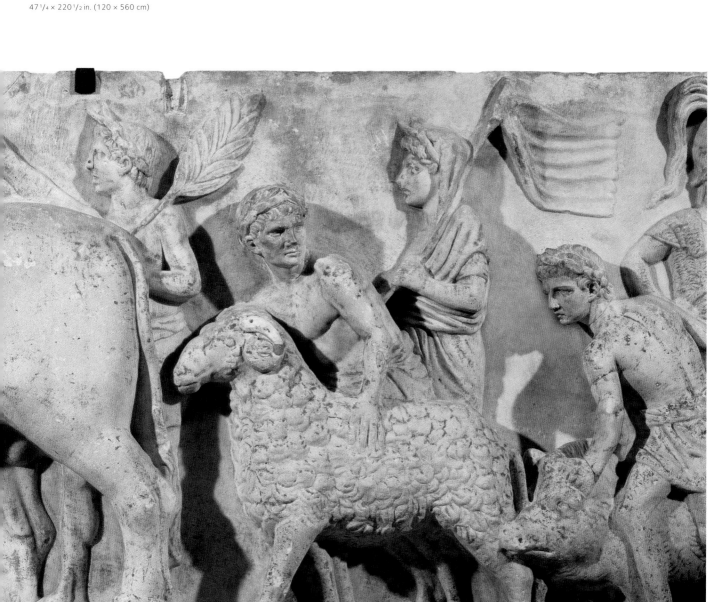

155A, 155B
**Fragment of a Mosaic
Pavement: Triumph of
Neptune and Amphitrite**
Roman, first quarter of 4th
century AD
Constantine (Algeria)
Marble, limestone, and molten glass
329 1/8 × 281 1/8 in. (836 × 714 cm)

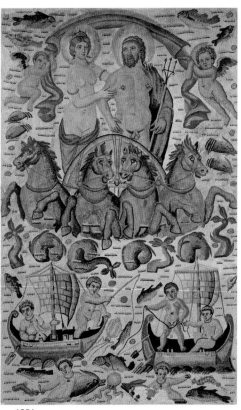

155A

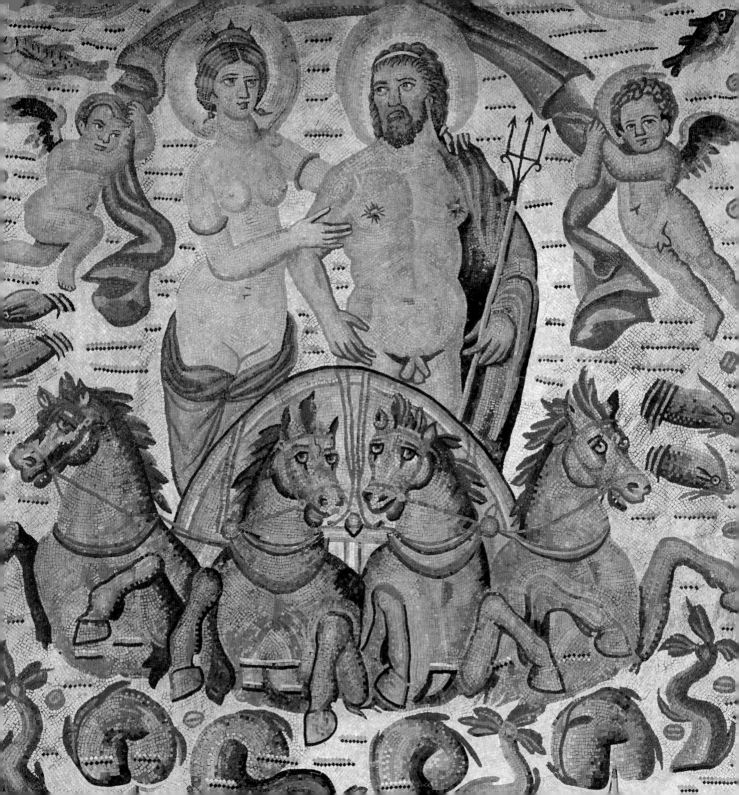

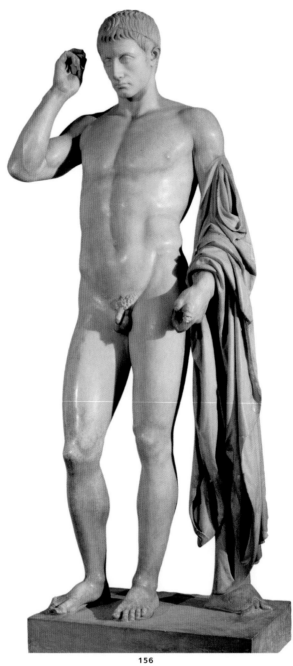

156

156
Marcellus
Roman, Rome, C. 20 BC
Marble
Height 74 3/4 in. (190 cm)
CLEOMENES THE ATHENIAN,
SON OF CLEOMENES

157
Augustus
Roman, AD 41–54
From Cerveteri (ancient
Caere), Italy
Marble
Height 13 3/4 in. (35 cm)

158
Livia
Roman, C. 31 BC
Basalt
Height 12 5/8 in. (32 cm)

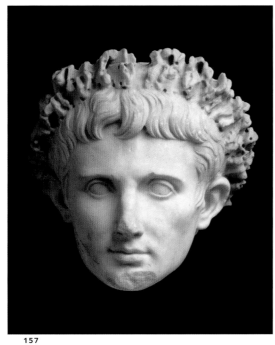

157

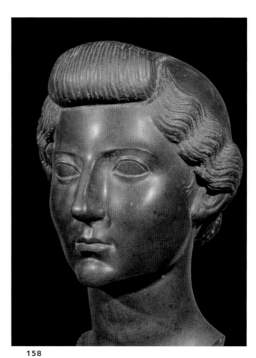

158

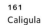

159
Caracalla
Roman, c. AD 212–215
Marble
Height 18 1/2 in. (47 cm)

160
Demosthenes
Roman copy of a bronze
statue by Polyeuctos (Greek,
c. 280 BC)
Found in Italy
Marble
Height 17 3/8 in. (44 cm)

161
Caligula
Roman, c. AD 39–40
From Thrace (currently
Greece, Bulgaria, and Turkey)
Marble
Height 18 1/2 in. (47 cm)

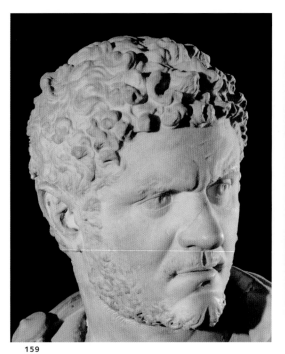

159

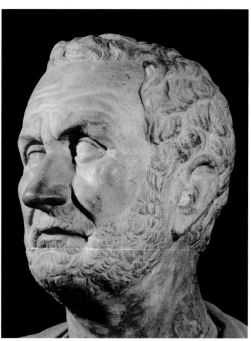

160

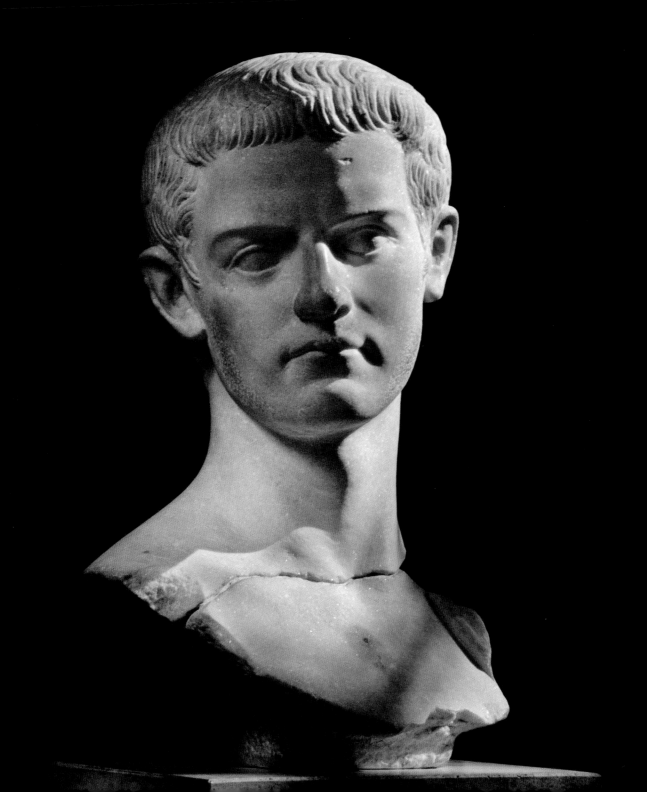

ISLAMIC ART

THE DEPARTMENT of Islamic Art, established in 2003, is the newest of the eight departments in which the Louvre's collections are apportioned. Yet, many of its holdings have been in the museum for a long time: some works belonged to the royal collections as early as the Middles Ages, and many others joined the public collections in the late nineteenth century. Influenced by the scholarship of a few curators and the tastes of some collectors and connoisseurs, the museum's period of great expansion was followed by an acquisition policy that enabled the Louvre to add to its collection of Islamic art on a regular basis. The first exhibition galleries were opened in 1905, but had to close in 1939 when the declaration of war made it necessary to evacuate the artwork. The Louvre's Islamic galleries were reopened following the Second World War as part of the Department of Near Eastern Antiquities, but during the 1970s they were reduced to a few display cases. The situation improved in 1993 when permanent galleries were installed in the museum's Richelieu Wing, where, finally, the public could view masterpieces previously hidden away in storage. A new, larger space for this distinguished collection is scheduled to open in 2010.

The works are widely varied. They come from a vast territory stretching from Spain to India and encompass thirteen centuries of history, from the seventh to the nineteenth century. Some of these works attest to the diplomatic and economic exchanges between Europe and the Oriental world since the Middle Ages. The Louvre's Islamic art collections are intimately linked with the museum's Antiquities departments, taking up chronologically where the other departments leave off. Islamic cultures were inspired by the ancient Oriental worlds of Syria and Iran, flourished in the heart of Coptic and Byzantine civilizations, and developed strong ties with Christian Spain. It naturally follows that the departments of Near Eastern Antiquities; Egyptian Antiquities; Greek, Etruscan, and Roman Antiquities; and Islamic Arts collaborate closely. Similarly, because of the nature of its holdings, the Department of Decorative Arts may have the closest ties to the Islamic collection.

Quantitatively and qualitatively, the Louvre's collections of Islamic art are among the most important in the world. Enhanced by a loan of several thousand items from the Museum of Decorative Arts, the collections constitute an encyclopedic survey highlighted by major works representing every aspect of Islamic art. Among the archaeological artifacts, one must mention those excavated on the site of the city of Susa in the south of Iran, a place last inhabited during the fifteenth century. Nine centuries of Islamic occupation have yielded a variety of pieces in ceramic, glass, and metal that depict the evolving economic life of an Iranian provincial capital.

The current display offers a comprehensive overview of Islamic artistic production, although some periods clearly stand out. The early Abbassid era saw the appearance of new techniques for decorating ceramics, shown here in blue-patterned earthenware (no. 166). Though it has relatively few examples of the art of Muslim Spain, the Louvre boasts a handful of genuine masterpieces, including the *Pyxis (lidded box) of al-Mughira* (nos. 164A, B), typical of the refined ivory work as much as the elaborate ornament and symbolic complexity developed under the Spanish caliphate. Medieval Iran is represented by a beautiful collection of ceramics displaying the entire range of decorative techniques then in use, including the highly complex, visually dazzling techniques of haft rang and metallic luster (no. 169). The

Louvre's collection of Near Eastern Ayyubid and Mamluk artifacts consists of silver-inlaid metalwork pieces from the principal centers of Syrian and Egyptian production, including the basin known as the *Baptistery of Saint Louis* (no. 172) and a major collection of mosque lamps in enameled glass.

The great modern empires of the Ottomans, Safavids, and Mughals also have their place in the Louvre's collections. The Ottomans, in particular, have left us a beautiful series of Iznik ceramics, most notably the celebrated *Peacock Dish* (no. 177). Safavid Iran is honored through a few critically important pieces such as the Mantes carpet (no. 173) and a very rare ceramic panel (no. 175) from a house in Isfahan, the "bellybutton of the world." The department also holds an impressive collection of Indian weapons and objects ornamented with precious stones and silver and gold plating (no. 176). Still other treasures include a small collection of Turkish, Iranian, and Indian illustrated manuscripts. Too fragile to be on permanent display, these precious artifacts are exhibited in rotation in one of the galleries. The entire exhibition enables the visitor to perceive the artistic evolution of the Islamic world; to grasp the importance of material and visual culture in a complex civilization; and to appreciate the beauty and refinement of its frequently unknown works of art.

The Department of Islamic Art is slated to expand. The Cour Visconti, a courtyard in the Denon Wing that has been selected to house the expansion, will be covered with an undulating glass veil designed by architects Mario Bellini and Rudy Ricciotti, the first major twenty-first-century architectural imprint on the old palace. The additional area thus obtained will allow the department to triple its exhibition space and to display numerous works currently held in storage. To best prepare this new exhibition space, the current galleries will be closed and the Islamic collections kept out of the public eye for three years until they reappear in all their splendor in 2010.

162

162
Panel with Stylized Bird
Egypt, late 9th–early 10th
century
Sculpted Aleppo pine
28 3/4 × 13 in. (73 × 33 cm)

163
Bowl with Standard Bearer
Iraq, 10th century
Earthenware with luster decoration
in an opaque glaze
Diameter 12 5/8 in. (32 cm)

162

164A, 164B

Pyxis (lidded box) of al-Mughira

Spain, Royal Workshop of Madinat al-Zahra, 968

Sculpted and engraved ivory with traces of black inlays

Height 7 1/8 in. (18 cm); diameter 4 3/4 in. (12 cm)

165

Lion with an Articulated Tail

Spain, 12th–13th century

Bronze cast, engraved decoration

Height 12 3/8 in. (31.5 cm); width 21 1/2 in. (54.5 cm)

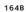
164B

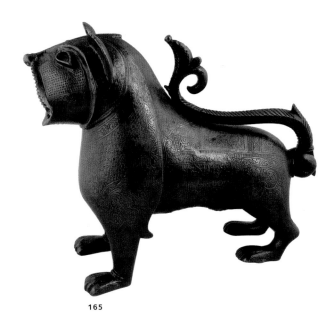
165

164A

166
Ewer with Rooster Head
Iran, Kashan, early 13th
century
Openwork fritware with underglaze
painted Waq-Waq decoration
Height 15 3/4 in. (40 cm); max.
diameter 7 7/8 in. (20 cm)

167
**Dish with Epigraphic
Decoration**
Iran, Khorasan, or Central
Asia, Transoxiana (currently
Uzbekistan, Tajikistan,
southwest Kazakhstan),
11th–12th century
Slip-coated ceramic clay with
transparent underglaze slip
decoration
Diameter 15 in. (38 cm)

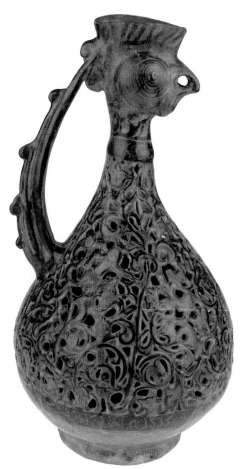

166

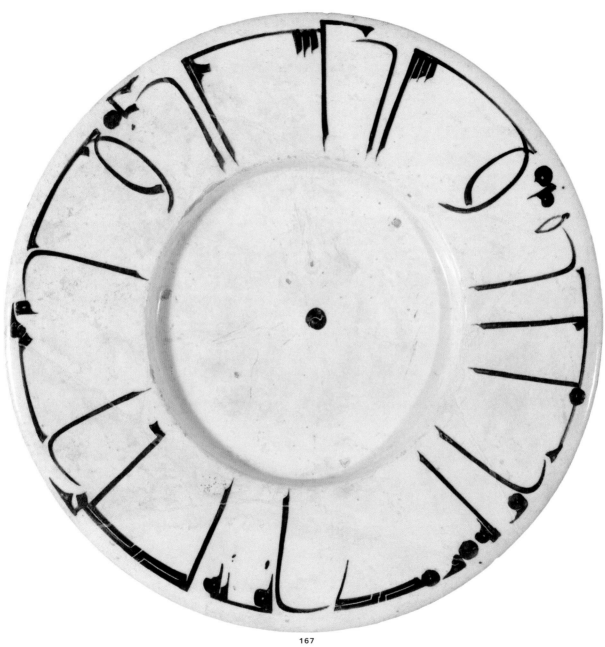

168A, 168B
Beaker with a Frieze of Horsemen
Syria, mid-13th century
Blown glass, enamel, and gilt decoration
Height 6 1/8 in. (15.5 cm); diameter 4 3/8 in. (11 cm)

169
Dish with Falconer on Horseback
Iran, early 13th century
Fritware with haft-rang decoration, luster, and gilt in an opaque glaze
Diameter 8 5/8 in. (22 cm)

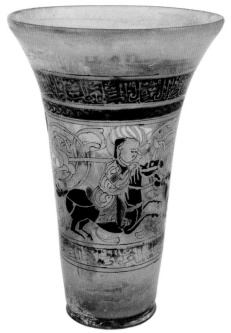

168A

168B

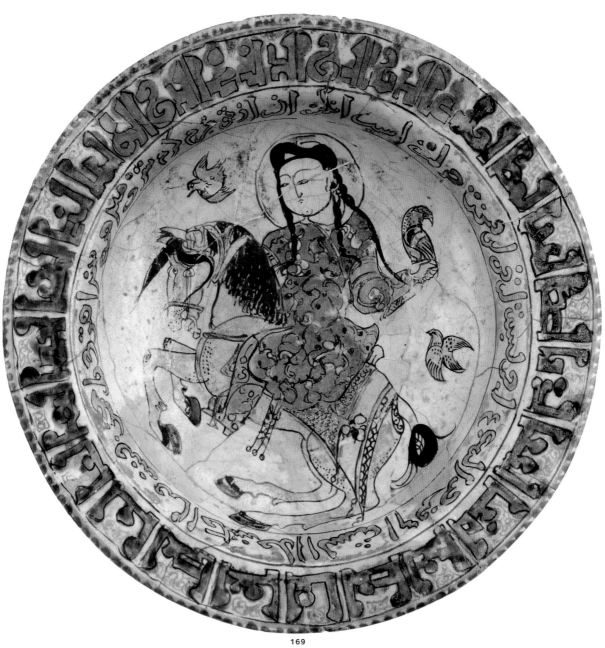

169

170
Celestial Globe
Syria or Iran (Isfahan?),
1144–45
Engraved brass inlaid with silver
Height 10 5/8 in. (27 cm); diameter
6 3/4 in. (17 cm)
SIGNED YUNUS AL-ASTURLABI

171
**Lamp Bearing the Name of
Sultan Nasir Salah al-Din
Hasan**
Egypt or Syria, Mamluk,
1347–61
Blown glass with enamel and gilt
Height 14 1/8 in. (36 cm);
diameter 18 1/2 in. (47 cm)

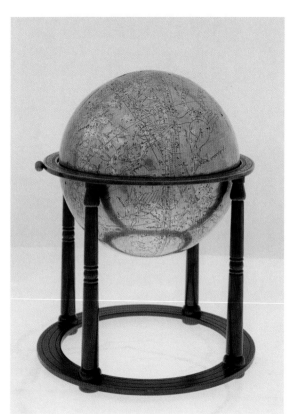

170

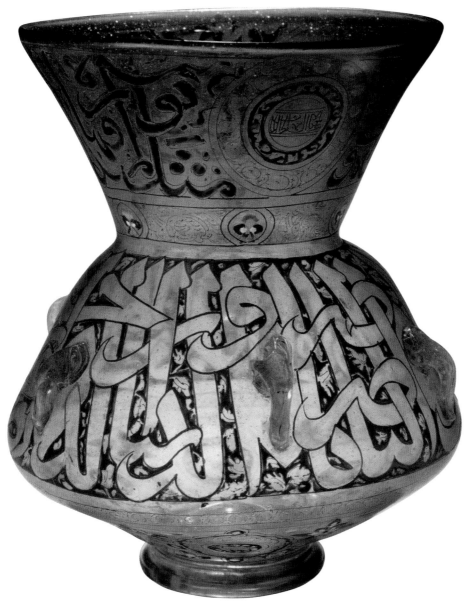

171

172A, 172B
Basin (Baptistery of Saint Louis)
Egypt or Syria, c. 1320–40
Hammered brass; decoration inlaid
with gold, silver, and black paste
Height 9 in. (23 cm); diameter
19 ³/₄ in. (50 cm)
SIGNED MUHAMMAD IBN AL-ZAIN

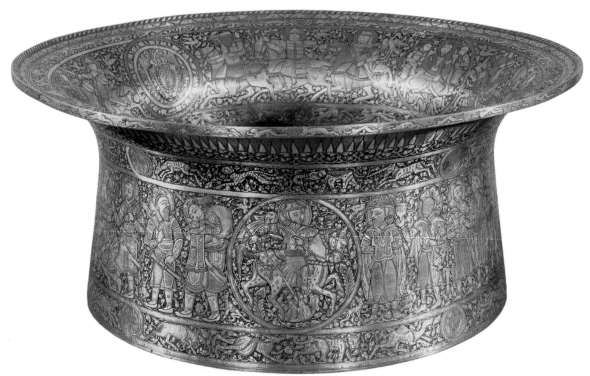

172A

172B

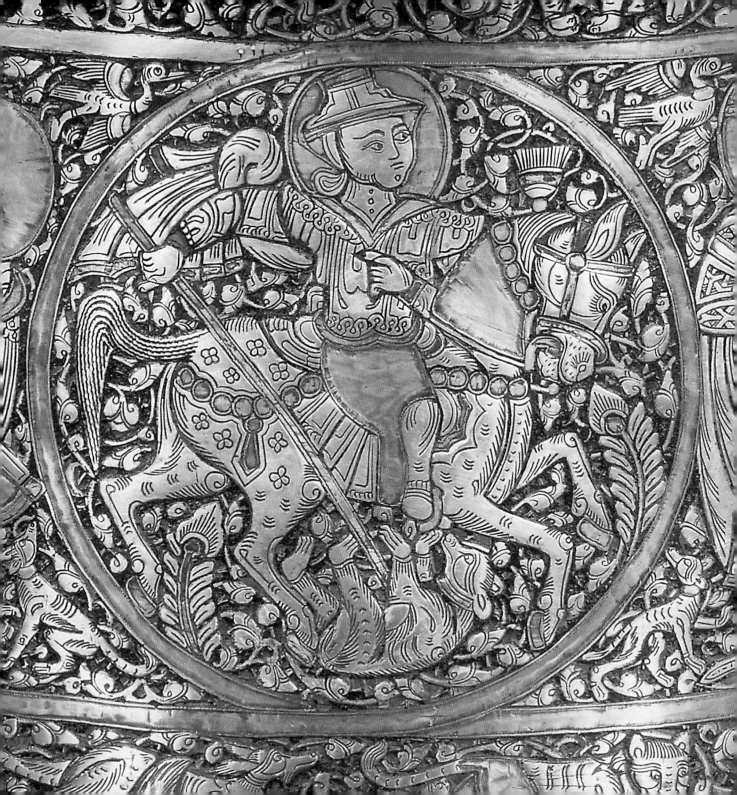

173
The Mantes Carpet
Northwestern Iran,
late 16th century
Wool and cotton, asymmetrical knots
151 5/8 × 308 1/4 in. (385 × 783 cm)

174
**Portrait of Shah Abbas I and
His Page**
Iran, Isfahan, 1627
Ink, color, gold, and silver on paper
Central image: 12 1/4 × 7 7/8
in. (31 × 20 cm); entire page
including margins: 20 7/8 × 15 3/4 in.
(53 × 40 cm)
SIGNED MUHAMMAD QASIM

175
**Mural Panel: Relaxation in a
Garden**
Iran, Isfahan, 17th century
Fritware decorated with colored
glaze known as *cuerda seca*
46 1/2 × 69 1/4 in. (118 × 176 cm)

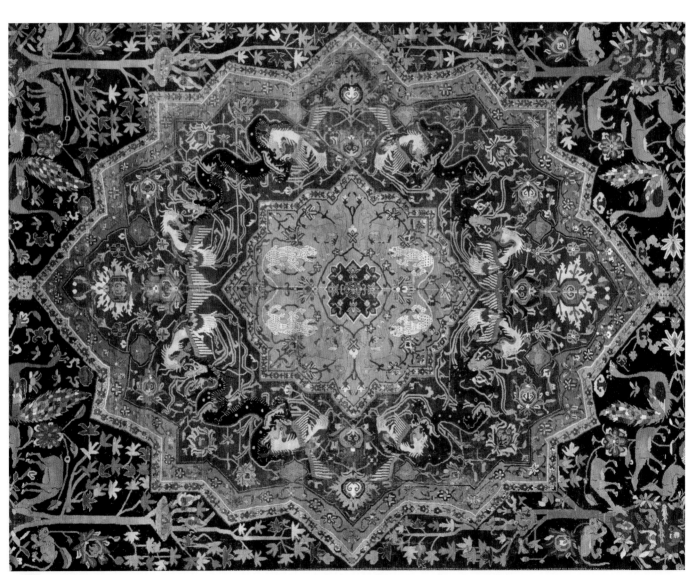

173

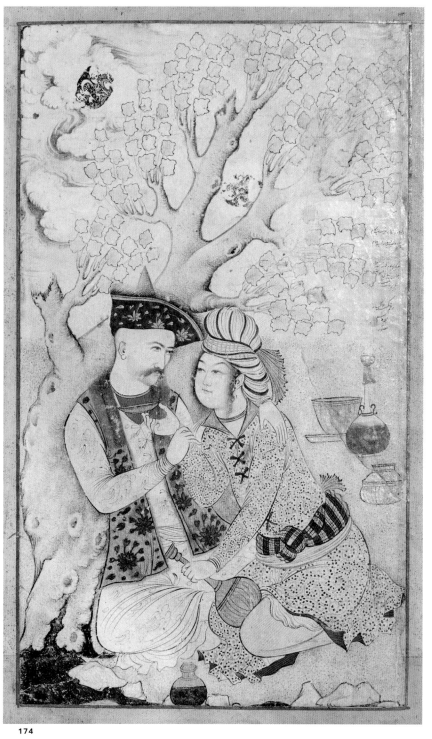

176
Dagger with Horse-Head Handle
India, 17th century
Steel inlaid with gold, jade, and
semiprecious stones
Length 19 5/8 in. (50 cm)

177
Peacock Dish
Turkey, Iznik, 1540–55
Fritware with underglaze painted
decoration
Diameter 14 5/8 in. (37 cm)

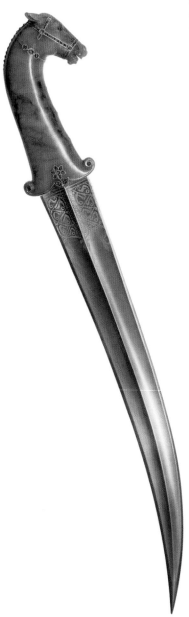

176

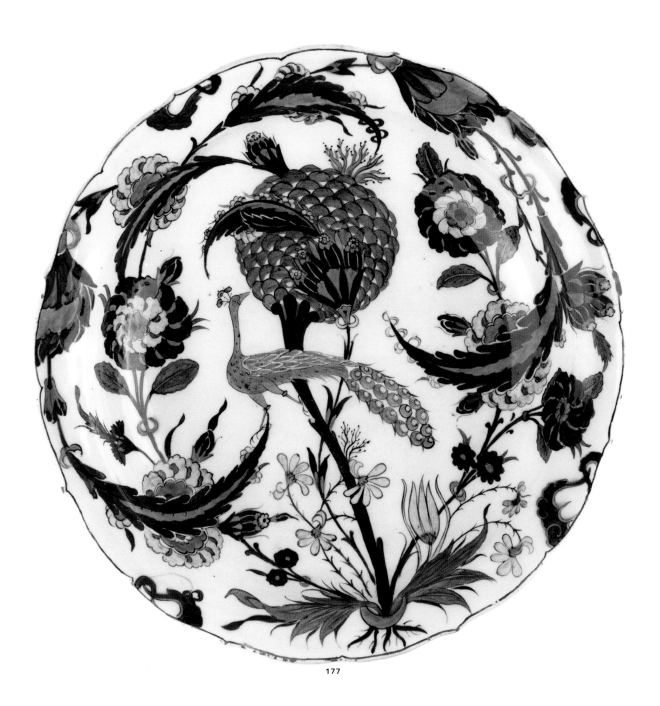

178
Mustafa II in Armor
Page from an album of
portraits of Ottoman sultans
Ottoman, Turkey, early 18th
century
Watercolor, ink, gold, and silver
on paper
6 1/4 × 4 3/8 in. (16 × 11 cm)
ABDÜLCELIL LEVNI

179
Portrait of Nasir al-Din Shah
Iran, mid-19th century
Oil on copper
14 1/8 × 8 7/8 in. (36 × 22.5 cm)
SIGNED BAHRAM KIRMANSHAHI

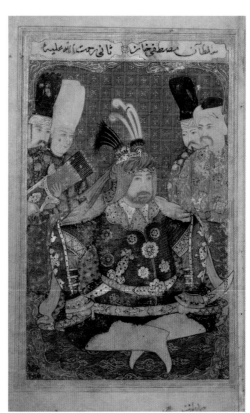

178

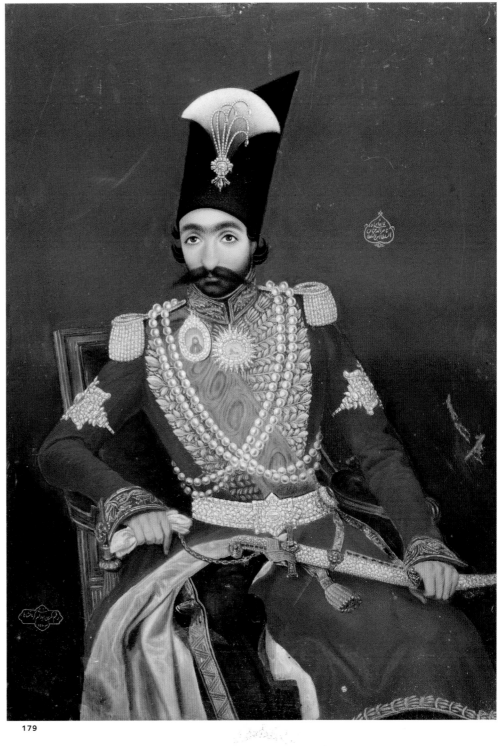

PAINTINGS

TO THE MANY VISITORS wandering through the museum's exhibition galleries, the Louvre is, above all, the *Mona Lisa* (no. 264) and, more generally, the place one visits to admire paintings.

With more than 7,000 pieces, the Paris collection is one of the most important in the world; few institutions can line up such a selection of masterpieces. Nearly half the paintings were originally held by France's royal families and have been in the country for centuries. Royal collections were started by Louis XII (r. 1498–1515) and sustained two periods of significant growth—one in the first half of the fifteenth century under Francis I, the other in the second half of the seventeenth century during the reign of Louis XIV. When the Museum Central opened its doors to the public in 1793, most of the sixteenth- and seventeenth-century Italian and Flemish masterpieces on display in the Louvre today were already on view. The collection also contained a superb selection of French paintings. Some, such as the Poussin paintings acquired by Louis XIV, came from the royal collections, while others derived from the great Parisian churches sacked during the Revolution. Nineteenth- and twentieth-century curators filled the gaps in the collection, increasing its overall value.

More than half the paintings in the Louvre are French, hardly surprising in a national collection that aims to reflect the country's artistic production in its entirety. In the field of French art, the Louvre has no significant competition. There is no better place to view great French painting, dating from the heart of the Middle Ages to the mid-nineteenth century. No significant artist is missing from the roll call of the department's holdings, and some are represented by impressive numbers of canvases: the Louvre exhibits forty Poussins, thirteen Watteaus, forty-seven Delacroix, and eighty-two Corots! But apart from quantity, it is the quality and diversity of the works that are truly exceptional. Every major work of French art produced prior to the mid-nineteenth century hangs in the Louvre, from Enguerrand Quarton's *Ville-neuve-lès-Avignon Pietà* (no. 183) to Delacroix's *Liberty Leading the People* (no. 236) via Hyacinthe Rigaud's *Portrait of Louis XIV, King of France* (no. 206), Watteau's *Pierrot* (no. 208) and Jacques-Louis David's *The Consecration of Emperor Napoleon I and the Coronation of Empress Josephine in the Cathedral of Notre-Dame de Paris on 2 December 1804* (no. 222). The works exhibited at the Louvre constitute a near-ideal catalogue of four-and-a-half centuries of French painting in all its aspects.

Italian painting is another of the department's strengths. Here, too, the Louvre's collection is encyclopedic; none of the great names of Italian art from the thirteenth to the late eighteenth centuries have been overlooked. The heart of the museum's Italian holdings consists of the former French royal collections. All the museum's Leonardo da Vincis were in the royal collections, as were most of its Titians, Raphaels, and Guido Renis. The tastes of connoisseurs and collectors have also left their mark on the collection through the acquisitions of Marquis Campana's "primitives" and Doctor La Caze's seventeenth-century paintings. The uniqueness of the Louvre's Italian collection rests both in the quantity and quality of the works assembled. What other museum can boast such an impressive array of seventeenth-century painting? Even in Italy, no institution can match it.

Spain occupies a somewhat isolated place in the Louvre's collections. Sadly, the works in Louis-Philippe's Spanish Museum were taken to England when the king abdicated

in 1848 and went into exile there. Had they remained in France, the Louvre would rival Madrid's Prado in Spanish art. As it is, the Louvre's Spanish collection is modest but brilliant, with several beautiful primitives and important works by El Greco, Zurbarán, Murillo, and Goya.

As for the Northern schools, the Louvre remains true to its tradition of diversity and quality. Outside Munich and Madrid, no museum can claim as many seventeenth-century Flemish masterpieces. Most of these paintings also came from the royal collections. In the early seventeenth century, Marie de Médicis, wife of Henry IV, commissioned Peter Paul Rubens (nos. 320–324), the greatest artist of his time, to paint the twenty-four canvases in the Luxembourg Gallery. Because the art of the Protestants was less appreciated, the Netherlands entered the collection a bit later. Luckily, enlightened eighteenth- and nineteenth-century enthusiasts helped fill the gaps in the Louvre's Dutch holdings. Today, Rembrandt, Frans Hals, and Vermeer are the glories of the Richelieu Wing. Only Germany is poorly represented, though the Louvre does have a few nice primitives from the Cologne School and five Holbein (no. 347) portraits bought by Louis XIV. Naturally drawn to the lines and colors of Italy and to the Flemish sumptuousness, France did not collect much art from its German neighbor; German realism probably seemed overly "Gothic" to art lovers of times past. English painting also got a late start in the museum's galleries, mainly in the last century. But thanks to judicious purchases, the museum offers an interesting selection of English painting from Thomas Gainsborough (no. 350) to J. M. W. Turner (no. 355). The recent acquisition of two paintings by John Martin and Benjamin West demonstrates the Louvre's continued emphasis on enriching this section of the collection.

The Louvre is a living museum. Its collections are never at a standstill. Certainly the major purchases and gifts enjoyed by the institution during the nineteenth century have become rare, but each department continues to acquire several works each year. Selections are based on the need to fill a gap in the collection or to reinforce a particular group of works. Recently, the roughly forty Poussins in the Louvre were bolstered by the purchase of another work by that artist. And for the last twenty years, a significant effort has been made to assemble a collection of nineteenth-century Central and Northern European painting, two areas meagerly represented in the Louvre's collections. The recently acquired German, Austrian, and Danish paintings provide an interesting, though incomplete, overview. The Department of Paintings is now seeking to enlarge the scope of its collections and will soon be turning its attention to North and Latin America.

The Louvre currently exhibits 3,500 paintings, or more than any other major international museum. The paintings are displayed in galleries designed during the first half of the nineteenth century, the 1880s and 1890s, and the late twentieth century. As a living museum, the Louvre must also adapt to evolving standards in museology. The new galleries will soon be out of date, in terms of both technology and aesthetics. Fifteen years from now, undoubtedly the entire display will have to be reconceived.

180
Attributed to Jean Malouel
French, 1370 (?)–1415
*Large Round Pietà
(Lamentation for Christ),*
c. 1400
Egg tempera (?) on wood; frame
sculpted from wood panel
Diameter 25 1/4 in. (64 cm)

181
School of Paris
French, mid–14th century
*John II (The Good), King of
France,* before 1350
Egg tempera on a coat of plaster
applied to a thin canvas mounted on
oak, guilloche ornamentation with
border on gold background; original
frame sculpted from wood panel
23 1/2 × 17 1/2 in. (60 × 45 cm)

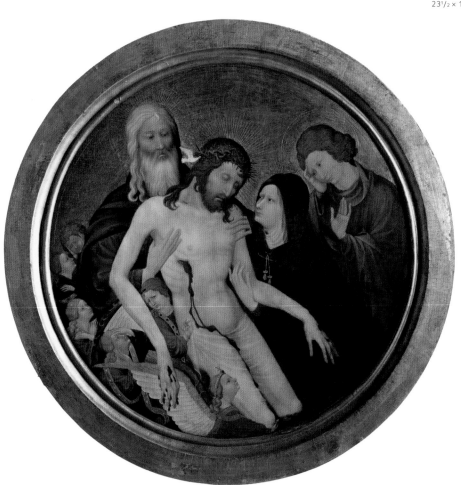

180

181

182
Henri Bellechose
French, active 1415–44
The Saint-Denis Altarpiece,
1415–16
Wood transferred to canvas
64 × 83 in. (162 × 211 cm)

182

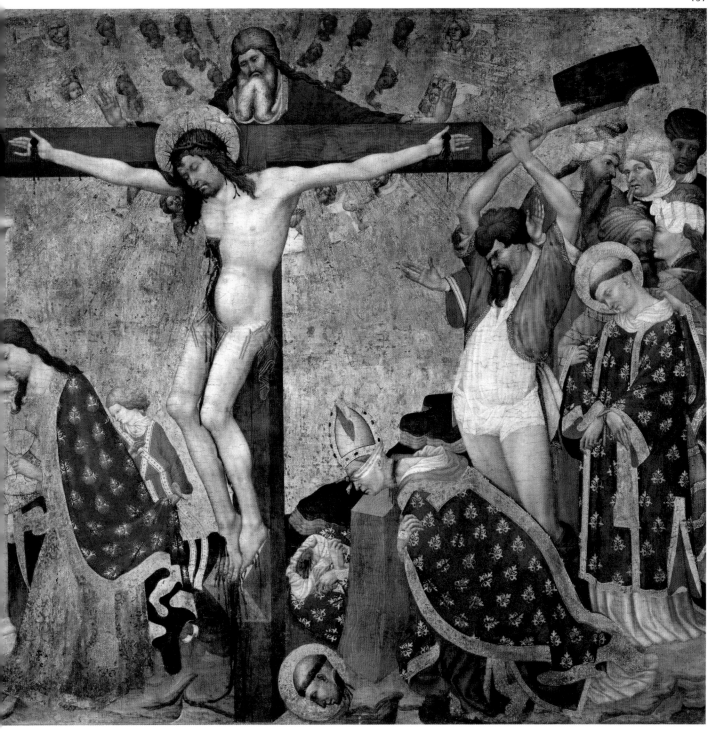

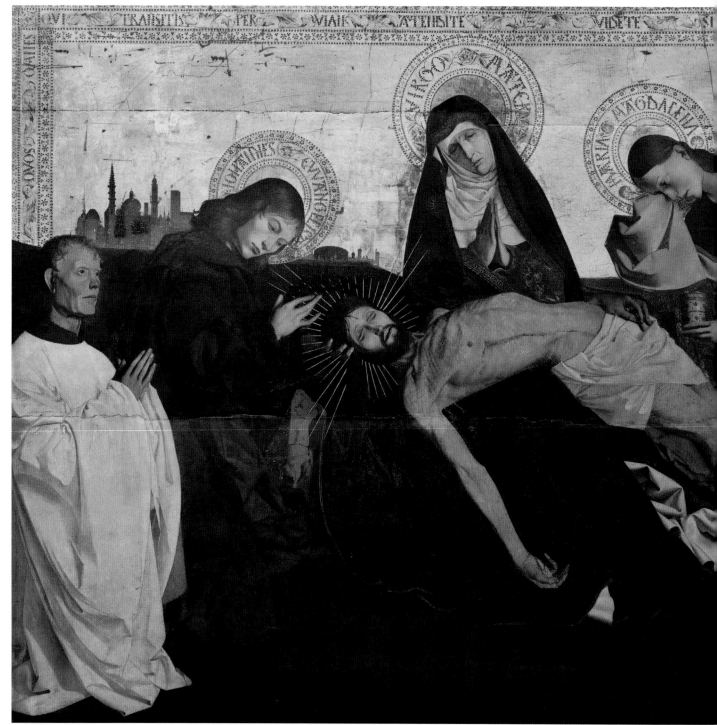

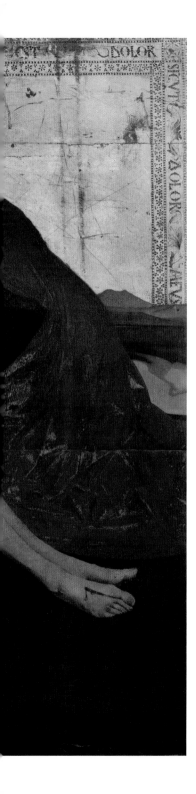

183
Enguerrand Quarton
French, active 1444–66
The Villeneuve-lès-Avignon Pietà, c. 1455
Oil on three walnut panels
64 1/4 × 86 1/4 in. (163 × 219 cm)

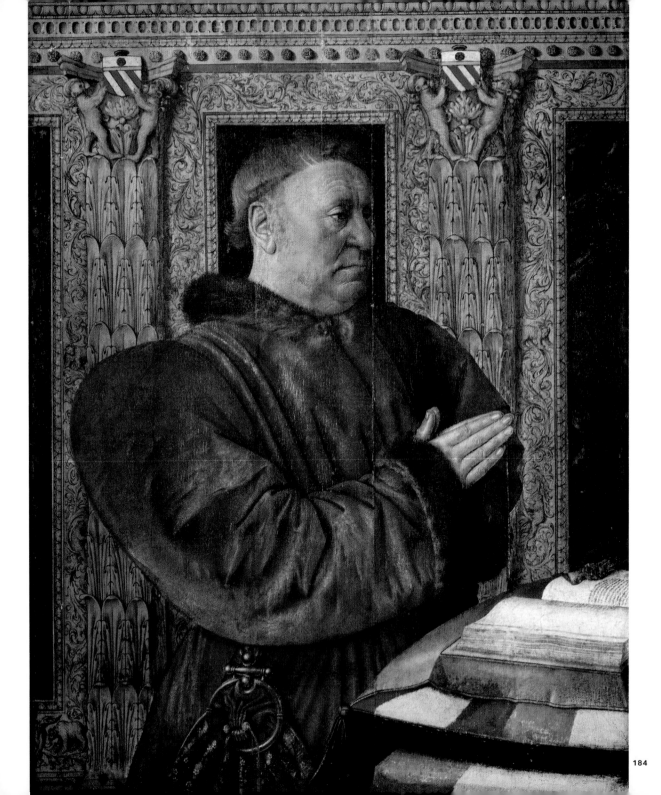

184

184
Jean Fouquet
French, c. 1415–c. 1481
Portrait of Guillaume Jouvenel des Ursins, c. 1465
Oil on wood
36 1/2 × 28 1/2 in. (93 × 73 cm)

185
Jean Fouquet
French, c. 1415–c. 1481
Portrait of Charles VII, King of France, c. 1445–50
Oil on wood
34 × 28 in. (86 × 71 cm)

185

186

Jean Clouet
French, c. 1480–c. 1541
Portrait of François I, King of France, c. 1530
Oil on wood
38 × 29 1/4 in. (96 × 74 cm)

187
Josse Lieferinxe
French, 1493–1505
Calvary, c. 1500–5
Oil on wood
67 × 49 1/2 in. (170 × 126 cm)

188
François Clouet
French, c. 1505–1572
Portrait of Pierre Quthe, 1562
Oil on wood
36 × 27 1/2 in. (91 × 70 cm)

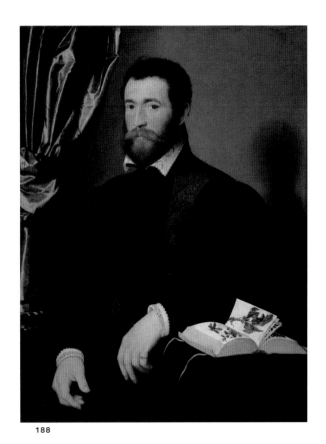

188

189
Jean Cousin the Elder
French, c. 1490–c. 1560
Eva Prima Pandora, c. 1550
Oil on wood
38 1/2 × 59 in. (98 × 150 cm)

190
Anonymous, School of Fontainebleau
French, 16th century
Diana the Huntress, c. 1550
Oil on canvas
75 1/4 × 52 in. (191 × 132 cm)

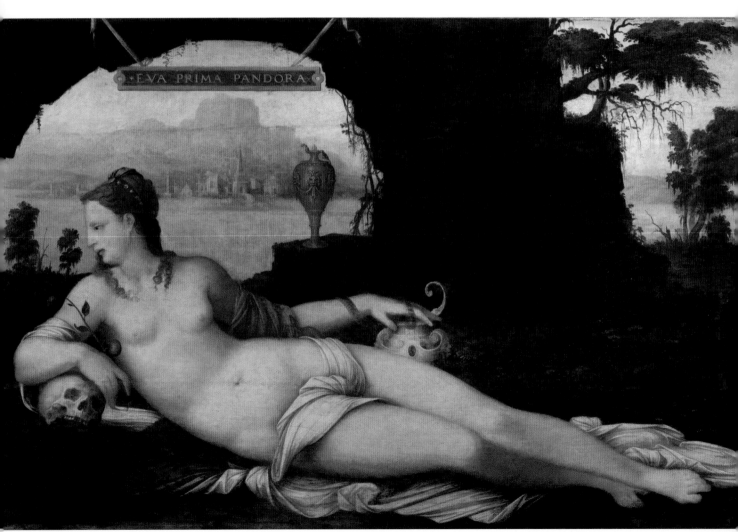

189

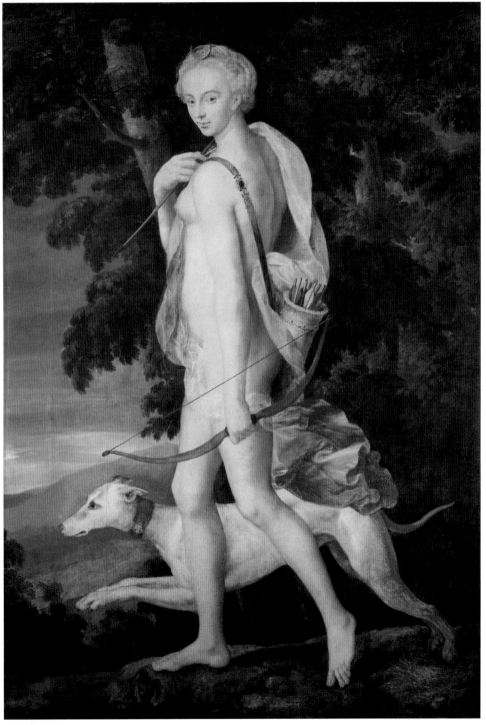

191

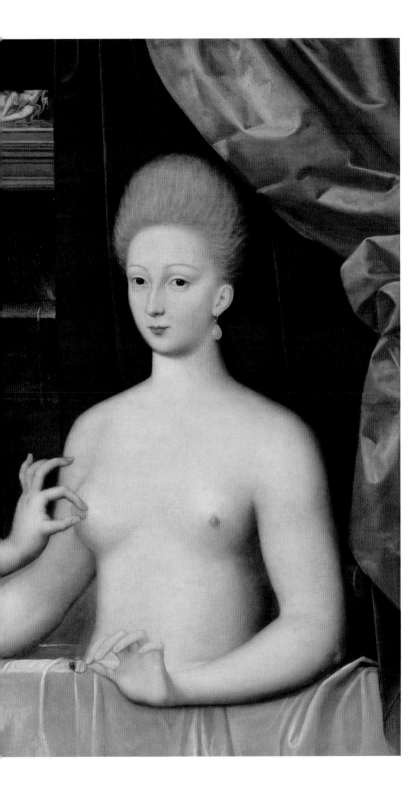

191
Anonymous, School of
Fontainebleau
French, 16th century
Gabrielle d'Estrées and One of
Her Sisters, c. 1594
Oil on wood
38 × 49 1/4 in. (96 × 125 cm)

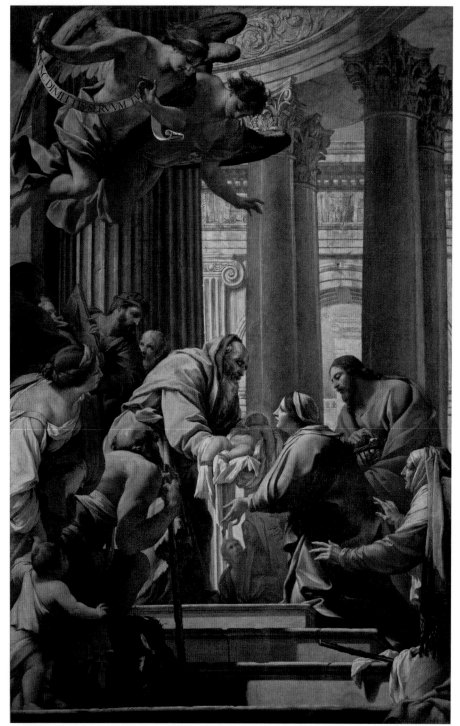

192

192
Simon Vouet
French, 1590–1649
The Presentation in the Temple, c. 1640–41
Oil on canvas
154 3/4 × 98 3/8 in. (393 × 250 cm)

193
Simon Vouet
French, 1590–1649
Portrait of Gaucher de Châtillon, c. 1632–35
Oil on canvas
85 7/8 × 54 in. (218 × 137 cm)

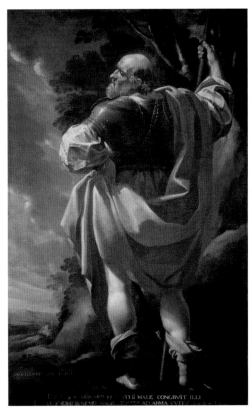

193

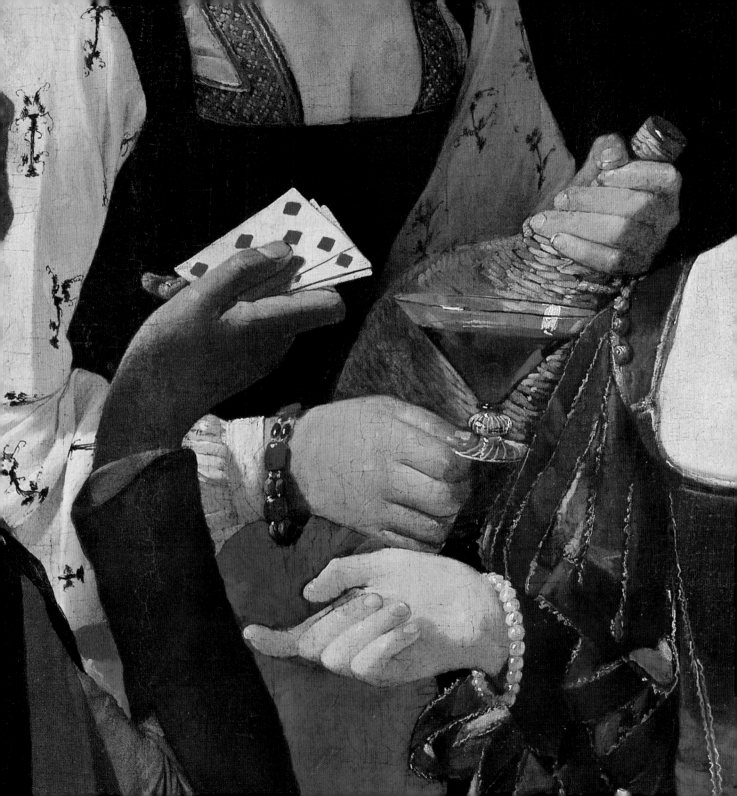

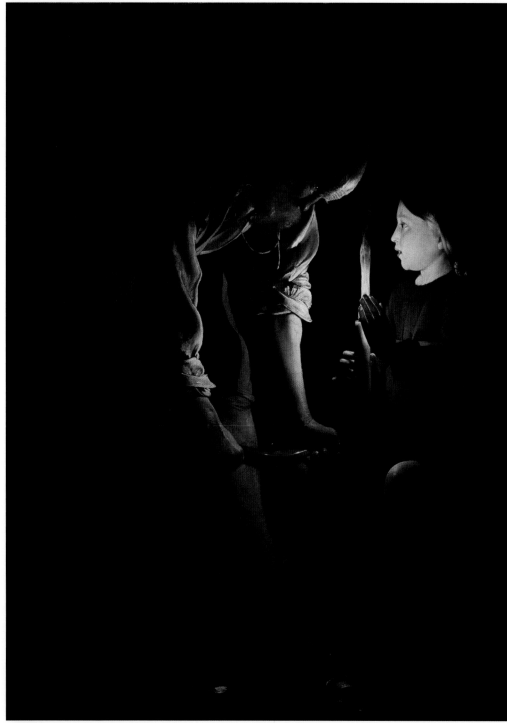

194A, 194B
Georges de La Tour
French, 1593–1652
*The Cheat with the Ace of
Diamonds,* 1635
Oil on canvas
41½ × 57½ in. (106 × 146 cm)

195
Georges de La Tour
French, 1593–1652
Saint Joseph the Carpenter,
c. 1640
Oil on canvas
54 × 40¼ in. (137 × 102 cm)

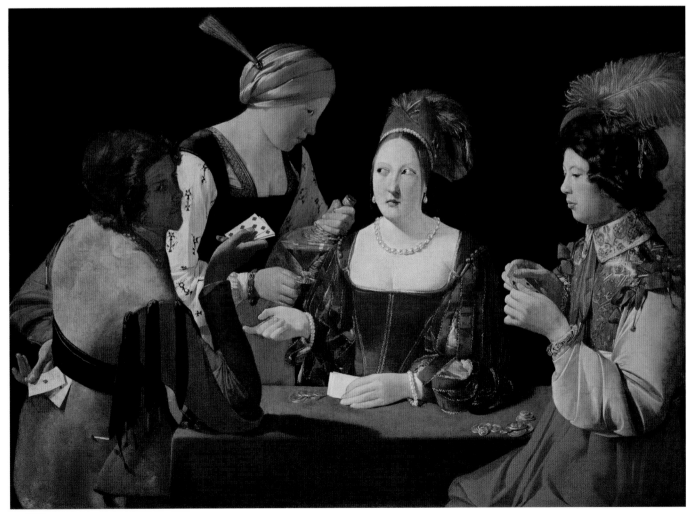

194B

196

197

196
Louis (or Antoine) Le Nain
French, c. 1600–1648
*The Happy Family, or Return
from the Christening*, 1642
Oil on canvas
24 × 30 ¾ in. (61 × 78 cm)

197
Valentin de Boulogne
French, 1591–1632
The Concert, c. 1622–25
Oil on canvas
68 ⅛ × 84 ¼ in. (173 × 214 cm)

198
Louis (or Antoine) Le Nain
French, c. 1600–1648
Peasant Family in an Interior,
c. 1643
Oil on canvas
44 ½ × 62 ½ in. (113 × 159 cm)

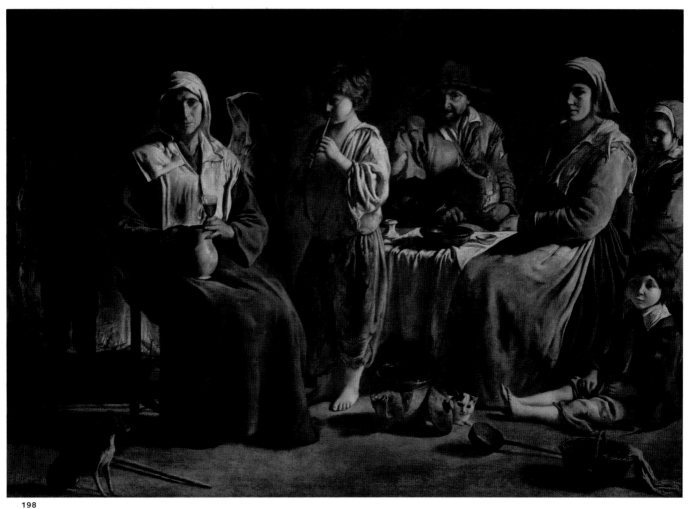

199
Nicolas Poussin
French, 1594–1665
The Inspiration of the Poet,
c. 1629–30
Oil on canvas
72 × 84 in. (183 × 213 m)

200
Nicolas Poussin
French, 1594–1665
Spring, or The Earthly
Paradise, 1660–64
Oil on canvas
46 ¹/₂ × 63 in. (118 × 160 cm)

201
Nicolas Poussin
French, 1594–1665
Echo and Narcissus, c. 1630
Oil on canvas
29 ¹/₄ × 39 ¹/₄ in. (74 × 100 cm)

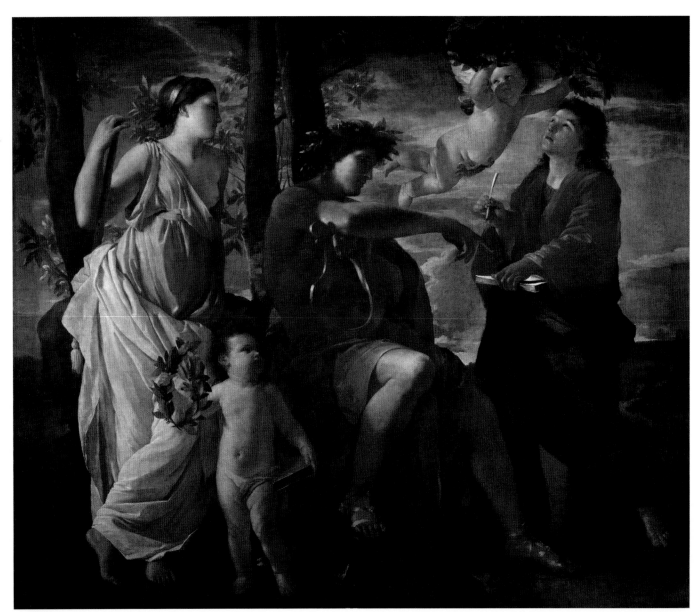

199

200

201

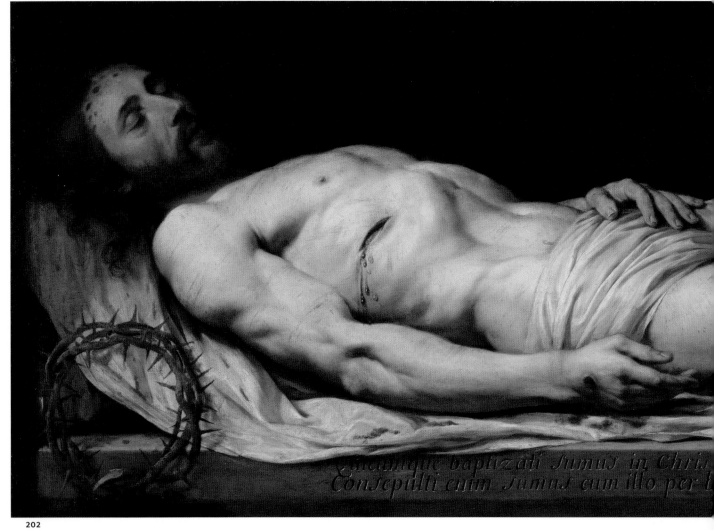

202

202
Philippe de Champaigne
French, 1602–1674
The Dead Christ, before 1654
Oil on wood
27 × 77¹/₂ in. (68 × 197 cm)

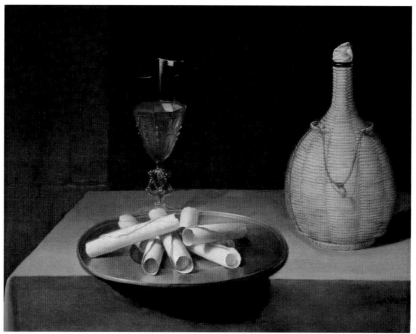

203

203
Lubin Baugin
French, c. 1612–1663
The Dessert of Wafers,
c. 1630–35
Oil on wood
16 1/4 × 20 1/2 in. (41 × 52 cm)

204
Claude Lorrain (Claude
Gellée)
French, c. 1602–1682
Seaport at Sunset, 1639
Oil on canvas
40 1/2 × 54 in. (103 × 137 cm)

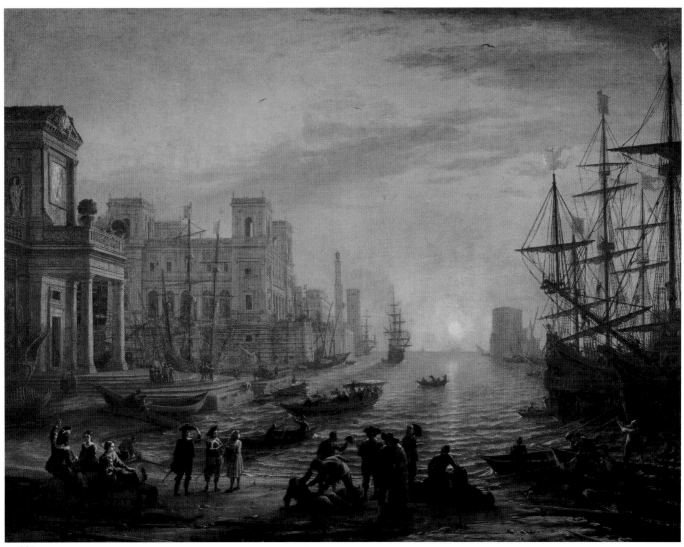

204

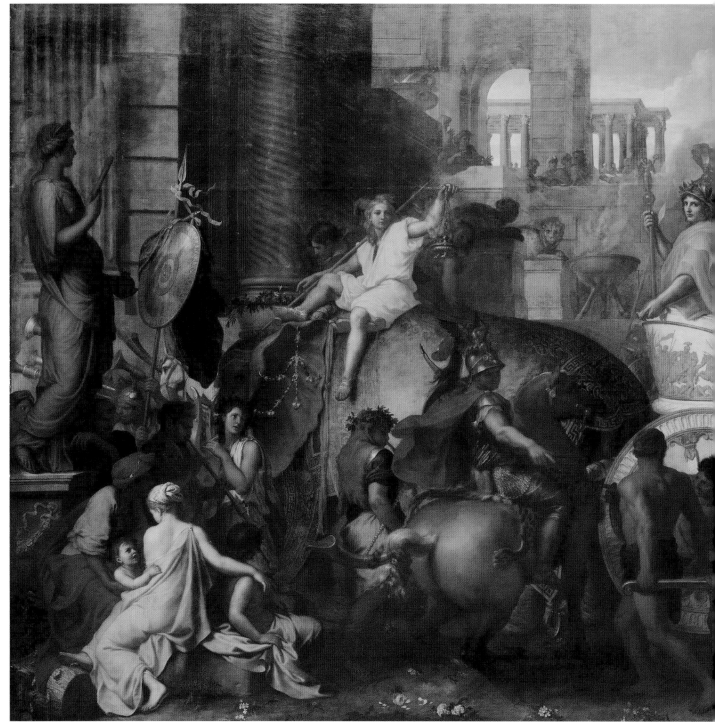

205
Charles Le Brun
French, 1619–1690
The Entry of Alexander into Babylon, 1665
Oil on canvas
177 1/8 × 278 3/8 in. (450 × 707 cm)

206
Hyacinthe Rigaud
French, 1659–1743
Portrait of Louis XIV, King of France, 1701
Oil on canvas
109 × 76 1/2 in. (277 × 194 cm)

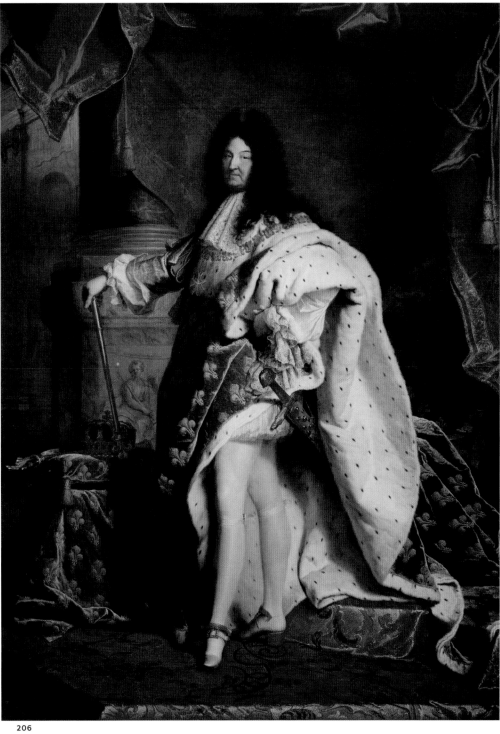

207
Jean Antoine Watteau
French, 1684–1721
The Pilgrimage to Cythera, 1717
Oil on canvas
51 × 76 1/2 in. (129 × 194 cm)

208
Jean Antoine Watteau
French, 1684–1721
Pierrot, formerly known as
Gilles, c. 1718–19
Oil on canvas
73 × 50 in. (185 × 150 cm)

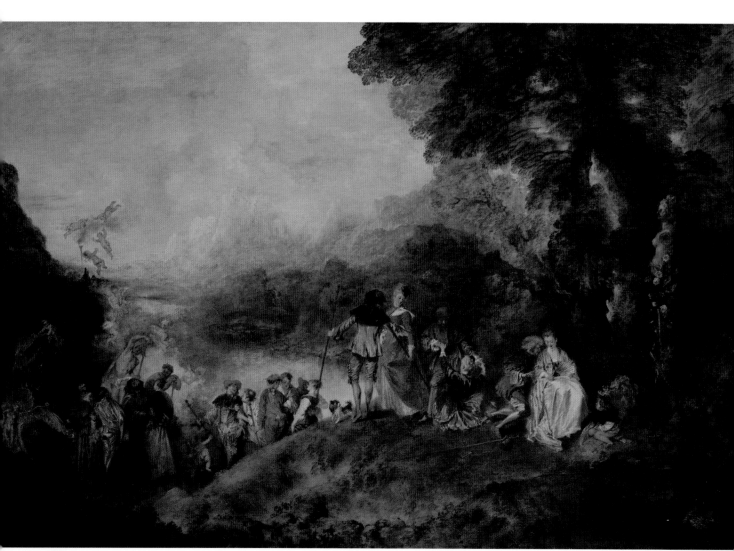

207

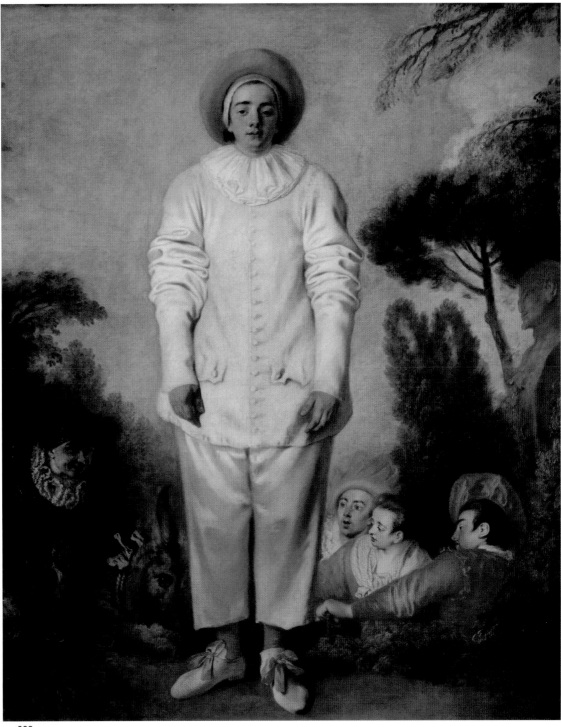

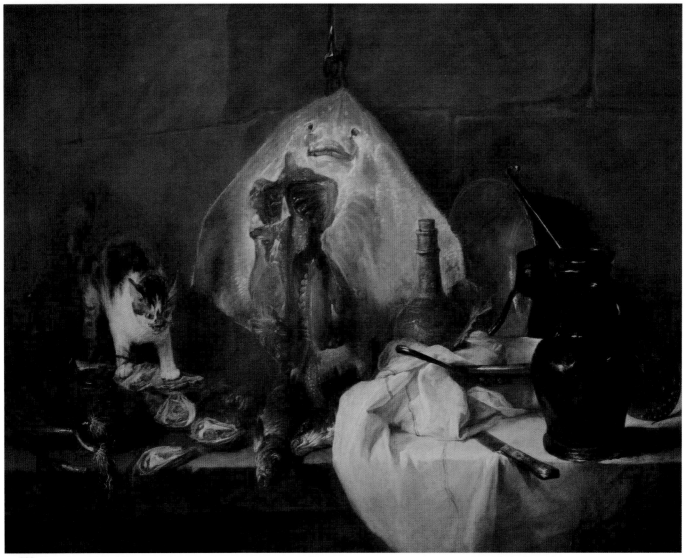

209
Jean-Baptiste Siméon
Chardin
French, 1699–1779
The Ray, c. 1725–26
Oil on canvas
45 1/4 × 57 1/2 in. (115 × 146 cm)

210
Jean-Baptiste Siméon
Chardin
French, 1699–1779
Grace, 1740
Oil on canvas
19 1/2 × 15 1/4 in. (50 × 39 cm)

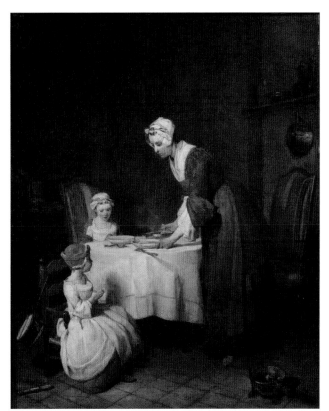

210

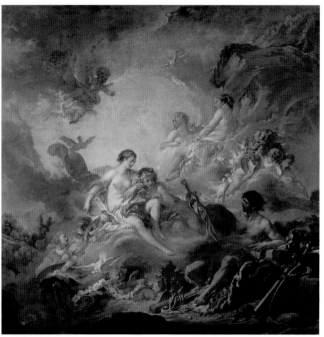

211

211
François Boucher
French, 1703–1770
The Forge of Vulcan (Vulcan Presenting Venus with Arms for Aeneas), 1757
Oil on canvas
126 × 126 in. (320 × 320 cm)

212
François Boucher
French, 1703–1770
Odalisque, c. 1745
Oil on canvas
20 7/8 × 25 1/4 in. (53 × 64 cm)

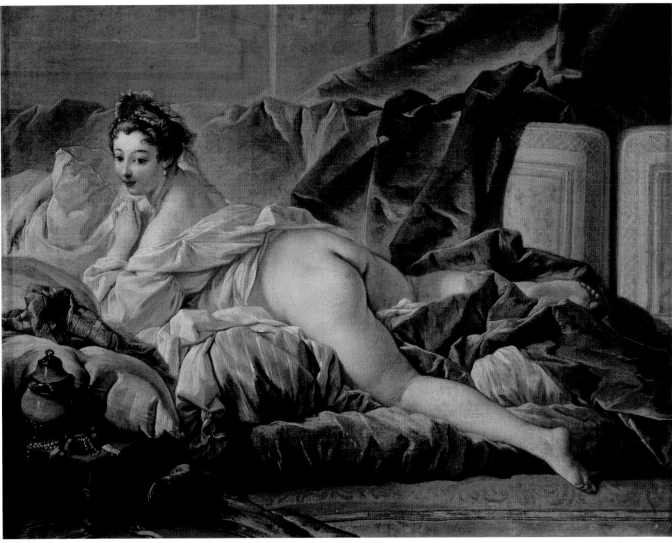

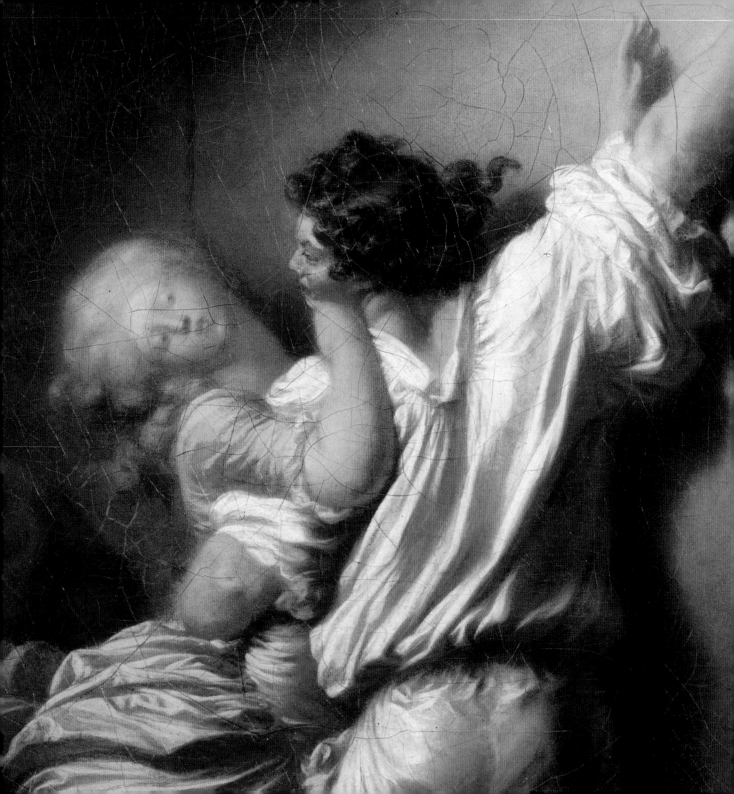

213A, 213B
Jean–Honoré Fragonard
French, 1732–1806
The Bolt, c. 1777
Oil on canvas
28 1/2 × 36 1/2 in. (73 × 93 cm)

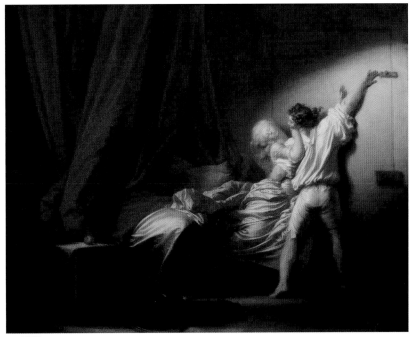

213B

213A

214
Jean-Honoré Fragonard
French, 1732–1806
Inspiration, c. 1769
Oil on canvas
31 1/2 × 25 1/4 in. (80 × 64 cm)

215
Jean-Honoré Fragonard
French, 1732–1806
Denis Diderot, c. 1769
Oil on canvas
40 × 25 1/2 in. (82 × 65 cm)

216
Jean-Honoré Fragonard
French, 1732–1806
A Study, c. 1769
Oil on canvas
32 1/4 × 26 in. (82 × 66 cm)

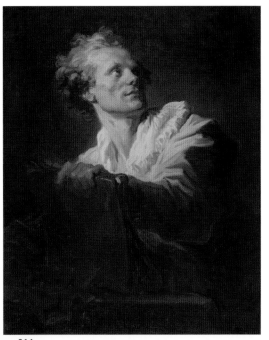

214

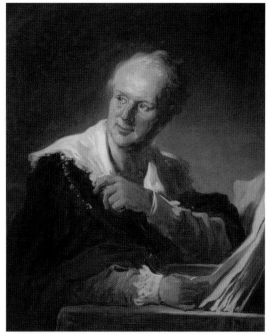

215

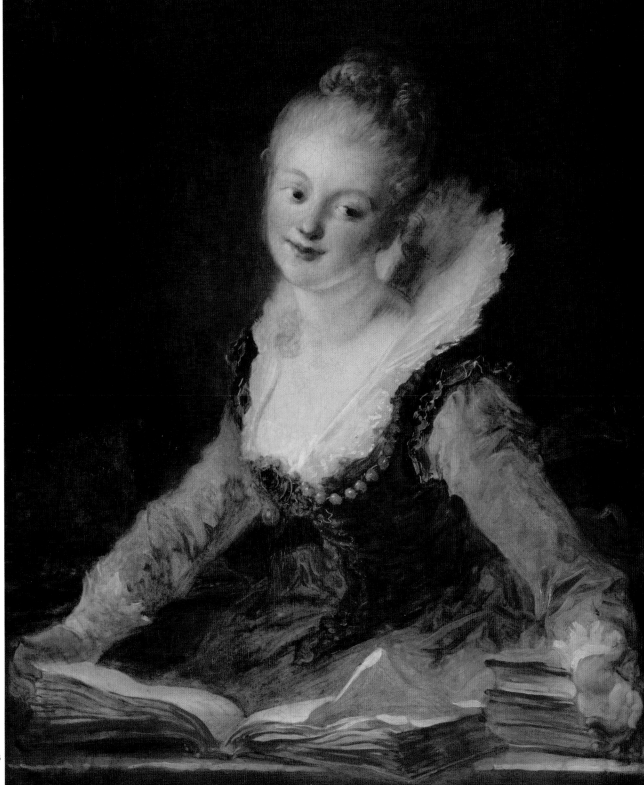

217
Jean-Baptiste Greuze
French, 1725–1805
The Village Betrothal, 1761
Oil on canvas
36 1/4 × 46 in. (92 × 117 cm)

218
Hubert Robert
French, 1733–1808
*Project for the Disposition
of the Grande Galerie of the
Louvre*, 1796
Oil on canvas
45 1/4 × 57 1/8 in. (115 × 145 cm)

219
Joseph Vernet
French, 1714–1789
Night: A Port in the Moonlight,
1771
Oil on canvas
38 5/8 × 64 5/8 in. (98 × 164 cm)

217

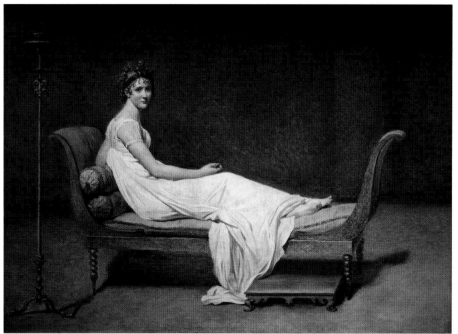

220

220
Jacques-Louis David
French, 1748–1825
Madame Récamier, 1800
Oil on canvas
57 1/2 × 96 in. (174 × 244 cm)

221
Jacques-Louis David
French, 1748–1825
The Oath of the Horatii, 1784
Oil on canvas
130 × 167 1/4 in. (330 × 425 cm)

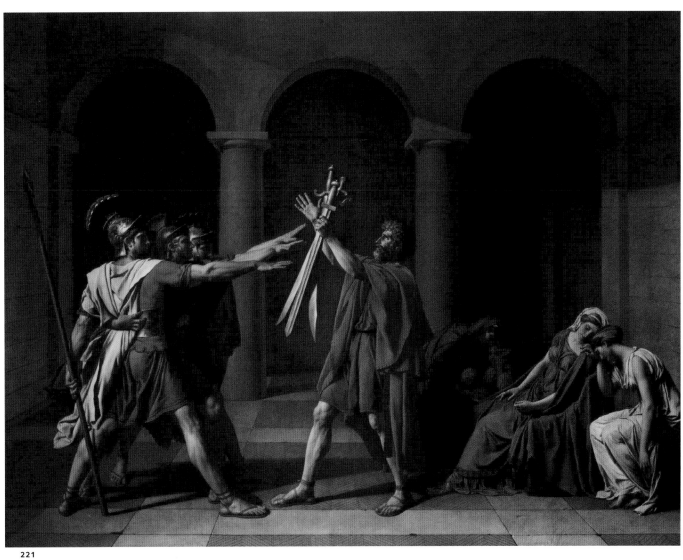

221

222A, 222B
Jacques-Louis David
French, 1748–1825
The Consecration of Emperor
Napoléon I and the Coronation
of Empress Josephine in the
Cathedral of Notre-Dame de
Paris on 2 December 1804,
1806–7
Oil on canvas
244 1/2 × 385 1/2 in. (621 × 979 cm)

222A

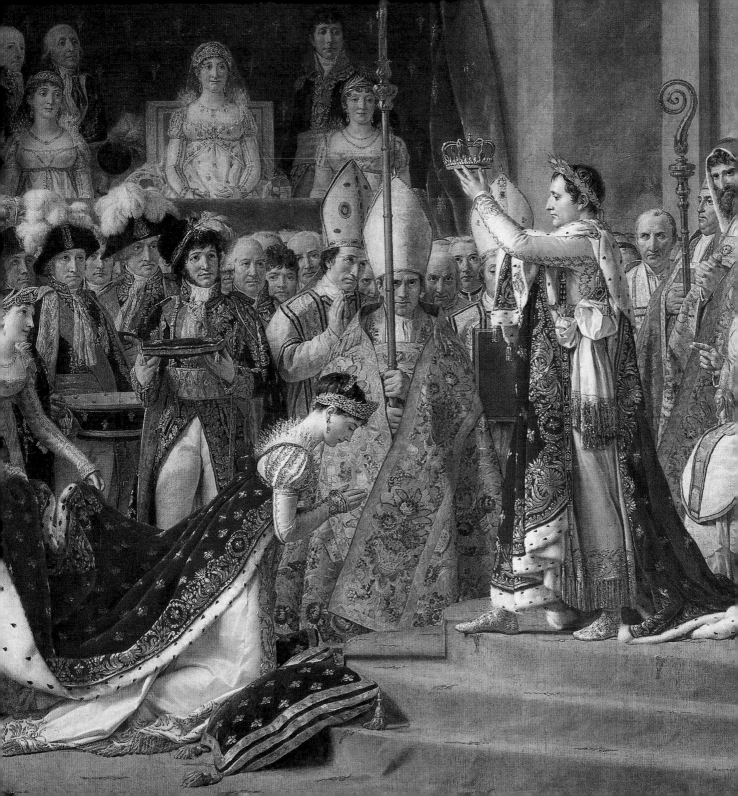

222B

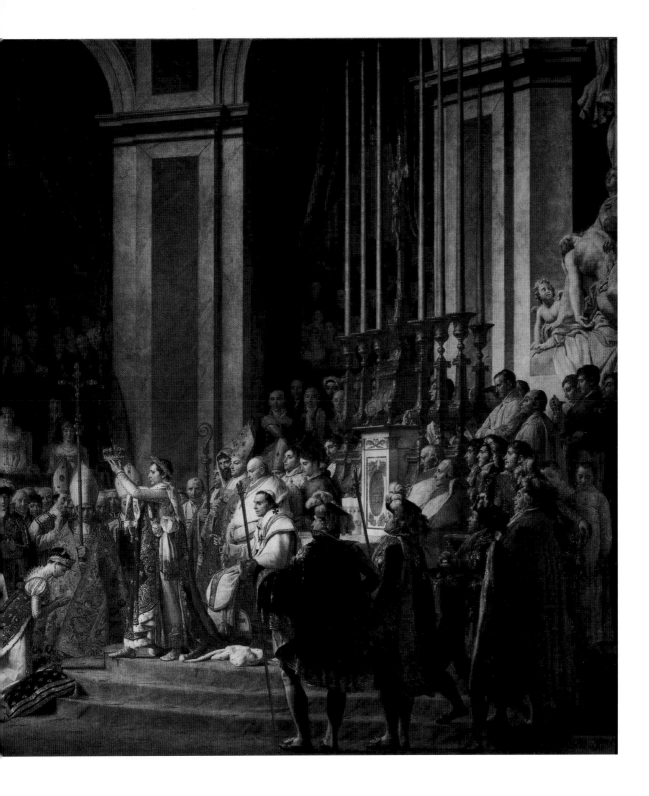

223
Marie Guillemine Benoist
French, 1768–1826
Portrait of a Negress, 1800
Oil on canvas
32 × 25 1/2 in. (81 × 65 cm)

224
Élisabeth Louise Vigée-Le Brun
French, 1755–1842
Self-Portrait with her Daughter Julie, 1786
Oil on canvas
41 3/8 × 33 1/8 in. (105 × 84 cm)

223

225
François Gérard
French, 1770–1837
Cupid and Psyche, 1798
Oil on canvas
73 1/4 × 52 in. (186 × 132 cm)

226
Pierre Henri de Valenciennes
French, 1750–1819
At the Villa Farnese, 1780
Paper on cardboard
9 7/8 × 15 in. (25 × 38 cm)

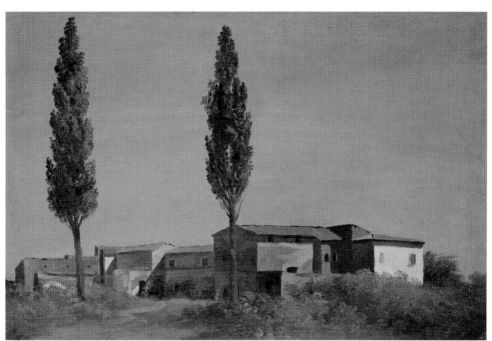

226

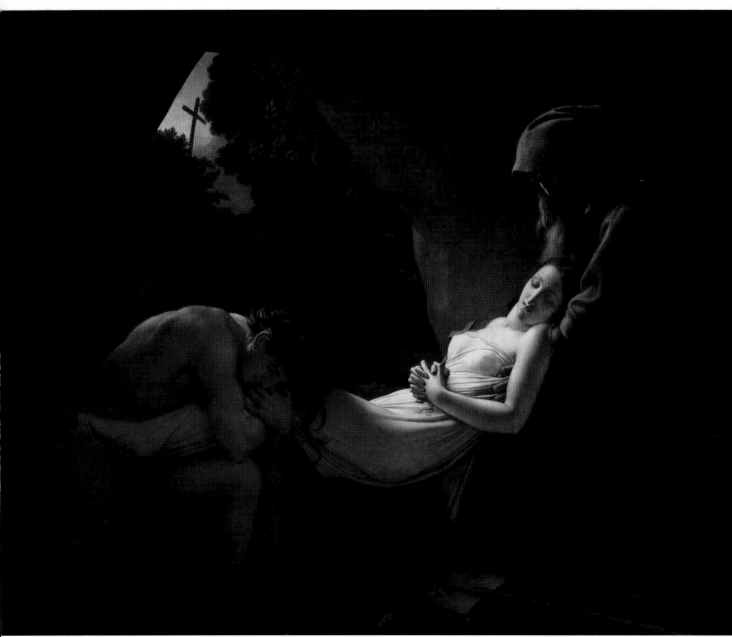

227
Girodet (Anne Louis Girodet de Roucy-Trioson)
French, 1767–1824
The Burial of Atala, 1808
Oil on canvas
81 1/2 × 105 in. (207 × 267 cm)

228
Girodet (Anne Louis Girodet de Roucy-Trioson)
French, 1767–1824
Portrait of the Young Romainville-Trioson, 1800
Oil on canvas
28 3/4 × 23 1/4 in. (73 × 59 cm)

228

229

229
Antoine-Jean Gros
French, 1771–1835
*Napoléon on the Bridge at
Arcola on 17 November 1796,
1796*
Oil on canvas
28 1/2 × 23 1/4 in. (73 × 59 cm)

230
Antoine-Jean Gros
French, 1771–1835
*Napoléon on the Battlefield at
Eylau on 9 February 1807, 1808*
Oil on canvas
205 × 308 1/2 in. (521 × 784 cm)

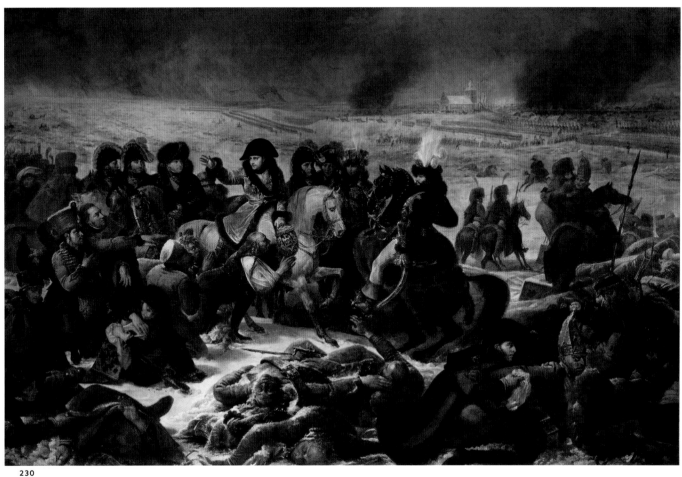

231
Jean Auguste Dominique Ingres
French, 1780–1867
Mademoiselle Caroline Rivière, 1806
Oil on canvas
39 1/4 × 27 1/2 in. (100 × 70 cm)

232
Jean Auguste Dominique Ingres
French, 1780–1867
Portrait of Louis François Bertin, 1832
Oil on canvas
45 3/4 × 37 3/8 in. (116 × 95 cm)

233
Jean Auguste Dominique Ingres
French, 1780–1867
La Grande Odalisque (Grand Odalisque), 1814
Oil on canvas
36 × 64 in. (91 × 162 cm)

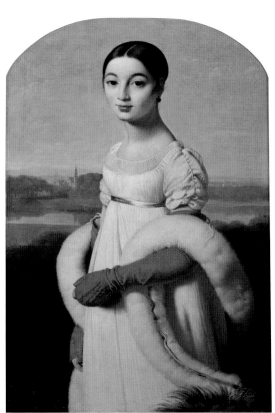

231

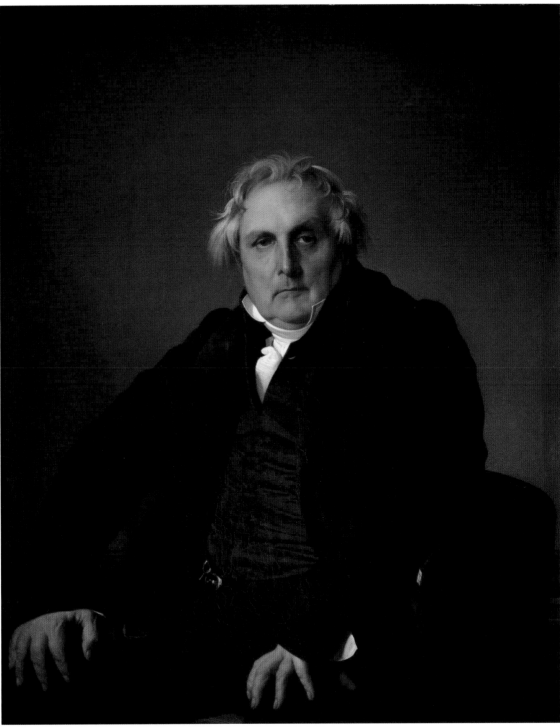

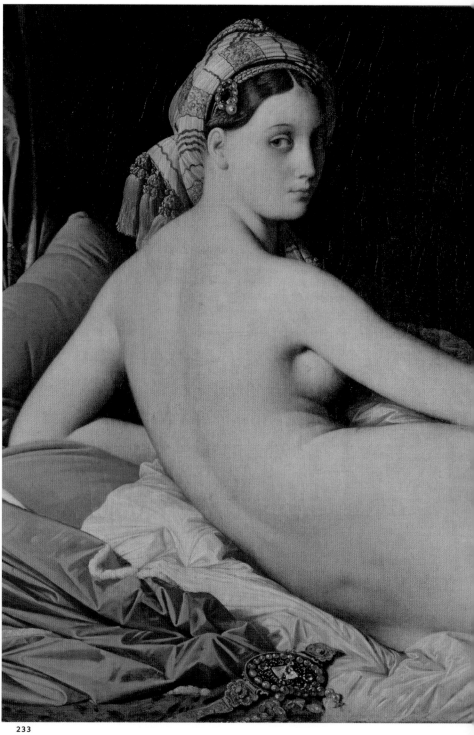

233

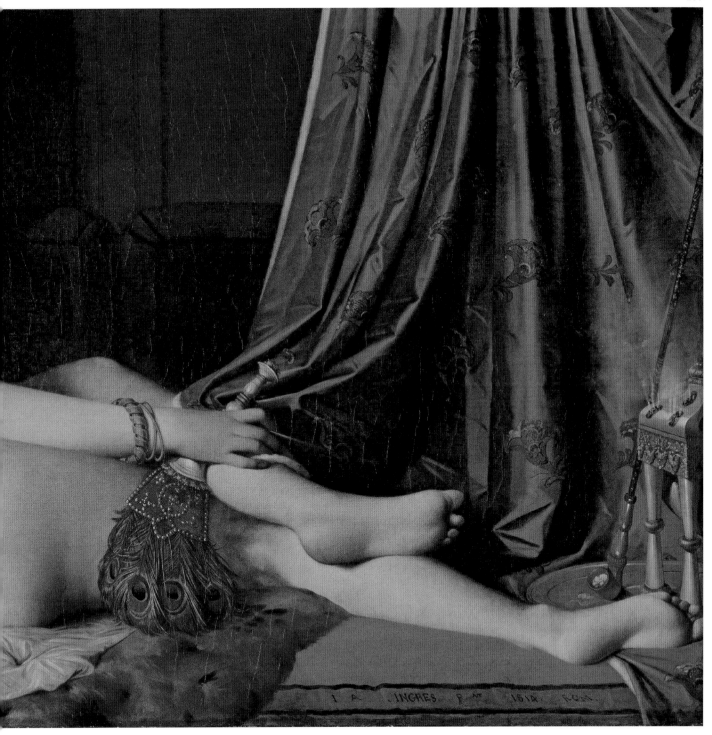

234
Jean Auguste Dominique
Ingres
French, 1780–1867
The Turkish Bath, 1862
Canvas mounted on wood
42 1/2 × 43 1/4 in. (108 × 110 cm)

235
Théodore Géricault
French, 1791–1824
The Raft of the Medusa, 1819
Oil on canvas
193 1/4 × 282 in. (491 × 716 cm)

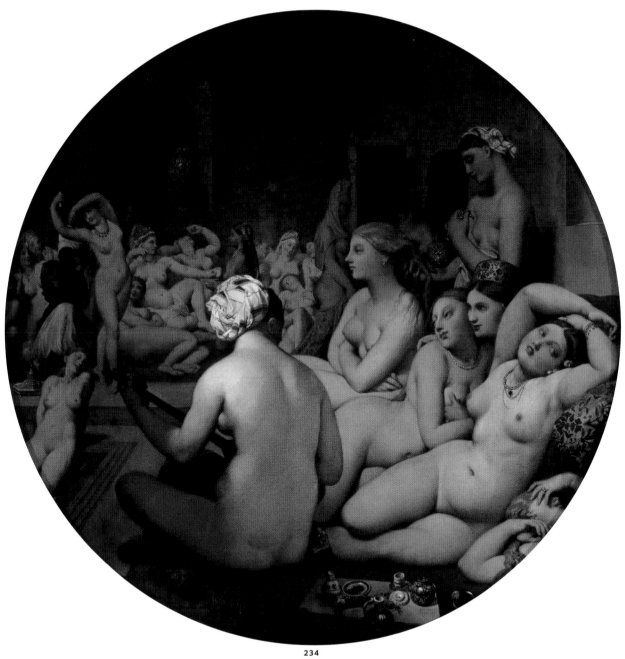

234

235

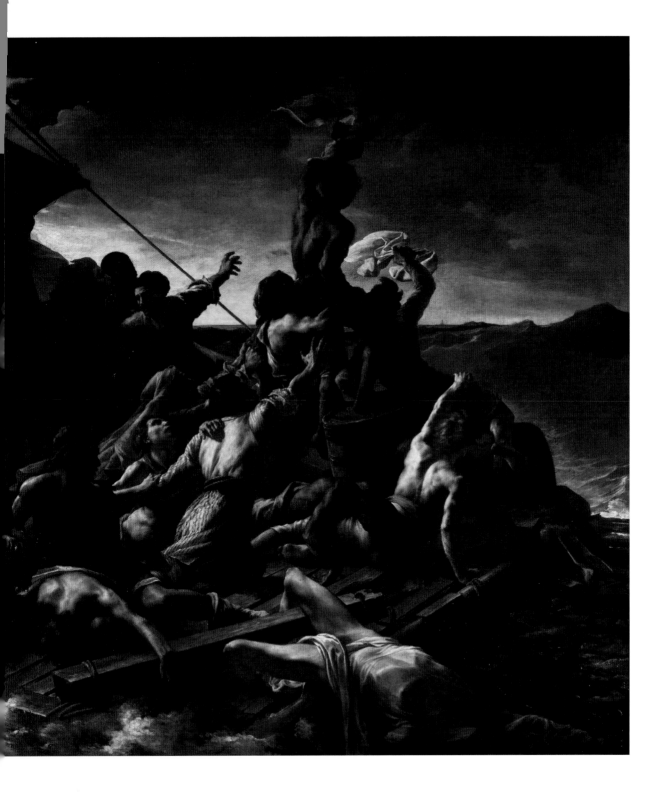

236A, 236B
Eugène Delacroix
French, 1798–1863
Liberty Leading the People,
1831
Oil on canvas
102 1/4 × 128 in. (260 × 325 cm)

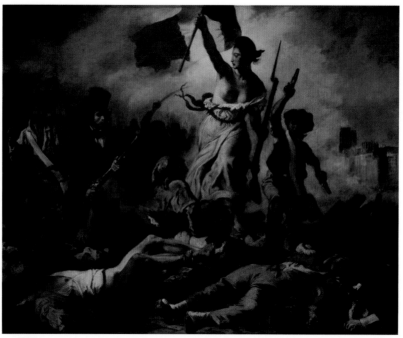

236A

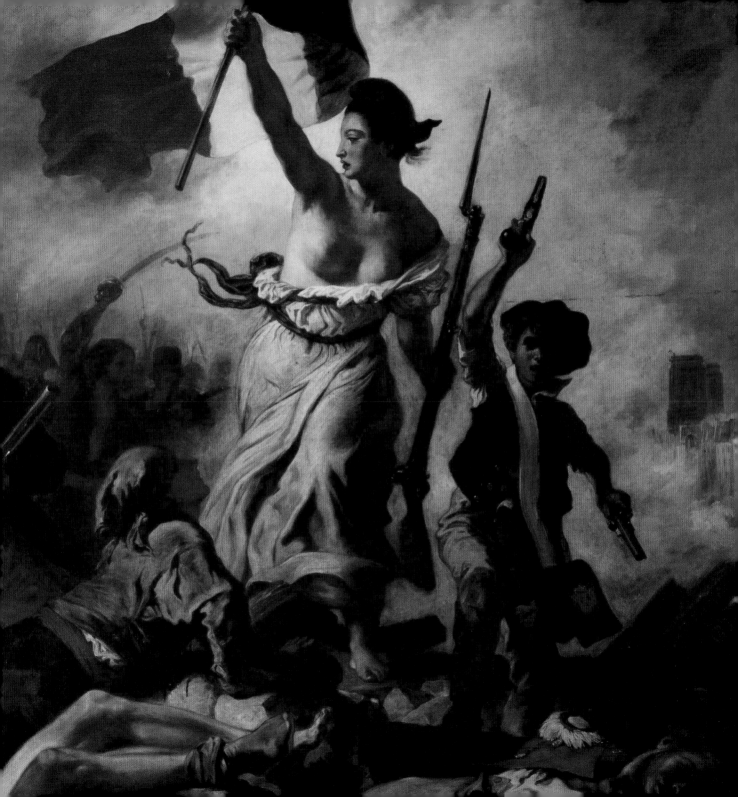

237
Eugène Delacroix
French, 1798–1863
Death of Sardanapalus, 1827
Oil on canvas
154 1/4 × 192 1/4 in. (392 × 496 cm)

238
Eugène Delacroix
French, 1798–1863
*Women of Algiers in Their
Apartment*, 1834
Oil on canvas
71 × 90 1/4 in. (180 × 229 cm)

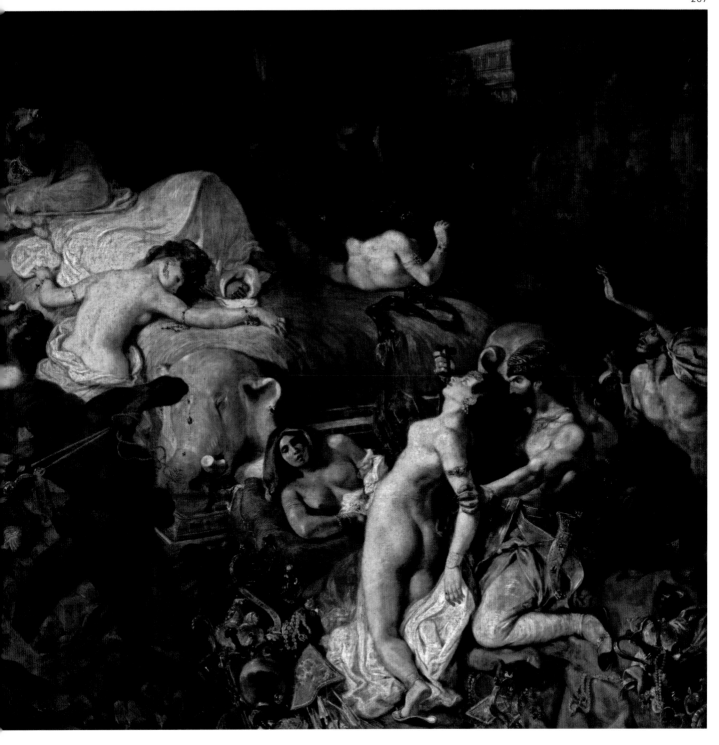

239

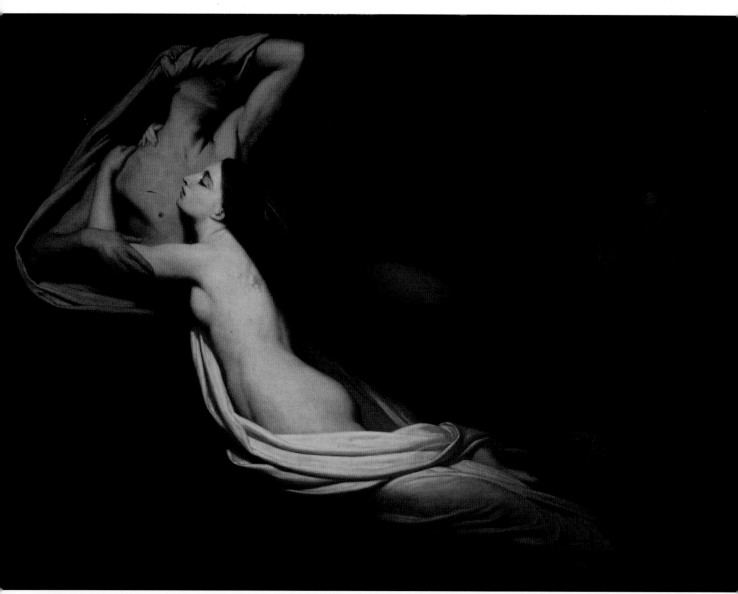

241
Ary Scheffer
French, 1795–1858
The Shades of Francesca da Rimini and Paolo Malatesta Appearing to Dante and Virgil, 1855
Oil on canvas
67 3/8 × 94 1/8 in. (171 × 239 cm)

242
Paul Delaroche
French, 1797–1856
The Children of Edward, 1831
Oil on canvas
71 1/4 × 84 5/8 in. (181 × 215 cm)

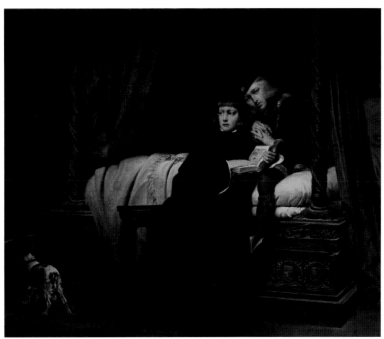

242

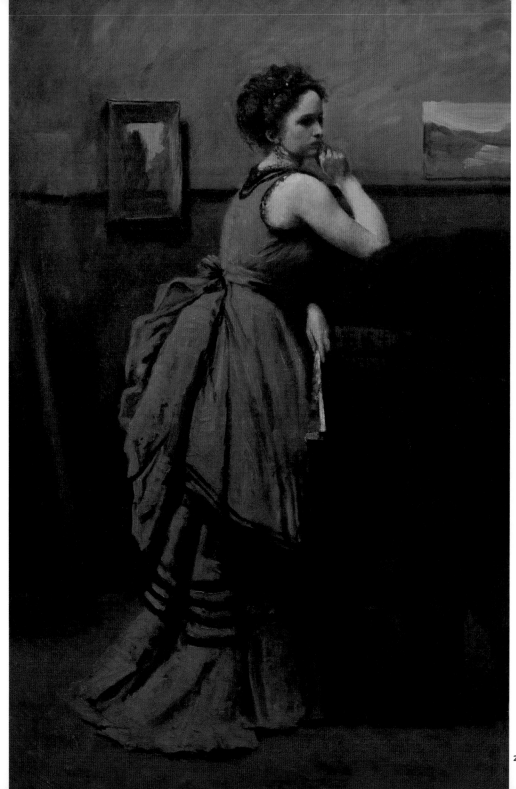

243
Jean-Baptiste Camille Corot
French, 1796–1875
Lady in Blue, 1874
Oil on canvas
31 1/2 × 20 in. (80 × 51 cm)

244
Jean-Baptiste Camille Corot
French, 1796–1875
Souvenir of Mortefontaine,
1864
Oil on canvas
25 5/8 × 35 in. (65 × 89 cm)

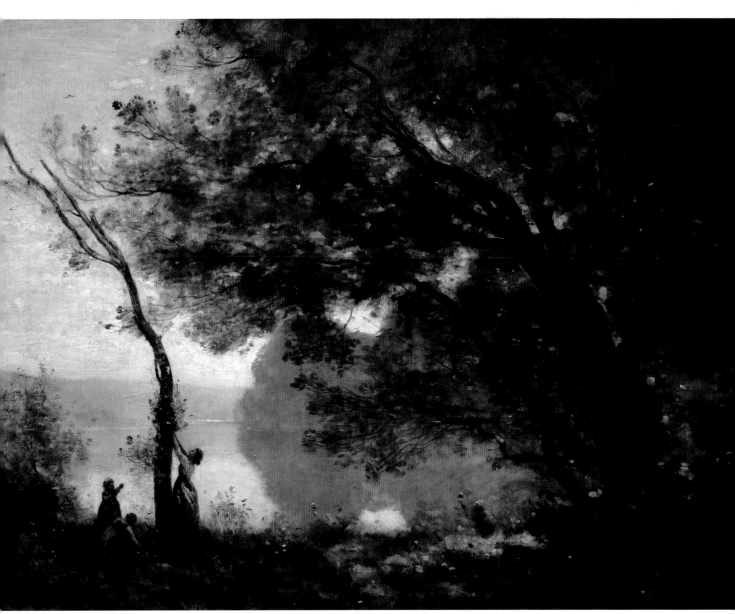

245
Théodore Chassériau
French, 1819–1856
The Two Sisters, 1843
Oil on canvas
71 × 53 ¹/₄ in. (180 × 135 cm)

246
Eugène Delacroix
French, 1798–1863
Orphan Girl at the Cemetery,
c. 1824
Oil on canvas
26 × 21¹/₄ in. (65 × 55 cm)

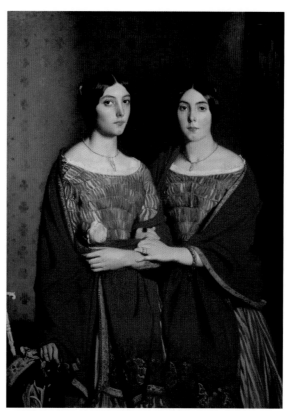

245

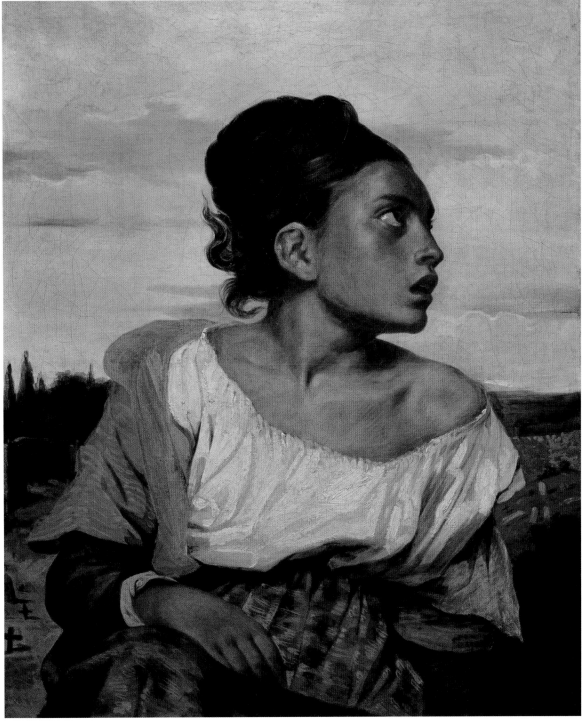

247A, 247B
Cimabue (Cenni di Pepo)
Italian, active 1272–1302
*Maestà (Madonna and Child
Enthroned with Angels),*
c. 1280
Tempera on wood panel
168 × 110 1/4 in. (427 × 280 cm)

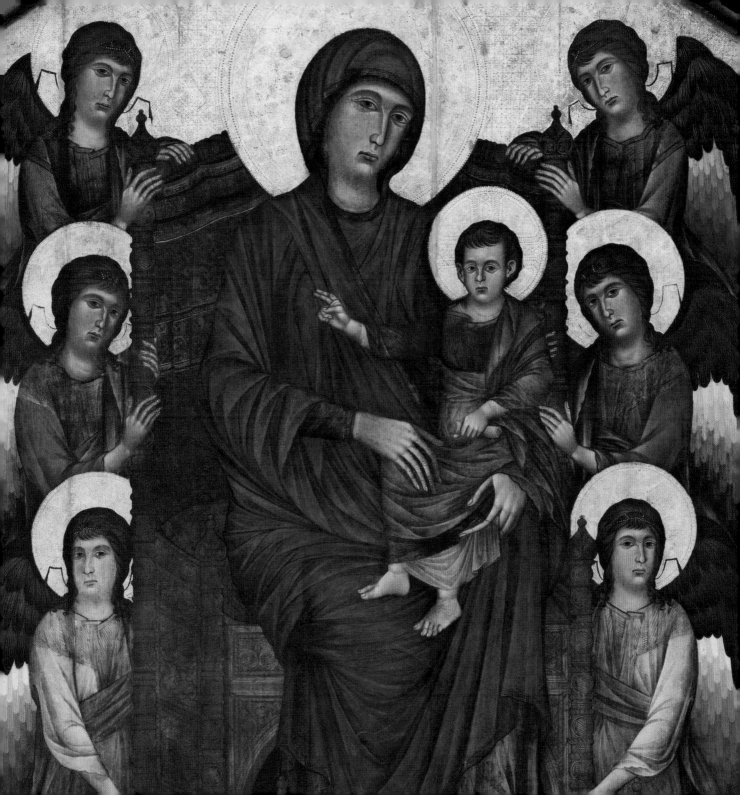

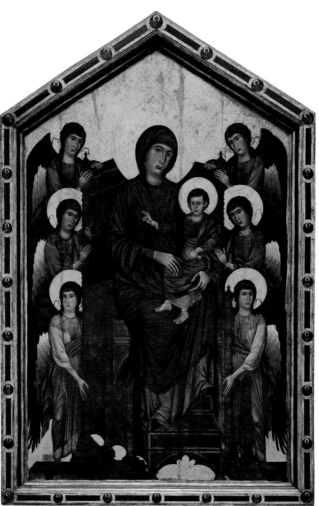

247B

248
Simone Martini
Italian, c. 1284–1344
The Carrying of the Cross,
c. 1335
Egg tempera on wood panel
11³/₄ × 8¹/₄ in. (30 × 21 cm)

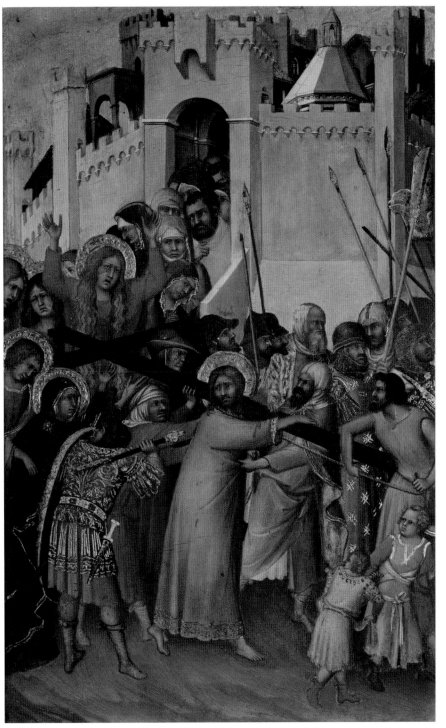

249A, 249B
Giotto (Giotto di Bondone)
Italian, c. 1265–1337
*Saint Francis of Assisi
Receiving the Stigmata* (detail:
*Saint Francis Preaching to the
Birds*), c. 1295–1300
Tempera on wood panel
123 1/4 × 64 1/4 in. (313 × 163 cm)

249B

249A

250

Sassetta (Stefano di Giovanni)

Italian, active 1426–50

Madonna and Child Surrounded by Six Angels, Saint Anthony of Padua, and Saint John the Evangelist,

c. 1437–44

Oil on wood panel

Central panel: 81¼ × 46½ in. (207 × 118 cm); each wing: 70¾ × 22½ in. (195 × 57 cm)

251

Pisanello (Antonio Puccio)

Italian, c. 1395–1455

Portrait of a Young Princess,

c. 1436–38

Oil on wood (poplar board)

17 × 12 in. (43 × 30 cm)

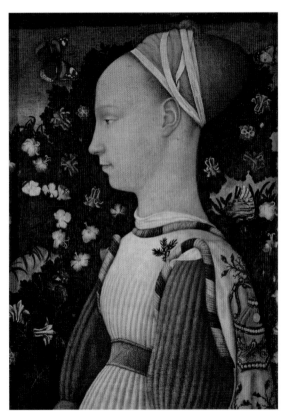

251

252A, 252B
Fra Angelico (Guido di Pietro)
Italian, active 1417–55
The Coronation of the Virgin,
c. 1430–32
Egg tempera on wood panel
82 ¼ × 81 in. (209 × 206 cm)

253
Uccello (Paolo di Dono)
Italian, 1397–1475
The Battle of San Romano,
1435–40 (?)
Tempera on wood panel
71 ½ × 125 in. (182 × 317 cm)

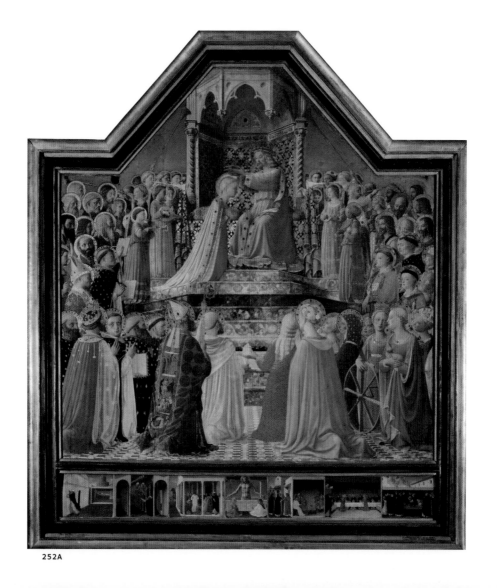

252A 252B

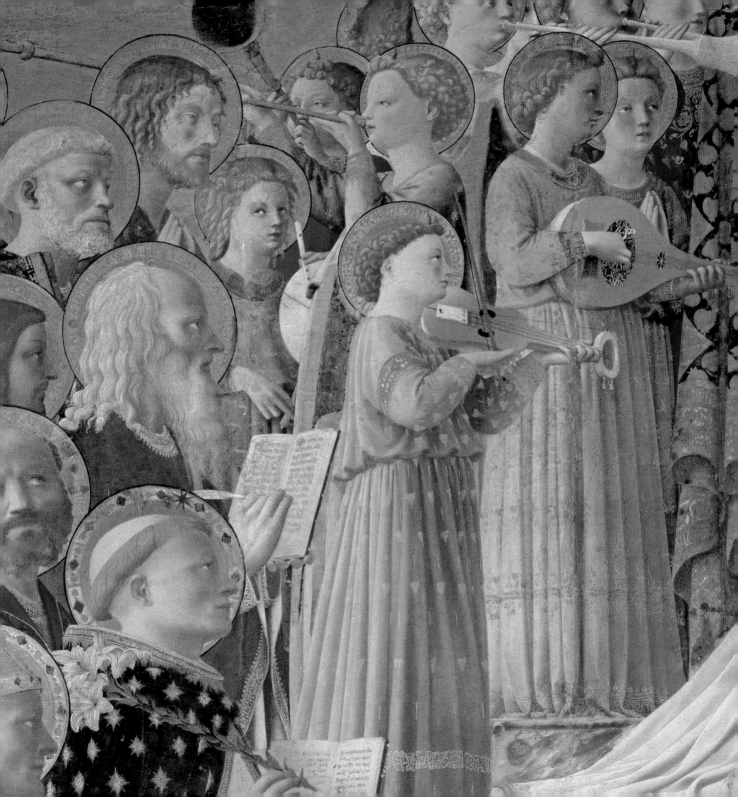

253

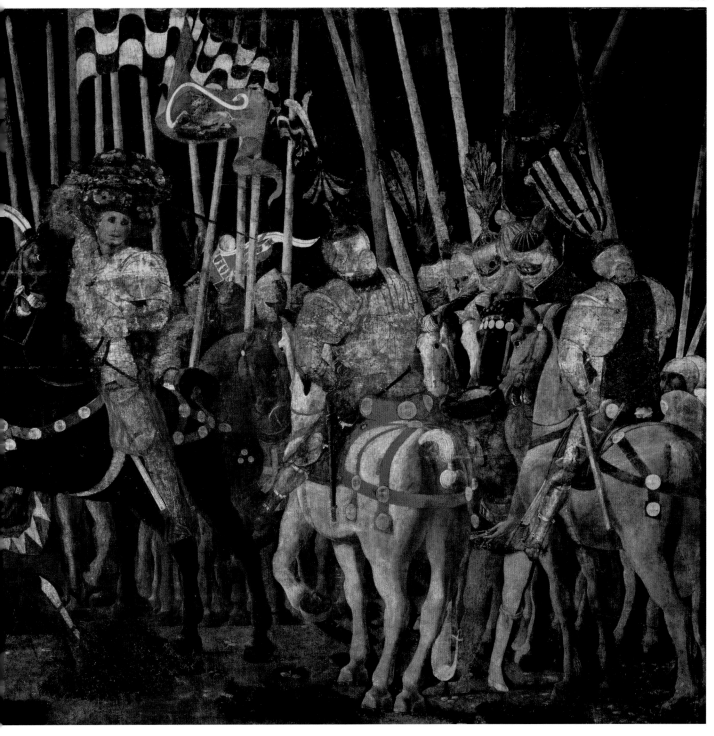

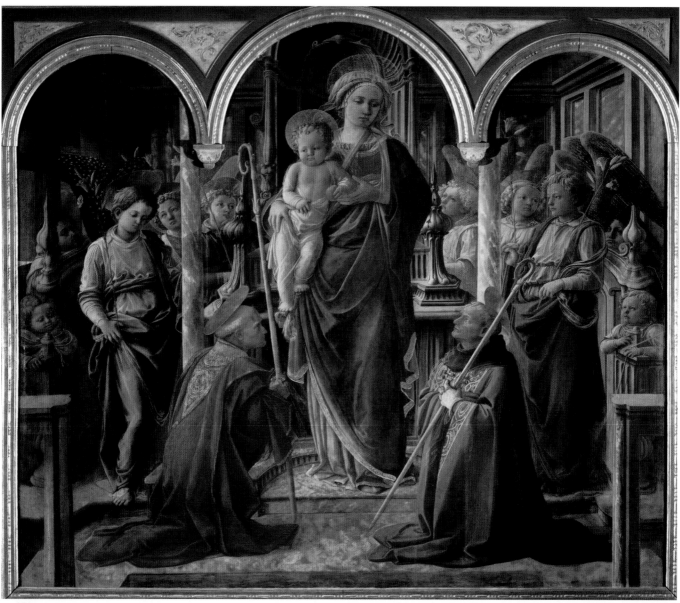

254
Filippo Lippi
Italian, c. 1406–1469
*Madonna and Child
Surrounded by Angels, with
Saint Frediano and Saint
Augustine* (The Barbadori
Altarpiece), 1437
Oil on wood
82 × 96 in. (208 × 244 cm)

255
Piero della Francesca (Piero
de' Franceschi)
Italian, c. 1416–1492
*Sigismondo Pandolfo
Malatesta*, c. 1450–51
Oil and egg tempera on wood panel
17 1/4 × 13 1/2 in. (44 × 34 cm)

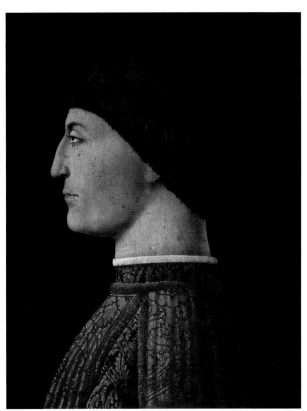

255

256
**Antonello da Messina
(Antonio di Salvatore)**
Italian, active 1457–79
Christ at the Column,
c. 1476–78
Oil on wood
11³/₄ × 8¹/₄ in. (30 × 21 cm)

257
Giovanni Bellini
Italian, active 1459–1516
Calvary, c. 1465
Oil on wood
28 × 25 in. (71 × 63 cm)

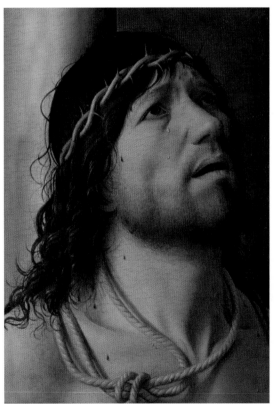

256

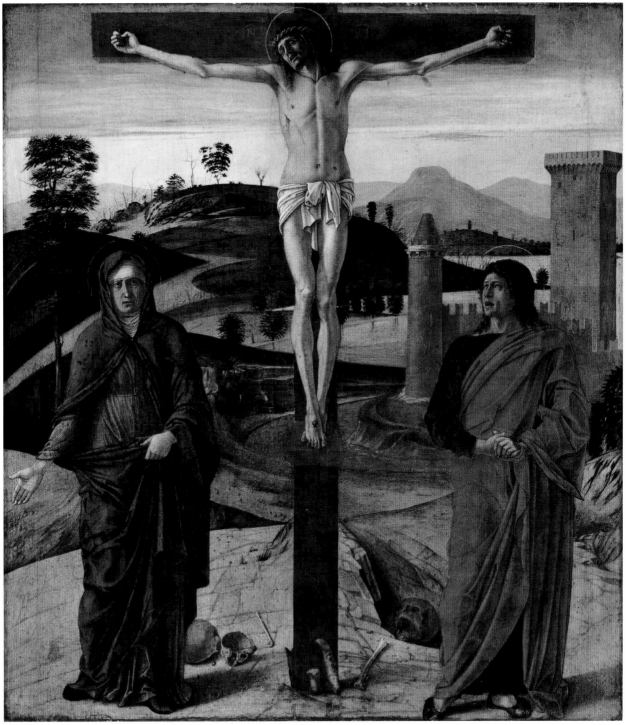

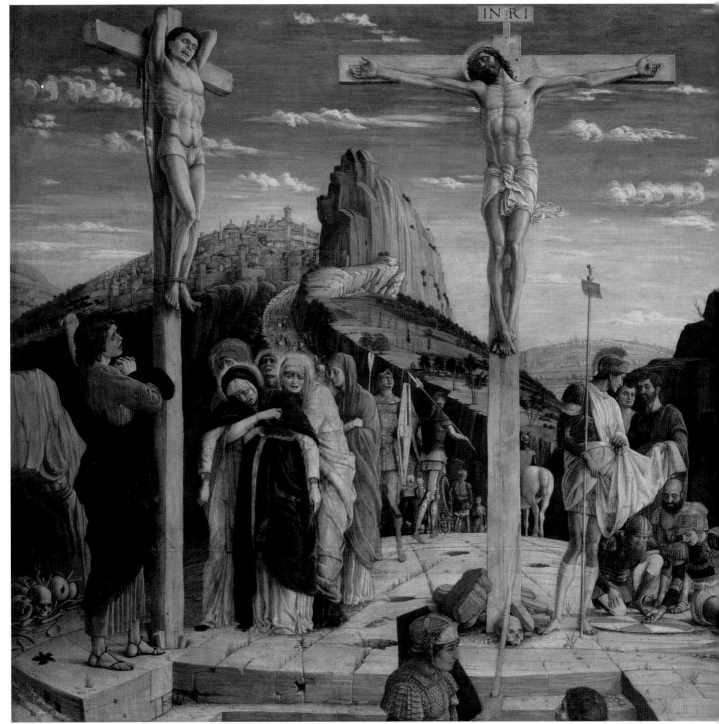

258
Andrea Mantegna
Italian, 1431–1506
Crucifixion, 1456–59
Tempera on wood
30 × 38 in. (76 × 96 cm)

259

Andrea Mantegna
Italian, 1431–1506
The Virgin and Child
Surrounded by Six Saints and
Gianfrancesco II Gonzaga (The
Madonna of Victory), 1496
Oil on canvas
112 1/2 × 66 1/4 in. (285 × 168 cm)

260

Sandro Botticelli (Sandro di
Mariano Filipepi)
Italian, c. 1445–1510
Venus and the Three Graces
Presenting Gifts to a Young
Woman, c. 1483–85
Fresco
83 × 111 1/2 in. (211 × 283 cm)

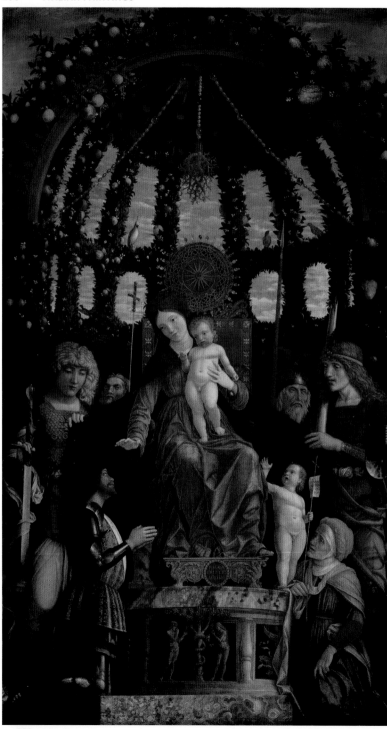

259

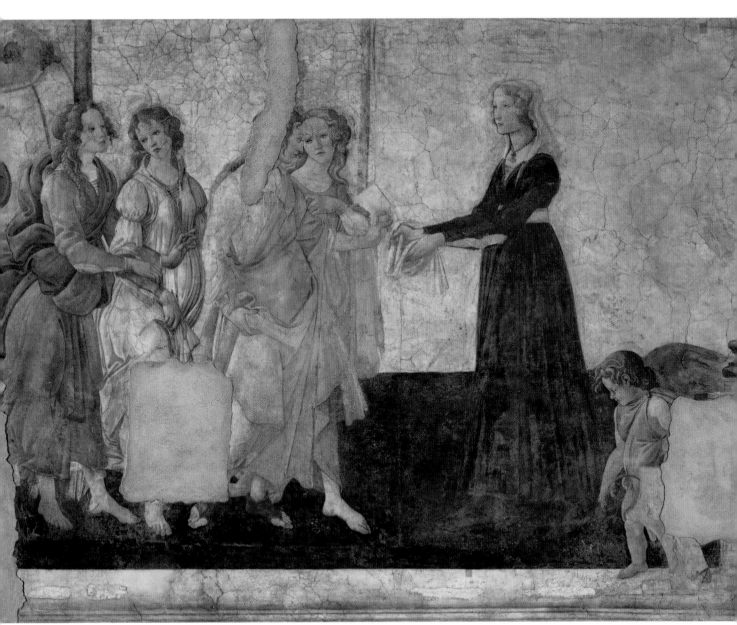

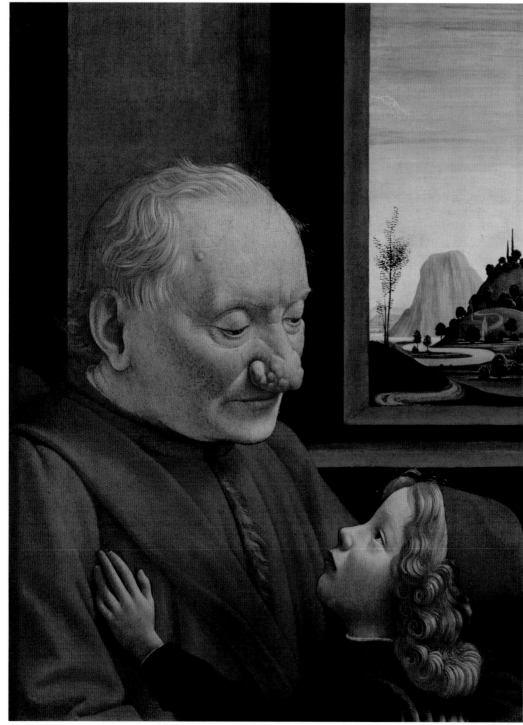

261
Domenico Ghirlandaio
(Domenico di Tommaso
Bigordi)
Italian, 1449–1494
*Portrait of an Old Man with a
Young Boy*, c. 1490
Egg tempera (?) on wood panel
24 3/8 × 18 1/8 in. (62 × 46 cm)

262
Perugino (Pietro di Cristoforo
Vannucci)
Italian, c. 1450–1523
Apollo and Marsyas, c. 1495
Wood panel
15 1/4 × 11 1/2 in. (39 × 29 cm)

263
Sandro Botticelli (Sandro di
Mariano Filipepi)
Italian, c. 1445–1510
*The Virgin and Child with
John the Baptist*, c. 1470–75
Wood panel
35 3/8 × 26 3/8 in. (90 × 67 cm)

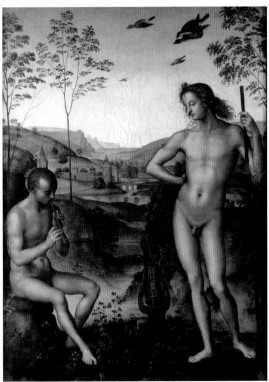

262

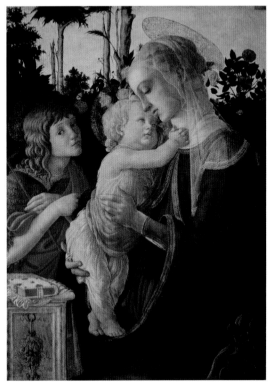

263

264
**Leonardo da Vinci (Leonardo
di Ser Piero da Vinci)**
Italian, 1452–1519
Mona Lisa, or *La Gioconda
(Portrait of Lisa Gherardini,
wife of Francesco del
Giocondo)*, c. 1503–6
Oil on poplar wood
30 1/4 × 21 in. (77 × 53 cm)

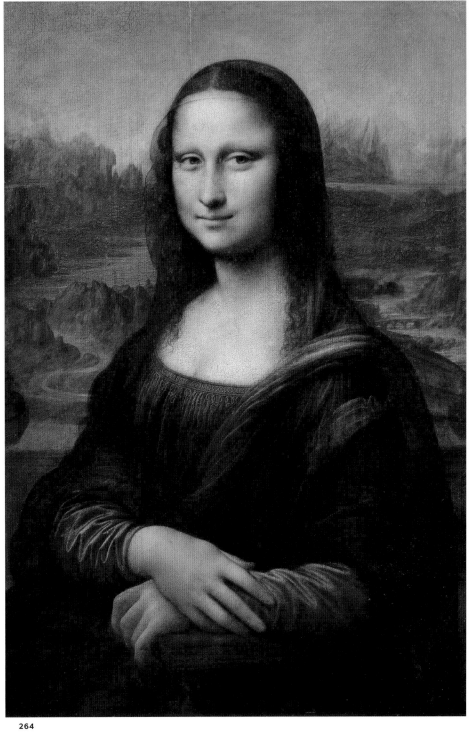

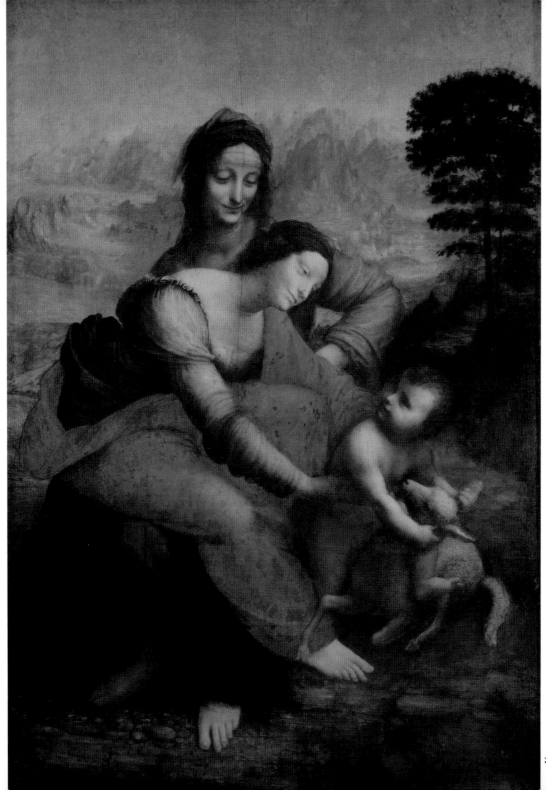

265

265
Leonardo da Vinci (Leonardo di Ser Piero da Vinci)
Italian, 1452–1519
The Virgin and Child with Saint Anne, 1501–13 (unfinished)
Oil on poplar wood
66 1/4 × 41 1/4 in. (168 × 130 cm)

266
Leonardo da Vinci (Leonardo di Ser Piero da Vinci)
Italian, 1452–1519
Portrait of a Lady, c. 1495–99
Oil on walnut wood
25 × 17 1/2 in. (63 × 45 cm)

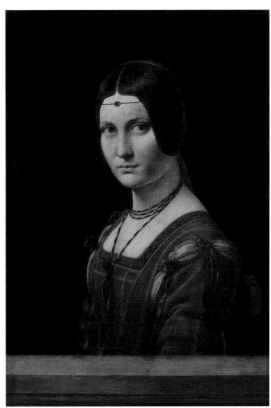

266

267
Solario (Andrea di Bartolo)
Italian, c. 1465–1524
Madonna with the Green Cushion, 1507–10
Oil on poplar wood
23 1/2 × 19 in. (60 × 48 cm)

268
Vittore Carpaccio
Italian, active 1472–c. 1525
The Sermon of Saint Stephen at Jerusalem, 1514
Oil on canvas
58 1/4 × 76 1/2 in. (148 × 194 cm)

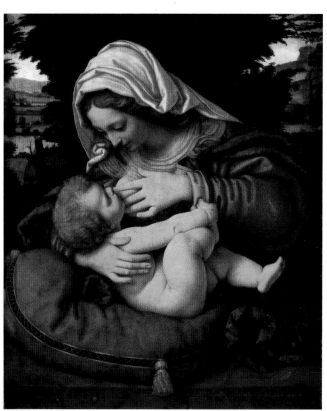

267

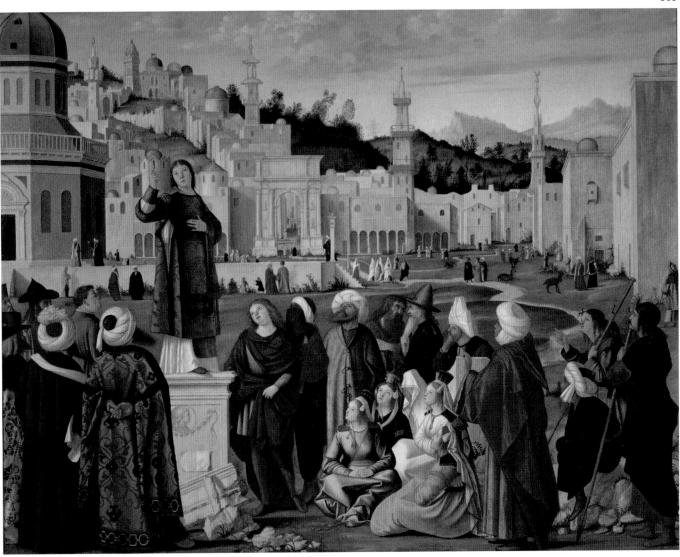

268

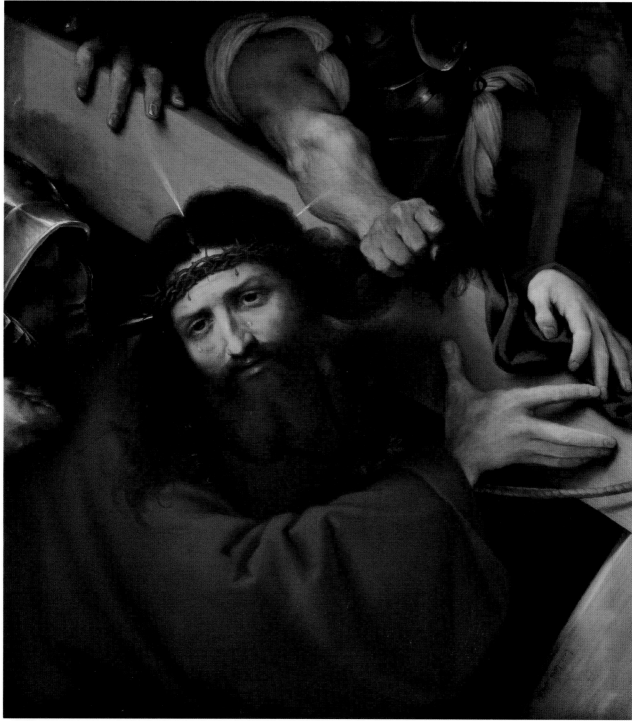

269
Lorenzo Lotto
Italian, 1480–1557
Christ Carrying the Cross, 1526
Oil on canvas
26 × 23 5/8 in. (66 × 60 cm)

270
Raphael (Raffaello Sanzio)
Italian, 1483–1520
Baldassare Castiglione, 1514–15
Oil on canvas
32 1/4 × 26 1/2 in. (82 × 67 cm)

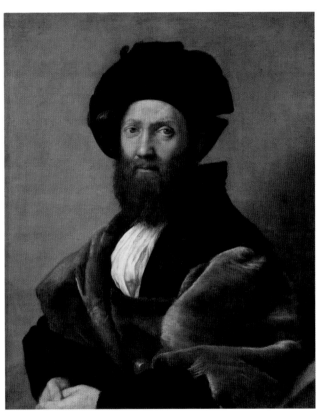

270

271
Raphael (Raffaello Sanzio)
Italian, 1483–1520
The Virgin and Child with the Infant Saint John the Baptist in a Landscape (La Belle Jardinière), 1507–8
Oil on wood panel
48 × 31½ in. (122 × 80 cm)

272
Raphael (Raffaello Sanzio)
Italian, 1483–1520
Saint George Fighting the Dragon, 1503–5
Oil on wood panel
11 ³/₈ × 9 ⁷/₈ in. (29 × 25 cm)

273
Titian (Tiziano Vecellio)
Italian, c. 1488–1576
The Entombment, c. 1520
Oil on canvas
58 ¹/₄ × 83 ¹/₂ in. (148 × 212 cm)

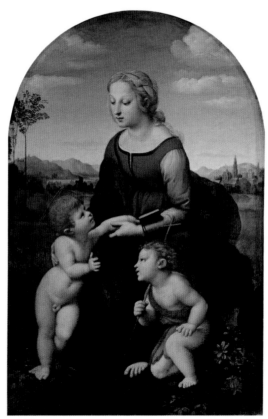

271

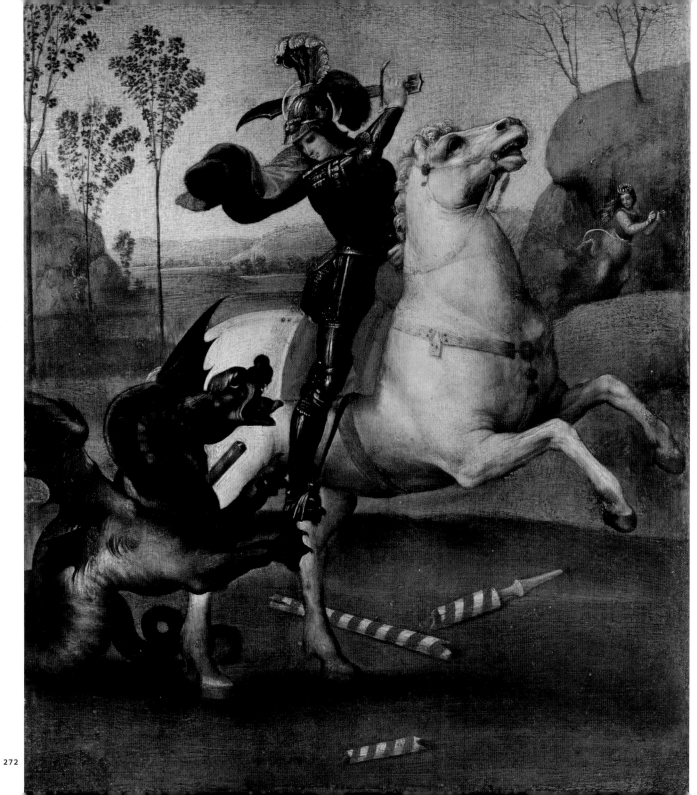

273

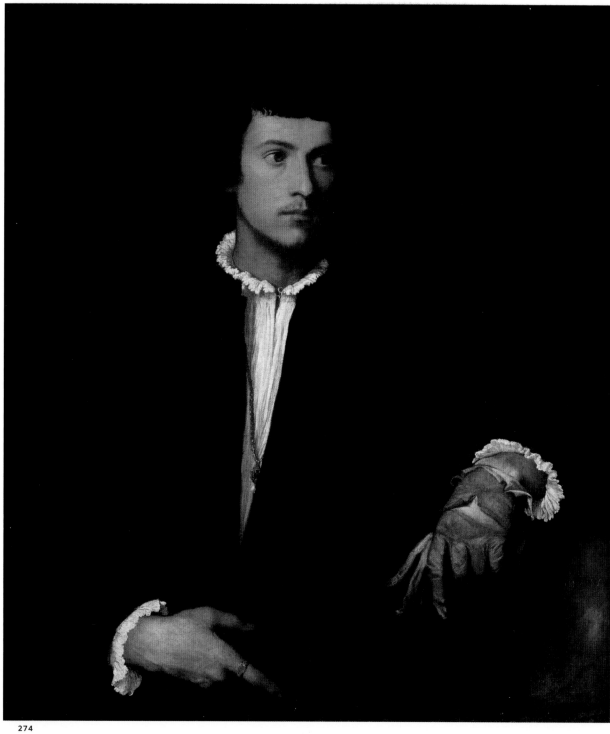

274
Titian (Tiziano Vecellio)
Italian, c. 1488–1576
Man with a Glove, c. 1520
Oil on canvas
39 1/4 × 35 in. (100 × 89 cm)

275
Andrea del Sarto (Andrea d'Agnolo di Francesco)
Italian, 1486–1530
Charity, 1518
Oil on wood, transposed to canvas in 1750
73 × 54 in. (185 × 137 cm)

276
Il Correggio (Antonio Allegri)
Italian, 1489–1534
Venus, Satyr, and Cupid (formerly known as *Jupiter and Antiope*), c. 1524–25
Oil on canvas
74 × 49 1/4 in. (188 × 125 cm)

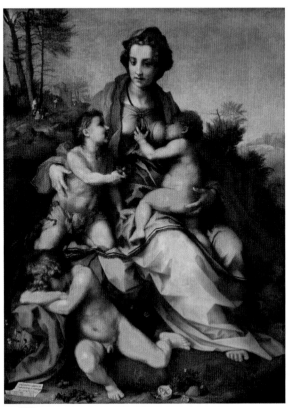

275

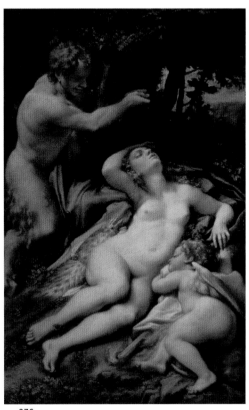

276

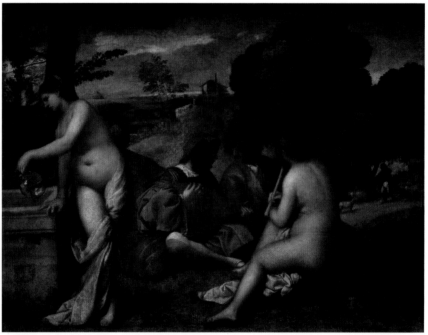

277

277
Titian (Tiziano Vecellio)
Italian, c. 1488–1576
Concert Champêtre (The Pastoral Concert), c. 1509
Oil on canvas
41¼ × 54 in. (105 × 137 cm)

278
Rosso Fiorentino (Giovanni Battista di Jacopo)
Italian, 1494–1540
Pietà, c. 1530–40
Oil on wood transposed to canvas in 1802
50 × 64¼ in. (127 × 163 cm)

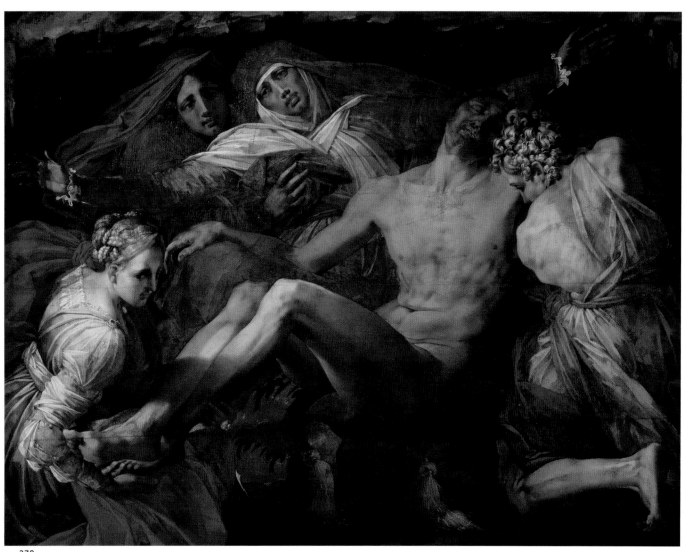

278

279

279

Giulio Romano (Giulio Pippi de' Giannuzzi)

Italian, c. 1490–1546

The Circumcision, c. 1520

Oil on wood transposed to canvas

43 7/8 × 48 in. (111.5 × 122 cm)

280

Parmigianino (Francesco Mazzola)

Italian, 1503–1540

The Mystic Marriage of Saint Catherine, c. 1527–30

Oil on poplar wood

8 1/4 × 10 5/8 in. (21 × 27 cm)

280

281

Tintoretto (Jacopo Robusti)
Italian, 1518–1594
Coronation of the Virgin
(Paradise), c. 1564
Oil on canvas
56 1/4 × 142 1/2 in. (143 × 362 cm)

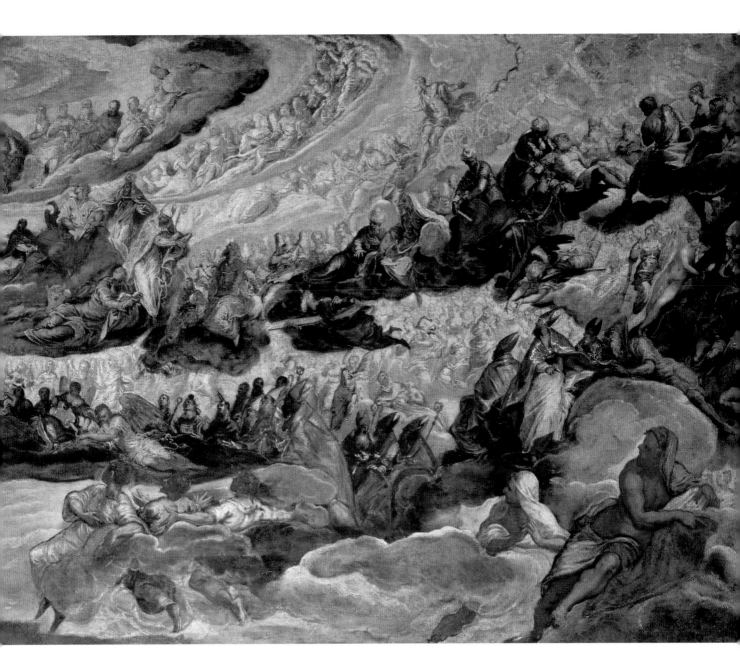

282A, 282B
Veronese (Paolo Caliari)
Italian, 1528–1588
The Wedding Feast at Cana,
1562–63
Oil on canvas
266 1/2 × 391 3/8 in. (677 × 994 cm)

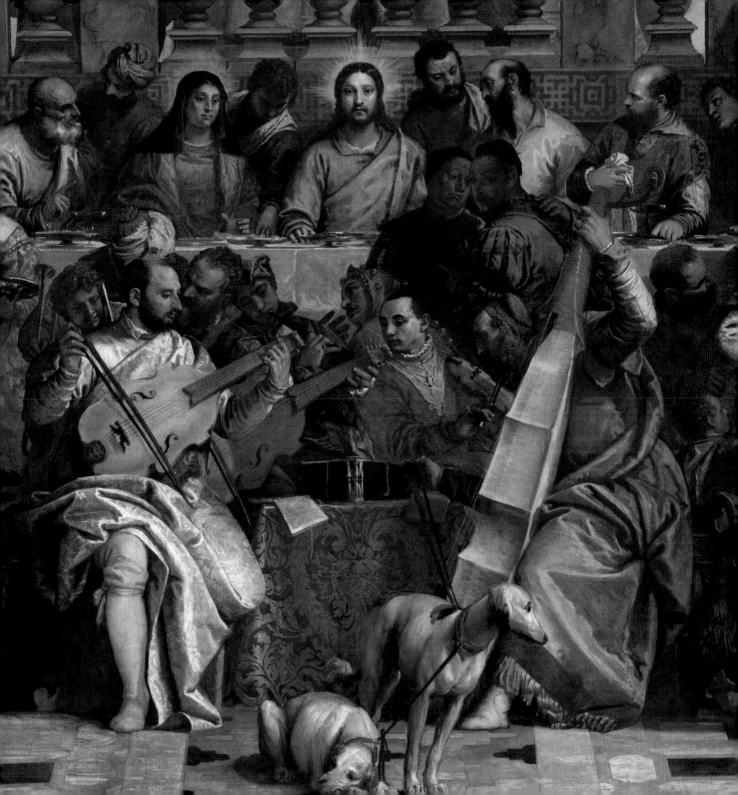

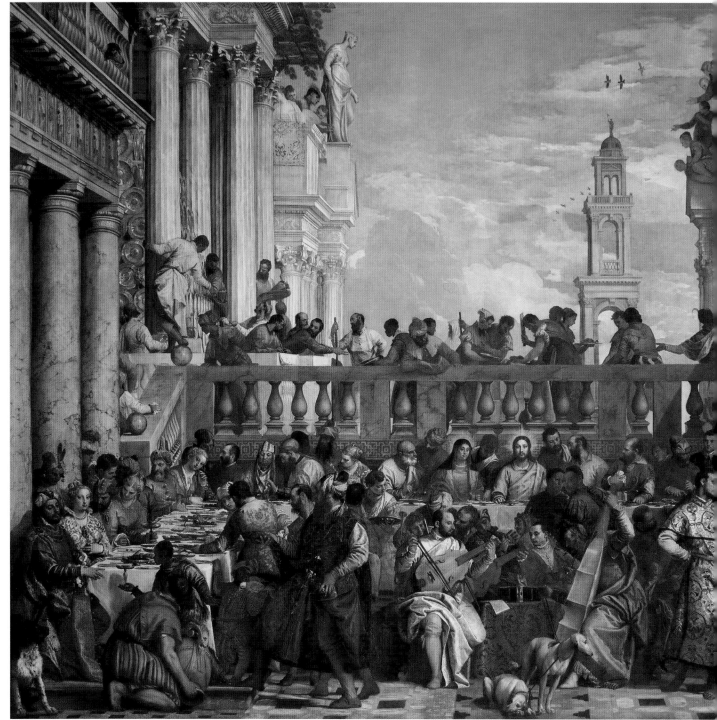

282B

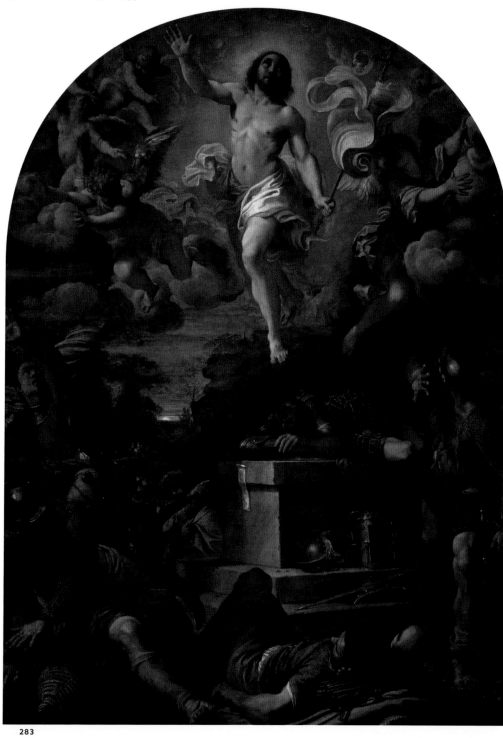

283
Annibale Carracci
Italian, 1560–1609
The Resurrection of Christ,
1593
Oil on canvas
85 × 63 in. (216 × 160 cm)

284
Veronese (Paolo Caliari)
Italian, 1528–1588
Portrait of a Lady (Bella Nani),
c. 1560
Oil on canvas
46 ⁷/₈ × 40 ¹/₂ in. (119 × 103 cm)

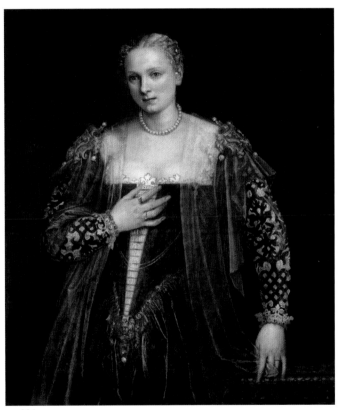

284

285
Annibale Carracci
Italian, 1560–1609
Hunting, c. 1585–88
Oil on canvas
53 1/2 × 100 in. (136 × 254 cm)

286
Annibale Carracci
Italian, 1560–1609
Fishing, c. 1585–88
Oil on canvas
53 1/2 × 100 3/8 in. (136 × 255 cm)

287
Guido Reni
Italian, 1575–1642
The Abduction of Helen,
c. 1626–29
Oil on canvas
99 1/2 × 104 1/4 in. (253 × 265 cm)

285

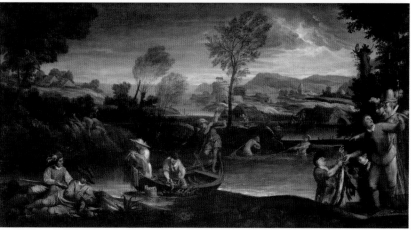

286

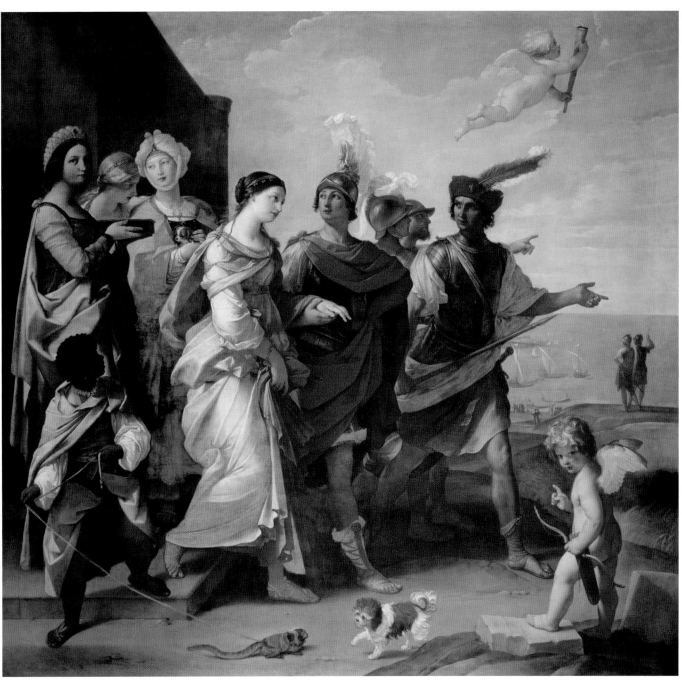

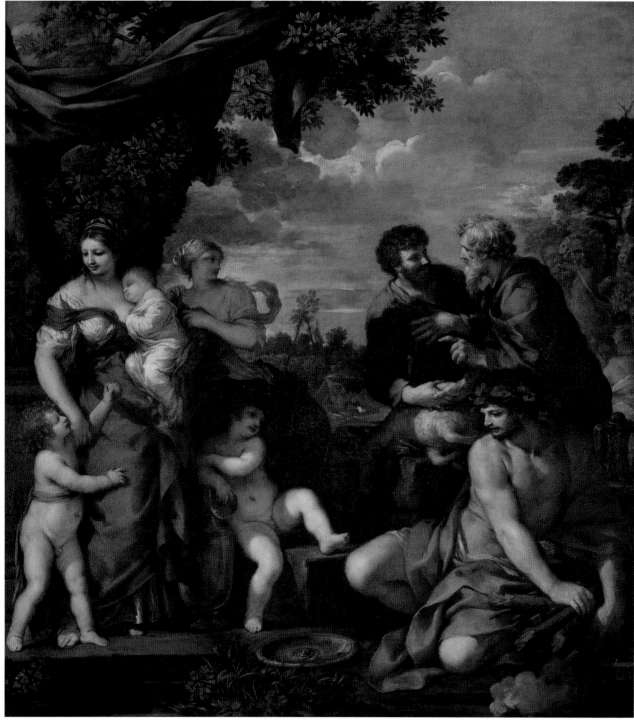





288
Pietro da Cortona (Pietro Berettini)
Italian, 1597–1669
Jacob and Laban, c. 1630–35
Oil on canvas
77 1/2 × 69 1/4 in. (197 × 176 cm)

289
Orazio Gentileschi (Orazio Lomi)
Italian, 1562–1639
Rest on the Flight into Egypt,
1628
Oil on canvas
62 × 88 1/2 in. (157 × 225 cm)

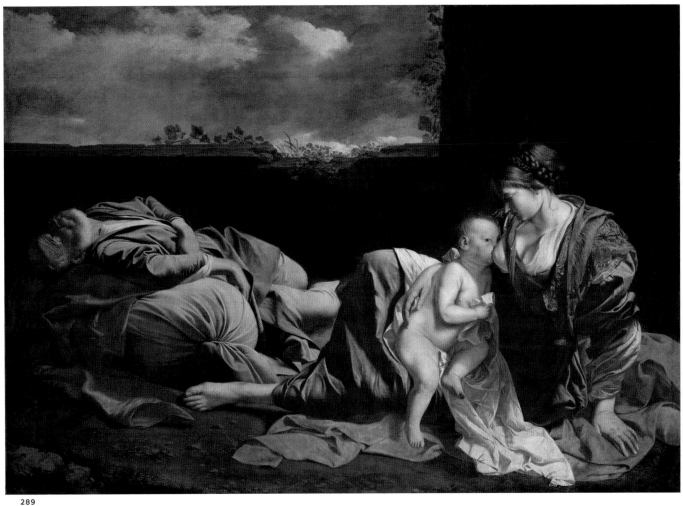

289

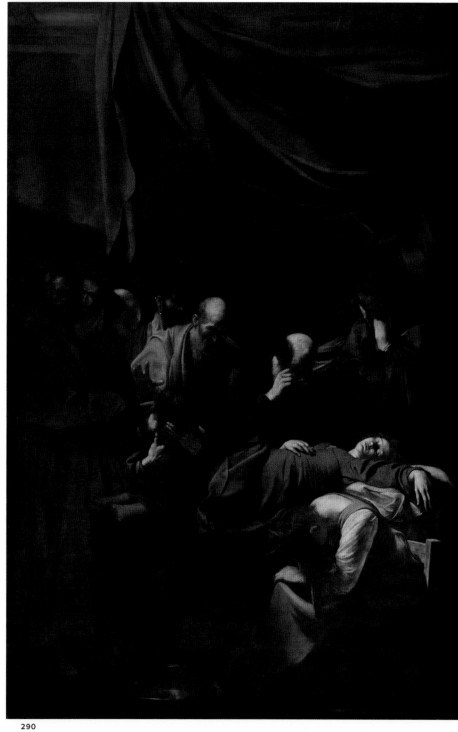

290
Caravaggio (Michelangelo
Merisi)
Italian, 1571–1610
Death of the Virgin, 1601–
c. 1606
Oil on canvas
145 1/4 × 96 1/2 in. (369 × 245 cm)

291
Caravaggio (Michelangelo
Merisi)
Italian, 1571–1610
The Fortune Teller, c. 1595–98
Oil on canvas
39 × 51 1/2 in. (99 × 131 cm)

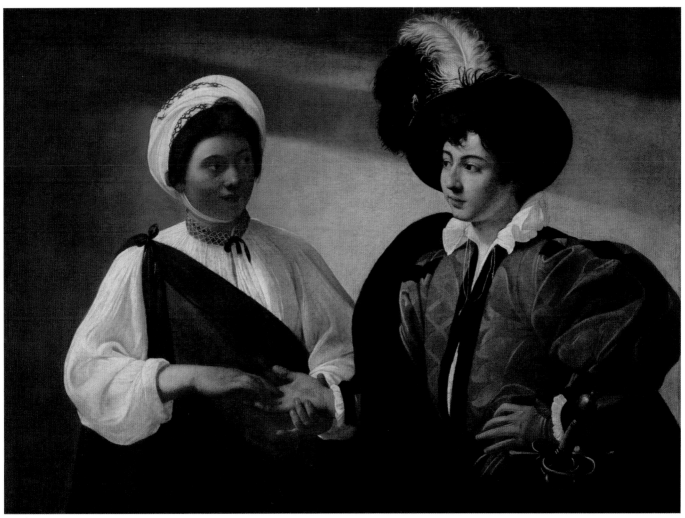

291

292
Lo Spagnolo (Giuseppe Maria Crespi)
Italian, 1665–1747
The Flea, c. 1720–30
Oil on canvas
21 ⅝ × 16 ⅛ in. (55 × 41 cm)

293
Giovanni Battista Tiepolo
Italian, 1696–1770
The Last Supper, c. 1745–47
Oil on canvas
32 × 35 ½ in. (81 × 90 cm)

292

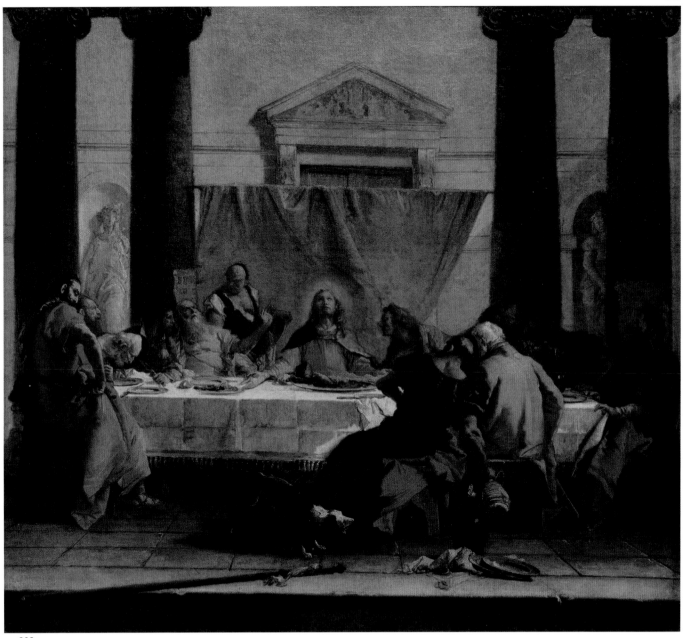

294
Domenico Fetti
Italian, c. 1588–1623
Melancholy, 1618–23 (?)
Oil on canvas
67 1/4 × 50 1/2 in. (171 × 128 cm)

295
Guido Reni
Italian, 1575–1642
David Holding the Head of Goliath, c. 1604–6
Oil on canvas
93 1/4 × 54 in. (237 × 137 cm)

296
Francesco Guardi
Italian, 1712 –1793
The Doge in the Bucentaur at San Nicolo di Lido on Ascension Day, c. 1775–80
Oil on canvas
26 1/2 × 40 in. (67 × 101 cm)

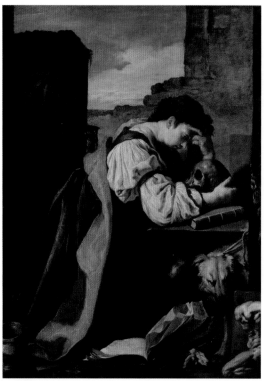

294

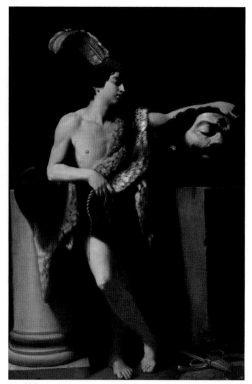

295

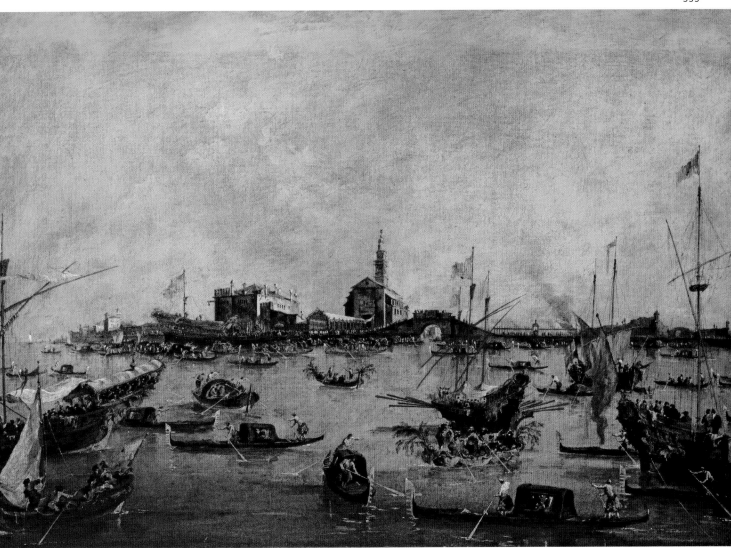

296

297

297
Giovanni Paolo Pannini
Italian, 1691–1765
*Gallery of Views of Modern
Rome*, 1759
Oil on canvas
91 × 119 1/4 in. (231 × 303 cm)

297

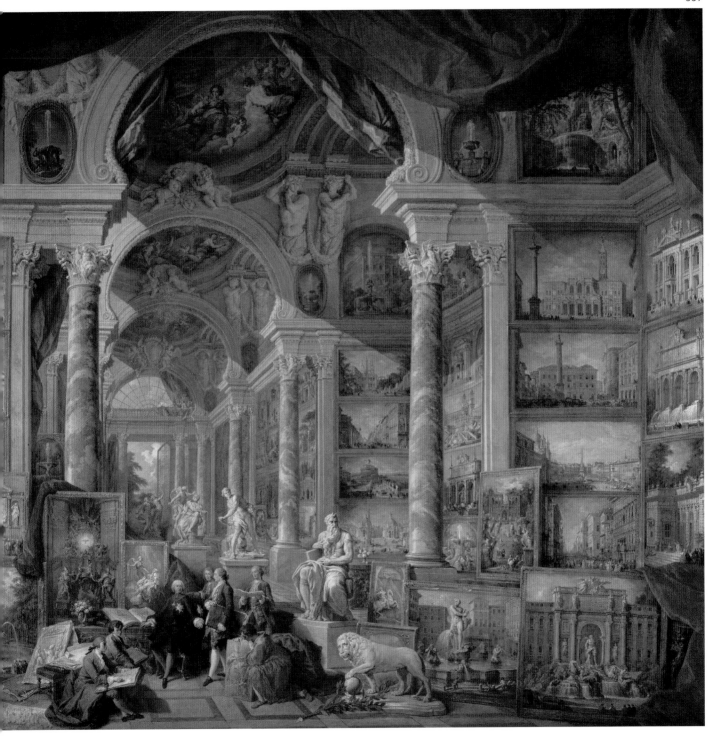

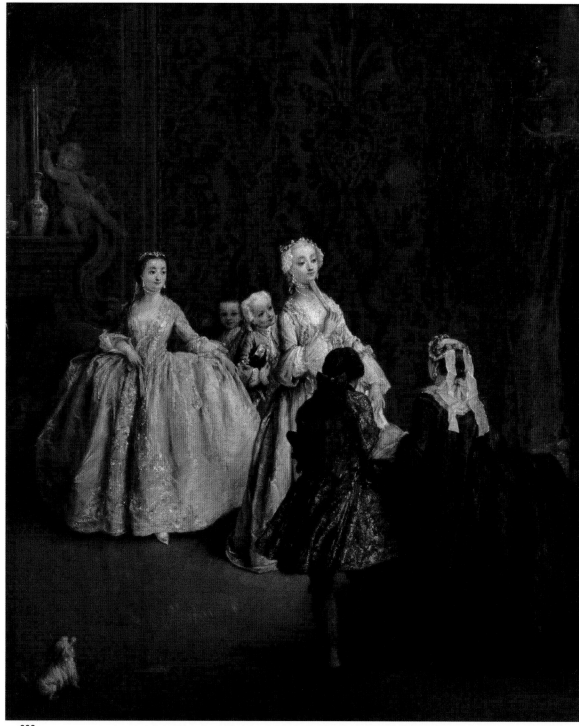

298
Pietro Longhi (Pietro Falca)
Italian, 1702–1785
The Introduction, c. 1740
Oil on canvas
26 × 21 5/8 in. (66 × 55 cm)

299
Canaletto (Giovanni Antonio
Canal)
Italian, 1697–1768
*Entrance to the Grand Canal
with the Church of the Salute*,
c. 1730
Oil on canvas
46 7/8 × 60 1/4 in. (119 × 153 cm)

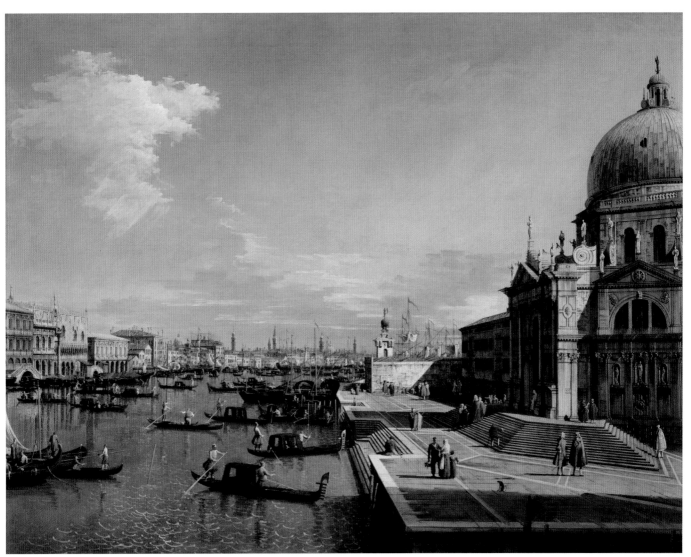

299

300
Pompeo Batoni
Italian, 1708–1787
The Virgin of the Annunciation,
c. 1741–42
Oil on canvas
19 1/4 × 15 3/8 in. (49 × 39 cm)

301
Giovanni Battista Tiepolo
Italian, 1696–1770
Apollo and Daphne, c. 1743–44
Oil on canvas
37 3/4 × 31 1/8 in. (96 × 79 cm)

300

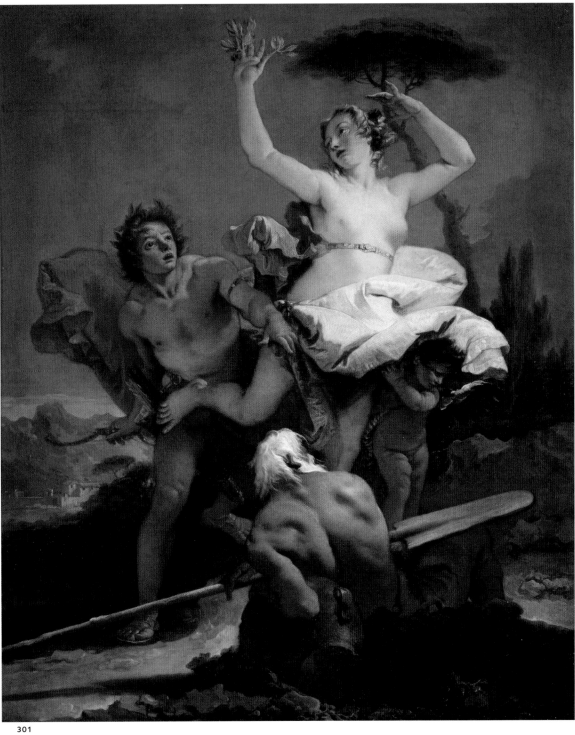

302
**El Greco (Domenikos
Theotokopoulos)**
Spanish, 1541–1614
*Christ on the Cross Adored by
Two Donors*, c. 1590
Oil on canvas
102 1/4 × 67 1/4 in. (260 × 171 cm)

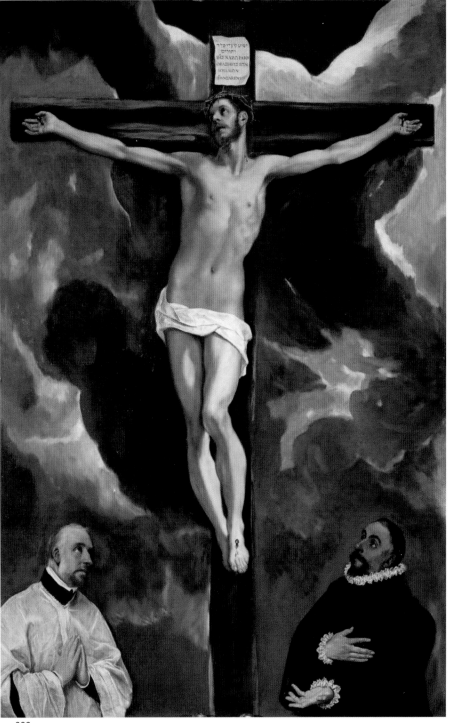

303
Francisco de Zurbarán
Spanish, 1598–1664
Saint Apollonia, c. 1630
Oil on canvas
53 × 26 1/2 in. (134 × 67 cm)

304
Francisco de Zurbarán
Spanish, 1598–1664
Saint Bonaventure's Body Lying in State, 1629
Oil on canvas
96 1/2 × 86 5/8 in. (245 × 220 cm)

303

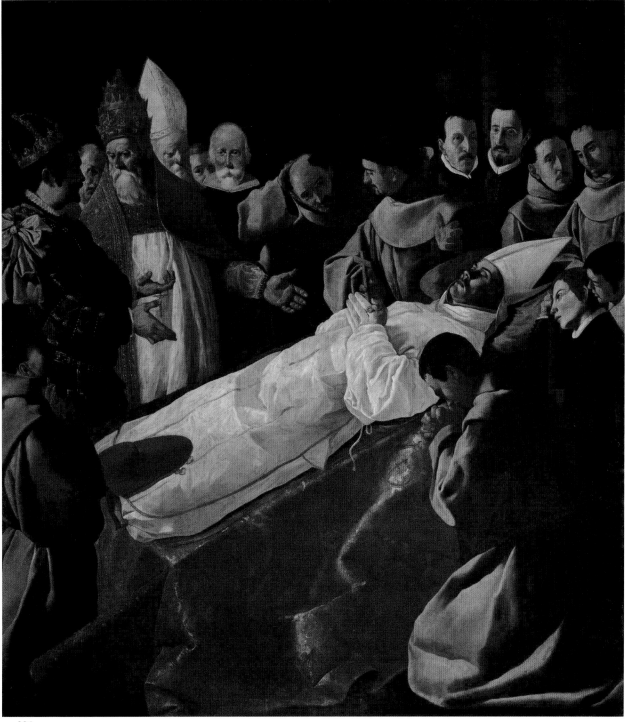

305
Bartolomé Esteban Murillo
Spanish, 1618–1682
The Young Beggar, c. 1645–50
Oil on canvas
52 ³/₄ × 43 ¹/₄ in. (134 × 110 cm)

306
Jusepe de Ribera
Spanish, 1591–1652
The Club-Footed Boy, 1642
Oil on canvas
64 ¹/₂ × 37 in. (164 × 94 cm)

307
Francisco de Goya y Lucientes
Spanish, 1746–1828
The Countess of Carpio, Marquise de la Solana, 1794–95
Oil on canvas
71 ¹/₄ × 48 in. (181 × 122 cm)

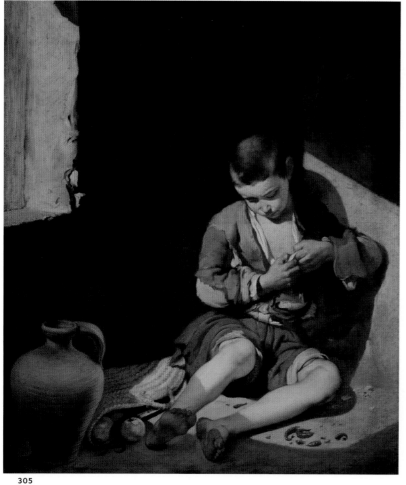

305

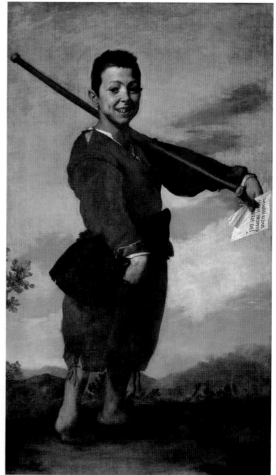

306

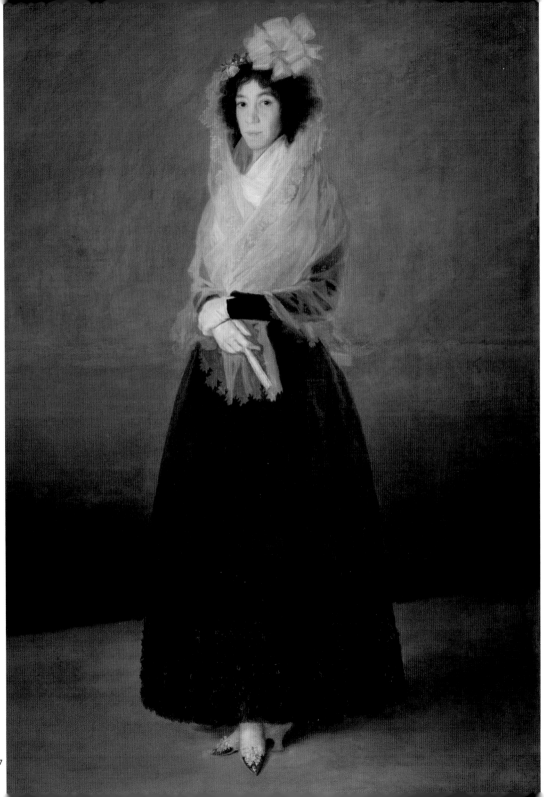

308

Quentin Metsys
Flemish, c. 1465–1530
Mary Magdalene, 1520–25
Oil on canvas
33 1/2 × 28 3/4 in. (85 × 73 cm)

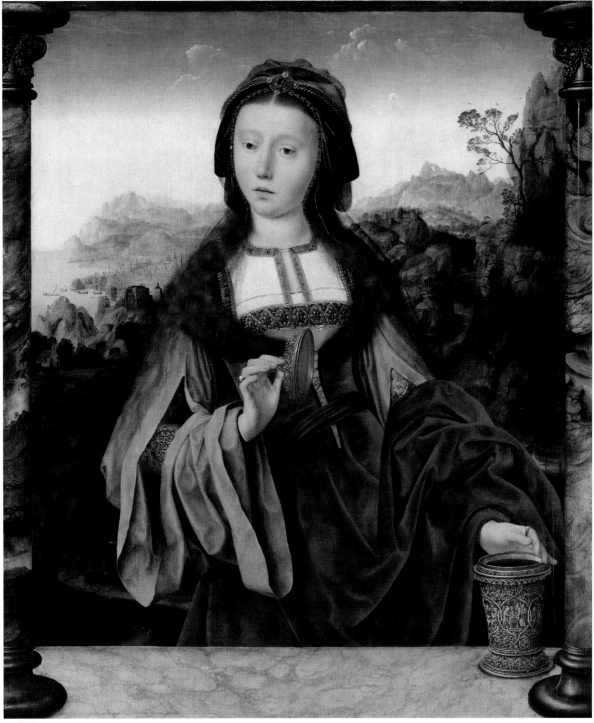

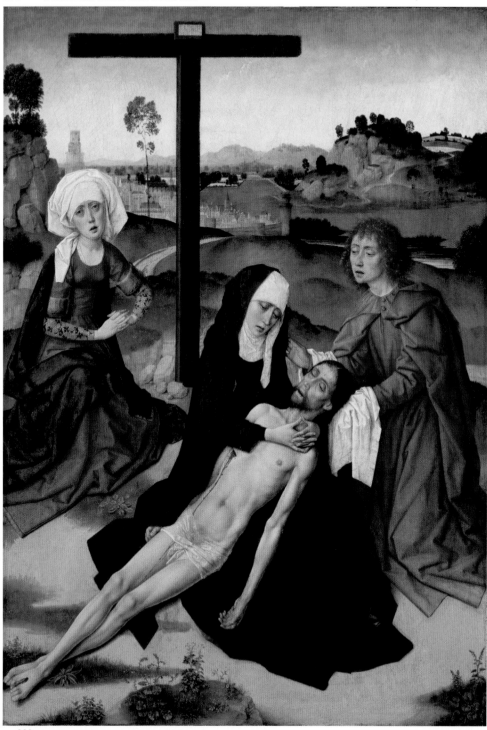

309
Dierick Bouts the Elder
Dutch, c. 1420–c. 1475
The Lamentation of Christ,
c. 1455–60
Oil on wood panel
27 1/8 × 19 1/4 in. (69 × 49 cm)

310
Jan van Eyck
Flemish, c. 1391–1441
The Virgin of Chancellor Rolin,
c. 1435
Oil on wood panel
26 × 24 1/2 in. (66 × 62 cm)

311
Rogier van der Weyden
Flemish, c. 1399–1464
The Annunciation, c. 1435–40
Oil on wood panel
34 × 36 1/2 in. (86 × 93 cm)

312
Rogier van der Weyden
Flemish, c. 1400–1464
Braque Family Triptych, c. 1452
Central panel: *Christ the Redeemer Between the Virgin and Saint John the Evangelist*; left wing: *Saint John the Baptist*; right wing: *Saint Mary Magdalen*
Oil on wood panel
Center: 16 1/8 × 26 3/4 in. (41 × 68 cm); each wing: 16 1/8 × 13 3/8 in. (41 × 34 cm)

312

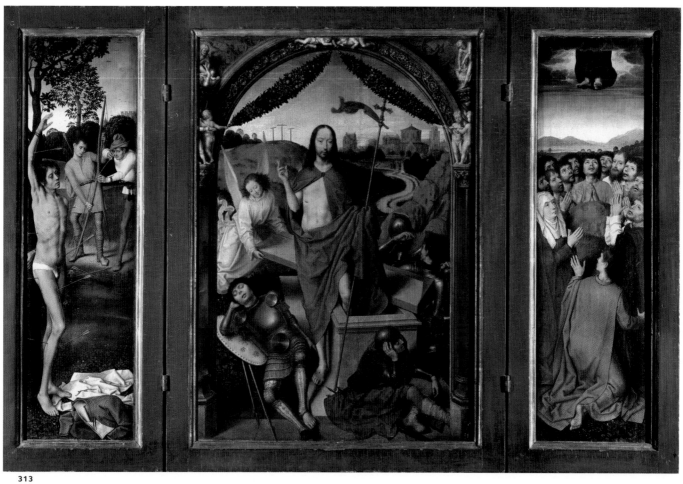

313

Hans Memling

Dutch, c. 1435–1494
Triptych of the Resurrection,
c. 1490
Central panel: *The Resurrection*; left wing: *The Martyrdom of Saint Sebastian*; right wing: *The Ascension*
Oil on wood panel
Center: 24 3/8 × 17 1/2 in.
(62 × 44 cm); each wing:
24 3/8 × 7 1/4 in. (62 × 18.5 cm)

314

Gerard David

Dutch, c. 1450–1523
Sedano Family Triptych,
c. 1490–95
Central panel: *Virgin with Child Between Angel Musicians*;
Left wing: *John of Sedano and His Son with Saint John the Baptist*; right wing: *Mary, Wife of John of Sedano, Presented by Saint John the Evangelist*
Oil on wood panel
Center: 38 1/4 × 28 1/4 in.
(97 × 72 cm); each wing:
36 ×12 in. (91 × 30 cm)

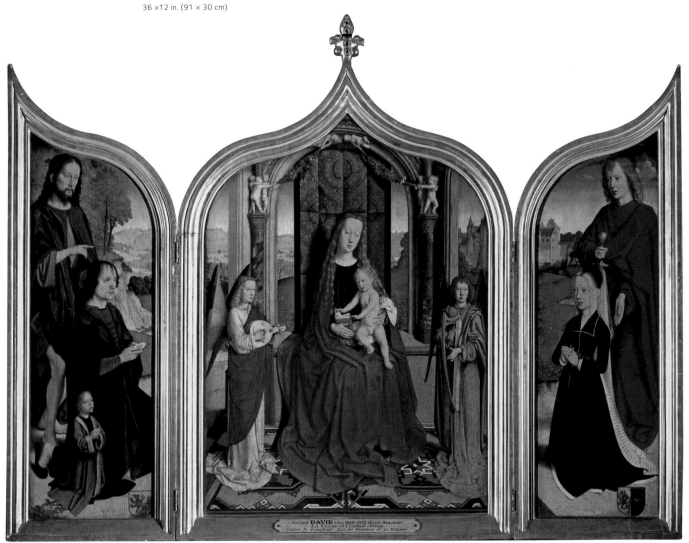

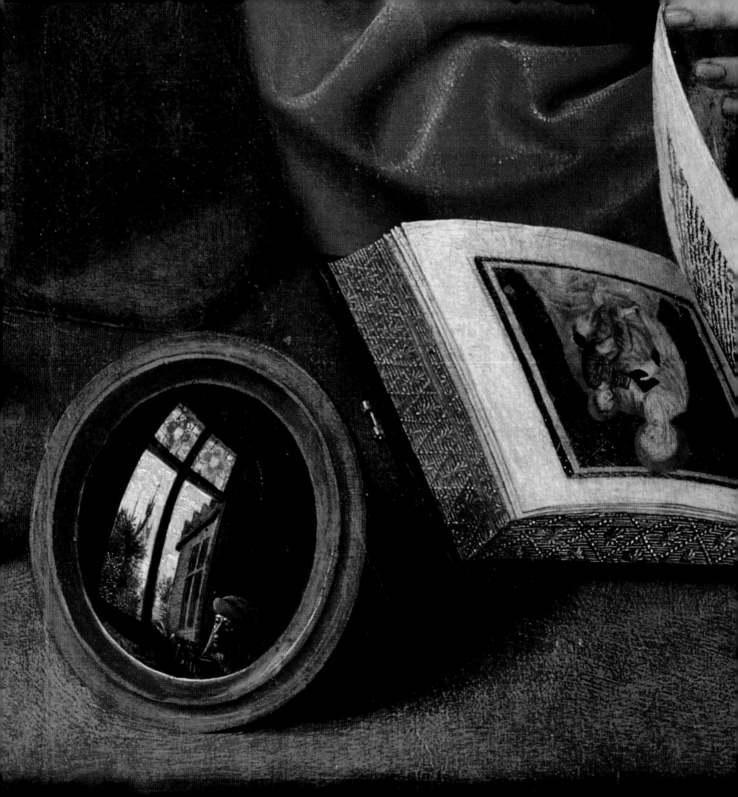

315A, 315B
Quentin Metsys
Flemish, c. 1465–1530
The Moneylender and His
Wife, 1514
Oil on wood panel
28 × 26 3/4 in. (71 × 68 cm)

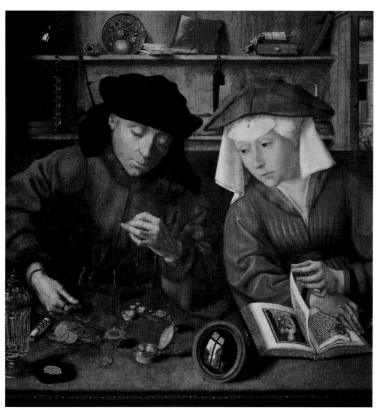

315B

315A

316
Pieter Bruegel the Elder
Flemish, c. 1525–1569
The Beggars (*The Cripples*), 1568
Oil on wood panel
7 1/8 × 8 1/4 in. (18 × 21 cm)

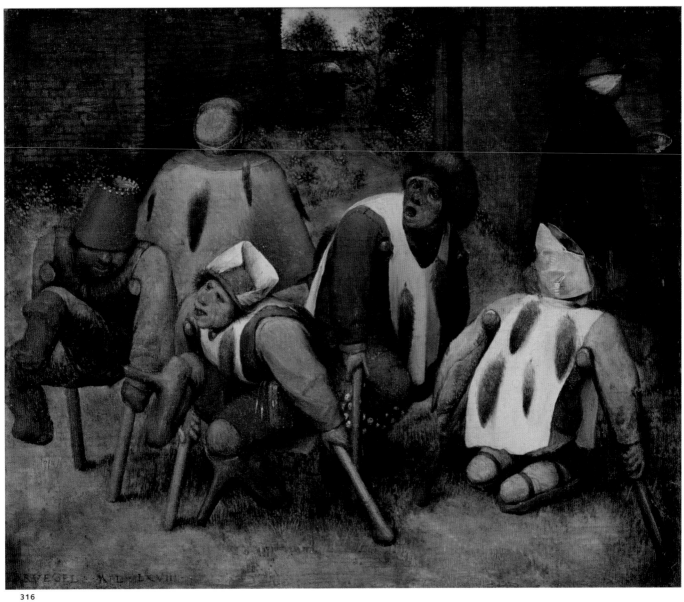

317
Hieronymus Bosch
(Hieronymus van Aken)
Dutch, c. 1450–1516
Ship of Fools, c. 1510–15
Oil on wood panel
23 × 13 in. (58 × 33 cm)

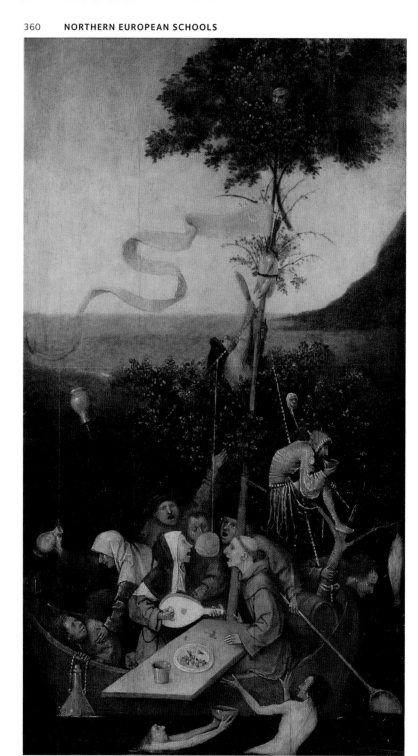

317

318
Joachim Patenier
Dutch, c. 1474–1524
Saint Jerome in the Desert,
c. 1515
Oil on wood panel
30 1/2 × 54 in. (78 × 137 cm)

319
Peter Paul Rubens
Flemish, 1577–1640
The Village Fête (*Village Wedding*), 1635–38
Oil on wood
58 1/2 × 103 in. (149 × 261 cm)

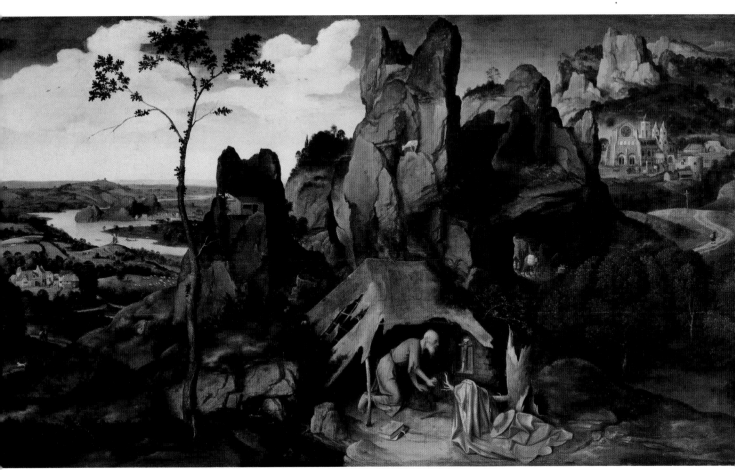

318

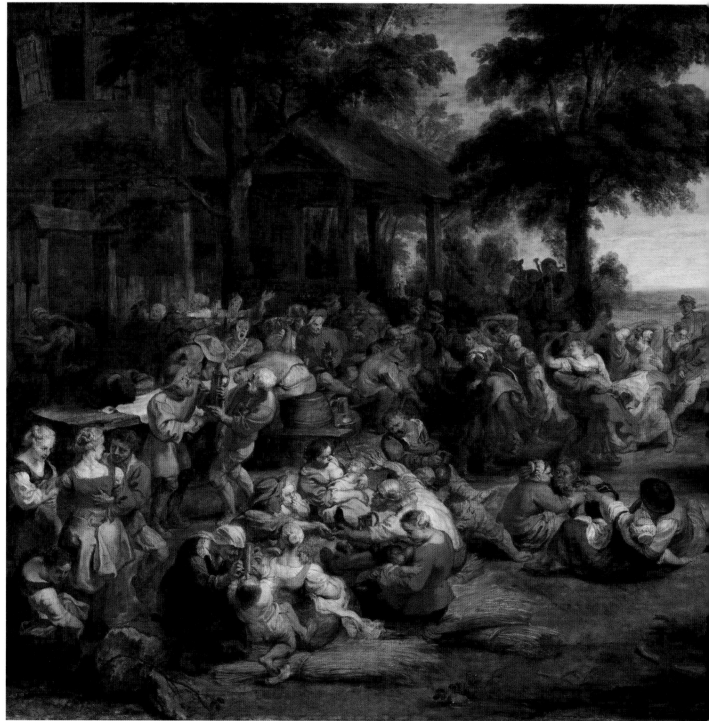

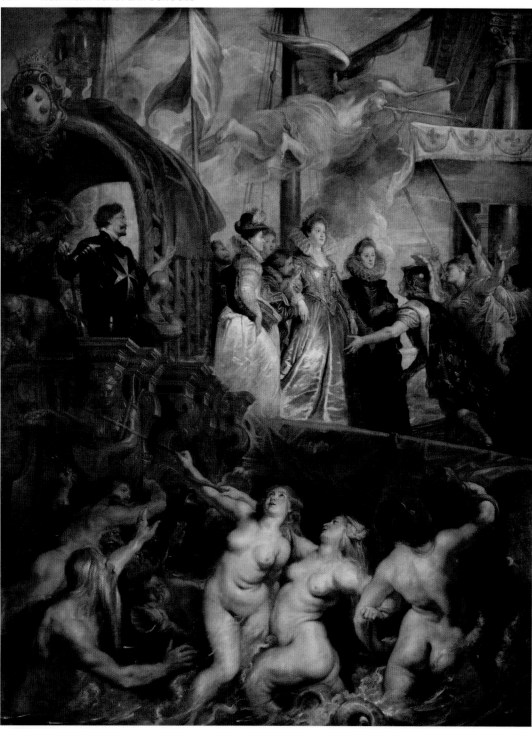

320
Peter Paul Rubens
Flemish, 1577–1640
The Arrival of Marie de Médicis at Marseilles, 3rd November 1600, 1622–25
Oil on canvas
155 × 116 1/4 in. (394 × 295 cm)

321
Peter Paul Rubens
Flemish, 1577–1640
The Meeting at Lyons (The Meeting of Marie de Médicis and Henri IV at Lyons), 1622–25
Oil on canvas
155 × 116 1/4 in. (394 × 295 cm)

322
Peter Paul Rubens
Flemish, 1577–1640
The Birth of Louis XIII, 1622–25
Oil on canvas
155 × 116 1/4 in. (394 × 295 cm)

323
Peter Paul Rubens
Flemish, 1577–1640
Marie's Education, 1622–25
Oil on canvas
155 × 116 1/4 in. (394 × 295 cm)

324
Peter Paul Rubens
Flemish, 1577–1640
The Peace of Angers, 1622–25
Oil on canvas
155 × 116 1/4 in. (394 × 295 cm)

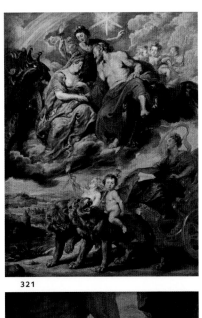

321

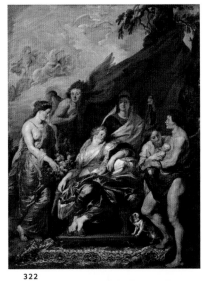

322

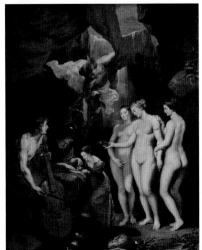

323

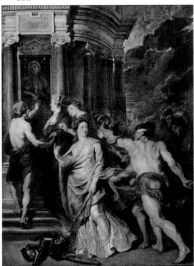

324

325
Frans Snyders
Flemish, 1579–1657
Two Monkeys Stealing Fruit from a Basket, c. 1640
Oil on canvas
33 × 46 7/8 in. (84 × 119 cm)

326
Peter Paul Rubens
Flemish, 1577–1640
Hélène Fourment with a Carriage, c. 1638
Oil on canvas
45 1/4 × 33 1/2 in. (115 × 85 cm)

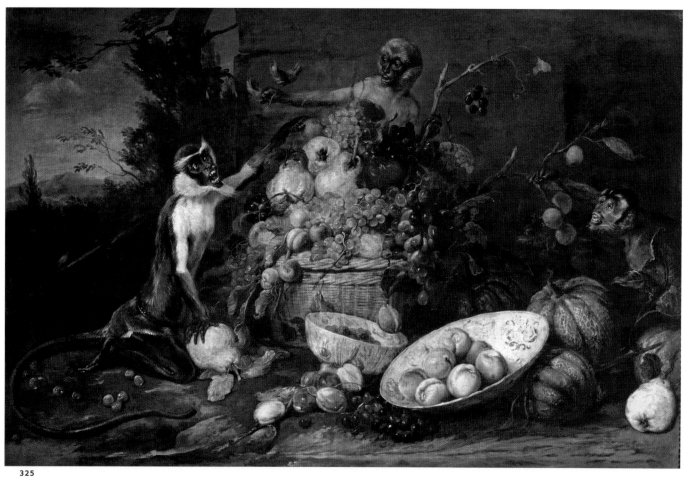

325

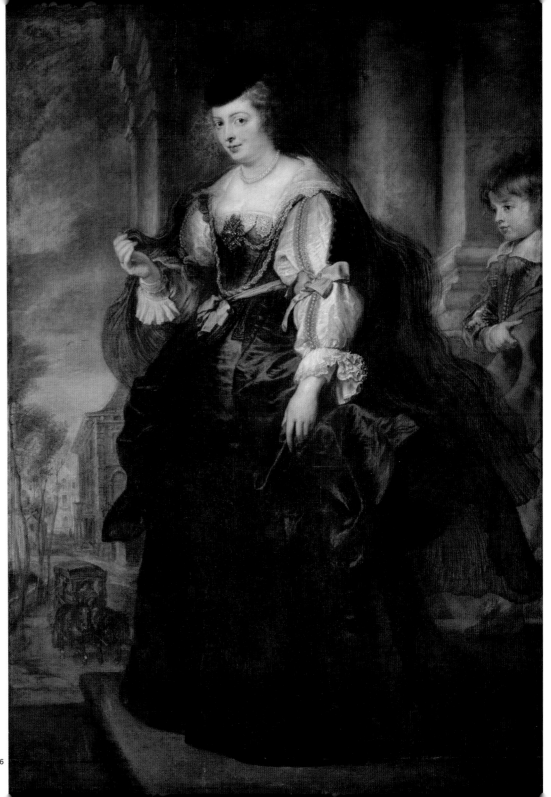

327
Pieter Boel
Flemish, 1622–1674
Studies of a Fox, c. 1669–71
Oil on canvas
20 7/8 × 25 5/8 in. (53 × 65 cm)

328
Pieter Boel
Flemish, 1622–1674
Triple Study of a Peacock,
c. 1669–71
Oil on canvas
48 7/8 × 74 3/4 in. (124 × 190 cm)

329
Sir Anthony van Dyck
Flemish (English), 1599–1641
Charles I, King of England,
(*Charles I at the Hunt*), c. 1635
Oil on canvas
104 1/2 × 81 1/2 in. (266 × 207 cm)

327

328

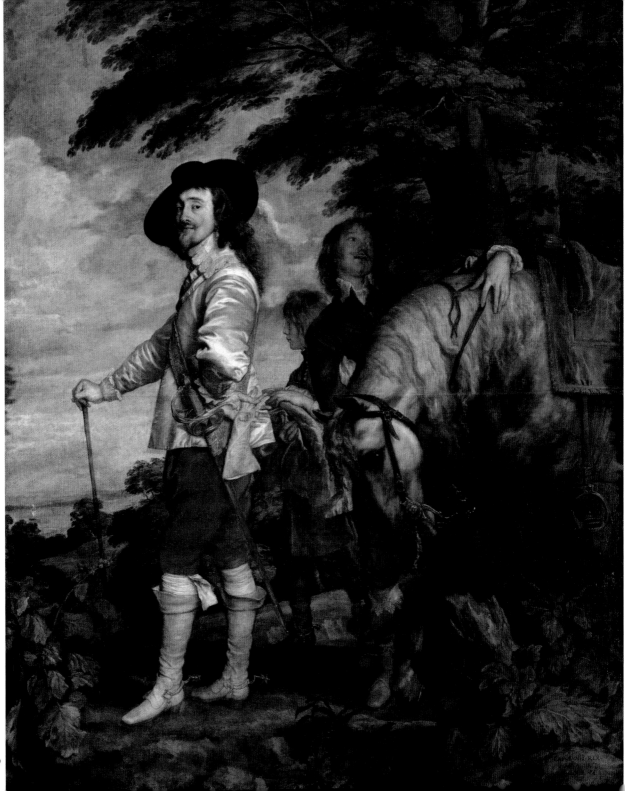

330
Jacob Jordaens
Flemish, 1593–1678
*Jesus Driving the Merchants
from the Temple*, c. 1645–50
Oil on canvas
113 1/2 × 171 1/2 in. (288 × 436 cm)

331
Sir Anthony van Dyck
Flemish (English), 1599–1641
*Crucifixion with the Virgin,
Saint John, and Mary
Magdalene*, 1617–19
Oil on canvas
129 7/8 × 111 in. (330 × 282 cm)

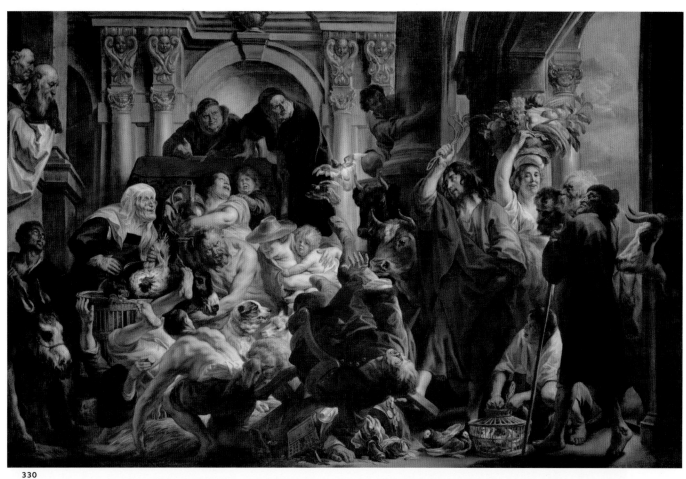

330

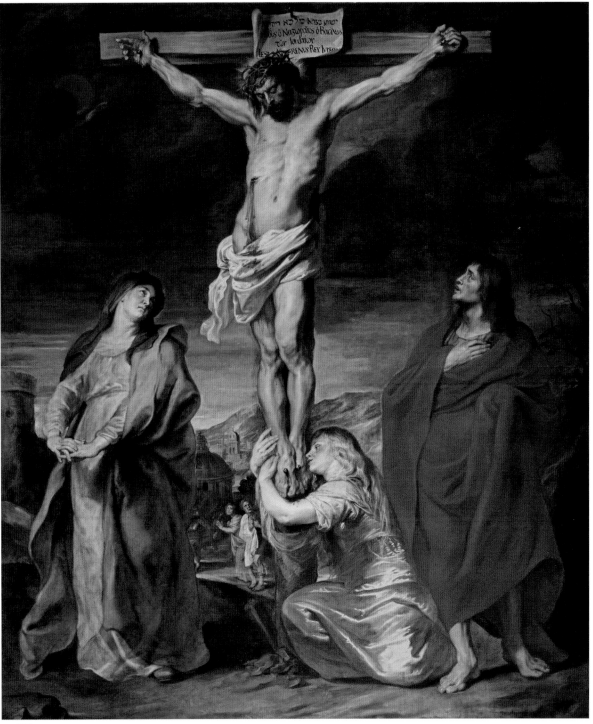

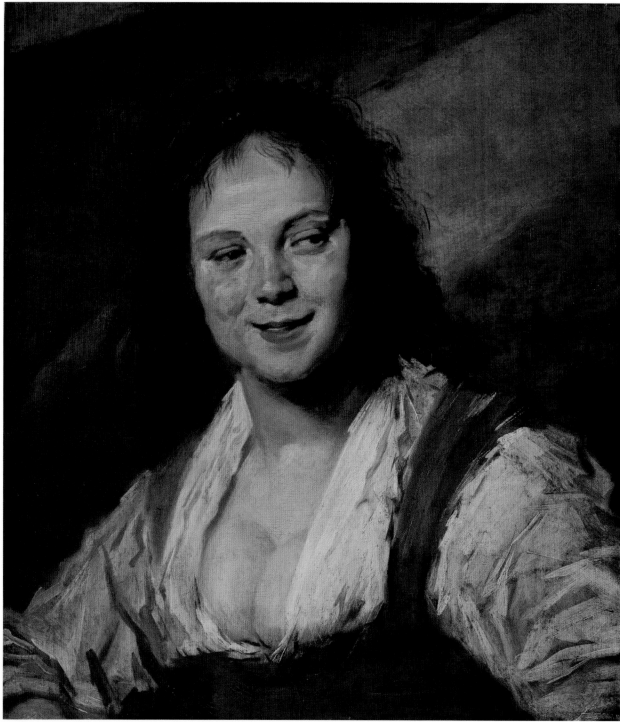

332
Frans Hals
Dutch, c. 1581–1666
The Gypsy Girl, c. 1628–30
Oil on wood panel
23 × 20 1/2 in. (58 × 52 cm)

333
Frans Hals
Dutch, c. 1581–1666
Jester with a Lute, c. 1624–26
Oil on canvas
27 1/2 × 24 3/8 in. (70 × 62 cm)

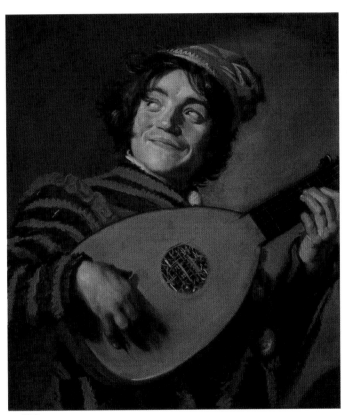

333

334
Jan Davidszoon de Heem
Dutch, 1606–c. 1684
A Table of Desserts, 1640
Oil on canvas
58 1/2 × 80 in. (149 × 203 cm)

335
Jacob Isaackszoon van Ruisdael
Dutch, c. 1628–1682
The Ray of Sunlight, c. 1660
Oil on canvas
32 1/2 × 39 in. (83 × 99 cm)

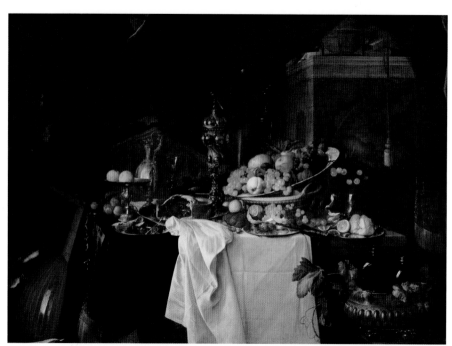

334

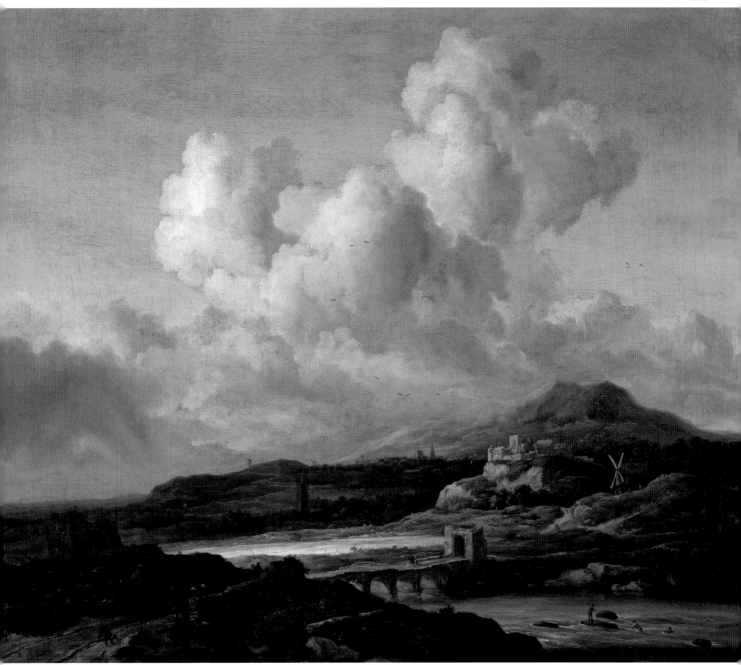

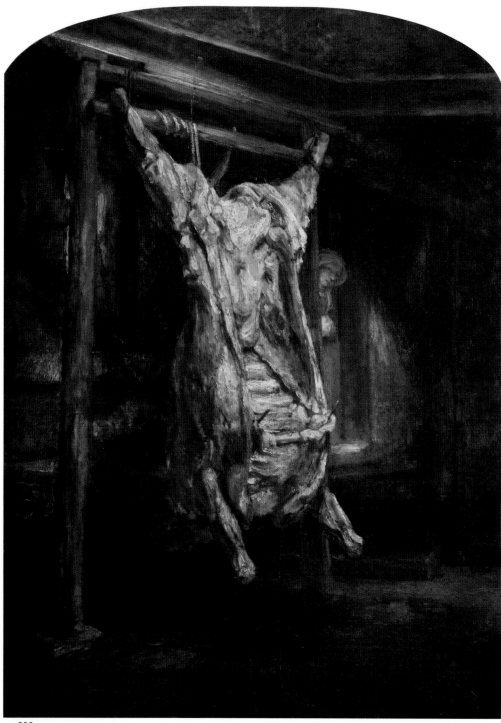

336
Rembrandt (Rembrandt Harmenszoon van Rijn)
Dutch, 1606–1669
The Slaughtered Ox, 1655
Oil on wood panel
37 × 27 1/4 in. (94 × 69 cm)

337
Rembrandt (Rembrandt Harmenszoon van Rijn)
Dutch, 1606–1669
Portrait of the Artist at His Easel, 1660
Oil on canvas
43 1/2 × 35 1/2 in. (111 × 90 cm)

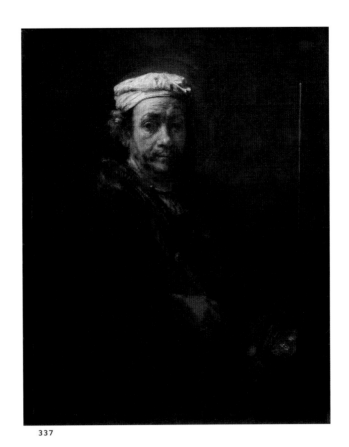

337

338
**Rembrandt (Rembrandt
Harmenszoon van Rijn)**
Dutch, 1606–1669
Bathsheba at Her Bath, 1654
Oil on canvas
56 × 56 in. (142 × 142 cm)

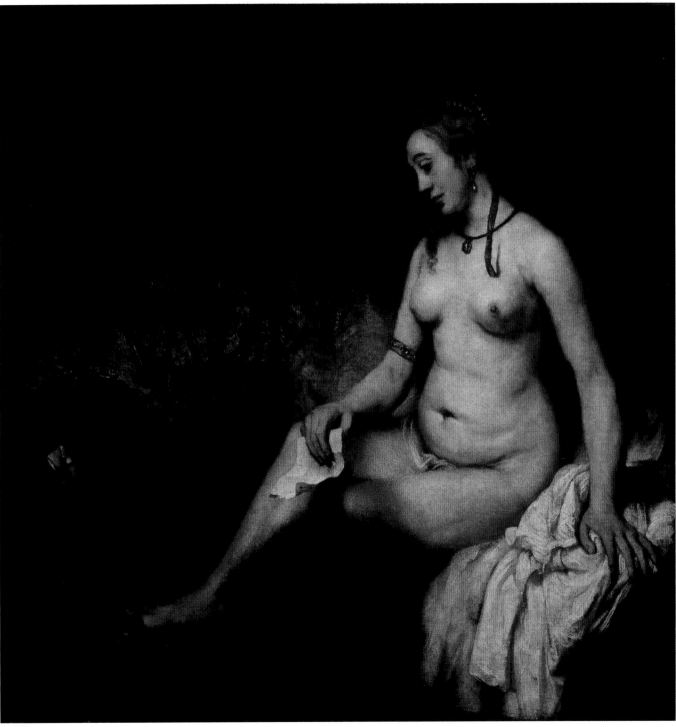

379

338

339
Adriaen van Ostade
Dutch, 1610–1685
Schoolmaster, 1662
Oil on wood panel
15 3/4 × 13 in. (40 × 33 cm)

340
Gerrit Dou
Dutch, 1613–1675
The Dentist, c. 1630–35
Oil on wood panel
12 5/8 × 10 1/4 in. (32 × 26 cm)

341
Samuel van Hoogstraten
Dutch, 1627–1678
Perspective of a Dutch Interior Viewed from a Doorway (*The Slippers*), 1654–62
Oil on canvas
40 1/2 × 27 1/2 in. (103 × 70 cm)

339

340

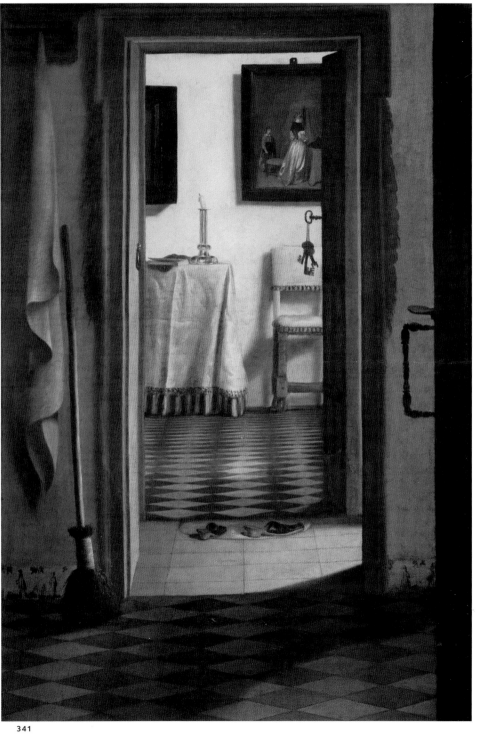

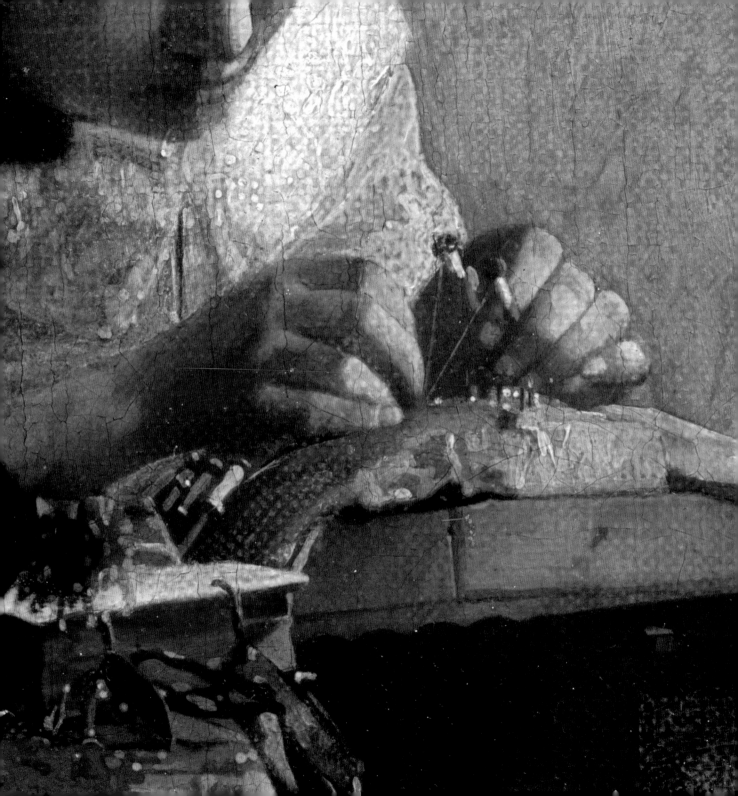

342A, 342B
Johannes Vermeer
Dutch, 1632–1675
The Lacemaker, c. 1669–70
Oil on canvas
9 $^1/_2$ × 8 $^1/_4$ in. (24 × 21 cm)

342B

342A

343
Johannes Vermeer
Dutch, 1632–1675
The Astronomer, 1668
Oil on canvas
20 × 17 1/2 in. (51 × 45 cm)

344
Pieter de Hooch
Dutch, 1629–1684
*A Woman Preparing
Vegetables with a Child,*
c. 1657
Oil on canvas
23 5/8 × 19 1/4 in. (60 × 49 cm)

344

345A, 345B
Albrecht Dürer
German, 1471–1528
*Self-Portrait (Portrait of the
Artist Holding a Thistle)*, 1493
Oil on parchment mounted on canvas
22 1/2 × 17 1/2 in. (57 × 45 cm)

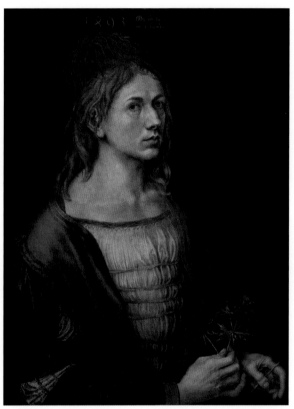

345A

345B

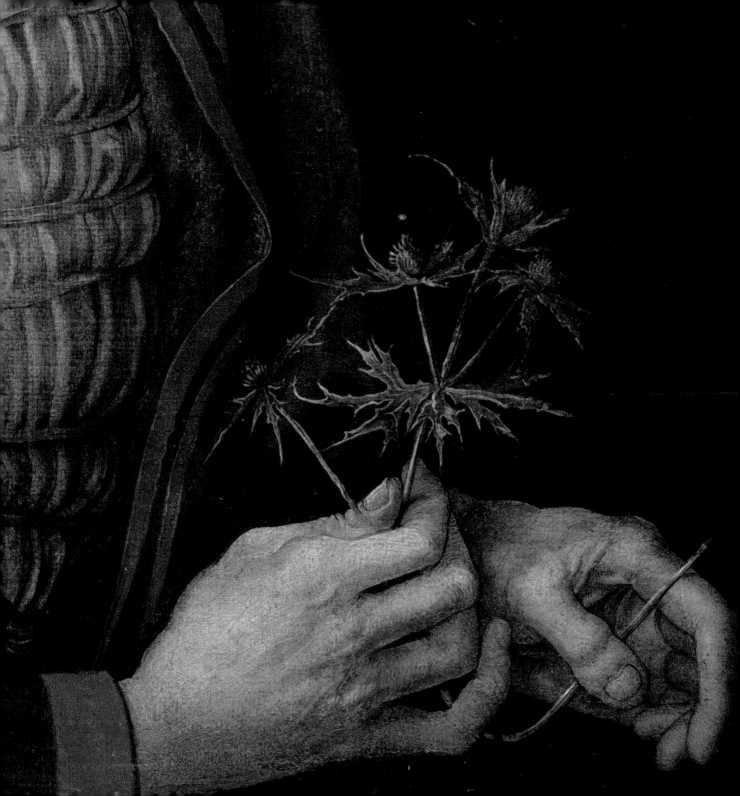

346
Lucas Cranach the Elder
German, 1472–1553
Venus Standing in a Landscape,
1529
Oil on wood panel
15 × 10 in. (38 × 25 cm)

347
Hans Holbein the Younger
German, 1497–1543
Erasmus, c. 1523
Oil on wood panel
16 ⁷/₈ × 13 in. (43 × 33 cm)

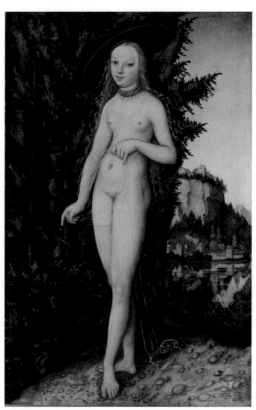

346

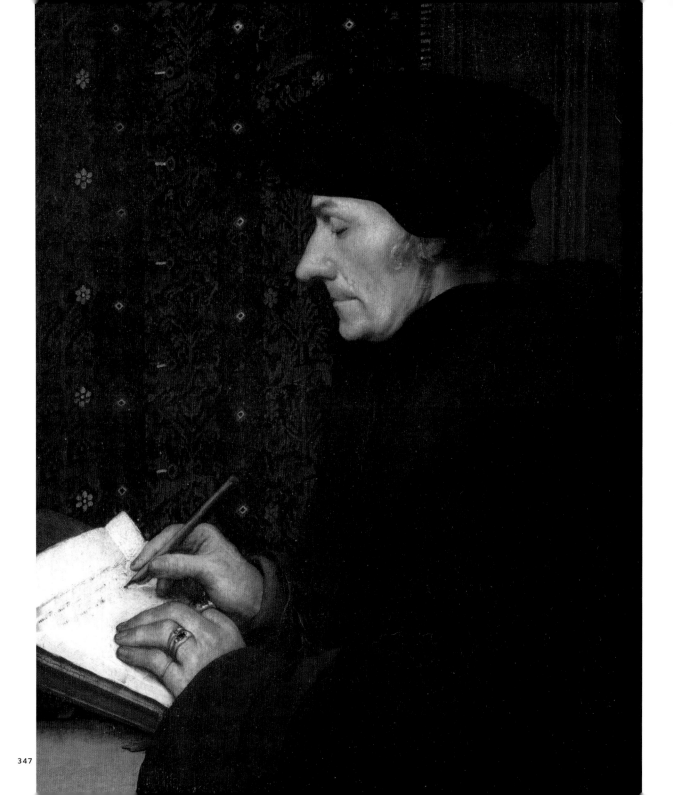

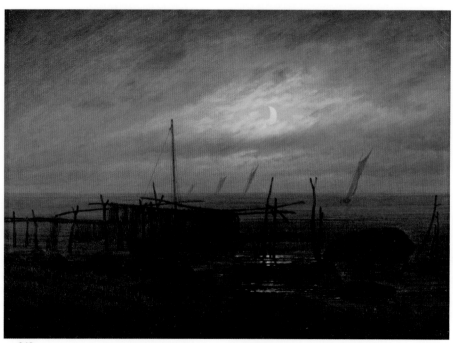

348

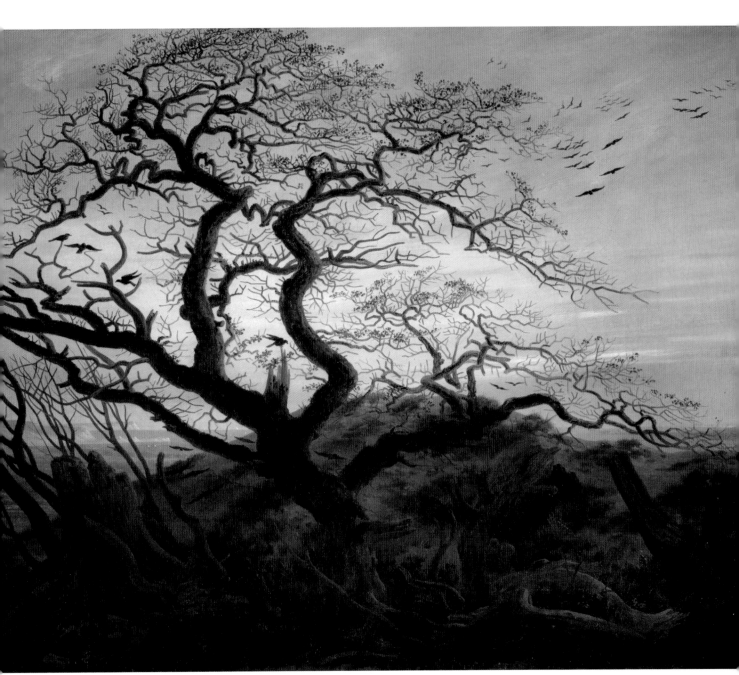

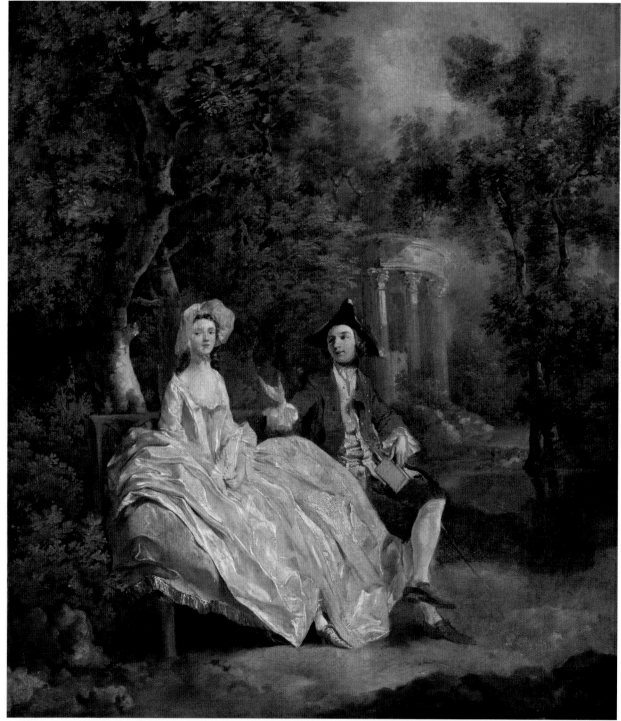

350

Thomas Gainsborough

English, 1727–1788

Conversation in a Park
(Perhaps the Artist and His
Wife), 1745

Oil on canvas

28 1/2 × 27 in. (73 × 68 cm)

351

Joshua Reynolds

English, 1723–1792

Master Hare, 1788–89

Oil on canvas

30 1/4 × 24 3/4 in. (77 × 63 cm)

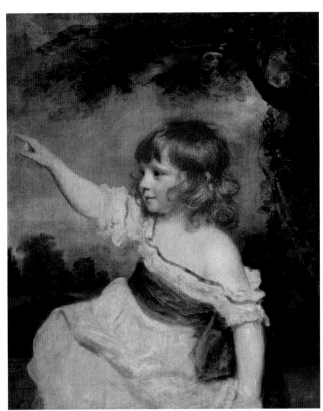

351

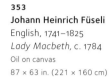

352
Thomas Lawrence
English, 1769–1830
*Portrait of the Children of
John Angerstein,* 1808
John Julius William (1801–
1866), Caroline Amelia
(d. 1879), Elizabeth Julia and
Henry Frederic (1805–1821)
Oil on canvas
76 3/8 × 56 3/4 in. (194 × 144 cm)

353
Johann Heinrich Füseli
English, 1741–1825
Lady Macbeth, c. 1784
Oil on canvas
87 × 63 in. (221 × 160 cm)

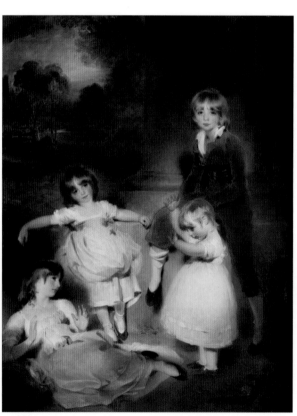

352

353

354
John Constable
English, 1776–1837
Weymouth Bay, 1819
Oil on canvas
34 5/8 × 44 1/8 in. (88 × 112 cm)

355
Joseph Mallord William Turner
English, 1775–1851
Landscape with Distant River and Bay, c. 1835–45
Oil on canvas
37 × 49 in. (94 × 124 cm)

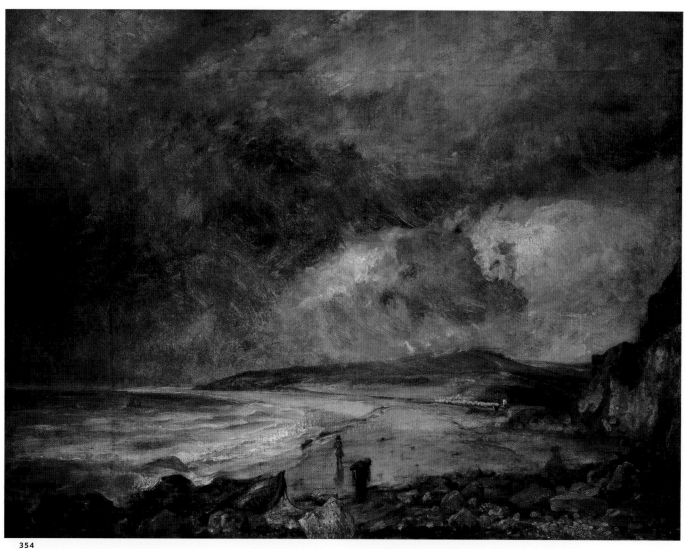

354

356
Constantin Hansen
Danish, 1804–1880
*Young Boys Playing Dice in
Front of Christiansborg Castle,
Copenhagen*, 1834
Oil on canvas
24 1/4 × 19 3/4 in. (61 × 50 cm)

357
Christen Schjellerup Købke
Danish, 1810–1848
*Portrait of Adolphine Købke
(1820–1880)*, the artist's sister,
1832
Oil on canvas
16 1/2 × 13 3/4 in. (42 × 35 cm)

356

PRINTS AND DRAWINGS

THE DEPARTMENT of Prints and Drawings is probably one of the oldest in the museum, as well as the richest in terms of the size of its collection—140,000 of the 400,000 items enumerated in the Louvre's inventory. Since the works in this collection are exceptionally fragile, they can be shown only in temporary exhibitions, under specific lighting conditions, for no more than three months at a time, with a break of at least six years between each exhibition. The museum compensates for this apparently limited visibility by opening its conference room to members of the public upon request and by providing unlimited access to its database on the Louvre's Web site, www.louvre.fr.

The Prints and Drawings collection is of royal origin. Here, too, Louis XIV served as a founding father by purchasing 5,552 drawings assembled by the banker Jabach. With this one acquisition, the King's Cabinet (*Cabinet du Roi*) took possession of an extraordinary group of works on paper from the Renaissance and seventeenth-century: they form the core of the department to this day. Following this initial purchase, the royal holdings were regularly enhanced through the acquisition of collections and artists' archives. The tradition by which the king could claim all the drawings left by his earliest painters brought thousands of works on paper by Charles Le Brun, Pierre Mignard, and Charles Antoine Coypel into the royal collection. New collections were acquired throughout the nineteenth century, filling gaps and bolstering the Louvre's established strengths. Fluctuating between independence and affiliation with the Department of Paintings, the Prints and Drawings collection became a full-fledged department in 1963, when it moved into rooms in the Flore Wing that it still occupies today.

The Louvre's holdings in the field of French drawing constitute the most important and comprehensive such collection in the world. Practically all the surviving works of certain artists are owned by the museum. Every era is superbly represented, although the earliest periods, going back to the late Middle Ages, are somewhat less richly illustrated than the others. Given that few paintings have survived from the medieval period, it is not surprising to learn that the drawings are so rare. With regard to the Renaissance, numerous works by the brilliant portraitist François Clouet and the artists of the Fontainebleau School exemplify the Italian influence on French art; yet they also demonstrate, through the art of the portrait, the vitality of local artists.

The Louvre's selection of seventeenth-century French drawings is incredibly rich: all the great names of the Baroque era, from Valentin de Boulogne to Hyacinthe Rigaud—including Simon Vouet, Nicolas Poussin, Claude Lorrain, Charles Le Brun, and Pierre Mignard—are represented. The same is true of the Louvre's eighteenth-century holdings, which provide a unique opportunity to study works on paper by Watteau, Boucher, Fragonard, and Jean-Baptiste Greuze. The nineteenth-century collection opens with a brilliant set of drawings by Jacques-Louis David and continues with thousands of pieces by Delacroix, Géricault, Girodet, and Corot. Since 1977, works on paper from the second half of the nineteenth century have been in the collection of the Musée d'Orsay.

The Italian School is the crown jewel of several departments in the Louvre, and this is certainly true of the graphic arts. Few museums have at hand so many works by the most acclaimed artists of the fifteenth to eighteenth centuries. Certain ensembles are world-famous, such as the groups of prized drawings by Pisanello, da Vinci, Michelangelo, and Raphael, as well as collections of Floren-

tine Mannerists. Outside Florence, only London and Vienna can compete with the Louvre in this area.

The selection of drawings from the Northern schools is smaller, although diverse and extremely rich, particularly with regard to the seventeenth century. From Flanders, the art of Peter Paul Rubens is illuminated by a matchless group of works, while the Netherlands is represented by a beautiful series of drawings Rembrandt made of himself and his entourage (no. 373). Hundreds of works on paper by those artists known as the "small masters" nicely fill out the collection.

The German School is represented more broadly in the graphic arts than in the Louvre's paintings. Indeed, the museum boasts a stunning series of drawings and watercolors by Albrecht Dürer and a few other great artists of the late fifteenth and early sixteenth centuries; the *View of the Arco Valley* (no. 372) is an acclaimed watercolor by the artist from Nuremberg. Even seventeenth-century German artists, who are nearly absent from other French collections, are represented here by some excellent drawings. The English and Spanish schools are featured in smaller but still interesting groups of work.

Although the Department of Prints and Drawings dazzles with its coverage of every school and all the major centers of artistic production, its greatest strength may be that it features all the graphic techniques and media employed since the Middle Ages—for example, ink, silverpoint, graphite, pastel, watercolor, and etching—as well as every support from parchment to the sketchpad, including magnificent papers prepared during the fifteenth and sixteenth centuries. For instance, the Louvre owns an important collection of seventeenth- and eighteenth-century pastels that reveals different aspects of this medium in illustrative works by leading practitioners, ranging from Chardin (no. 377) in Paris to Jean-Étienne Liotard (no. 378) in Geneva; among them is Quentin de La Tour's mid-eighteenth century *Full-Length Portrait of the Marquise de Pompadour* (no. 380), an imposing full-length pastel portrait of this patron of the arts, literature, and philosophy who was also mistress and adviser to Louis XV.

The Department of Prints and Drawings encompasses a variety of graphic arts. The donation, in 1937, of the Edmond de Rothschild collection, which included drawings as well as thousands of engravings, profoundly altered the department's structure. Thanks to the Rothschild gift, the Louvre now owns engravings by Dürer and Rembrandt that complement the paintings and drawings by these artists in the museum's collections.

Finally, the department is famous for its chalcography, the art of engraving on copper. Founded in 1797, its matchless collection of several thousand copper-plate engravings dates back to the 1660s, when Louix XIV established the King's Cabinet, which also held plates and engravings depicting subjects such as royal monuments, palaces, natural phenomena, and art in the royal collections. Its copper plates have enabled the museum to produce countless prints through the years; and it continues to enhance its holdings with contemporary works.

358A, 358B
Anonymous
French, late 14th century
The Narbonne Altar Cloth,
c. 1364–78
Gray wash on fluted silk imitating
samite
30 3/4 × 81 7/8 in. (78 × 208 cm)

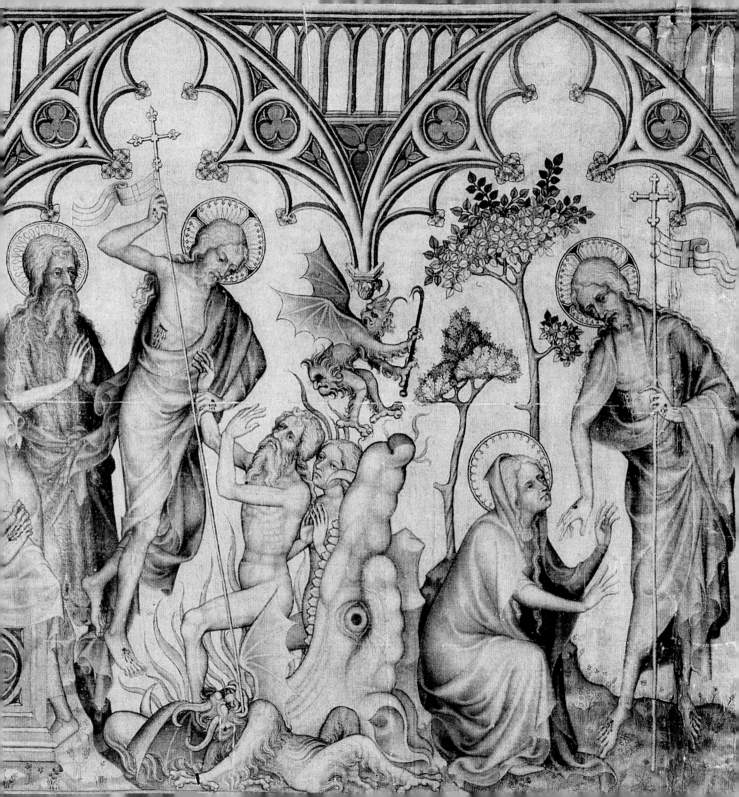

358B

359
Pisanello (Antonio Puccio)
Italian, c. 1395–1455
Head of Horse to Front, with
Bridle Hanging, first half of
15th century
Pen and brown ink, preparatory
outline in black chalk, rounded
corners
10 5/8 × 6 1/4 in. (27 × 16 cm)

359

360
Rogier van der Weyden
Flemish, c. 1399–1464
Head of the Virgin, c. 1460
Drypoint on prepared paper
5 ¹/₈ × 4 ³/₈ in. (13 × 11 cm)

361
Jean Fouquet
French, c. 1415–c. 1481
Hours of Etienne Chevalier:
Saint Margaret Tending the
Sheep, c. 1452
Illumination highlighted with gold
on vellum
3 ¹/₂ × 4 ³/₄ in. (9 × 12 cm)

360

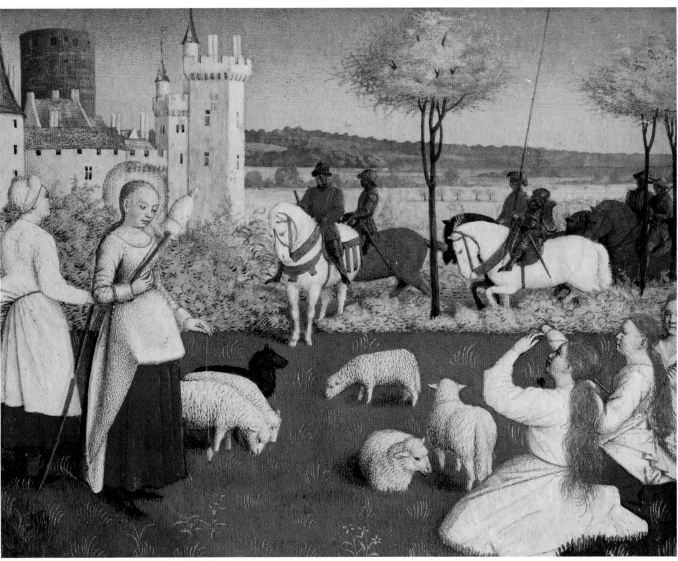

361

362
Jacopo Bellini
Italian, c. 1400–c. 1471
*Saint John the Baptist
Preaching in a Harbor City,*
c. 1440–45
Ink on vellum
15 × 10 1/4 in. (38 × 26 cm)

363
Antonio del Pollaiuolo
Italian, c. 1431–1498
Battle of Nude Men,
c. 1470–75
Engraving
15 3/4 × 23 5/8 in. (40 × 60 cm)
EDMOND DE ROTHSCHILD
COLLECTION

364

364
Solario (Andrea di Bartolo)
Italian, c. 1465–1524
Head of Saint John the Baptist,
1507
Black chalk, pen and brown wash,
with trace of sanguine
7 1/2 × 10 1/4 in. (19 × 26 cm)

365
Leonardo da Vinci (Leonardo
di Ser Piero da Vinci)
Italian, 1452–1519
Portrait of Isabella d'Este,
1499–1500
Black, red, and ochre chalk, stump,
with white highlights
24 × 18 1/8 in. (61 × 46 cm)

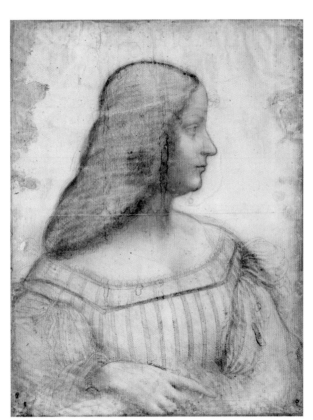

365

366
Leonardo da Vinci (Leonardo di Ser Piero da Vinci)
Italian, 1452–1519
Study of Drapery for a Kneeling Figure, last quarter of 15th century–first quarter of 16th century
Brush and gray tempera with white highlights on gray-colored linen canvas
7 1/8 × 9 in. (18 × 23 cm)

367
Leonardo da Vinci (Leonardo di Ser Piero da Vinci)
Italian, 1452–1519
Study of Drapery for a Seated Figure, c. 1470-79
Brush and gray tempera with white highlights on gray-colored linen canvas
12 5/8 × 8 5/8 in. (32 × 22 cm)

368
Leonardo da Vinci (Leonardo di Ser Piero da Vinci)
Italian, 1452–1519
Study of Drapery for a Seated Figure, 1470
Brush and gray tempera with white highlights on gray-colored linen canvas
10 5/8 × 9 in. (27 × 23 cm)

366

367

369
Michelangelo (Michelangelo
Buonarroti)
Italian, 1475–1564
*Christ on the Cross Between
the Virgin and Saint John,*
c. 1560
Black chalk with white highlights on
gray paper
17 × 11 3/8 in. (43 × 29 cm)

370
Michelangelo (Michelangelo
Buonarroti)
Italian, 1475–1564
Study for a Pietà, c. 1536–41
Black chalk with white highlights on
gray paper
9 7/8 × 12 5/8 in. (25 × 32 cm)

371
Raphael (Raffaello Sanzio)
Italian, 1483–1520
Head of an Avenging Angel,
Three Quarters to the Right,
c. 1512–13
Charcoal, black chalk, red and gray
wash with white highlights on
gray-beige paper
10 ⅝ × 13 in. (27 × 33 cm)

372
Albrecht Dürer
German, 1471–1528
View of the Arco Valley, c. 1495
Pen and brown ink, watercolor, with
gouache highlights, retouched in
black ink
8 ⅝ × 8 ⅝ in. (22 × 22 cm)

371

372

373
Rembrandt (Rembrandt Harmenszoon van Rijn)
Dutch, 1606–1669
The Three Crosses, 1653
Etching (first state)
15 × 17 3/4 in. (38 × 45 cm)
EDMOND DE ROTHSCHILD
COLLECTION

374
Peter Paul Rubens
Dutch, 1577–1640
*The Battle of the Standard
(The Battle of Anghiari),*
c. 1615
Black chalk, pen and brown ink, brush
and brown and gray ink, gray wash,
with white and gray-blue highlights
16 7/8 × 22 7/8 in. (43 × 58 cm)

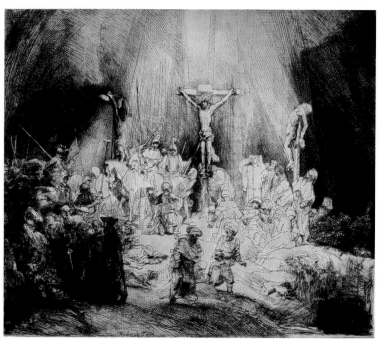

373

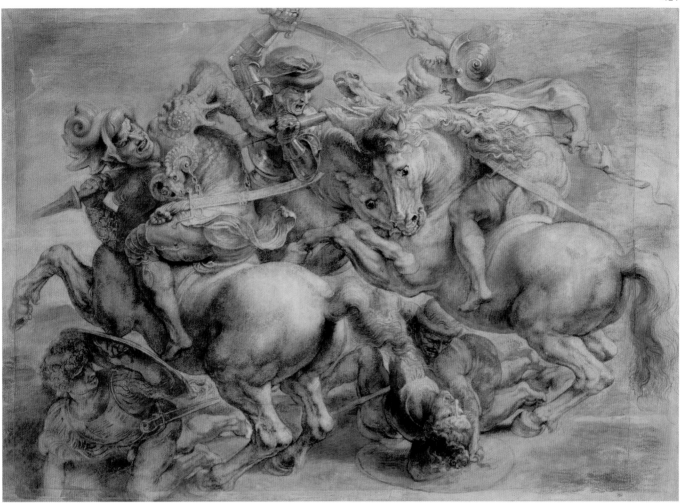

375
Nicolas Poussin
French, 1594–1665
Venus at the Fountain, 1657
Pen and brown ink, brown wash, with
traces of black chalk squaring
9 7/8 × 9 in. (25 × 23 cm)

376
Sir Anthony van Dyck
Flemish (English), 1599–1641
*The Adoration of the
Shepherds*, c. 1620
After Peter Paul Rubens
(1577–1640)
White gouache, black chalk,
sanguine, brown wash, pen and
brown ink, gray wash, with white
highlights
22 1/2 × 16 1/2 in. (57 × 42 cm)

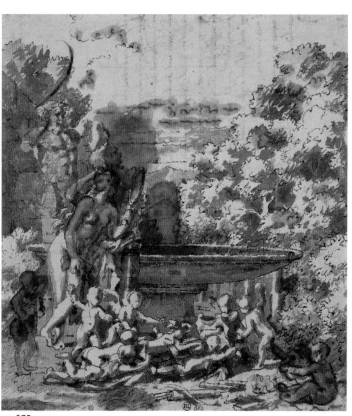

375

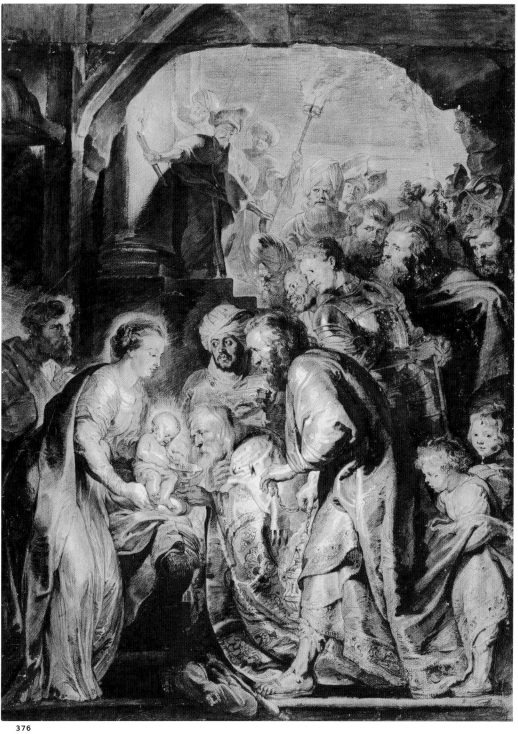

377
Jean-Baptiste Siméon Chardin
French, 1699–1779
Self-Portrait with Spectacles, 1771
Pastel
18 1/8 × 15 in. (46 × 38 cm)

378
Jean-Étienne Liotard
Swiss, 1702–1789
Portrait of Madame Jean Tronchin, born Anne de Molesnes, 1758
Pastel
24 3/4 × 19 3/4 in. (63 × 50 cm)

379
Charles Antoine Coypel
French, 1694–1752
Portrait of a Lady Known as the Marquise de Bomron, c. 1730
Pastel
33 1/2 × 28 3/4 in. (85 × 73 cm)

380
Quentin de La Tour (Maurice Quentin Delatour)
French, 1704–1788
Full-Length Portrait of the Marquise de Pompadour, 1748–55
Pastel on blue paper, with gouache highlights
69 3/4 × 51 1/8 in. (177 × 130 cm)

378

379

381

381
Girodet (Anne Louis Girodet
de Roucy-Trioson)
French, 1767–1824
*Head of an Oriental (Head of a
Turk),* c. 1810
Pastel, sanguine, and charcoal
22 7/8 × 17 3/4 in. (58 × 45 cm)

382
Hubert Robert
French, 1733–1808
*Two Young Women Drawing
Amid Classical Ruins,* 1786
Pen and watercolor
27 1/2 × 38 5/8 in. (70 × 98 cm)

382

383
Jacques-Louis David
French, 1748–1825
The Intervention of the Sabine Women, 1794
Black pencil, pen and black ink, gray wash, with white highlights
10 1/4 × 13 3/8 in. (26 × 34 cm)

384
Joseph Mallord William Turner
English, 1775–1851
View of the Château de Saint-Germain-en-Laye, c. 1830
Watercolor
11 3/4 × 18 1/8 in. (30 × 46 cm)

385
Jean Auguste Dominique Ingres
French, 1780–1867
Sketch for the Turkish Bath, c. 1860
Black chalk
24 3/8 × 19 1/4 in. (62 × 49 cm)

384

386
Jean Auguste Dominique Ingres
French, 1780–1867
Portrait of Madame Louis François Bertin, 1834
Graphite
12 5/8 × 9 in. (32 × 23 cm)

387
Jean Auguste Dominique Ingres
French, 1780–1867
The Stamaty Family, 1818
Graphite
18 1/8 × 14 5/8 in. (46 × 37 cm)

388
Eugène Delacroix
French, 1798–1863
North African and Spanish Album: The Arrival in Meknes, 1832
Graphite, pen and brown ink, and watercolor
6 1/4 × 4 in. (16 × 10 cm)

386

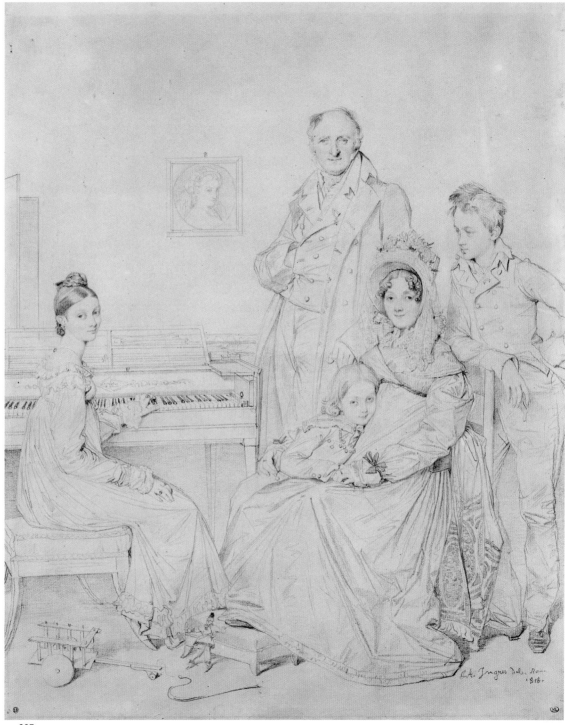

bel effet en montant, en passant & se détachant en
terre sur l'azur & plus jaune tendre

passé le long du tombeau d'un saint

porte de la ville très haute, porcelaine vernies
une fois entré, à gauche les cavaliers & les tentes jusq. les
remparts

palmiers auprès, bâti en briques

389
Jean-Baptiste Camille Corot
French, 1796–1875
Wooded Landscape with Figure near a Tree, c. 1852
Pen and brown ink
8 1/4 × 6 3/4 in. (21 × 17 cm)

390
Jean-Baptiste Camille Corot
French, 1796–1875
A Little Girl Crouching, 1835
Graphite, pen, and black ink
9 × 10 5/8 in. (23 × 27 cm)

389

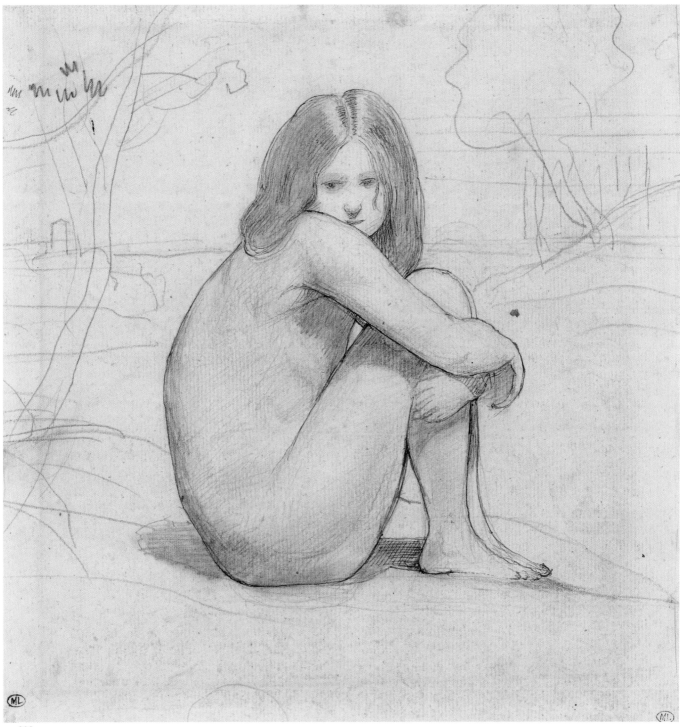

SCULPTURES

THE LOUVRE'S sculpture collection embraces a particularly long stretch of the history of Christian Europe, beginning with the fall of Rome in the fifth century AD and leaving off with the revolutions of 1848.

As is often the case in the Louvre, some works in the Department of Sculptures originated in old collections—those of the Crown as well as the Royal Academy—but it was revolutionary turmoil that led to the birth of the sculpture collection. When the Museum Central opened in 1793, relatively little sculpture created after antiquity was on display, although Michelangelo's Slaves (nos. 400, 401) were already shown in the Louvre's halls. Monumental sculpture that had escaped demolition during the Revolution was gathered in the Museum of French Monuments, which Alexandre Lenoir established in the former convent of the Petits-Augustins, now the École des Beaux-Arts, and in the museum devoted to the French school at the Château of Versailles. The Museum of French Monuments was closed during the Restoration, when the monarchy was restored under Louis XVIII (1814–24) and Charles X (1824–30); and some sculptures were stored in the Louvre. When the Louvre opened its "museum of modern sculptures" in 1824 on the ground floor of the Cour Carrée, the collection was attached to the Antiquities department until 1871 for administrative purposes, then to Decorative Arts until 1893. Following the opening of these early galleries, the Louvre's holdings were enriched by numerous gifts—Davillier, Arconati-Visconti, Schlichting—and by the acquisitions of brilliant curators such as the Marquis de Laborde during the Second Empire (1852–71) and, later, Louis Courajod. From then on, the Department of Sculptures has striven to be the collection of reference in the field of French sculpture and to present the most comprehensive display of the great Western schools.

Accounting for two-thirds of the collection, French works constitute the heart of the department. No other institution provides such a detailed overview—so rich in masterpieces—of the evolution of sculptural art in the former territories of the kingdom. The oldest works date from the pre-Romanesque era: reliefs and architectural fragments that reveal the persistence of classical traditions along with the emergence of new decorative motifs. From the Romanesque period, the Louvre exhibits capitals, reliefs, and sculpture-in-the-round from Burgundy, Île-de-France, Champagne, and Auvergne. The Gothic period is represented by many renditions of the Virgin and Child, fragments of architectural ornament, and a beautiful set of funerary statuary from the Museum of French Monuments. The statues of Charles V and his wife Jeanne de Bourbon (no. 394) are particularly important to the museum for they are believed to have originally decorated the eastern façade of the Louvre that was renovated during Charles's rule.

The epochs succeeding the Middle Ages are abundantly represented in the collection; not a single important artist is overlooked nor are any regional variations. The Louvre also occasionally owns sizable bodies of work by a single artist; this is the case for Jean Goujon, who worked at the Louvre under Francis I and Henry II, along with Pierre Puget, Antoine Coysevox, the Coustou brothers, Jean-Baptiste Pigalle, Jean-Antoine Houdon, David d'Angers, and Antoine Louis Barye, notable French sculptors of the seventeenth through nineteenth centuries. The transfer of the Royal Academy's collections to the museum enabled the Louvre to display a complete series of reception pieces by the greatest eighteenth-century sculptors. French sculpture occupies some of the finest

spaces in the palace, particularly the Marly and Puget courtyards, which provide magnificent settings for the display of a unique collection of monumental statuary from parks in the great royal residences of the seventeenth and eighteenth centuries—Versailles, Marly, Saint-Cloud, and the Tuileries.

Although the Louvre's collections of foreign sculpture may be less diverse and comprehensive than those devoted to French works, they are not lacking in masterpieces. Italy holds the place of honor, with a display that invites visitors to comprehend the evolution of Italian sculpture from the High Middle Ages to the nineteenth century: works by Donatello, Mino da Fiesole, the Della Robbias, Michelangelo, Bernini, and Canova are among the highlights of this dazzling survey. This collection of Italian works is handsomely complemented by the royal bronzes of masters such as Il Riccio and Giambologna found in the Department of Decorative Arts.

The Northern and Spanish schools are not as well represented, although the Louvre owns a few treasures in both fields. The German School is particularly well served by the museum's representation of the extraordinarily abundant creativity that characterizes the late Gothic in Southern Germany. Gregor Erhart's *Mary Magdalene* (no. 398A, B, C), for instance, can easily stand comparison with other famous women depicted in the Louvre, such as the *Venus de Milo* (no. 149), *The Winged Victory of Samothrace* (no. 146), and the *Mona Lisa* (no. 264). An altarpiece from Antwerp and some sculptures from Brussels round out the selection. The seventeenth, eighteenth, and nineteenth centuries are more poorly represented, but the recent acquisition of a character head by Austrian sculptor Franz Xaver Messerschmidt indicates that, in this domain as well, the future might hold some pleasant surprises.

In addition to its statuary collection, the Department of Sculptures is responsible for conserving the decorative sculptures that embellish the palace's façades. To this end, it maintains a large warehouse where it stores damaged stone originals that have been replaced in the galleries by copies. The department's range of scientific competence also extends to the sculptures in the Tuileries gardens and to the galleries dedicated to the history of the Palais du Louvre.

391
Anonymous
Daniel in the Lions' Den
French, mid-6th and early 12th
century (recarved)
Marble
Height 19 1/4 in. (49 cm);
width 20 7/8 in. (53 cm)

392
Anonymous
Descent from the Cross
French (Auvergne), second
quarter of 12th century
Polychrome and gilt maple wood
Height 61 in. (155 cm);
width 66 1/8 in. (168 cm)

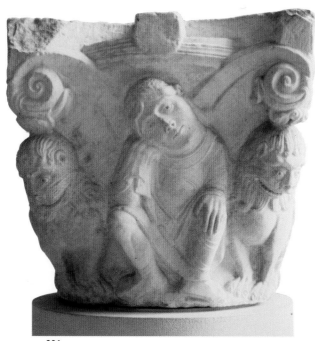

391

392

393A, 393B
Anonymous
A King and a Queen (King Solomon and the Queen of Sheba?)
French, last quarter of 12th century
Stone
King: Height 96 in. (244 cm); queen: height 92 ½ in. (235 cm)

394
Anonymous
Charles V, King of France, and Joan of Bourbon, Queen of France
French, 1365–80
Stone
Height 76 ³/₈ in. (194 cm)

393A

393B

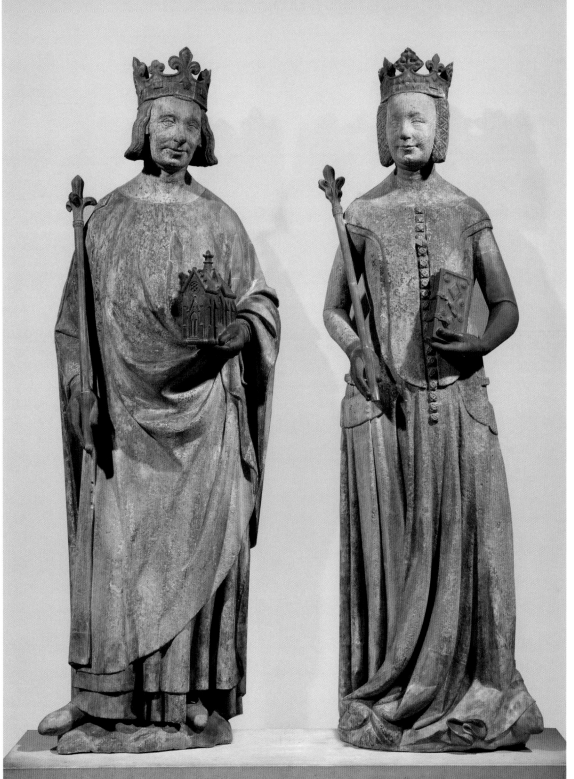

394

395

Anonymous
*Tomb of Philippe Pot, Grand
Senechal of Burgundy, then
Chamberlain to the King of
France*
French, c. 1477–1483
Polychrome limestone
Height 71 1/4 in. (181 cm);
width 102 3/8 in. (260 cm)

396
Tilman Riemenschneider
German, c. 1460–1531
Virgin Annunciate, c. 1495
Alabaster and polychrome highlights
Height 20 7/8 in. (53 cm);
width 15 3/4 in. (40 cm)

397
**Donatello (Donato di Niccolo
di Betto Bardi)**
Italian, c. 1386–1466
Madonna and Child, c. 1440
Polychrome terracotta
Height 40 1/8 in. (102 cm);
width 29 1/8 in. (74 cm)

396

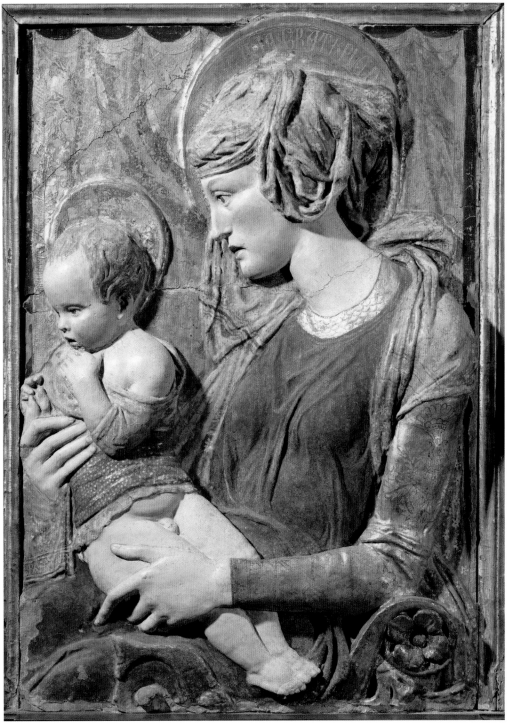

398A, 398B, 398C
Gregor Erhart
German, c. 1470–1540
Mary Magdalene, 1510
Limewood, original polychromy,
modern pedestal and front of feet
Height 69 5/8 in. (177 cm)

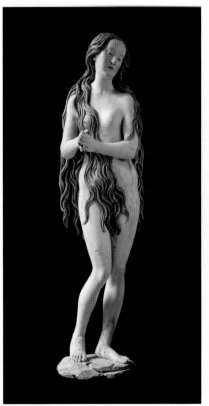

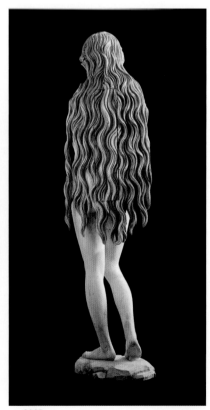

398A 398B 398C

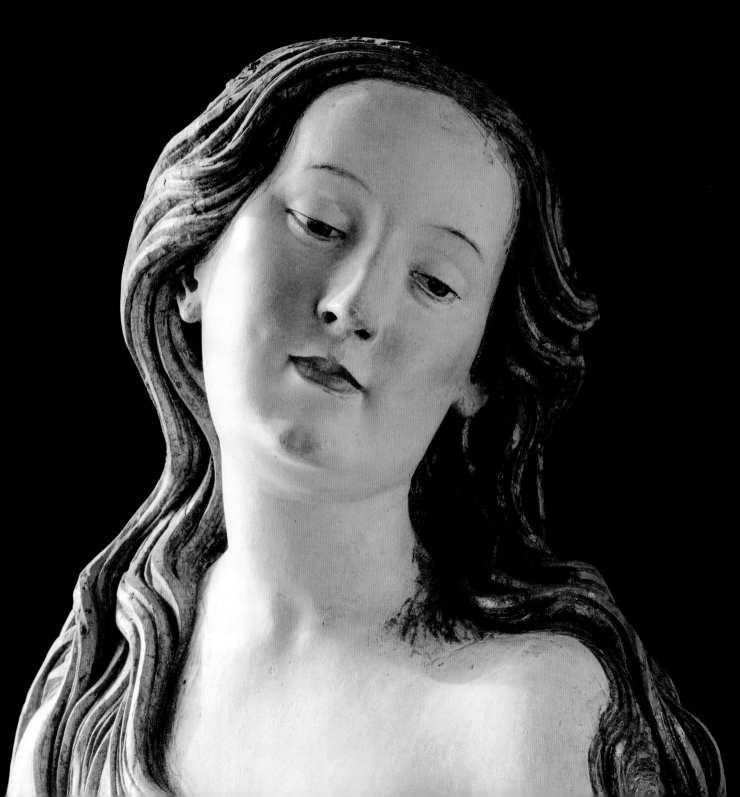

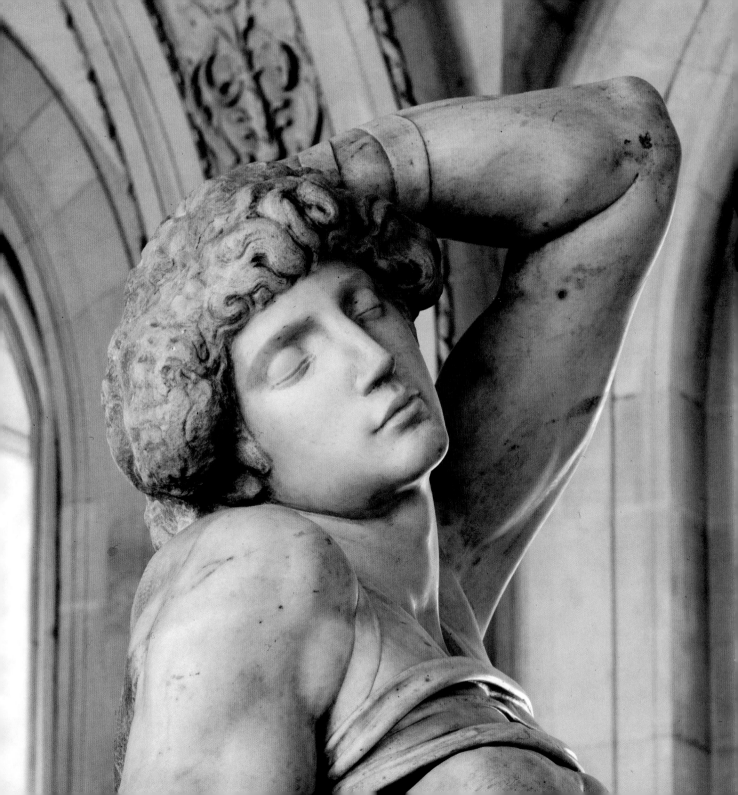

399A, 399B
Michelangelo (Michelangelo
Buonarroti)
Italian, 1475–1564
Dying Slave, 1513–15
Marble
Height 92 in. (228 cm)

400
Michelangelo (Michelangelo
Buonarroti)
Italian, 1475–1564
Rebellious Slave, 1513–15
Marble
Height 84 ⁵/₈ in. (215 cm)

401
Michel Colombe
French, c. 1430–after 1511
Saint George and the Dragon,
1509–10
Altarpiece from the Château
de Gaillon
Marble
50 ³/₈ × 71 ⁵/₈ in. (128 ×182 cm)

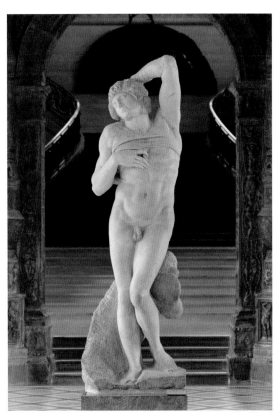

399A 400 399B

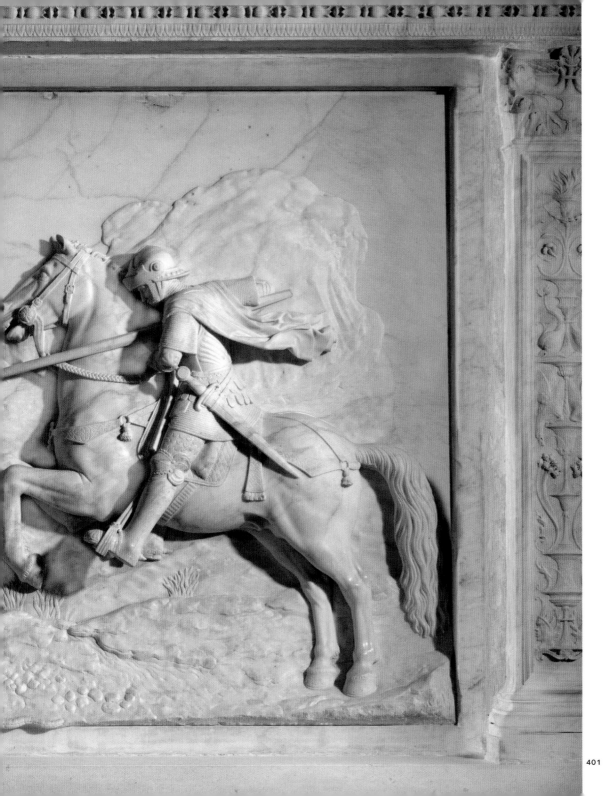

402
Anonymous
Death—Holy Innocent
French (Île-de-France), c. 1530
From the Cemetery of the
Innocents (Cimetière des
Innocents), Paris
Alabaster
Height 47 1/4 in. (120 cm)

403
Anonymous
Diana the Huntress (The Diana of Anet)
French, mid-16th century
From the Château d'Anet
Marble
Height 83 1/8 in. (211 cm);
width 101 5/8 in. (258 cm)

404
Attributed to Germain Pilon
French, active 1540–90
Recumbent Figure of Henry II,
c. 1560
Model for the king's tomb in
Saint-Denis
Terracotta
Height 7 1/2 in. (19 cm);
length 22 1/2 in. (57 cm)

402

405
Adriaen De Vries
Dutch, 1556–1626
Mercury and Psyche, 1593
Bronze
Height 84 5/8 in. (215 cm)

406
Pierre Puget
French, 1620–1694
Milo of Croton, 1670–82
Carrara marble
Height 106 1/4 in. (270 cm)

407
Guillaume Coustou the Elder
French, 1677–1746
Horse Restrained by a Groom,
(One of the Marly Horses),
1739–45
Carrara marble
Height 133 7/8 in. (340 cm);
width 111 3/4 in. (284 cm)

408
Antoine Coysevox
French, 1640–1720
Mercury Riding Pegasus,
1699–1702
Carrara marble
Height 124 in. (315 cm);
width 114 5/8 in. (291 cm)

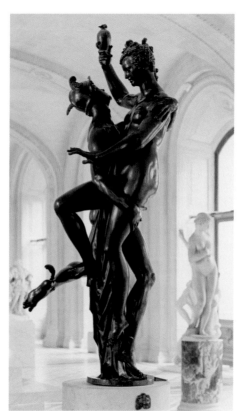

405

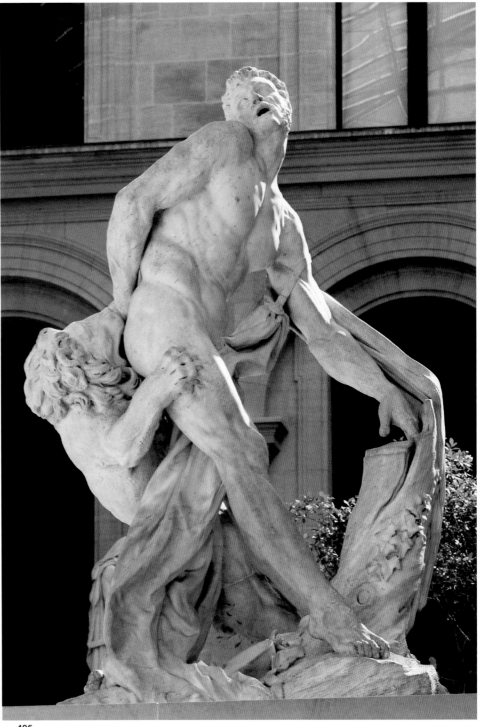

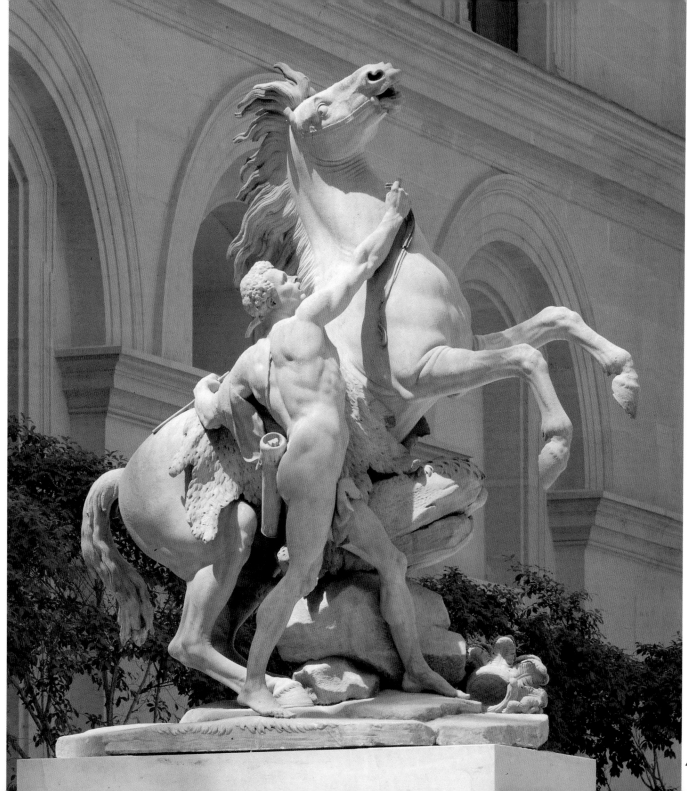

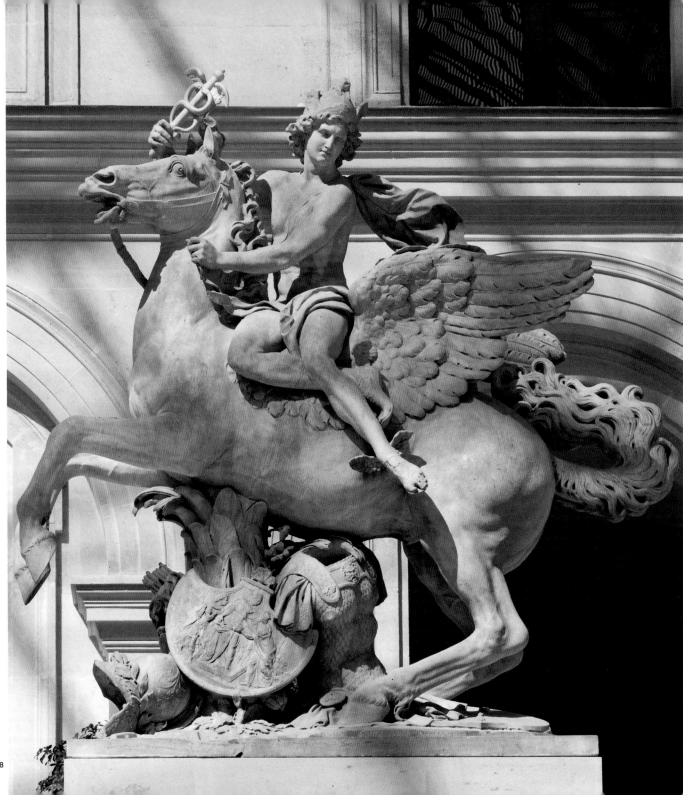

409A

409B

409C

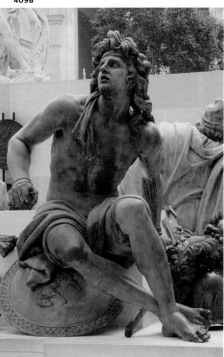

409D

409A, 409B, 409C, 409D
Martin van den Bogaert
(Martin Desjardins)
Dutch (French), 1637–1694
Four Captives (*Four Defeated*
Nations: Spain, the Holy
Roman Empire, Brandenburg,
and Holland), 1682–85
Bronze, formerly gilt
Height 86 5/8 in. (220 cm)

410
François Girardon
French, 1628–1715
Louis XIV on Horseback
Scale model of equestrian
statue erected in Paris in 1699
Bronze
Height 40 1/8 in. (102 cm)

411
Augustin Pajou
French, 1730–1809
Psyche Abandoned, 1790
Marble
Height 69 3/4 in. (177 cm)

412
Jean-Baptiste Pigalle
French, 1714–85
*Mercury Attaching His Winged
Sandals,* 1744
Marble
Height 22 7/8 in. (58 cm)

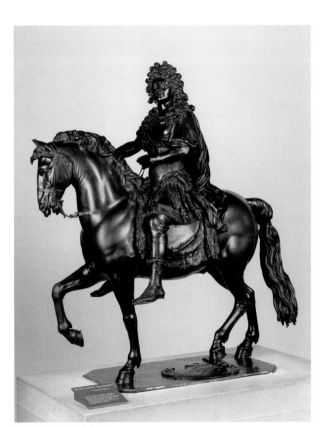

410

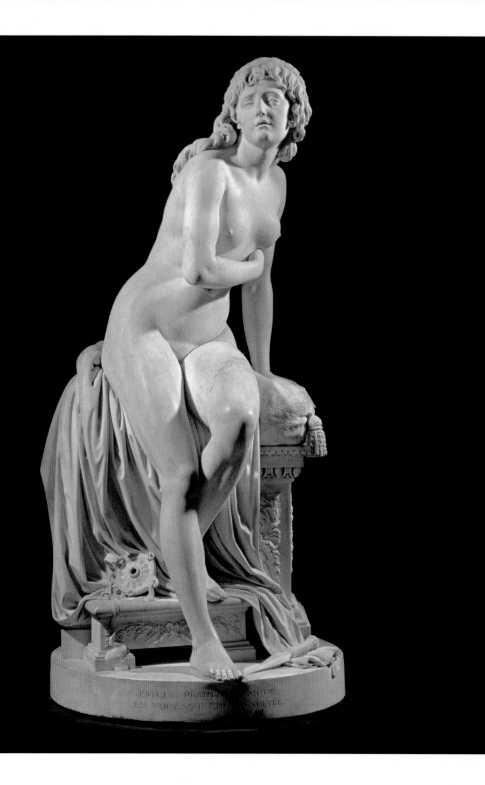

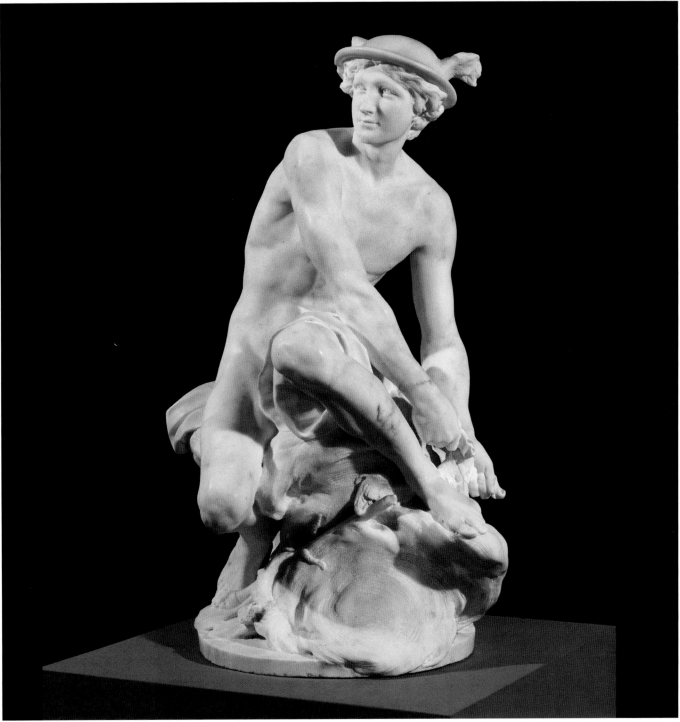

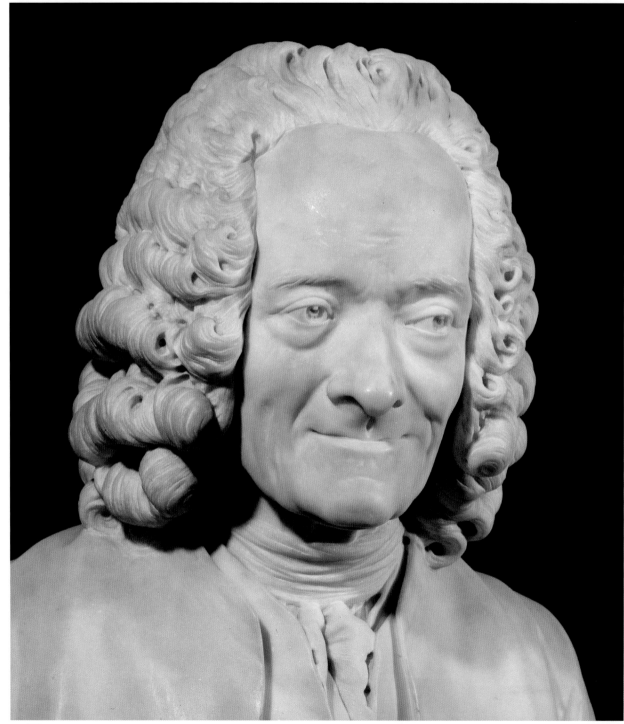

413
Jean-Antoine Houdon
French, 1741–1828
Voltaire (1694–1778), 1778
Marble
Height 18 7/8 in. (48 cm)

414
Jean-Antoine Houdon
French, 1741–1828
Alexandre Brongniart (1770–1847), 1777
Terracotta
Height 14 1/8 in. (36 cm)

415
Jean-Antoine Houdon
French, 1741–1828
Louise Brongniart (1772–1845), 1777
Terracotta
Height 13 3/8 in. (34 cm)

414

415

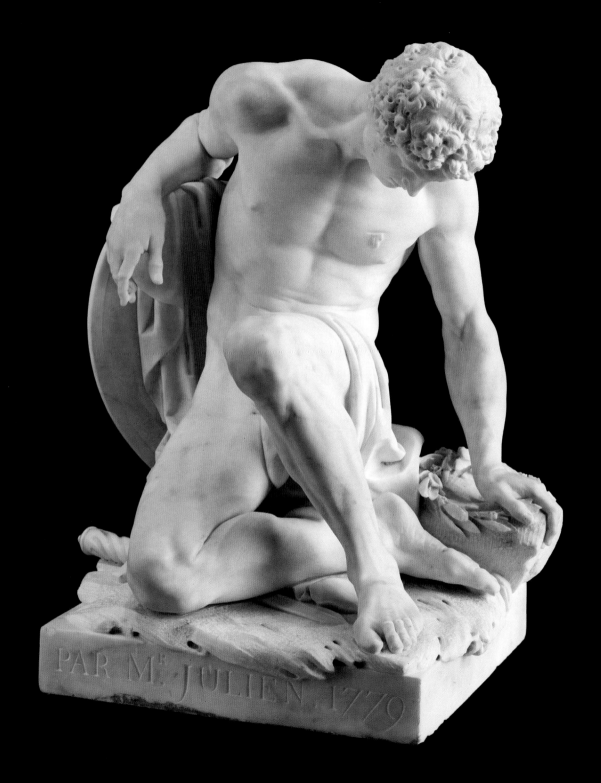

PAR M^E JULIEN. 1779



416
Pierre Julien
French, 1731–1804
Dying Gladiator, 1779
Marble
Height 23 ⁵/₈ in. (60 cm)

417
Louis Simon Boizot
French, 1743–1809
Marie-Antoinette, Queen of France (1755–1793), 1781
Marble
Height 35 ³/₈ in. (90 cm)

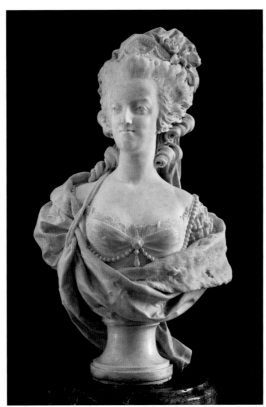

417

418
Clodion (Claude Michel)
French, 1738–1814
*Venus and Cupid Bathing with
Leda and the Swan*, 1782
Tonnerre stone
40 1/2 × 127 1/8 in. (103 × 323 cm)

419
Antonio Canova
Italian, 1757–1822
Eros and Psyche, 1793
Marble
Height 61 in. (155 cm);
width 66 1/8 in. (168 cm)

418

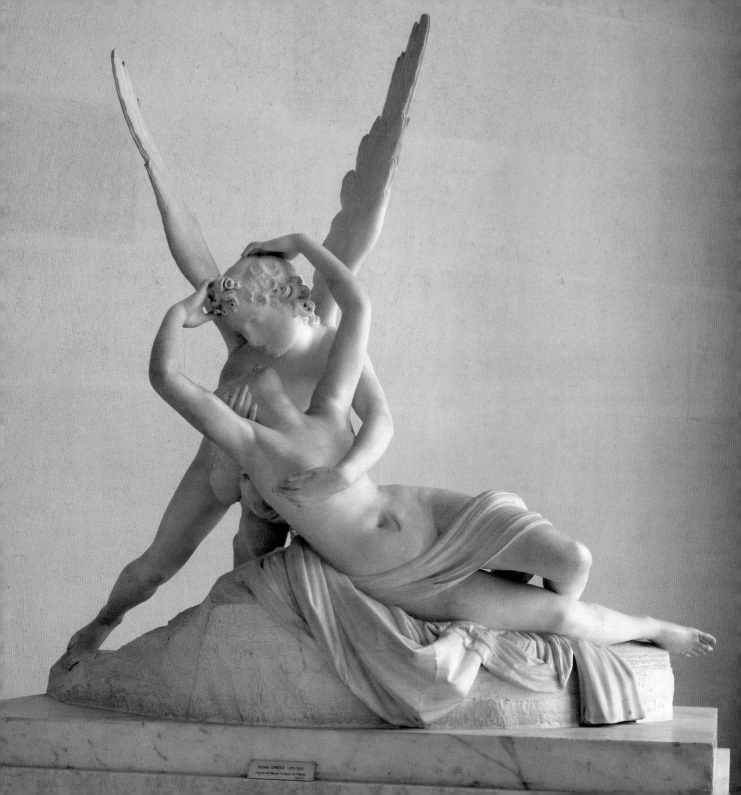

420
Antoine Denis Chaudet
French, 1763–1810
Peace, 1806
Silver, gilt silver, bronze, and gilt
bronze
Height 65 ³/₄ in. (167 cm)

421
Jean Auguste Barre
French, 1811–1896
Rachel (1821–1858), 1848
Ivory on gilt bronze pedestal
Height 18 ¹/₈ in. (46 cm)

422
**David d'Angers (Pierre Jean
David)**
French, 1788–1856
Child with Grapes (detail),
1845
Marble
Height 51 ⁵/₈ in. (131 cm)

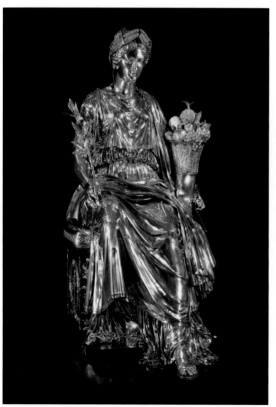

420

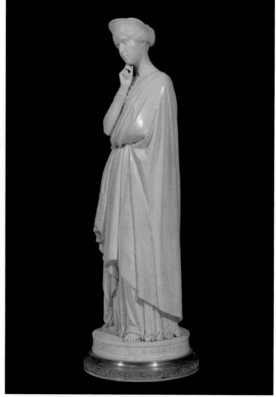

421

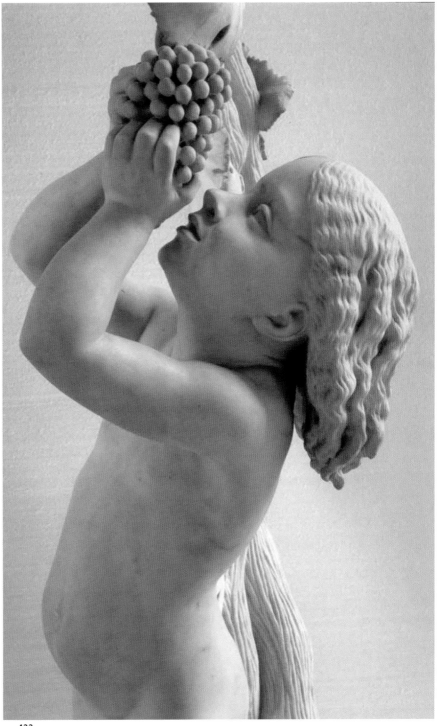

423
Antoine Louis Barye
French, 1795–1875
Lion Killing a Snake, 1835
Bronze, cast in molten wax
Height 53 1/8 in. (135 cm);
width 70 1/8 in. (178 cm)

424
Jean-Jacques Feuchère
French, 1807–1852
Satan, 1833
Bronze
Height 11 in. (28 cm)

425
François Rude
French, 1784–1855
Head from La Marseillaise,
1834–35
Plaster
Height 16 1/8 in. (41 cm)

424

DECORATIVE ARTS

THE DECORATIVE ARTS collections consist of luxurious objets d'art, decorative objects and artwork made in Europe from the dawn of the Middle Ages in the fifth century to the mid-nineteenth century.

The beginnings of the Department of Decorative Arts date from the foundation of the Museum Central des Arts in 1793. At that time the Louvre was given several pieces preserved from the treasures of the Abbey of Saint-Denis and the Sainte-Chapelle de Paris, as well as a group of bronzes and gems belonging to Louis XIV that were kept in the former royal warehouses. The purchase of entire collections during the Restoration (1814–30) and Second Empire (1852–70) significantly enlarged these initial holdings. Among the most notable collections acquired, one must cite those of Durand, purchased in 1825; Révoil in 1828; and Campana in 1861. In 1830, the Louvre's holdings were further enriched by the treasure of the Order of the Holy Spirit. From the mid-nineteenth century through the twentieth, donors to the Louvre have ranked among the greatest collectors of their time, among them Sauvageot, Thiers, Rothschild, Camondo, Schlichting, David-Weil, Niarchos, and Grog-Carven. More than the other Louvre departments, Decorative

Arts relies on the generosity of donors. In 1870 and 1901, the Mobilier National, in charge of France's treasure in furnishings, donated important pieces of eighteenth-century furniture taken from royal residences or seized from émigrés. Today, an active acquisition policy continues to add to the department's holdings and fill particular needs of the collection. During the last few years, acquisitions have focused on French and European works from the nineteenth century. Most recently, a set of Austrian pieces from the Biedermeier period was acquired.

The department's collections are vast. They begin with a remarkable group of Byzantine pieces ranging from the fifth to the fifteenth century and largely consisting of sculpted ivory and works in silver and gold. The Middle Ages in the West are represented in all their glory. The Merovingian Queen Arégonde's jewelry, discovered in Saint-Denis; French and Germanic gold pieces from the Romanesque era; an unrivaled set of twelfth- and thirteenth-century Limosin enamel work; and a fabulous series of Gothic ivory pieces highlight the medieval period in the department's holdings. This magnificent panorama includes elements preserved from

the Regalia, a set of objects used in the coronation of French kings, including the *Scepter of Charles V* (no. 431), along with tapestries, stained-glass windows, glass, and ceramics.

France and Italy dominate the department's Renaissance holdings with beautiful pieces of furniture, an exceptional selection of majolica, glazed pottery, and painted enamel, and one of the most beautiful collections of fifteenth- and sixteenth-century bronzes in the world. Northern Europe is represented by some spectacular works, among them the *Maximilian Hunting Tapestries* (no. 438), a magnificent series of twelve sixteenth-century tapestries woven in Brussels after cartoons designed by the Flemish Renaissance painter Bernaert van Orley.

The art of the seventeenth century is displayed in earthenware, glass, silver, and gold work, as well as an imposing selection of tapestries, predominantly French. Lavish Boulle cabinets and cupboards—named after the cabinetmaker who specialized in ebony, copper, and tortoiseshell decoration—illustrate the end of Louis XIV's reign around 1715.

The eighteenth century is one of the collection's mainstays. An expansive selection of furniture enables visitors to follow the evolution of the great Parisian cabinet-

makers and carpenters during the Regency period (1715–23), when King Louis XV was too young to rule, and the eras of Louis XV (1715–74) and Louis XVI (1774–92). Several pieces from royal residences no longer standing—the Tuileries, Saint-Cloud, Bellevue—reveal the prominent role played by the sovereign and his family. In addition to furniture, Vincennes and Sèvres porcelain, gilt bronzes, and works in silver and gold exemplify this pinnacle in the history of French art. The department also exhibits "boiseries," or decorative wood paneling, removed from Parisian grand mansions, or *hôtels particuliers,* and from châteaux, often in settings that capture their original ambience.

The nineteenth-century collection is uneven. Innovative works from the Directoire period (1795–99) are represented by the furnishings recently acquired from Mme Récamier's living room and bedroom (no. 457). The Empire style dominates in furniture and numerous objects commissioned by the Imperial family, particularly for the Tuileries, along with Sèvres porcelain (nos. 460, 461) and silverware. For several years, the Louvre has focused many of its acquisitions on the Restoration and Louis-Philippe

(1830–48) periods. And it has nurtured new perspectives aimed at a more inclusive presentation of objects from other European countries. Finally, although the time frame of these collections extends only to 1848—as does the scope of the entire museum—the apartments of Napoléon III provide one of the few completely preserved Second Empire décors on view in Paris: furniture, bronzes, wall hangings, and paintings that allow visitors to immerse themselves in this official presentation of the epoch's decorative arts.

The department exhibits its medieval, Renaissance, seventeenth- and nineteenth- century collections in the modern galleries specifically designed for them on the first floor of the Richelieu Wing, beside the apartments of Napoléon III. The Apollo Gallery, one of the museum's historic rooms, which was originally decorated under Louis XIV and recently restored, holds the Sun King's gems and the remaining Crown jewels. The rooms in the Sully Wing dedicated to the eighteenth century, currently closed, are set to undergo a complete refurbishing that will soon permit this exceptionally rich collection of decorative arts to be shown in its best light.

426
**Equestrian Statuette of
Charlemagne or Charles
the Bald**
Roman world, late Imperial or
9th century (horse); Western
Europe, 9th century (rider)
Bronze, formerly gilded
Max. height 9 1/2 in. (24 cm);
horse: 8 1/4 in. (21 cm);
rider: 7 1/2 in. (18 cm)

427
**Triumphant Emperor
(The Barberini Ivory)**
Byzantine, Constantinople,
first half of 6th century
Wing of diptych: Ivory with traces
of inlay
13 3/8 × 10 5/8 in. (34 × 27 cm)

426

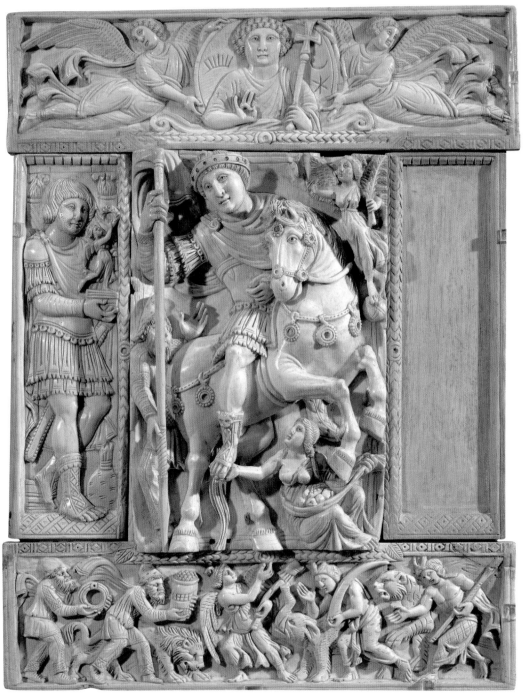

427

428
Serpentine Paten (shallow dish for bread at the Eucharist)
Roman world, late Imperial, 1st century BC or AD (paten); Western Europe, second half of 9th century (surround)
Serpentine plate inlaid with gold, precious stones, pearls, and colored glass
Max. diameter 6 3/4 in. (17 cm)

429
Porphyry Vase (Suger's Eagle)
Roman world, Antiquity (vase); French, before 1147 (mount)
Red porphyry, nielloed and gilded silver
Height 16 7/8 in. (43 cm)

428

429

430
Hand of Justice
French, 1804
MARTIN GUILLAUME BIENNAIS,
1764–1843
Ivory, leather, gold, and cameos
Height 15 ³/₈ in. (39 cm)

431
Scepter of Charles V
French, 1364–80
Gold (top), gilt silver (shaft), rubies,
colored glass, and pearls
Height 23 in. (60 cm)

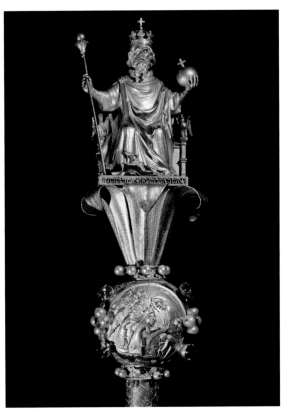

431

432
**Triptych Reliquary of
the True Cross (Floreffe
Polyptych)**
French, after 1254
From the Abbey of Floreffe
Gilt copper, nielloed and gilded silver,
and gemstones
Height 31 1/8 in. (79 cm); width
36 1/4 in. (92 cm) (open)

433
**Portable Icon: Transfiguration
of Christ**
Byzantine, Constantinople,
early 13th century
Mosaic
20 1/2 × 13 3/4 in. (52 × 35 cm)

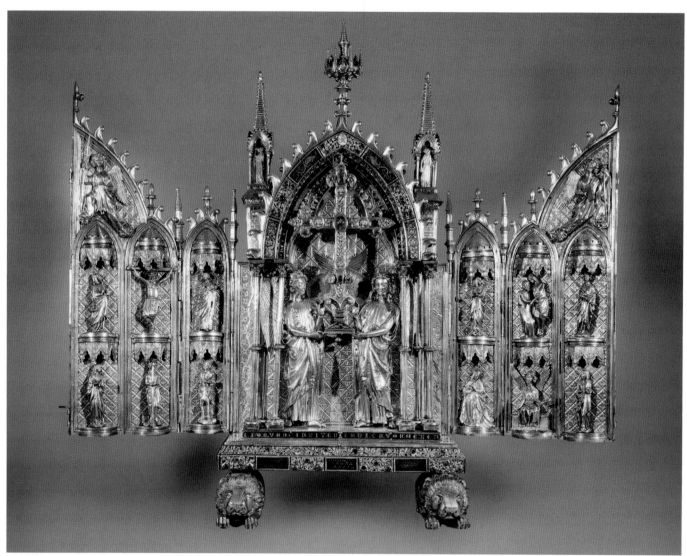

432

434

434
Jean Fouquet
French, 1415–1481
Self-Portrait, c. 1450
Painted enamel on copper
Diameter 2 3/8 in. (6 cm)

435
Virgin and Child from the Sainte-Chapelle
French, Paris, c. 1260–70
Ivory with traces of polychromy
Height 16 1/8 in. (41 cm); width 4 3/4 in. (12 cm) (pedestal)

436
The Jeanne d'Evreux Virgin and Child
French, Paris, c. 1324–39
Gilt silver, basse-taille enamel on gilt silver, precious stones, and pearls
Height 26 3/4 in. (68 cm); width 11 3/8 in. (29 cm) (pedestal)

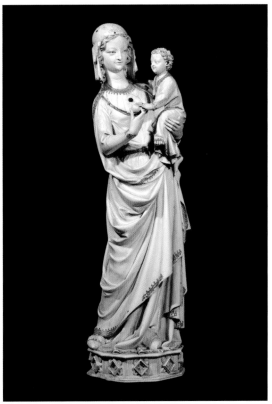

435

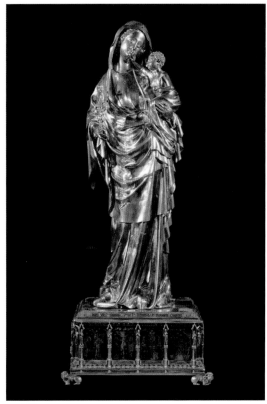

436

437
Plate from the Service of Isabella d'Este, Marquess of Mantua: Abimelech Spying on Isaac and Rebecca,
Italian, c. 1524
NICOLÀ DA URBINO (NICOLÀ DI GABRIELE SBRAGA), c. 1480–c. 1538
Earthenware and high-fired tin glaze
Diameter 10 5/8 in. (27 cm)

438
Seventh Tapestry of The Hunts of Maximilian: The Month of September
Flemish, Brussels, 1531–33
DESIGN BY BERNAERT VAN ORLEY (C. 1488–1541). LANDSCAPE BY JAN TONS (C. 1500–1570). WORKSHOP OF GUILLAUME AND JEAN DERMOYEN
Low-warp tapestry woven in wool and silk with gold and silver
173 1/4 × 221 5/8 in. (440 × 563 cm)

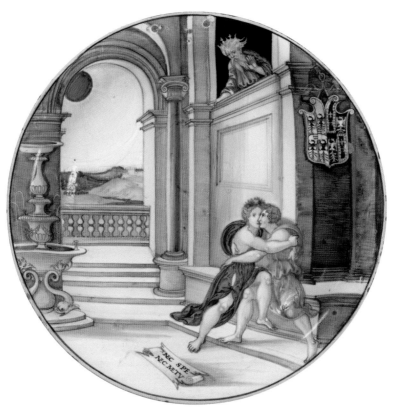

437

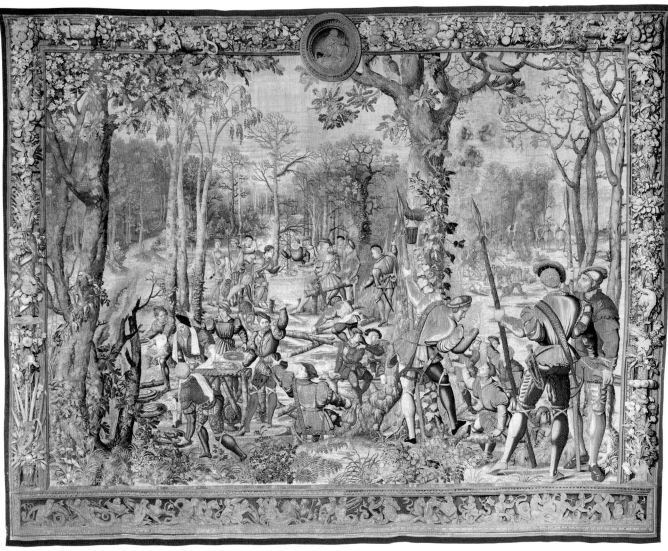

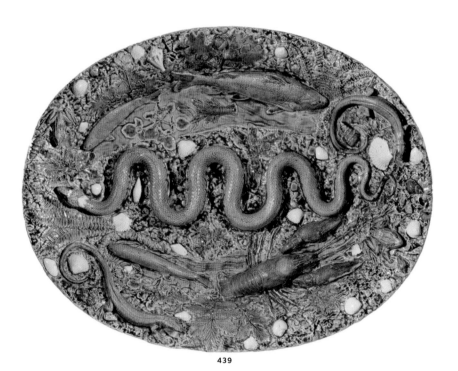

439

440

441A, 441B
Armor of Henri II
French, sixteenth century
ÉTIENNE DELAUNE, C. 1519–1583
Steel
Height 72 1/2 in. (184 cm)

441B

441A

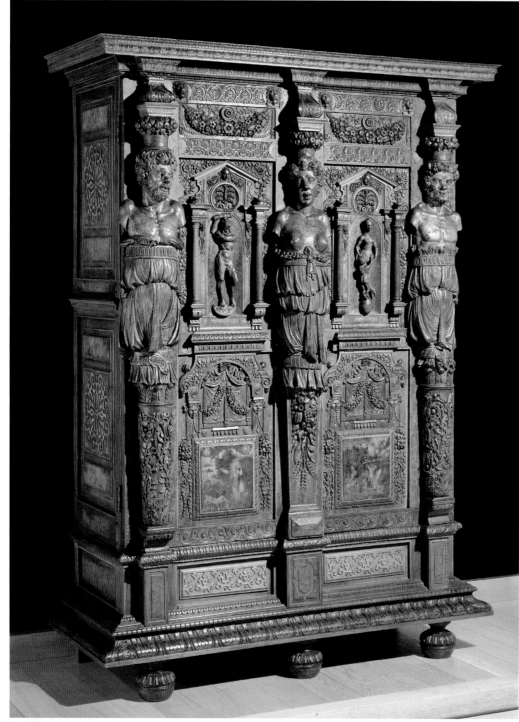

442
Sambin Cupboard
French, c. 1580
ATTRIBUTED TO HUGUES SAMBIN,
C. 1520–1601
Partially gilded and painted walnut
and oak
81 1/8 × 59 × 23 5/8 in.
(206 × 150 × 60 cm)

443
Moses in the Bulrushes
French, c. 1630–50
BASED ON A CARTOON BY
SIMON VOUET, 1590–1649
High-warp tapestry woven in wool
and silk
194 7/8 × 231 1/2 in. (495 × 588 cm)

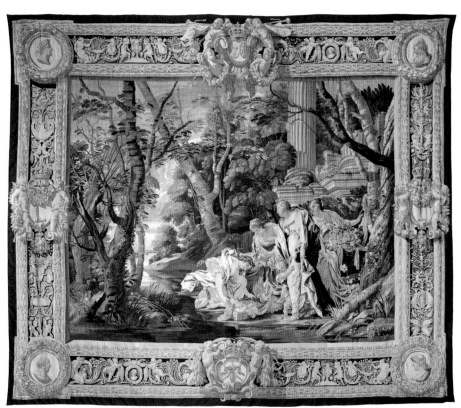

443

444
Ostrich
Italian, 17th century
AFTER GIAMBOLOGNA
(JEAN BOULOGNE), 1529–1608
Bronze
Height 12 1/4 in. (31 cm)

445
The Rape of a Sabine Woman
Italian, 17th century
AFTER GIAMBOLOGNA
(JEAN BOULOGNE), 1529–1608
Bronze
23 5/8 × 9 × 10 1/4 in.
(60 × 23 × 26 cm)

446
Musician, Orpheus or Arion
Italian, c. 1510
ATTRIBUTED TO RICCIO
(ANDREA BRIOSCO), 1470–1532
Brown patinated bronze
Height 9 7/8 in. (25 cm)

444

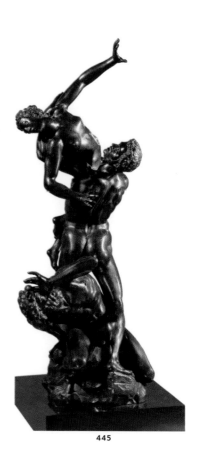

445

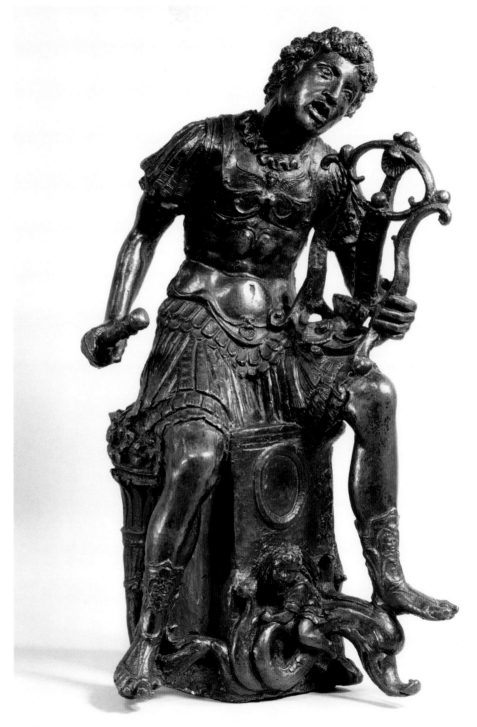

447
Wall Clock: Love Conquering Time
French, c. 1740–45
CHARLES CRESSENT (1685–1768),
CABINETMAKER, SCULPTOR,
AND BRONZE SMITH. NICOLAS
GOURDAIN (D. 1753), CLOCKMAKER
Gilt bronze, brass, and tortoiseshell
52 × 18 1/2 in. (132 × 47 cm)

448
Crown of Louis XV
French, 1722
AUGUSTIN DUFLOS, 1700–1786
Partially gilt silver, facsimiles of
the original precious stones, and
embroidered satin
Diameter 8 5/8 in. (22 cm);
height 9 1/2 in. (24 cm)

449
Table Centerpiece
French, 1736
JACQUES ROETTIERS, 1707–1784
Silver
23 5/8 × 36 5/8 in. (60 × 93 cm)

447 448

449

450
Snuffbox
French, 1765–69
JEAN JOSEPH BARRIÈRE, ACTIVE
1763–C. 1793
Gold and miniatures
Height 2 in. (5 cm)

451
Guéridon (pedestal table)
French, 1774
MARTIN CARLIN, C. 1730–1785
Tabletop: oak frame, veneered
with amaranth, soft-paste Sèvres
porcelain, and gilt bronze; base: solid
mahogany and gilt bronze
Diameter 31½ in. (80 cm);
height 32¼ in. (82 cm)

452
**Empress Joséphine's Jewel
Cabinet (Grand Écrin)**
French, 1809
FRANÇOIS-HONORÉ-GEORGES
JACOB-DESMALTER, 1770–1841
Woodwork, yew, amaranth, mother
of pearl, and gilt bronze
107⅛ × 78¾ × 23⅝ in.
(272 × 200 × 60 cm)

450

451

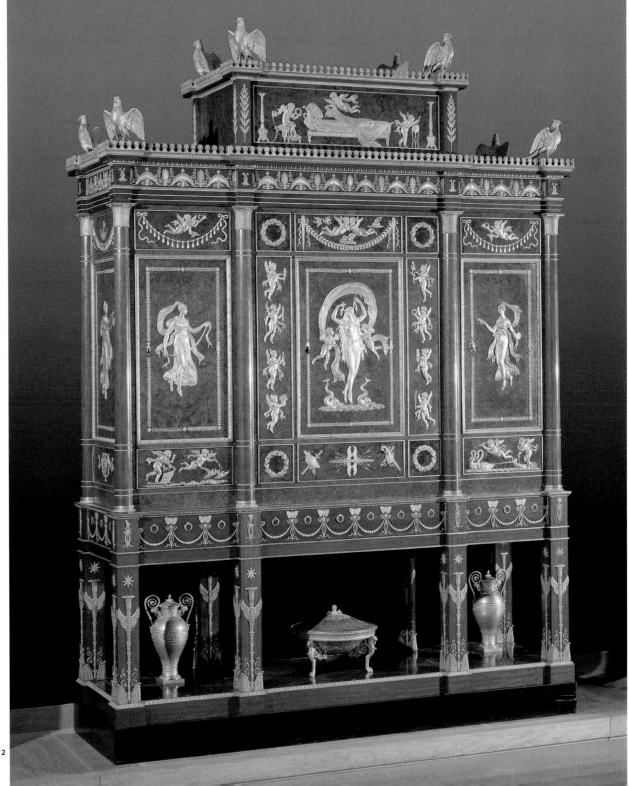

452

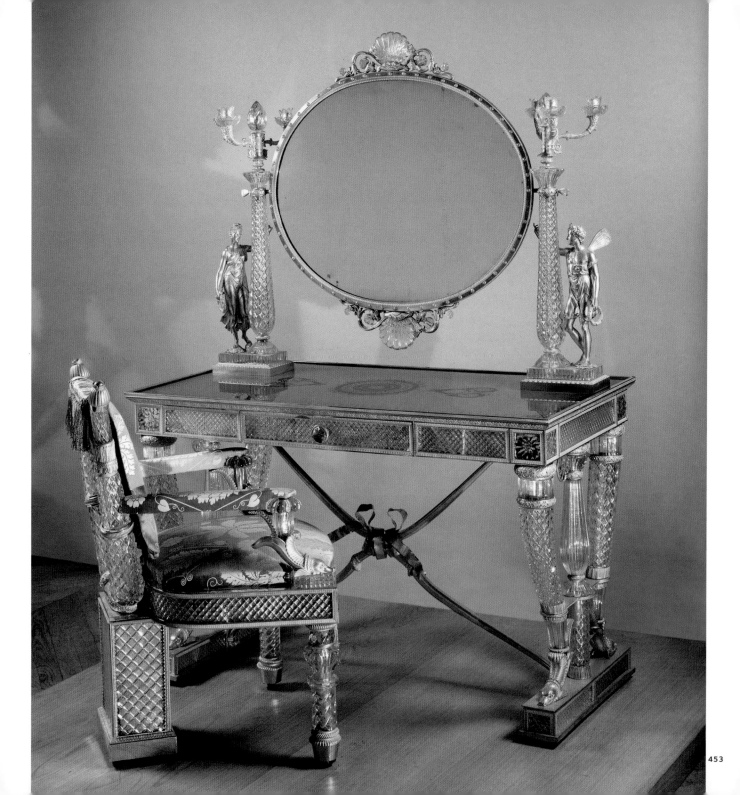

453
Dressing Table and Armchair of the Duchess of Berry
French, Paris, 1819
DESIGNED NICOLAS-HENRI JACOB, 1782–1871
MANUFACTURED BY MARIE-JEANNE-ROSALIE DESARNAUD-CHARPENTIER, 1775–1842
Crystal, gilt glass, and gilt bronze
Table: 67 3/8 × 48 × 25 1/4 in. (171 × 122 × 64 cm); chair: 35 7/8 × 25 1/4 × 22 in. (91 × 64 × 56 cm); height of mirror: 36 5/8 in. (93 cm)

454
Perfume Dispenser
Chinese, French (Paris), c. 1780
Chinese K'ang Hsi turquoise-blue porcelain and gilt bronze
Height 11 3/8 in. (29 cm); width 9 1/2 in. (24 cm)

455
Pot à oille (ragout tureen) from the Nicolas Demidoff service
French, 1817–19
JEAN-BAPTISTE-CLAUDE ODIOT, 1763–1850
Gilt silver
Height 15 in. (38 cm)

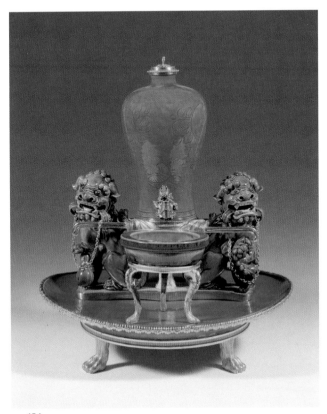

454

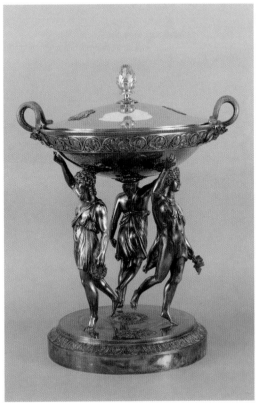

455

456
Settee
French, c. 1830
Cherry wood, cherry veneer,
turned mahogany, inlaid mahogany,
ebony-stained wood, and modern
upholstery
$38\,^5/_8 \times 71\,^5/_8 \times 26\,^3/_8$ in.
($98 \times 182 \times 67$ cm)

457
**Salon of Mme Récamier
(daybed, pair of wing chairs,
pair of armchairs, pair of
chairs, stool)**
French, c. 1800
ATTRIBUTED TO JACOB FRÈRES
[THE JACOB BROTHERS: GEORGES
(1763–1803) AND FRANÇOIS-
HONORÉ-GEORGES (1770–1841)]
Walnut frame veneered with Santo
Domingo espenille and amaranth,
solid espenille, and painted solid
walnut
Armchairs: $35 \times 22\,^1/_2 \times 23\,^1/_4$ in.
($89 \times 57 \times 59$ cm)
Chairs: $33\,^1/_2 \times 18\,^1/_2 \times 13\,^3/_4$ in.
($85 \times 47 \times 35$ cm)
Stool: $17\,^3/_8 \times 19\,^3/_4 \times 16\,^1/_8$ in.
($44 \times 50 \times 41$ cm)
Daybed: $30\ 3/4 \times 23\ 5/8 \times 63$ in.
($78 \times 60 \times 160$ cm)
Wing chairs: $33\ 1/8 \times 24\ 3/8 \times$
$24\ 3/8$ in. ($84 \times 62 \times 62$ cm)

456

458
Six plaques intended to
decorate the pedestals of the
"Cordelier" vases
French, 1808–10
SÈVRES PORCELAIN MANUFACTORY
AFTER MARIE PHILIPPE COUPIN DE
LA COUPERIE, 1773–1851
Hard-paste porcelain
Height 20 1/8 in. (51 cm)

459
Crown (The Charlemagne
Crown)
French, 1804
MARTIN GUILLAUME BIENNAIS,
1764–1843
Guilt copper and cameos
Diameter 7 1/8 in. (18 cm);
height 9 7/8 in. (25 cm)

459

458

460
Fuseau (Tapered) Vase
French, 1810
THE SÈVRES PORCELAIN
MANUFACTORY
Hard-paste porcelain and gilt bronze
42 ¹/₈ × 15 × 13 ³/₈ in.
(107 × 38 × 34 cm)

461
**Plates from the Egyptian
Cabaret Set (breakfast
service of Napoléon I)**
French, 1810
THE SÈVRES PORCELAIN
MANUFACTORY
Hard-paste porcelain and gilt bronze
Diameter 3 ³/₄ in. (9.5 cm)

461

460

ARTS OF AFRICA, ASIA, OCEANIA, AND THE AMERICAS

THE LOUVRE has been a classical museum dedicated to archaeology and fine arts since it was established in 1793. As a cultural temple committed to the great artists of the past, it has always been considered a sanctuary: to be represented in its collections is akin to an official consecration; to be excluded implies the absence of a recognized talent. In the past, this value judgment has been applied to entire cultures and civilizations, leaving them altogether unrepresented in the museum's displays. Not until the year 2000 was any of the art produced in Africa, Asia, Oceania, or the Americas included in the museum's holdings. Yet, today, who would question the extraordinary distinction of the art from these continents? The Louvre's recent acquisition of artwork from these regions has filled a gaping void in the collections.

The treasures exhibited in the Pavillon des Sessions do not belong to the Louvre. They form a sort of bridgehead to the recently opened Musée du Quai Branly (the Quai Branly Museum), an embassy in the heart of the most classic of Parisian museums.

Some of these collections are intimately linked to the Louvre's history. Beginning in 1827, some galleries featured "exotic" works associated with a section of the Navy Museum, then still housed in the Louvre. In 1850, a Mexican museum displaying an impressive group of pre-Columbian artifacts, notably Aztec sculptures, was opened in several rooms off the Cour Carrée. This collection was moved in 1878 to the ethnographic museum on the Trocadero, a forerunner of the Musée de l'Homme (Museum of Man) and the Quai Branly. Collecting works from remote lands is hardly a novelty. The royal collections already included a number of African, American, and Oceanic pieces. Some painted bison robes considered to be among the Louvre's most prized possessions are listed in the inventories of the Crown's holdings as far back as the eighteenth century, as are African ivories and objects brought back by the great explorers of the Pacific. Their exhibition in the Louvre is therefore more of a homecoming than an innovation.

But since the Louvre is primarily an art museum, Jacques Kerchache, the curator who initiated the project and is responsible for choosing works for exhibition in the Pavillon des Sessions, has been extremely discriminating in his selection: the items displayed are limited in number, and each is an exceptional artwork with distinctive aesthetic qualities. Rather than choose implements of everyday life, Kerchache focused on sculptures comparable to the Louvre's most glorious objects from antiquity and the Classical era. The geographic territory covered by the Quai Branly Museum is also represented here: Africa, Oceania, the Americas, and the Malay Archipelago. The art of China, Korea, Japan, Vietnam, and India is absent from the Pavillon, but it is superbly represented in the Guimet Museum.

The pieces exhibited at the Louvre originated in the collections of the Museum of Man and the former Museum of African and Oceanic Arts at the Porte Dorée; a significant portion were acquired during the last decade. These purchases have filled certain gaps in the collection and enhanced the display of masterpieces in the Pavillon des Sessions with works of the highest quality.

Although the Quai Branly Museum owns approximately 350,000 artifacts, the Louvre exhibits only about 150 objects from that immense treasure. Africa is represented by a selection of pieces ranging from Pharaonic Egypt to the more recent distinctive cultures in the western and eastern regions of the continent. Certain groups stand out, including a remarkable series of ancient works:

Nigerian Nok statuary (500 BC–AD 500), eleventh- and twelfth-century Dogon sculptures, a sumptuous head from the twelfth- to fourteenth-century Ife culture, and bronzes from Benin. Among the more recent works, several busts and sculptures from the Fang culture provide an interesting complement to a large group of pieces from Cameroon.

The Malay Peninsula is well represented by a superb statue of a figure holding a bowl, one of the most beautiful pieces preserved from the Ifugao culture (no. 468). In the Oceanic collection, the Hawaiian statue of the God Ku-Kaili-Moku may have been brought back from Captain Cook's third journey to the islands. It has been in France since 1796, when it entered the museum's main collections before being moved to the National Library's Cabinet of Antiquities two years later. For many years, visitors to the Musée de l'Homme were greeted by the large stone *moai* from Easter Island. Today it stands in the Louvre as the most massive work displayed in the Pavillon des Sessions.

The American civilizations are among the collection's strengths. Most of the great pre-Hispanic cultures of Central and South America are represented: the Olmecs with a statuette of a seated man; the cul-ture of Teotihuacán featuring stone masks (no. 476); the Mayan and Aztec people with ceramics and sculptures. A pre-Christian terracotta statuette from Chupicuaro, Mexico (no. 475), is the emblem of the Quai Branly's collections in the Louvre: it represents a female figure with accentuated curves, probably associated with the celebration of fertility rites. A transformation mask from British Columbia (no. 478) is a unique example of the Native American art of North America, as are several masks from Alaska.

The exhibition of objects from the Quai Branly at the Louvre has been hailed as officially recognizing the importance of cultures heretofore labeled primitive and dismissed. The opportunity that viewers now have to engage these works in the context of the museum's paintings, sculpture, and archaeological objects will restore their rightful standing alongside Western artworks. Perhaps they will reclaim the status they had when Picasso and other early modern painters were inspired by this art to originate Cubism and Expressionism.

462

Bitegue Statuette
Africa, Democratic Republic
of Congo
Teke people, 19th century
Wood, brass tacks, mother-of-pearl
buttons, cloth, string, magico-
religious charge, and traces of
sacrificial materials
Height 15 in. (38 cm)

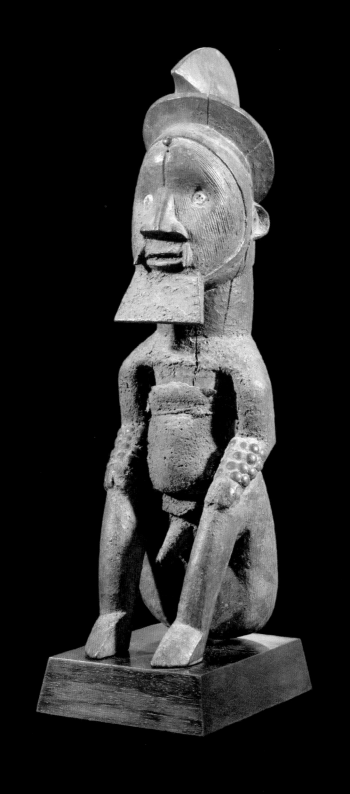

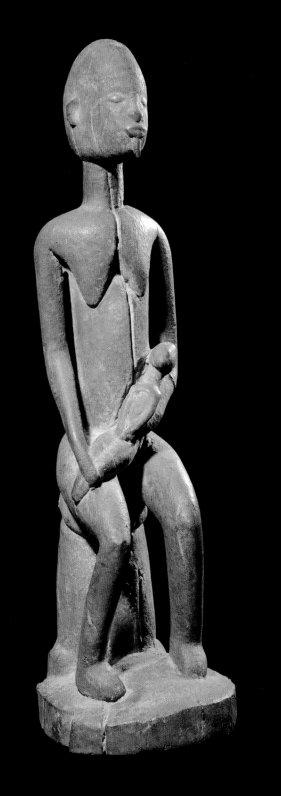

463
"Master of the Red Maternity" Statue
Africa, Mali
Dogon peoples, 14th century
Wood and pigments
Height 29 1/2 in. (75 cm)
FROM THE MUSÉE DU QUAI BRANLY (HUBERT GOLDET DONATION, 1999)

464
Nuna Sculpture
Africa, Burkina Faso
Leo Region, 18th century
Wood
Height 45 1/4 in. (115 cm)

465
Seated Male Orebok Figure
Africa, Guinea-Bissau
Bidjogo people, Caravela Island, Bissagos archipelago, 18th(?)–19th century
Wood
Height 14 5/8 in. (37 cm)

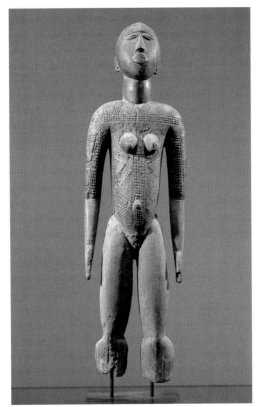

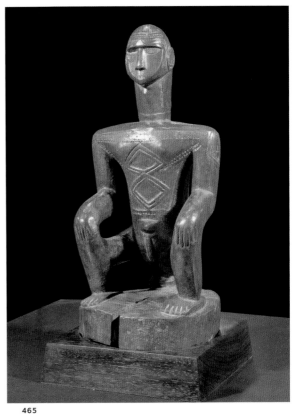

463

464

465

466
**Headrest of the "Master of
the Cascade Coiffures"**
Africa, Democratic Republic
of Congo
Luba people, 19th century
Wood
Height 7 1/8 in. (18 cm)
FROM THE MUSÉE DU QUAI
BRANLY (HUBERT GOLDET
DONATION, 1999)

467
**"Master of the Oblique Eyes"
Sculpture**
Africa, Mali
Dogon peoples, 17th–18th
century
Wood and metal
Height 23 1/4 in. (59 cm)
FROM THE MUSÉE DU QUAI
BRANLY (HUBERT GOLDET
DONATION, 1999)

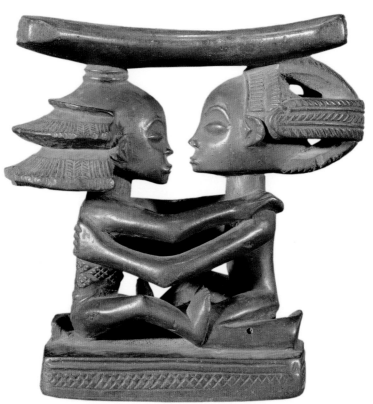

466

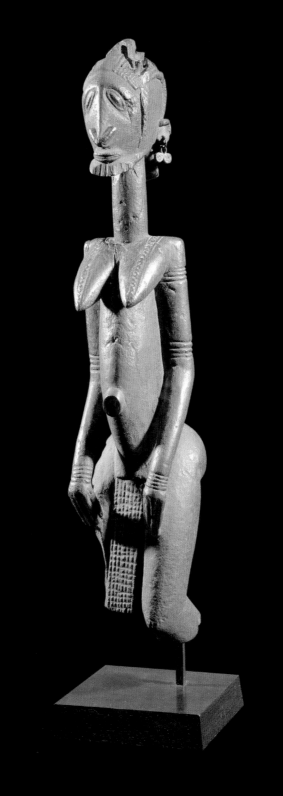

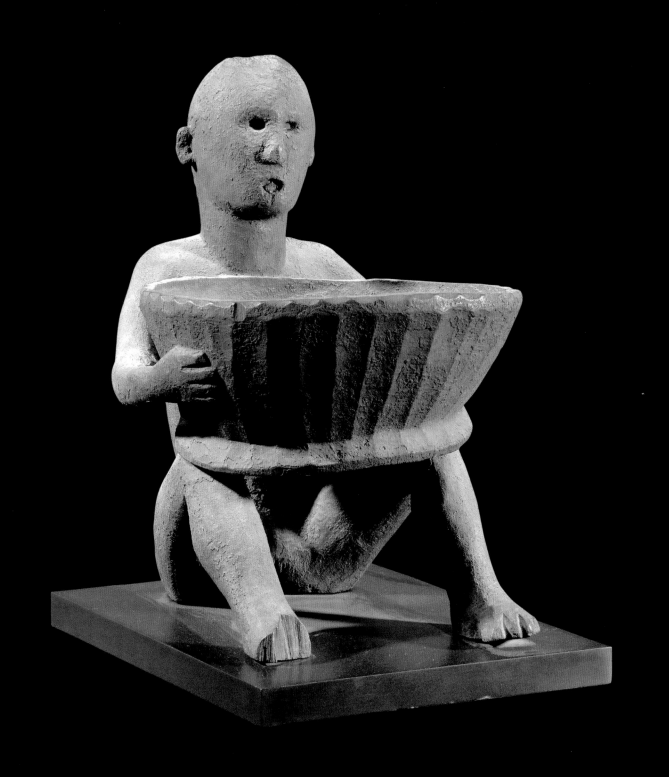

468
Seated Bulul Figure Holding a Bowl
Asia, Philippines
Ifugao people, 15th century
Narra wood and encrusted substances
Height 18 7/8 in. (48 cm)
FROM THE MUSÉE DU QUAI BRANLY (ANNE AND JACQUES KERCHACHE DONATION, 1999)

469
Toba Batak Sculpture
Asia, western Indonesia
Toba Batak peoples, North Sumatra, mid-15th century
Wood covered with a patina of soot
Height 50 3/8 in. (128 cm)
FROM THE MUSÉE DU QUAI BRANLY

470
Ana Oleo Figures
Asia, eastern Indonesia
Nage people, Flores Island, late 18th century
Wood
Height 64 5/8 and 59 in. (164 and 150 cm); (figures alone) 13 3/8 and 13 3/4 in. (34 and 35 cm)
FROM THE MUSÉE DU QUAI BRANLY (MONIQUE AND JEAN PAUL BARBIER-MUELLER DONATION, 1999)

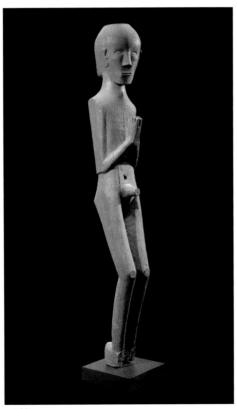

468 469 470

471
Male Figure (Moai Kavakava)
Oceania, Easter Island
17th–18th century (?)
Wood, obsidian, and bone
Height 11³/₄ in. (30 cm)
FROM THE MUSÉE DU QUAI BRANLY

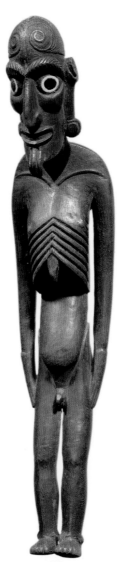

471

472
Malagan Figure
Oceania, New Ireland
19th century
Wood, red ochre, powdered lime,
charcoal, coconut fiber, and resin
Height 48 in. (122 cm)
FROM THE MUSÉE DU QUAI BRANLY

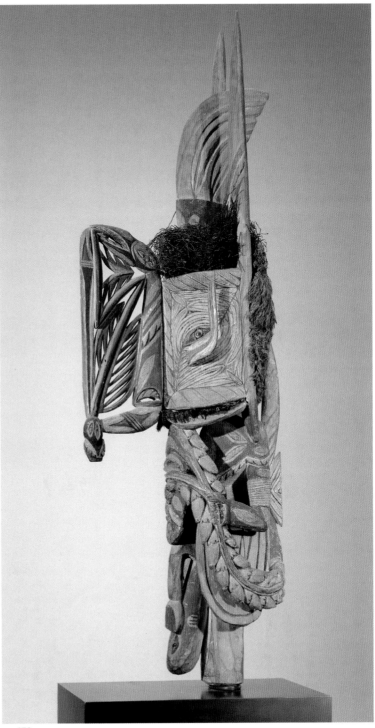

472

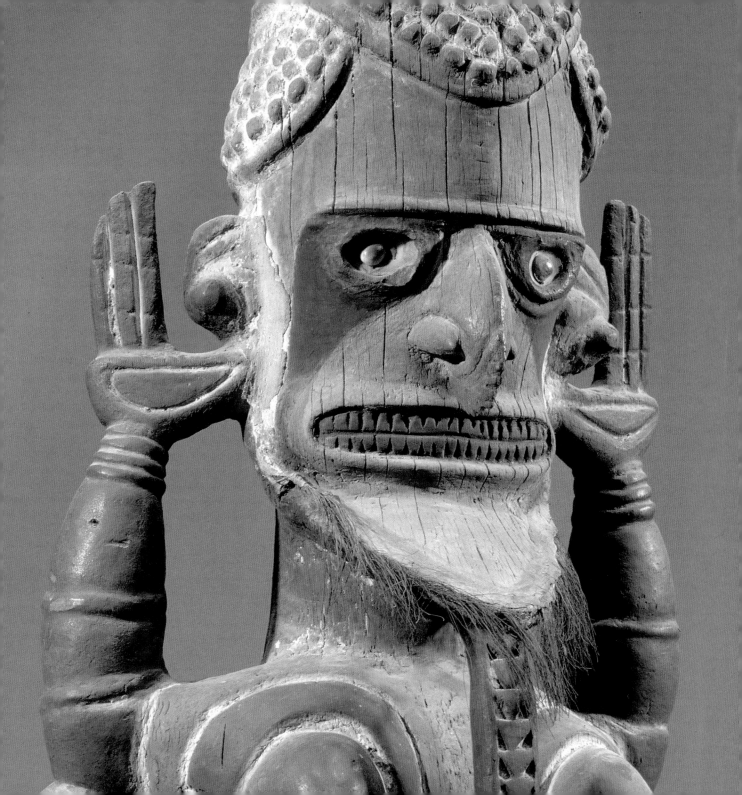

473A, 473B
Uli Figure (Ealandik type)
Oceania, New Ireland
18th–early 19th century
Hardwood, red ochre, charcoal,
lime, rootlet fibers, resin, and Turbo
petholatus catch-shell
Height 59 in. (150 cm)
FROM THE MUSÉE DU QUAI BRANLY

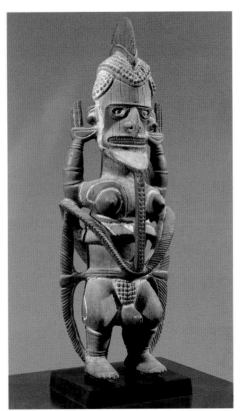

473B

473A

474A, 474B
Huastec Sculpture
Americas, Mexico
AD 1300–1500
Stone
Height 64 1/8 in. (163 cm)

475
Female Figure
Americas, Mexico
Chupícuaro, 600–100 BC
Glazed terracotta
Height 12 1/4 in. (31 cm)
FROM THE MUSÉE DU QUAI BRANLY

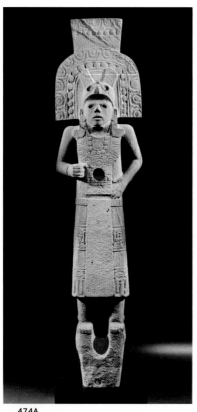

474A

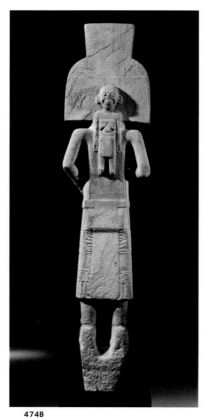

474B

475

476
Mask
Americas, Mexico
Teotihuacán, Classic Period,
200–600
Marble
Height 6 3/4 in. (17 cm)
FROM THE MUSÉE DU QUAI BRANLY

477
Large Ceremonial Ax
Americas, West Indies
Taino people, Puerto Rico,
12th century–1492
Polished gray stone
17 3/4 × 13 3/4 in. (45 × 35 cm)
FROM THE MUSÉE DU QUAI
BRANLY (ALPHONSE PINART
DONATION, 1878)

478
**Transformation Mask
(Tatltatlumtl)**
Americas, Canada
Kwakwaka'wakw (Kwakiutl)
people, 19th century
Painted wood, graphite, cedar,
canvas, and cord
Height 13 3/8 in. (34 cm); width
(closed) 20 7/8 in. (53 cm), (open)
51 1/8 in. (130 cm)
FROM THE MUSÉE DU QUAI BRANLY

476

477

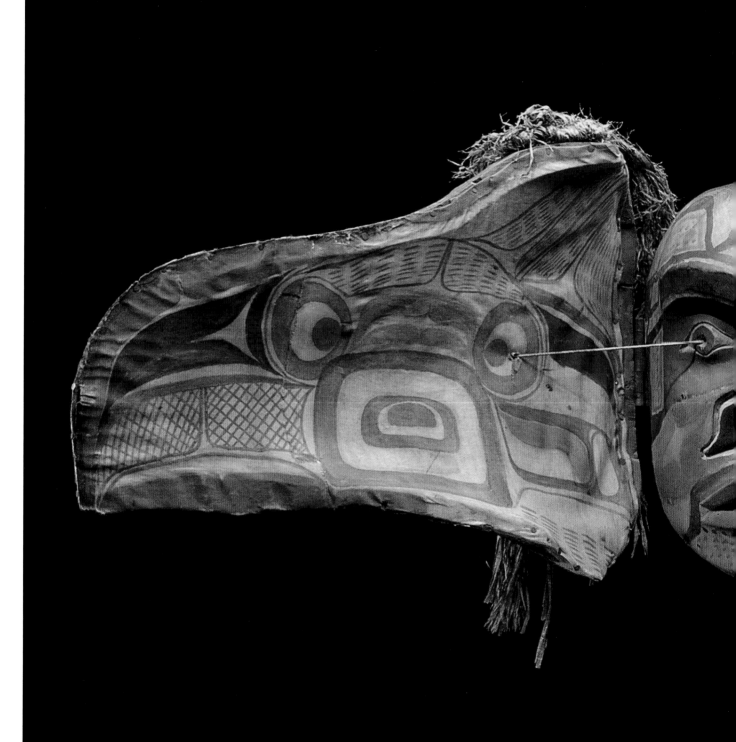

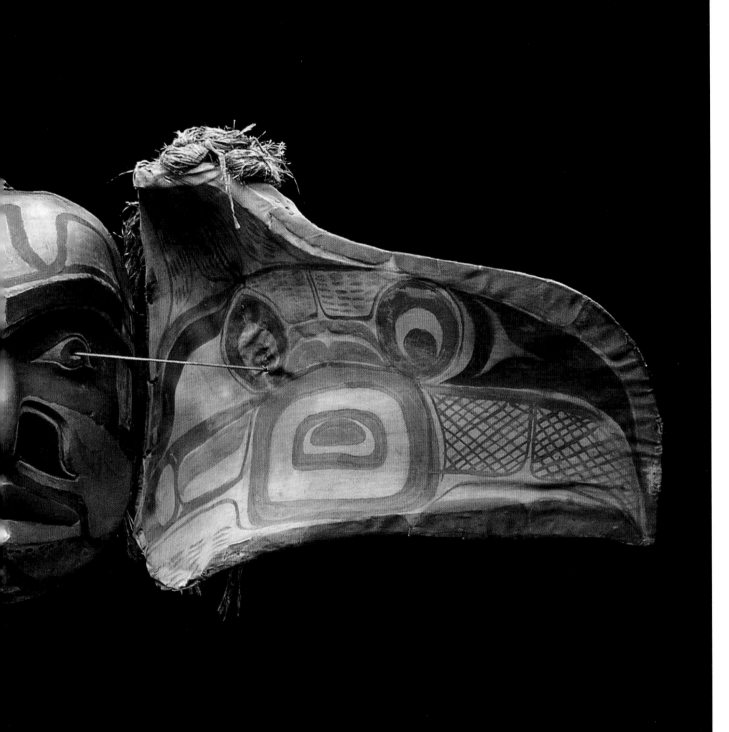

INDEX

PHOTO CREDITS

Acknowledgments

Béatrice André-Salvini
Marc Bascou
Geneviève Bresc-Bautier
Marine Degli
Jannic Durand
Gwenaëlle Fellinger
Guillaume Fonkenell
Yves le Fur
Chrystel Martin
Jean-Luc Martinez
Fanny Meurisse
Clair Morizet
Madeleine Parpet
Vincent Pomarède
Patricia Rigault-Deon
Carel van Tuyll

Musée du Louvre

Henri Loyrette
President-Director

Didier Selles
Chief Operating Officer (COO)

Catherine Sueur
Assistant COO

Christophe Monin
Cultural Service Director

Violaine Bouvet-Lanselle
Publication Director, Cultural Service

Daniel Soulié
Editorial Consultant,
Customer Service Head Office

■■■ MUSÉE DU
■■■ LOUVRE
■■■ ÉDITIONS

Éditions de la Martinière

Brigitte Govignon
Editor-in-Chief

Isabelle Grison
Editor

Marie Caillaud
Photo Researcher

**Éditions
de la Martinière**

Abrams

Magali Veillon
Project Manager

Nicholas Elliot
Translator

Sheila Friedling
Editor

Shawn Dahl
Designer

Jules Thomson
Production Manager

▲ Abrams

Design

Philippe Apeloig
Designer

Gaël Le Maître
Assistant Designer

Library of Congress Cataloging-in-Publication Data

Soulié, Daniel.
 Louvre : 400 masterpieces / by Daniel Soulié.
 p. cm.
 ISBN 978-0-8109-7116-5 (Abrams)
 ISBN 978-2-35031-185-2 (Louvre, Paris)
 1. Musée du Louvre. 2. Art—France—Paris.
 3. Musée du Louvre—History. I. Title.
 N2030.S68 2008
 708.4'361--dc22

 2008014252

Printed and bound in China
10 9 8 7 6 5 4 3 2 1

Abrams books are available at special
discounts when purchased in quantity
for premiums and promotions as well as
fundraising or educational use. Special
editions can also be created to specification.
For details, contact specialmarkets@
hnabooks.com or the address below.

HNA ■■■■■
harry n. abrams, inc.
a subsidiary of La Martinière Groupe
115 West 18th Street
New York, NY 10011
www.hnabooks.com